Burma to Myanmar

Burma to Myanmar

Edited by
Alexandra Green

The British
Museum

Published to accompany the exhibition *Burma to Myanmar* at the British Museum from 2 November 2023 to 11 February 2024.

Supported by Zemen Paulos and Jack Ryan
WIth additional support from Gillian and Ron Graham

First published in the United Kingdom in 2023
by The British Museum Press

A division of The British Museum Company Ltd
The British Museum
Great Russell Street
London WC1B 3DG
britishmuseum.org/publishing

Burma to Myanmar
© 2023 The Trustees of the British Museum
Text by Melissa Carlson © Melissa Carlson

A catalogue record for this book is available from the British Library.

ISBN 978-07141-2495-7

Designed by Daniela Rocha
Colour reproduction by Altaimage
Printed in Belgium by Graphius

Images © 2023 The Trustees of the British Museum, courtesy of the British Museum's Department of Photography and Imaging, unless otherwise stated on p. 268.

Further information about the British Museum and its collection can be found at britishmuseum.org.

Front cover
Shwe-chi-doe (*kalaga*) illustrating scenes from the Ramayana, *c.* 1900–30. British Museum, London, 1999,1103,0.2. Donated by Henry Ginsburg.

Back cover
Soe Yu Nwe, *Green Burmese Python*, 2018. British Museum, London, 2022,3019.1. Purchased from the artist in 2022 via the Brooke Sewell Permanent Fund.

Frontispiece
The Golden Letter from King Alaungpaya of Myanmar to King George II of Great Britain, 7 May 1756. Gottfried Wilhelm Leibniz Library, Hannover, Germany, Ms IV,571a.

Note on the text
The terms 'Burma' and 'Myanmar', and their use throughout the book, are explained in the introduction. Diacritics are generally omitted in transliterated languages. The map on p. 9 uses modern names for places, with the exception of rivers: Irrawaddy, Chindwin and Salween. If an object's place of origin is simply 'Myanmar' rather than a specific location, it is omitted from the caption.

CONTENTS

DIRECTOR'S FOREWORD

HARTWIG FISCHER

opposite (see also fig. 9.15)
Thynn Lei Nwe, *The Moving Years*, 2022. Yangon. Watercolour on paper. H. 54.6 cm, W. 38.1 cm. British Museum, London, 2022,3039.1.a. Purchased from the artist in 2022 via the Brooke Sewell Permanent Fund.

This publication springs from the first major exhibition in the United Kingdom covering the history of Myanmar. Isolated for many decades after a military coup in 1962, Myanmar is relatively unknown to most of the world, including the UK, which as a colonial power controlled the region for over 120 years. Yet one of Myanmar's historic kingdoms became mainland Southeast Asia's largest empire between the sixteenth and eighteenth centuries, and its wealthy kingdoms and polities engaged with the world around them through trade, diplomacy, religious networks and warfare. Incorporating significant objects ranging in date from the 400s CE to 2022 – from lustrous green jadeite and elaborate teak carvings to luxurious court robes, silver coins for trade, intricate textiles, colourful maps, modern banknotes and contemporary art – this book focuses on the impact that historical, cross-cultural interactions have had on art and material culture and the amazing creativity and industry of the many peoples of Myanmar. A feature of the country is that its many regions were not a single political entity until independence from the British in 1948, and Myanmar is one of the world's most diverse countries culturally. *Burma to Myanmar* seeks to construct an integrative history that explores how to comprehend multiplicity without unduly prioritising the majority.

Fruitful discussions in 2019 and early 2020 between the British Museum and Myanmar's many museums, its Department of Archaeology and the Ministry of Religious Affairs and Culture were terminated by the military coup of 2021 that plunged the country into extreme violence. The ongoing civil war and humanitarian crises in Myanmar have precluded institutional collaboration. However, many museums and collections across the UK hold quantities of Burmese material, much of which has never been on display before. By drawing primarily on objects in the UK, the exhibition and book comment on the role of objects in the creation of colonial connections.

We are grateful to be able to include two exceptional objects from institutions further afield: Hannover and Singapore. From the Gottfried Wilhelm Leibniz Library comes the letter written by King Alaungpaya of Myanmar to King George II of Great Britain in 1756. A diplomatic overture from one head of state to another, the sumptuous missive, now registered as a UNESCO Memory of the World object, is written on a sheet of gold studded with twenty-four Burmese rubies (see pp. 2–3). The other object, from the Asian Civilisations Museum, is less commonly associated with Myanmar – a Qur'an box from the Muslim community (see p. 88). Elegantly decorated in the Burmese *hmansi-shwe-cha* technique using lacquer and inlaid pieces of glass, it speaks to the long-standing presence of Muslims in Myanmar and the diverse nature of the region as a whole.

For the generous loans to this unique exhibition and publication, my sincere thanks go to the Asian Civilisations Museum, Singapore; Brighton & Hove Museums; The British Library; Calderdale Museum Services; Cambridge University Library; Gottfried Wilhelm Leibniz Library, Hannover; Gurkha Museum, Winchester; Imperial War Museum, London; National Museums Liverpool, World Museum; National Museums Scotland; the National Trust (Kedleston Hall, Derbyshire); Pitt Rivers Museum, University of Oxford; Royal Asiatic Society, London; Royal Collection Trust; Russell-Cotes Art Gallery & Museum, Bournemouth; Victoria and Albert Museum, London; Wellcome Trust, London; private collections and galleries; and artists from Myanmar. We are also indebted to colleagues from around the world who have contributed time and expertise to the development of this project, especially the authors and contributors to this book. *Burma to Myanmar* could not have been realised without the generosity of Zemen Paulos and Jack Ryan and the support of numerous friends, patrons and donors.

INTRODUCTION

ALEXANDRA GREEN

On 7 May 1756 King Alaungpaya (r. 1752–60), founder of the Konbaung dynasty based in central Myanmar, wrote a letter to King George II of Britain (fig. 0.1, see also pp. 2–3). The letter was sumptuously written in refined and elegant Burmese on a gold sheet, set with twenty-four Burmese rubies and enclosed in an ivory container. Meant as a diplomatic overture between rulers, the text of the letter graciously sought to establish friendly relations between the two kings and granted to the British the use of a port location in Pathein (Bassein) that they had been keen to acquire. Unfortunately, King George never responded, merely dispatching the letter to his library at Hannover in Germany.

King Alaungpaya's initiative to form a direct and equitable connection with a European monarch, as well as to establish a firm trading relationship with the East India Company, thus failed.[1] Despite this particular disappointment, the Konbaung kingdom of the mid- to late eighteenth century was dynamic and aggressive, participating in land and sea trade networks, promoting Buddhism and expanding militarily into Arakan, Bago, the Shan states, northern and central Thailand, southwestern China, the kingdoms of Ahom and Manipur in present-day India and down the Thai-Malay peninsula to form one of mainland Southeast Asia's largest empires. It was this extended empire that the British annexed in three phases in the nineteenth century and which was lumped together, without consideration for the histories of the separate parts, into a modern nation state in 1948. This volume explores the kingdoms and peoples of the area that is now Myanmar to demonstrate how different cultures and their interactions with the world around them have contributed to the region historically as well as in the present.

Place and people

Formed as a complete entity for the first time only in 1948, Myanmar is a kite-shaped country located at the western edge of mainland Southeast Asia (fig. 0.2). The country borders Bangladesh, India, China, Laos and Thailand, and sits atop the Bay of Bengal, the Andaman Sea and the Gulf of Martaban. It stretches from the foothills of the Himalayas to the Thai-Malay peninsula, encompassing tropical rainforest, semi-arid zones, snowy mountains, and subtropical and temperate climes. Comprising numerous regions, including the western mountain ranges, the deltas of the Irrawaddy and Salween rivers and the coastal plains, an eastern mountainous plateau, northern mountains and a central lowland dry zone, its landmass covers more than 675,000 square kilometres. The regions are populated by a myriad of different ethnic groups, creating a rich mosaic of peoples speaking over 100 different indigenous languages and dialects. Burman Buddhists, who live mostly in the central and delta regions, form the majority. The Shan, who are primarily Buddhist, are related to the Tais of northern and central Thailand and Laos, and the Rakhine peoples are predominantly Buddhist. The highland areas encircling the central lowland region are particularly diverse and, of the many upland groups, only the Karen peoples have settled on the plains in substantial numbers.

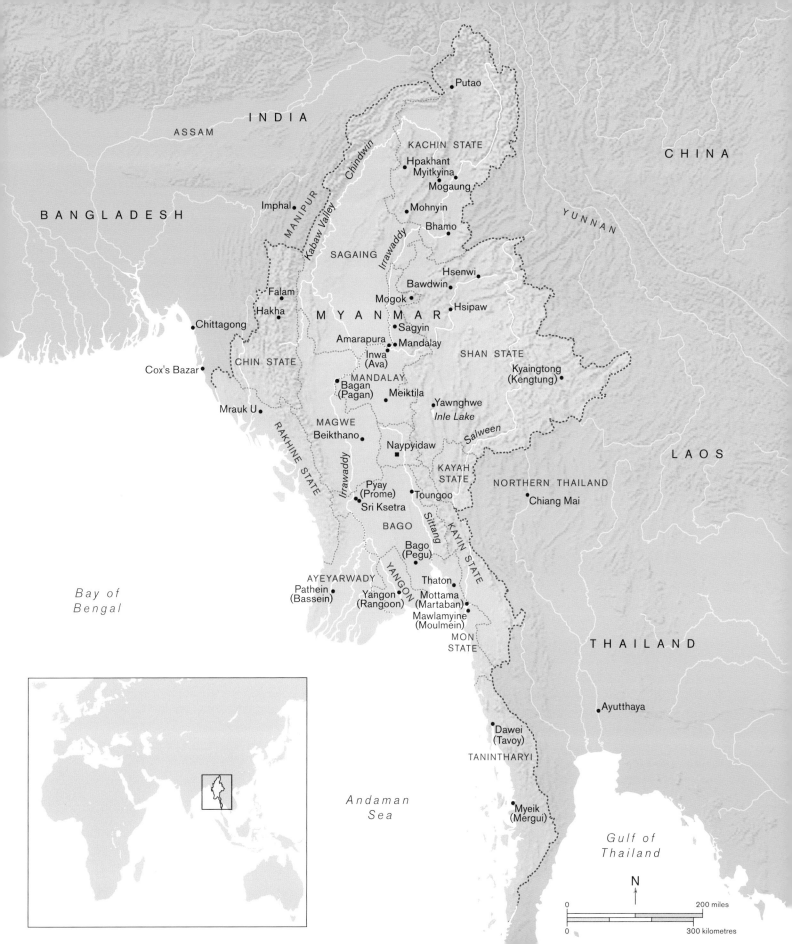

INDIA

ASSAM

BANGLADESH

CHINA

Putao

KACHIN STATE

Hpakhant
Myitkyina
Mogaung

Imphal

MANIPUR

Chindwin

Kabaw Valley

Mohnyin

Bhamo

YUNNAN

SAGAING

Irrawaddy

Hsenwi
Bawdwin

Falam

Mogok

Hsipaw

Hakha

M Y A N M A R

Sagyin

Chittagong

Amarapura · Mandalay

Cox's Bazar

CHIN STATE

Inwa
(Ava)

SHAN STATE

Kyaingtong
(Kengtung)

Mrauk U

MANDALAY

Bagan
(Pagan)

Meiktila

Yawnghwe

Inle Lake

MAGWE

Beikthano

Salween

LAOS

Naypyidaw

RAKHINE STATE

Irrawaddy

KAYAH
STATE

Bay of
Bengal

Pyay
(Prome)

Sri Ksetra

NORTHERN THAILAND

Toungoo

Chiang Mai

BAGO

Sittang

KAYIN STATE

Bago
(Pegu)

AYEYARWADY

YANGON

Thaton

Pathein
(Bassein)

Yangon
(Rangoon)

Mottama
(Martaban)

Mawlamyine
(Moulmein)

MON
STATE

THAILAND

Andaman
Sea

Ayutthaya

Dawei
(Tavoy)

TANINTHARYI

Myeik
(Mergui)

Gulf of
Thailand

N

0 200 miles

0 300 kilometres

Many of these various groups are now Christian, some Buddhist and others animist. Myanmar also has substantial Muslim and Hindu communities, as well as smaller groups espousing other religions, some historical and others dating to the colonial period or after independence. In the process of categorising various groups, which primarily occurred during colonial times, many have been subsumed under comprehensive names that can belie the complexity and variety of the region. Today, about 55 million people live in Myanmar, most of whom are cultivators, as the country is overwhelmingly rural. Important cities in the past included the ports of Bago (Pegu) and Mrauk U, centrally located Amarapura and upland Bhamo, Mogaung and Kyaingtong (Kengtung). The current major cities developed in the nineteenth century, in particular Mandalay, built in 1857, and Yangon (Rangoon), which became the capital of British Burma after 1852 and of the independent nation state after 1948 until the capital was relocated to a newly constructed city, Naypyidaw, in 2005.

Burma or Myanmar?

When discussing Myanmar, the question of its name arises. Does one call it Burma, a name associated with early visits by Europeans, the British colonial period, and the country between 1948 and 1989? Or does one use Myanmar, a name associated with the courts of central Myanmar before colonial times and the official name designated by the authoritarian military governments since 1989? There is no consensus. Yet, even this dichotomy is not as straightforward as it seems. 'Bama' and 'Myanma' are both historical terms used to describe the ethnic group that formed the basis of the Bagan kingdom (c. eleventh–thirteenth centuries). The phrase 'the country of Myanmar' can be found in an inscription at Bagan dated to 1235 and in later official writings to designate only the kingdom based in the central region, which is part of the much bigger modern nation state. Other polities, such as the Shan states and the southern region associated with the Mon peoples, Arakan, and so forth, were called by their own names. Burma, Burmah, Birmanie and other similar terms were used by European travellers and then by the British during colonial times and the Japanese during the Second World War. 'Burmese' was a descriptive term developed in the 1930s by local nationalists to describe all people in the country as efforts to throw off the colonial yoke accelerated. Upon gaining independence in 1948, the country was officially designated the Union of Burma, a name that lasted until it was changed by the military government in 1989.

Although used to refer to the country as a whole since 1948, neither Burma nor Myanmar are terms that technically represent all the different peoples within the modern state, the two names being an inherent reference to the Burman (Bamar) ethnic group (the vast majority of whom are Buddhist). Even the descriptor of the majority ethnic group is problematic – should it be romanised as Burman or Bamar? In addition, this category itself does not account for the descendants of people brought into Myanmar's kingdoms during periods of warfare and colonisation who have been subsumed into the Burman group – people from Yunnan, Lan Na (northern Thailand), Ayutthaya (central Thailand), the kingdom of Luang Prabang in present-day northern Laos, Arakan and elsewhere.

It is beyond the scope of this volume to address or resolve these issues of terminology, if that is even possible. Here, Myanmar will refer to the country generally, including the whole area that now forms the modern state but which was once numerous separate political entities. These entities varied over time but will be referred to by their individual names. The name 'British Burma' will be used for the colonial period. This is complicated by the fact that the British annexed the region in three phases – first Arakan and Tanintharyi, then Bago and Yangon, and finally what the British called Upper Burma. British Burma will include both the directly ruled central and lower regions and Arakan – where social structures were replaced by a colonial apparatus – and the Scheduled (later Frontier)

Areas that were indirectly ruled by the British through local social hierarchies in conjunction with some British systems. During the colonial period, but prior to 1885, the different parts of the country will be referred to by their individual names or through three more general designations – Upper Burma (the landlocked kingdom after the second annexation), Lower Burma (the areas taken by the British in the first two Anglo-Burmese wars) and Upland Burma (the hill regions subjected to indirect rule that were mostly acquired after 1885). The term Burman, rather than Bamar, will refer to the ethnic group, and because 'Myanmar' does not lend itself to being transformed readily into an adjective in English, 'Burmese' will be used instead.

Some of the issues besetting terminology for Myanmar come from Southeast Asian political traditions where spheres of influence and the control of people predominated, and hard territorial boundaries were not of significance. Political relationships among the numerous peoples and societies were often tribute-based, including exchanging women as wives and concubines. Patron–client ties, where a powerful or wealthy person bestowed goods and services on followers who provided political support, were common. There have been numerous political centres, including polities in Arakan in the west; the Shan principalities in the east; kinship and marriage networks resulting in complex social ties across groups in upland areas; ports and kingdoms in lower Myanmar dominated by the Mon; and the Pyu peoples and the kingdom of Bagan in central Myanmar. After the decline of Bagan, kingdoms in central Myanmar waxed and waned, at times becoming mainland Southeast Asia's largest empires. In the sixteenth to the early nineteenth centuries, they expanded and contracted over lower Myanmar, the Shan states, central and northern Thailand, northern Laos, the Thai-Malay peninsula, Manipur and Assam in India, Sipsong Panna in Yunnan Province in southwestern China, and Arakan. All these other entities, including the kinship networks, also expanded and contracted during this period, though the kingdoms never became as large as the empires of central Myanmar at their peaks. Starting with the First

Anglo-Burmese War of 1824–6, increasingly hard borders with India, China and Thailand were imposed. Eventually, as the peoples of the Kachin and Chin regions and the Shan states were persuaded to join the Union of Burma in 1947, and the Karen and Karenni were included by the British, the current shape of the country was established.

Left in ruins as well as severe debt after the Second World War and the departure of the British, Myanmar has subsequently struggled to bring together the various regions to function effectively as a country, as evidenced by the fact that, since 1949, it has seen the longest-running civil wars anywhere in the world. There are currently 135 officially recognised ethnic groups, as well as many who are not recognised by the military government, including the Chinese, Gurkhas and Rohingya (against whom genocide was perpetrated in 2017 and who are among the many groups that continue to be persecuted). Multiple competing perspectives, anxieties about cultural and religious decay, stress from poverty and oppression, prejudice, misinformation and rigid ideas of what constitutes unity within the state make it impossible for the country to function cohesively. The lack of reliably functional social, educational and governmental structures has exacerbated these issues, and the country is now highly fragmented and embedded in an intractable situation. Myanmar's military dictatorships and governmentally imposed isolation from the early 1960s to the 1990s have led the world to view it as poor and dysfunctional, with its importance primarily related to its resources and geographical position, yet this has not been the case historically.

A diverse space

The organisation of this book is largely chronological. However, it does not provide a straightforward series of events; rather, the essays explore Myanmar's history through transcultural interactions. Each chapter starts from the premise that 'civilisation' compels us to analyse not just

cultures' distinctive features, but also how they spread into one another and merge with one another.[2] Instead of viewing the global and the local in a binary fashion, however, we should see them as an interconnected web of modulating practices where external changes flow towards the centre, and external ones ripple outwards to impact the network, with a diminishing effect the further from each other they move.[3] Transformed by assimilation and adaptation, material objects both reflect and play a part in this creation of cultures.[4]

Diverse interactions around the region and further afield have contributed to the production of art and material goods, and one purpose of this book is to look at these 'multiple genealogies'[5] – how intercultural engagements have shaped Myanmar's arts and how, in turn, those objects have been agents of change themselves. The numerous cultures in Myanmar, past and present, demonstrate the tremendous heterogeneity of the country. Even those who are considered the majority people – the Burmans – are not homogeneous, having come voluntarily (or not) from the cultures of the wider region, a complexity that was obscured when Buddhists were 'Burmanised' under the British. While it is not possible to address all the political centres and cultures that have existed within the area now demarcated as Myanmar internationally, this book strives to demonstrate the complexity of a region that is too often simplistically described, if at all.

Myanmar's various polities participated in global trade networks between India, China, Africa, the Middle East and Europe, exporting their rich natural resources, importing items from salt to luxury textiles, and functioning as a trans-shipment area between the coast and southwestern China and inland regions (the subject of chapter 1). Chapter 2 addresses trade, cultural and religious links with India and Sri Lanka, focusing on the Pyu peoples and the Bagan kingdom of central Myanmar, as it is these that have been studied in the greatest detail. Other regions still await substantive archaeological investigation.[6] The interaction and warfare between the different political

centres, the expansion of the various kingdoms between the sixteenth and nineteenth centuries, and the extensive movement of people – both voluntary and involuntary – promoted the development of arts that displayed the regions', and now the country's, diversity (see chapter 3). The fourth chapter focuses on the cultural productions of the nineteenth and early twentieth centuries, when Myanmar was part of the British empire, having come under colonial control after a series of wars. In chapter 5, a project testing the dyes and fibres of Karen textiles from the nineteenth century by the British Museum's Scientific Research Department indicates the speed at which synthetic dyes and fibres spread far and wide, challenging the notion of the supposed remoteness of the highland areas of Myanmar which, in fact, were clearly once highly connected with global trends. The colonial experience oversaw dramatic changes to local societies, impacting the arts and cultures extensively and, in some instances, setting the stage for the conflicts of today. Chapter 6 explains the context of the Second World War and the Japanese Occupation from 1942 to 1945, which hugely damaged the country, but the Burmese used the conflict to pressure the British to begin independence talks. The often tragic events of the second half of the twentieth and the early twenty-first centuries are addressed in the final three chapters, which explore issues associated with the representation of diversity and minoritised communities (chapter 7), the role, development and use of material culture in the independent nation (chapter 8) and how modern and contemporary artists have responded to the challenges and authoritarianism of the time (chapter 9).

By exploring Myanmar's histories through cross-cultural interactions, it is possible to perceive its numerous cultures generating and responding to change in tandem with the networks in which the world is enmeshed. This volume is a history through objects, but it is not a straightforward exploration of artistic production over time; rather, it seeks to explore the roles of objects in history. How have Myanmar's cultures engaged with the world around them

and incorporated these experiences into their own arts and material cultures? What were the historical as well as creative responses to key events, such as when the kings of Bagan sent missions to repair the Buddhist temple at Bodh Gaya in India; when the kings of central Myanmar colonised Lan Na in present-day northern Thailand and relocated people back to its heartland; when Arakan's kings traded extensively with the Indian Ocean world, Kachin chiefs controlled entrances and exits to mountain passes, and the Mon of lower Myanmar were invaded by the kingdom of Ayutthaya in central Thailand? Or the consequences of numerous trade routes crossing the Shan states, Burmese silversmiths expanding their clientele during the British colonial period, and General Ne Win setting the country on the 'Burmese Way to Socialism'?

Conversely, why did a straight-sided superstructure become particularly popular at Bagan in the thirteenth century? Why did King Dhammaraja Hussain of Mrauk U in Arakan issue coins with inscriptions in three languages? What was the purpose behind a Kachin chief wearing a Chinese court robe? Why were acanthus-leaf designs incorporated into Burmese silver? Why were conventional objects converted into substrates for painting in the twentieth century? These questions demonstrate how objects reveal historical and social events and interactions, as well as how they project imagery and ideas outwards in time and space through longevity or replication or reuse further afield. Through objects we can see how ideas are retained, discarded or adapted, with their presence also promoting perpetuation or change.

Myanmar is a heterogeneous place. In answering these questions and exploring the country's histories from a cross-cultural and material perspective, the question of how to write an equitable history arises. Mandy Sadan discusses minoritised communities in chapter 7 – people who only become 'minorities' when considered within the remit of the modern nation state and who are not minorities in their own regions or when their regions were not part of a centralised state. These communities also have extensive histories of cross-cultural interactions, absorbing ideas from the world around them and contributing to shaping that world. The structure of the volume therefore accepts the diversity of Myanmar as a fundamental feature. As there is insufficient space to discuss all the peoples of Myanmar in this book, the selection of communities has been based on the collections available for examination in the United Kingdom (UK). While this emphasises some societies and does not give a full picture of Myanmar, it is a means to introduce the country and its complexities.

This book reveals that the modern nation state of Myanmar, with its perceived foundations in the central region, was not historically inevitable, nor can it be viewed as a homogeneous space. Although the kingdoms based in central Myanmar did periodically colonise and conquer parts of the world around them, violent political amalgamation is often not permanent and does not imply cultural convergence. For instance, Arakan was held as part of the centrally based kingdom with its Burman majority for only forty-two years before it was acquired by the British. They in turn gave Arakan to the Burmese state in 1948 without consideration of its status as separate historical kingdoms for approximately 1,500 years prior to annexation in 1784 by the court based in central Myanmar.

The kingdoms in lower Myanmar, including Hanthawaddy, were also independent entities that periodically came under the control of the kingdoms located in the central region. In 1948, they had the same experience as Arakan, despite seeking self-determination. The Shan states entered into tribute and marriage relationships with the various kingdoms around them, as well as being periodically at war with, and overrun and colonised by, armies from the central region. They were ruled separately during the colonial period and joined the new Union of Burma as an amalgamated Shan State with the right to secede after a decade, something that was later denied. Relationships between central Burmese courts and the various highland groups prior to the British colonial period were not ones of territorial or cultural domination.

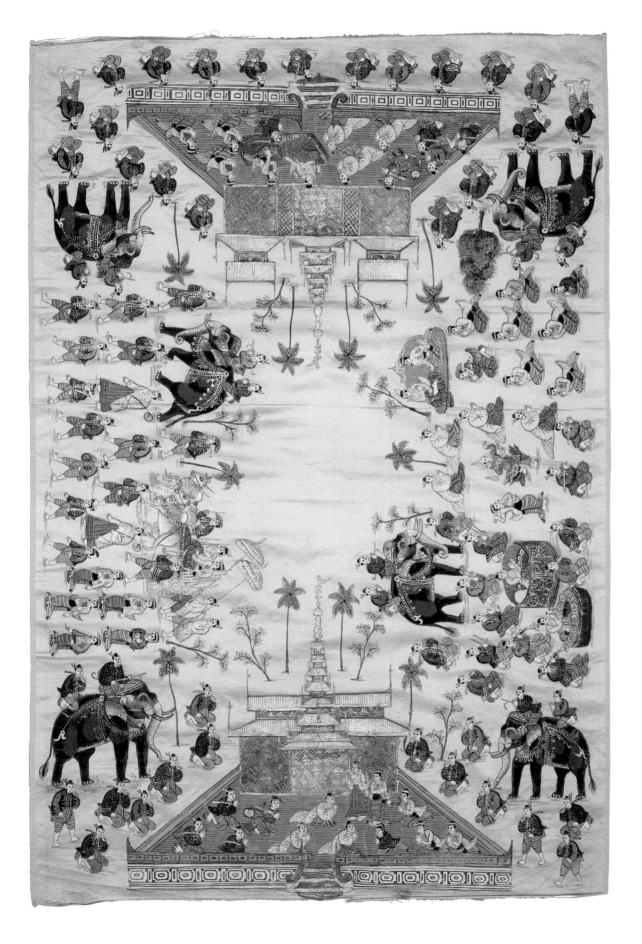

Often meeting stiff resistance, the British gained control
of the highlands incrementally over the thirty years after
the Third Anglo-Burmese War in 1885, and some areas
were never conquered but were simply included as part of
'British Burma' when borders were drawn on a map. Upon
independence in 1948, the Chin Hills were made a special
administrative division, while Karenni State was accorded a
status like that of Shan State. The Kachin were given a state
but no right to secede, and so forth. Since independence,
particularly after the military takeover in 1962, the history
of the central realms with their Buddhist roots has been
used to represent the entire country in the state curriculum.
The complexities of Myanmar thus become abundantly
clear through even such simple surveys of its histories.
The chapters in this book untangle some of the threads of
political, social, religious and artistic interactions among
these entities through the lens of material culture.

The shape of collections

Most of the objects illustrated in this book come from
collections in the UK. Burma was an important colony to
the British, although it is little known in the UK today. As
a result of British colonisation, however, many museums –
national, regimental, regional – and institutional collections
in the UK contain at least a few objects from the country.
As I travelled around the UK looking at these collections in
preparation for this project, I was surprised to discover that
many hold the same types of object – white stone Buddha
images from the nineteenth to the early twentieth centuries;
textiles from the major ethnic groups such as the Karen (see
chapter 5); silk table runners (fig. 0.3); wooden figures (see
fig. 4.21); picture and mirror frames in the shape of Burmese
thrones (fig. 0.4); and objects of use, including letter openers,
gongs, silver bowls, wall-mounted brackets and lacquer
boxes. Occasionally, there were pieces of furniture. Overall,
the objects were remarkably repetitive, though usually there
was something extraordinary in each collection. Given the

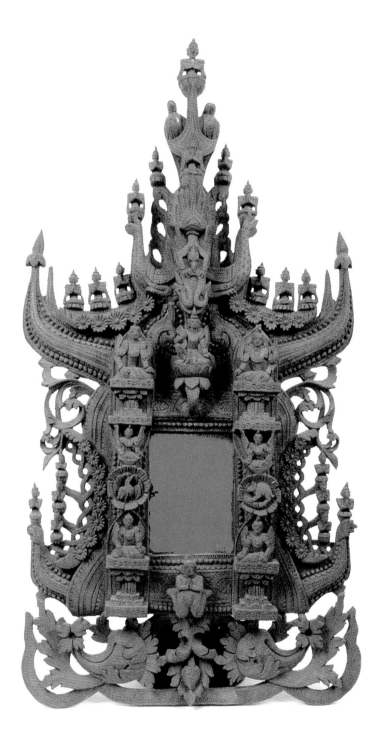

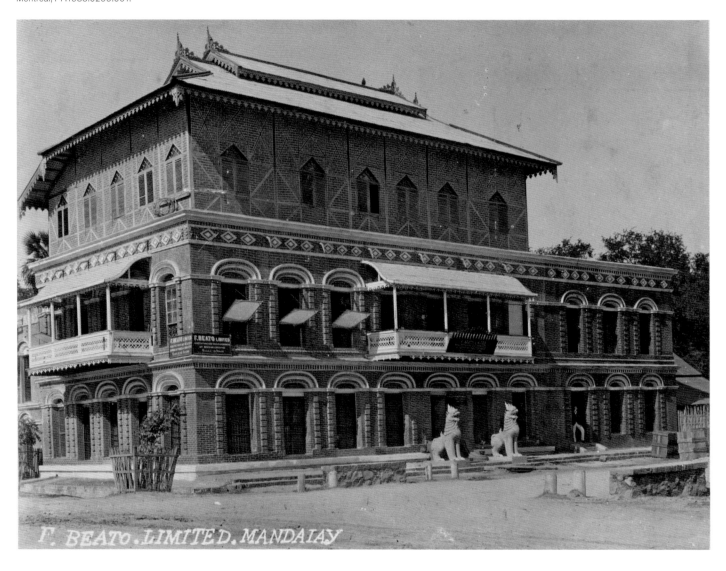

F. BEATO. LIMITED. MANDALAY

variety of Burmese art, I thought the selection must be more a reflection of the British and their tastes and material requirements than of what Burmese artists were producing for local consumption. In other words, the objects were produced for Europeans in a Burmese style, not pieces made for local use and secondarily acquired by Europeans. Then I found two mail-order catalogues dated to 1903 in the Victoria and Albert Museum's collections, and the similarities of the Burmese collections across the UK started to make more sense.

The mail-order books were produced by the Italian photographer Felice Beato. He travelled around the region from 1886 to 1905, opening photographic studios and curio shops aimed at Western customers in Mandalay and later Rangoon in the 1890s (fig. 0.5). It has been argued that his representation of the country through the catalogues can be understood as 'a commodification of the Burmese experience for the consumer'.[7] Beato's mail-order catalogues of wares for potential customers displayed everything from furniture such as sideboards and gong stands to ivory letter openers,

painted fans, silk table runners, *kalaga* or *shwe-chi-doe* tapestries, silver objects and utensils, card holders, mirrors, spoons and tea services (figs 0.6–0.8) – a similar selection to that above (see p. 15). As John Lowry, curator at the Victoria and Albert Museum, wrote in his discussion of Beato's catalogues, they:

provide a fascinating glimpse of fashionable decorative taste among Europeans (mostly British) … and also remind us of some of the social conditions that prevailed. The items that Beato offered for sale are decorated with florid Victorian ornament carried out in an unmistakably Burmese idiom.[8]

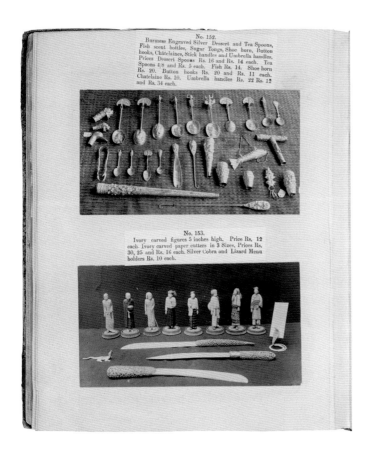

These kinds of catalogue pieces, made to order
by Burmese craftsmen and artists, now comprise the
Burmese collections in numerous British institutions.
The repetitiveness of such objects comes from the fact
that these were the things that were easily accessible and
culturally comprehensible for the majority of British people,
who were not specialist collectors. This is borne out by the
British Museum's own Burmese collection, also originating
in colonial contexts.[9] What we see in UK collections is
a dynamic combination of Burmese artistic production
and British interest in a specific body of materials, and
the adaptations made by Burmese artists to suit a new
clientele. The objects also came to stand for Burma as a

cultural space in British perceptions. UK collections reflect
the impact of new markets and collecting (choosing what
is considered noteworthy and worth collecting) upon how
one culture is represented to another through objects.
The result is that particular aspects of Myanmar can be
seen in the collections, while others are much less well
represented or even largely invisible. For instance, although
representing a substantial presence in the country, as
indicated by the large mosque in Yangon (fig. 0.9),
the Burmese Muslim community was not considered
by collectors to represent 'Burma' and were therefore
rarely collected. The focus was on the Buddhist Burman
majority, and that is what is represented in UK collections.

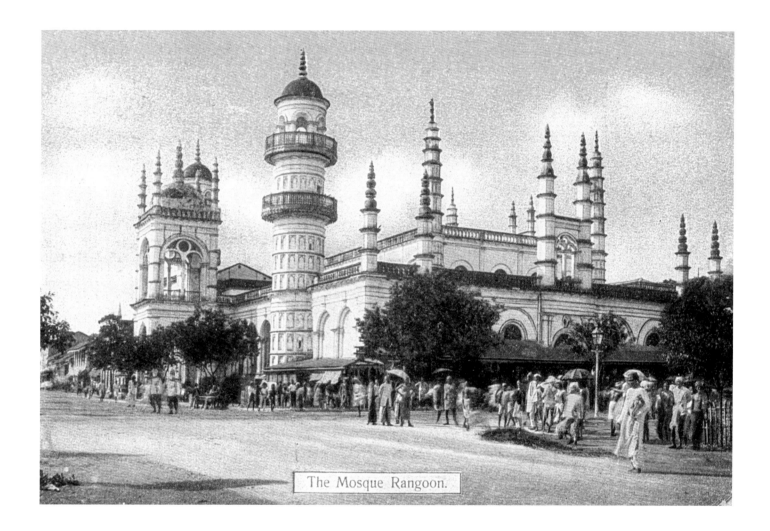

The Mosque Rangoon.

Minoritised groups were also not viewed with the same interest as the majority, and their material cultures were primarily explored through textiles, even though such objects were not considered 'art' by collectors and were often another way of classifying the various peoples according to contemporary anthropological theory. This is of course not to say that there are no exceptional pieces in British institutions, nor that specialist collecting with a focus on creating comprehensive bodies of material, such as the manuscripts and books at the British Library, has not occurred. However, these efforts emerged from the interests of specific individuals or institutions rather than through mail-order catalogues or haphazard acquisition.

This book explores the numerous histories and ideas that have coalesced in artistic production among the diverse peoples of Myanmar. The objects illustrated, while largely based on UK collections, ultimately demonstrate the 'multiple genealogies' that compose artistic and cultural worlds.

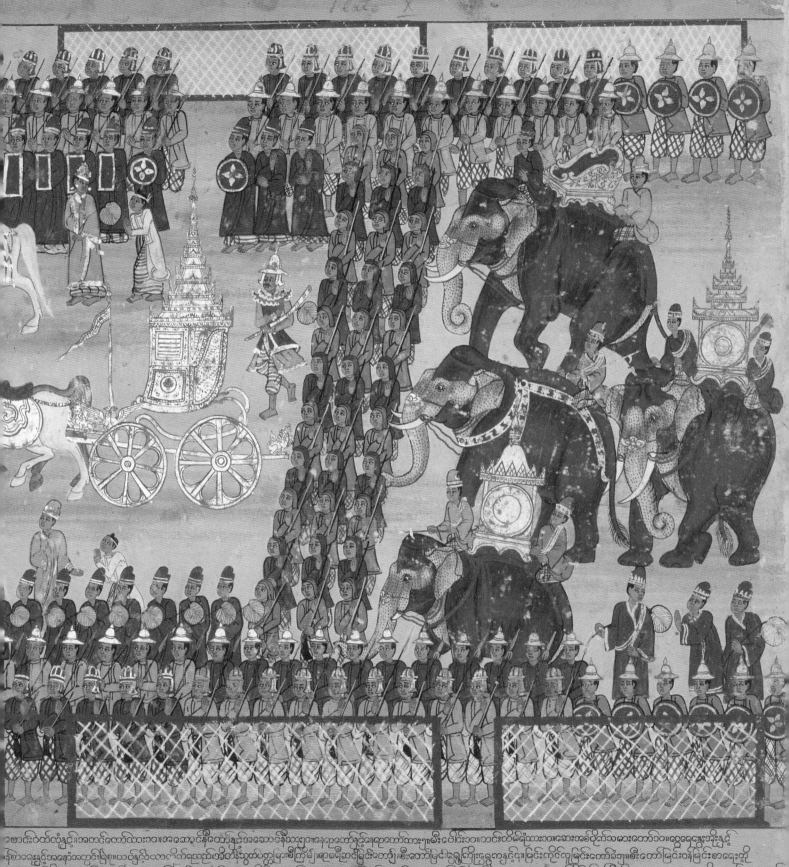

ၜဃင်းဝ်တ်ယုံနှင့်၊အခင်တော်သား၁၀၊၊အသာဃၚိုၕတော်နှင့်၊အသောၚိန်သားၚၜုၜနှၚုၜေၚုၚာ္ၚော်သားၚ၊မ်းၜေၚ်ၚ၊တၚ်းတၚ်မၜသားၚ၊၊ဆေးအဥ္ေတ်သလၚ်သား၊ဂၚ၊ၜၙ္ေၚၜုၚနှၚ်
ၜၚ်ေၚၚ္ၚၜနေၚ်ၚအတၚ်းၚၞ္ၚၜၜၚ်ၚၚ်ၚကၚ်ၚၚၜ္ၚေၚၚၚ၊၊အၚၚ္ၚၞ္ၚၜၜ္ၚၞၜ၊ၜကၜ္ၚ၊ၚၚၙၜၞၜၚၚၜၜ္ၚၚၚၞ၊၊ၜၜတၚ်ၜၚ္ၚၜၚ်းၜၚၜ်၊၊ၜၚ၊တၚၜၞ္ၚ၊ၜၚ်ၚၜ္ၚၚ၊ၜၚ်ၚၜဃ်၊ၚၚၚၜ္ၚၜၚ၊၊ၜၜၞၚ၊ၜဃၚ်းၚၞတၚ၊
ၞၚၜၞၜ္ၜ္ၚၞၜ၊၊ၚၚၜ္ၚၜ္ၚၚ၊ၚၜၚၚ၊၊ၜၞၜၚၚ၊ၜ္ၚၞၜၜ၊ၚ၊ၜၞ၊ၚၞၜ၊ၚၜ္ၚၞၚၜ၊ၜ၊ၚၜ္ၞ၊ၜ္ၚ၊ၜၞၜ္ၚၜ၊ၜၞ္ၜၜၜ္ၚၞၜၜ၊ၜၞ္ၜၜ္ၚၜ္ၚၚ၊ၜၞ္ၜၞ္ၜၜ္ၚၜၞၜ၊ၜၚ္ၚၜ္ၜ္ၚၞ၊ၜၞ္ၚၜ၊ၞၜ၊
ၜၚၞ္ၜၞ္ၚၜၚ၊ၜၞ္ၚၜ္ၚၜၜ္ၚၜၚၞ၊ၜ္ၚၜ္ၚၜၞ္ၚၜၞၜ၊၊ၜၞၜ္ၚၜၞ္ၚၜ၊ၞၜၞ္ၚ၊ၚၞ၊ၜ္ၜၞ္ၚၜၞ္ၚၜ၊၊ၜ္ၚၜ္ၚၞၜၞၜၚၞ၊ၚၞ္ၜၚ၊ၜ္ၜၞ၊ၜၞၚၞ္ၜ၊ၜၜ္ၚၜၞ္ၜ၊ၜၞၚၜၚ၊ၜၞ္ၜၜ္ၚ၊ၜၞၚ၊
ၜ္ၚၜၞ္ၚၜၞ၊ၜၞ္ၚ၊ၜၞ္ၜၜ္ၚၞၜၚၞ္ၚၜၞၚၜ၊ၜၞ္ၚ၊ၜၞ္ၚၜ္ၚၞၜၚၞ္ၜၜ္ၚၜၞ္ၚ၊ၜ္ၚၜ္ၚၜၞၜ္ၚၜ၊ၜၞ္ၜၜ၊ၜၚ္ၞ၊ၜၞၚ၊ၜၞ္ၜ၊ၜၞ္ၜၜၞ္ၚၚ၊ၜၞ္ၚၜ၊ၜၞၜ၊

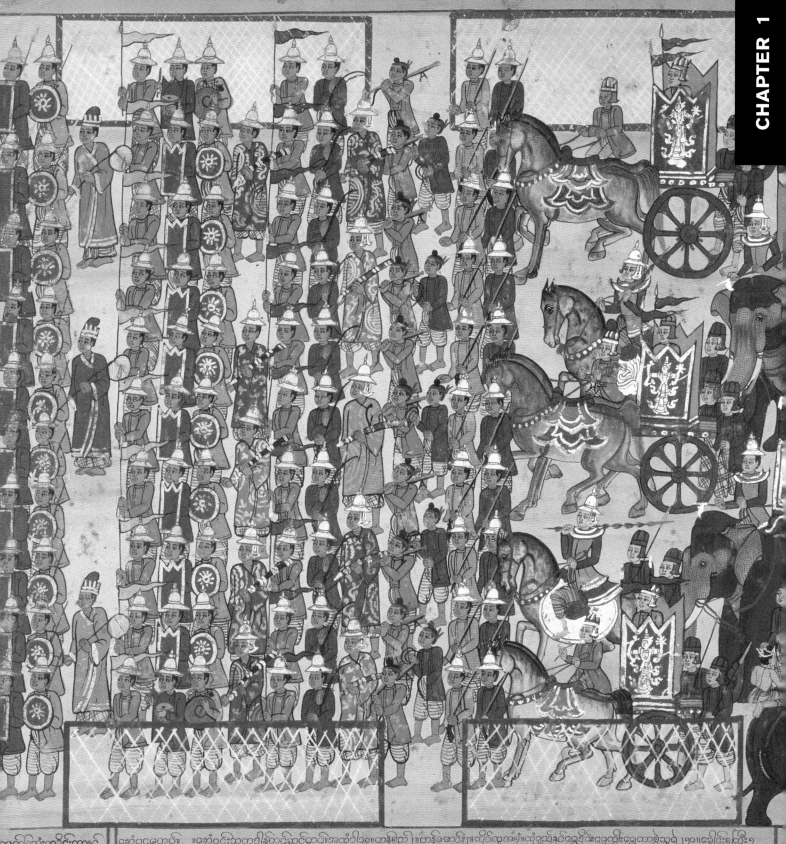

သင်္ချေဘုံးလွှင့်ကာဥှင်းကာဥှင်
ပြိုရှုလှုံ့ကိုင့်ရှုရှုဒျဒျးရှု့
ဂယာပြိုရှုလှိုက်ရသည်။။

AN ABUNDANCE OF RICHES

ALEXANDRA KALOYANIDES

Previous pages
Manuscript (*parabaik*) illustrating the
pageant of King Mindon, 1865–78.
Mandalay. Paper and gold. H. 53 cm,
W. 47 cm (per fold). The British Library,
London, Or 12013. Probably originally
taken from the royal court at Mandalay
in 1885; acquired by Rodway Swinhoe,
a lawyer in British Burma from 1888
to 1927.

Myanmar is a land of extraordinary natural resources. Its subterranean rocks have produced the world's most valued rubies. Its tropical forests grow the tall teak trees that formed the ships for the most powerful early modern empires. Today, it is one of the largest producers of heavy rare earths, elements crucial for the production of increasingly important commodities like electric cars, fighter jets and wind turbines. Exceptional objects have been set with prized gems, fashioned out of precious metals, preserved in tree sap, and carved out of wood, stone and tusk. Together, these objects tell of a land whose resources have been forming for millions of years, creating immense riches and distinctive cultural traditions for historical dynasties, global empires, borderland communities and nation states.

The country is located between India and China and is connected through land and water trade routes to Africa, the Middle East and Europe. Its realms have prospered through the extraction of prized commodities. The nation is currently the largest in mainland Southeast Asia, measuring over 2,000 kilometres from north to south and approximately 1,000 kilometres from east to west (making it about twice the size of Germany). It borders Bangladesh to the west, India to the northwest, China to the north and northeast, Laos to the east, and Thailand to the southeast, with the Bay of Bengal and the Andaman Sea along the south and southwest coasts. Its largest kingdom was ruled by the Toungoo dynasty from the mid-sixteenth to the mid-eighteenth centuries. At the height of its power, this empire encompassed all of modern Thailand, much of Laos, what is now the northeastern Indian state of Manipur, and the Shan regions of southwest China. While borders have expanded and contracted, the kingdoms of central Myanmar have consistently encompassed the territories around the middle reaches of the great Irrawaddy (Ayeyarwady) River and periodically the southern regions around the Gulf of Martaban (Gulf of Mottama). The Irrawaddy, which bisects the country and runs north to south, is the region's main waterway, carrying resources and people from political centres in the Irrawaddy Valley to trading ports along the Bay of Bengal and the Andaman Sea. The region around the Gulf of Martaban, an arm of the Andaman Sea, includes Yangon, the country's most populated and commercially powerful city since the British colonial period. From this particular combination of river valleys, mountainous borders and sea ports, communities in the country now called 'Myanmar' have extracted resources and transformed them into dazzling cultural creations as well as imposing political might. This chapter sketches histories of Myanmar's gems and other stones, opium, forest products, rice, oil, mined metals and other resources to glimpse what they might reveal about the beauty and brutality of human civilisation.

Rubies

A rich understanding of natural resources emerges from geophysical forces. The most dazzling resource in modern Myanmar has been forming for fifty million years since the Indian-Australian Plate of the earth's outer layer collided with the Eurasian Plate, pushing up the mountain ranges in the north and the west whose snowmelt and rainwater form the Irrawaddy River. As these plates collided, they buried the Tethys Sea, an ancient ocean that used to lie between them. Limestone deposits on this ocean floor were thrust deep into the earth where, under extreme pressure and heat, they transformed into glittering marble laced through with molten granite, which produced the rare red crystals known as rubies in English and *pattamyar* or *badamya* in Burmese.[1] The most prized rubies come from Mogok in northern Myanmar, including the Sunrise Ruby, the world's most valuable ruby (and the world's most expensive gemstone next to diamonds): a 25.59-carat gem that sold for $30 million in 2015.[2] The stones range from a pinkish hue to a dark red known as 'pigeon's blood'.

The market for rubies is an ancient one. Burmese rubies have endured as a key commodity in trade with China. For example, during the Ming dynasty (1368–1644),

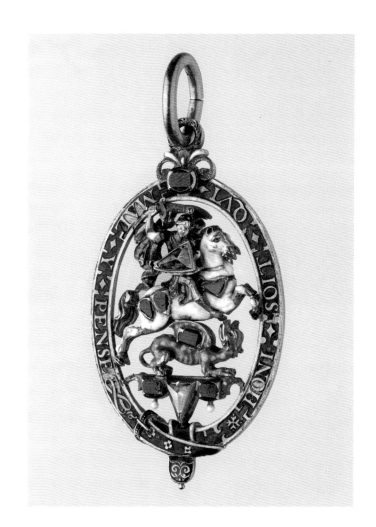

Burmese rubies were highly sought after for bejewelled ornamentation. Because of the elite market for Burmese rubies, the Ming court took to employing specialists to procure rubies in northern Myanmar, who oversaw the negotiations that ensured the royal family and elite classes had precious stones to decorate objects such as officials' hats and women's hairpins.[3] Burmese rubies also arrived in Europe at an early date, where they were incorporated into jewellery, such as the badge of the Lesser George of the Order of the Garter thought to have been made for William Compton, 1st Earl of Northampton, who was created a Knight of the Garter in 1628 and installed in 1629 (fig. 1.1). This elaborate gold badge is set with fourteen rubies and depicts St George on horseback about to slay the dragon with his sword. In Myanmar, rubies have long been symbolic of kingship, and sumptuary laws limited their possession to the royal family and members of the elite. A small gold vase decorated with rubies is the work of a sophisticated craftsperson, suggesting it was made for royalty or nobility (fig. 1.2). Rubies were also used in the areas from which they originated – the Kachin regions and Shan states. Locals worked as miners, and according to the ownership structures imposed by the British in the late nineteenth and early twentieth centuries, Shan elites owned or leased mines in Mogok.[4] Rubies are still mined in Mogok today (fig. 1.3).

An authoritative Indian encyclopaedia from the sixth century CE, the *Brihat-Samita*, explains that excellent rubies are distinguished by their bright red colour, heaviness, smoothness, fine shape, purity and brilliance. This text tells of a magical ruby found on the heads of serpents. A king who wears these serpent rubies will be protected from disease and poison, receive divine rains throughout his realm and defeat his enemies.[5] This tradition of Indian gemmology has long been influential in Burmese royal courts, which regularly employed specialists (brahmins) to advise kings on South Asian knowledge systems. Even after the collapse of the last Burmese kingdom in 1885, Burmese governments have practised forms of this gemmology

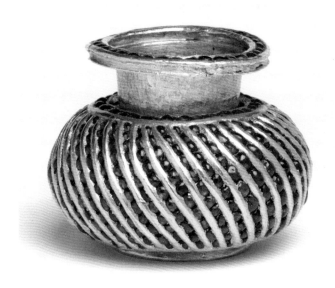

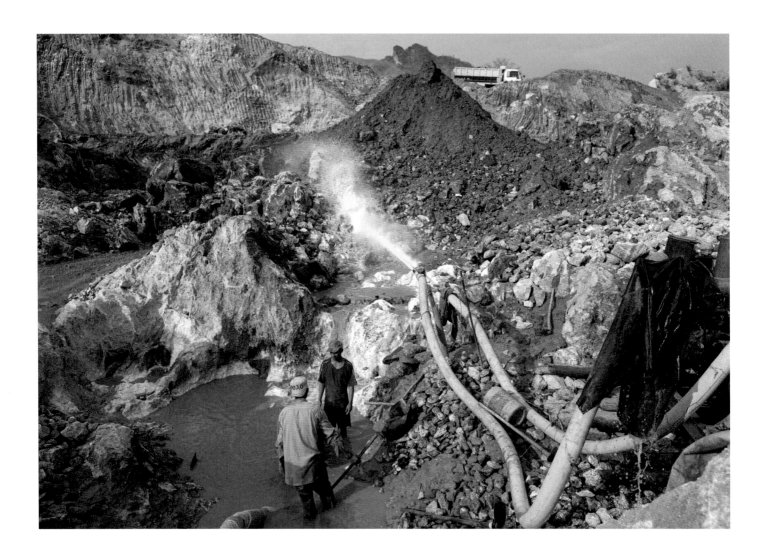

and related astrology. In 1947 the Burmese government presented ninety-six rubies, one for each disease that the human body can succumb to according to Burmese medical traditions, as a wedding gift to Queen Elizabeth II (r. 1952–2022, then Princess Elizabeth of York). These were set into a tiara by her jeweller, the House of Garrard, and the sparkling result reflected the global dominance of Burmese rubies.[6]

Jade

Myanmar mines other valued gems such as sapphires and spinels and is the only source of painite. However, next to rubies, jade is the most lucrative stone. Myanmar is the world's largest exporter of jade. While the green gemstone is not especially treasured within Myanmar, it has long been traded with China, where it is singularly appreciated.

1.4
Incense burner with cover, 1662–1722.
Jadeite from Kachin or Shan regions,
carved in China. H. 19.5 cm, W. 17.6 cm,
D. 8.1 cm. The Metropolitan Museum
of Art, New York, 02.18.428a, b. Gift of
Hebert R. Bishop, 1902.

In Chinese culture, jade has been more highly prized
than gold and silver. For thousands of years, Chinese
communities have used jade (*yu*) for tools and ornaments
and have understood the stone to have special powers
and symbolic meanings. The philosopher Confucius held
up jade as a symbol of benevolence and intelligence, and
fortune-tellers use jade to predict good and bad luck.

Imperial powers in Beijing and the most skilled gemstone
carvers in Chinese workshops began favouring jade
extracted by miners in northern mountainous regions of
what is now Kachin State in the late eighteenth century.
The rich green shades and semi-transparency of the
particular Burmese jade known as 'jadeite' were so prized
in China that this stone became known as 'Imperial Jade'.
For centuries, local Burman, Shan and other merchants
traded jade for Chinese silk, satin, metals and household
items. The production of the pieces would have occurred
in China. Elegantly carved in an antiquarian style, the
incense burner here was made of Burmese jade in the late
seventeenth or early eighteenth century (fig. 1.4).

The regions in which jade is mined were once
controlled by chiefdoms. Before the British colonial
period, Kachin chiefs would allocate mining rights to
numerous kinship groups in an effort to distribute their
economic benefits widely. The Opium Wars between
Britain and China (1839–60) disrupted the overland jade
trade routes between Yunnan and Canton (Guangzhou).
As Britain began annexing Myanmar, starting with the
First Anglo-Burmese War of 1824–6 and continuing with
the Second Anglo-Burmese War of 1852–3, the Burmese
monarchy tried to raise funds for its collapsing kingdom
through royal monopolies, including a monopoly on jade,
which led to increased unauthorised trading.[7] Indeed, illicit
exchange has marked the history of the jade market down
to the present day. With the military coup of 1962, access
to jade deposits was denied first to foreign mining and then
to private prospecting. As the government nationalised
the industry, most jade went to China and other countries
through the black market.[8] Adding to the ethical concerns

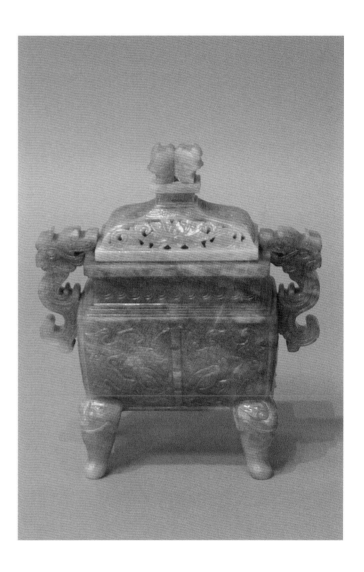

raised by these opaque economic systems, many jade
deposits are in regions suffering from ethnic conflict
and systematic, state-sanctioned violence. As Mandy
Sadan writes in chapter 7, the exploitative extraction of
jadeite in Hpakant in Kachin State in the twentieth and
twenty-first centuries has led to widespread drug misuse
and environmental devastation.

1.5
A man extracts raw opium at a poppy
field near Pekon, southern Shan State,
December 2015.

Opium

Myanmar's most infamous natural resource is opium.
The opium poppy grows well in northern Shan and other
border states – where high prices incentivise farmers in
these conflict-torn regions to start or expand cultivation of
the flower. Producers score immature seed pods, causing a
milky fluid to leak out and dry into a sticky residue, opium,
from which they extract morphine for conversion into
heroin (fig. 1.5). Humans have been collecting and using
poppy seeds for pain relief, recreation, rituals and more for
millennia. However, it was probably not until the eighteenth
century that people in Myanmar began consuming opium
with regularity. In China opium transitioned from being

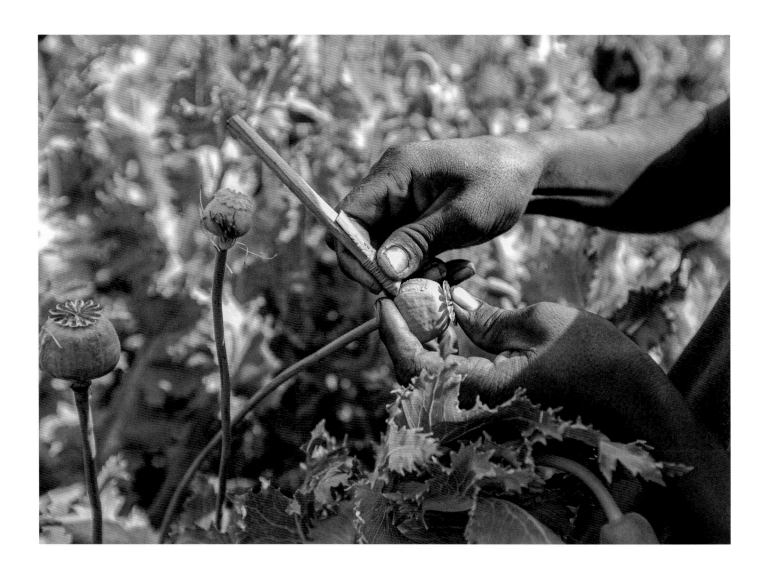

taken as a medicinal herb to being enjoyed as a luxury item in the late fifteenth century. During the remainder of the Ming dynasty and into the Qing, elites smoked opium (with tobacco introduced from the Americas) as part of sexual recreation since it was used to stimulate desire, invigorate intercourse and control ejaculation. By the eighteenth century, opium consumption had become more common in the mainland and with the growing Chinese diaspora throughout Southeast Asia, including Myanmar.[9]

As the British empire incrementally occupied Myanmar, it profited from the opium trade. By the mid-nineteenth century, opium was one of the most valuable international commodities for the British, who sold Indian opium to China for massive profits and to force open Chinese ports for other trade. European victories in the mid-nineteenth-century wars with China (1839–60) compelled China to sign unequal treaties granting Western powers extraordinary economic and territorial advantages.[10] By the late nineteenth century, Asian and Western authorities began treating opium as a vice and a public hazard that needed to be regulated and criminalised. The 1894 British ban on popular opium consumption in British Burma was the first of its kind among European powers in Southeast Asia and led to more widespread prohibitionist stances in the region.[11] While opium had long been traded through, and consumed in, Myanmar, local production did not take off until the mid-twentieth century when the United States' anti-communist alliances facilitated poppy cultivation in the borderlands between Laos, Thailand and Myanmar, the area termed the 'Golden Triangle' by the Central Intelligence Agency (CIA). In the 1960s and 1970s, opium grown in the Shan borderlands began to be refined into heroin, which was becoming popular as a narcotic among American soldiers as well as internationally.[12] Burmese authorities, and especially the military, have since campaigned variously to suppress as well as profit from the heroin industry. After Afghanistan, Myanmar is the world's largest source of the heroin-producing substance, and opium production in the country has soared since the 2021 coup.[13]

Amber

Like the opium industry, Myanmar's amber industry has grown exponentially in recent years. Amber is a translucent fossilised tree resin that ranges in colour from yellow to orange to brown and is valued for jewellery as well as for the clues it preserves about ancient worlds. Communities in Myanmar have traditionally fashioned local amber into jewellery. Earplugs have long been popular among Kachin women and girls, for example, who wear the pointed ends facing outwards (fig. 1.6).[14] While usually made of silver, earplugs in amber were worn by women and girls living near the mines.[15]

In recent years, with changes to the way it is dated, amber has taken on value as a window into a pre-human world. Scientific studies of Burmese amber in the last three decades have identified ants and other insects that share exciting connections to creatures found in other amber dated to the Cretaceous Period (66–145 million years ago), suggesting that the dating of Burmese amber had been short by 20–100 million years. Scientists worldwide have discovered thousands of insects and even dinosaur feathers, establishing Myanmar as the source of the most important Cretaceous amber (fig. 1.7), and such revelations have created an amber boom.[16] Following this initial excitement, journalists and human rights organisations reported on how the Burmese military profits from the amber industry and how Kachin communities and other marginalised peoples living in the regions of the mines suffer from abusive labour practices and conflicts with the same military that is enriched by the industry. Over concern about the ethics of its extraction, some scientists have responded by boycotting Burmese amber.[17] Brutality against communities making a living from amber is not new. A Burmese royal order from 1788 sanctions the attack, capture and killing of Chin and Kachin people perceived to be obstructing roads to amber mines.[18] This history raises critical questions about the role that Myanmar's extractive industries have long played in systems of violence.

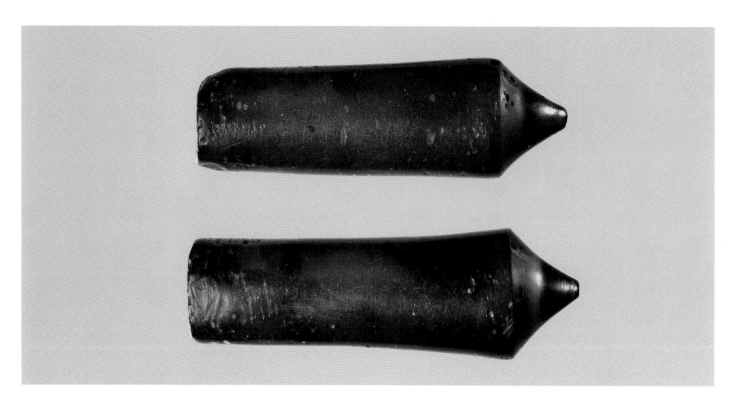

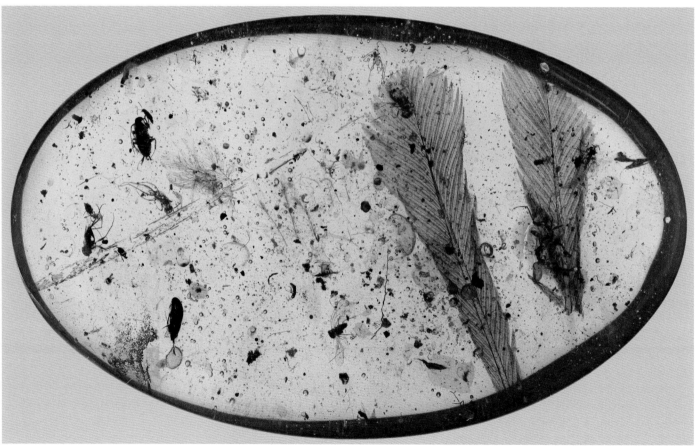

Teak

While amber has recently taken the international spotlight, it is another tree product that made Myanmar a global force: teak wood. Long treasured for its suitability for shipbuilding, teak is native to South and Southeast Asia. Myanmar's forests, found in the country's mountainous regions, produce nearly half the world's supply. Teak grows up to 40 metres high, and its resin makes its logs naturally resistant to water corrosion and insects. For centuries, Burmese foresters have refined a practice known as 'girdling', whereby they carve deep rings around trunks, causing them to die and dry out over two or three years while still standing. By the time they are cut down, they are lightweight enough for elephants and humans to move them to rivers and buoyant enough to float downstream to seaports. Traders along the Bay of Bengal once sought Burmese teak for merchant and military vessels. From an early date, South and Southeast Asian royalty, Indo-Persian powers and, later, European empires paid high prices for the profitable planks.

The Burmese teak industry became especially powerful at the end of the eighteenth and the beginning of the nineteenth century when the French and British empires established trading posts in Rangoon (Yangon). By the early nineteenth century, the British were already depleting their own oak forests to make ships as they built their global empire. As oak supplies dwindled, they began to exploit the teak forests of the Indian Malabar coast, but those forests were exhausted by the 1820s. Therefore, when the British annexed portions of southern Myanmar after the First Anglo-Burmese War, they turned to the area's high-quality teak, conveniently located and accessible to the Bay of Bengal via the Irrawaddy River.[19]

In the past, Burmese kings maintained monopolies over the teak industry. These Buddhist monarchs were understood as having dominion over the earth, obliged to generate wealth for the realm and to use a significant part of that wealth to support monks, shrines and rituals. The Burmese king Mindon Min (r. 1853–78) monopolised the teak industry during its rise to global prominence. His royal city, Mandalay, features some of the country's finest examples of carved teak, including the Shwenandaw, or Golden Palace Monastery (fig. 1.8), built in 1878 and adorned with intricate sculptures. There is a story that captures King Mindon's pride in Burmese teak well. After his manager of glass factories (*pangyetwun*) returned from studying arts and manufacturing in Paris, King Mindon asked him whether the European city had any buildings rivalling the magnificence of Mandalay. The minister pleased the king by replying, '[T]he luckless people have not the magnificent teak; how then can they hope to raise anything comparable to the meanest of your palaces?'[20]

Myanmar's teak constructions are not only massive buildings but also mobile objects carved for utilitarian and aesthetic reasons, such as steering chairs (fig. 1.9). A nineteenth-century steering chair used on a boat navigating the Irrawaddy River was collected by Lord Curzon, the British statesman who served as viceroy of India between 1898 and 1905 (fig. 1.10). This chair is an example of a Burmese wood carving, one of the country's ten traditional arts, or *pan se myo* (the others are blacksmithing, gold and silversmithing, bronze casting, masonry, stone carving, stucco work, turnery, lacquerware and painting). Burmese wood carving has long been renowned for its high relief. This exceptional piece is carved almost three-dimensionally with flowers and foliage in forms extant from the Bagan period (eleventh–thirteenth centuries), mythical creatures and peacocks (the symbol of the sun and the emblem of the Konbaung, the last dynasty). Like the teak sculptures at the Golden Palace Monastery, the carvings on this steering chair include winged spirits. The large celestial being on the bottom section appears to be influenced by the winged boys from European art known as *putti*, marking the impact that European travels and studies by specialists like the *pangyetwun* had on the country's visual culture. As this extraordinary chair glided down the river, it may have appeared to have been carried by this unusual spirit.

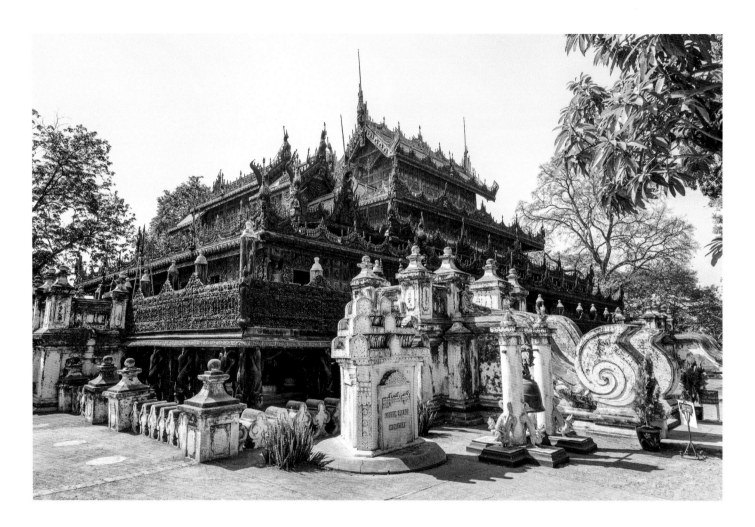

As unusual as this spirit may have looked, the country has long been understood to be populated by spirits called *nats* who have important connections to natural resources, especially because they are said to dwell in trees, rivers and forests, the very places humans go to extract precious stones, metals and timber. For royalty and regular people alike, the exploitation of the land involves negotiations with *nats*. For example, one of King Mindon's royal orders from 1856 demanded that offerings be made to such spirits to help with mining. A 1638 royal order from the previous empire, the Toungoo dynasty, commanded subjects not to neglect offerings made to a guardian god of precious gems and metals (see fig. 7.2).[21] Therefore, while we term these resources 'natural', they have important connections with the 'supernatural'. Perhaps the term *loka* – used in classical South and Southeast Asian literature to describe the world with all its visible and invisible beings and things – is more fitting. All the resources featured here belong to the *loka* and are therefore connected to all its material and immaterial powers.

1.9 *right*
Philip Klier, Stern of a paddy boat with teak steering chair, 1895. Rangoon (Yangon). Photographic print. Published in Harry L. Tilly, *Wood-Carving of Burma*, 1903, pl. XVIII.

1.10 *below*
Steering chair, *c.* 1870–1900. Central or lower British Burma. Teak. H. 122 cm, W. 162 cm, D. 53 cm. Kedleston Hall, National Trust, NT 107700. Collected by Lord Curzon during his visit to Burma in 1901.

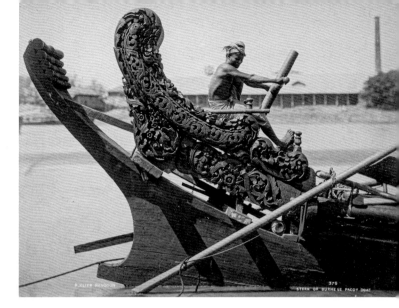

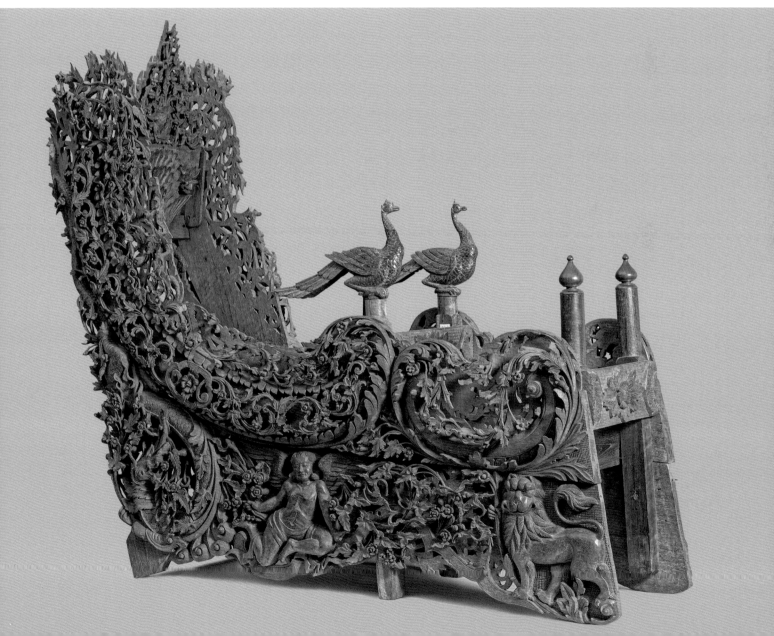

1.11

Offering vessels (*hsun-ok*), *c.* 1860–90. Probably Mandalay. Bamboo, lacquer, coloured glass, gold leaf, gilded metal sheet and wood. H. 116 cm, Diam. 60 cm (left); H. 119 cm, Diam. 56 cm (right). British Museum, London, 1994,1116.1–2. Acquired by Herbert Allcroft during his travels in British Burma in 1894–5; auctioned in 1994 and bought by Spink & Son Ltd; purchased by the British Museum via the Brooke Sewell Permanent Fund in 1994.

Lacquer

A third tree product that has shaped Myanmar's culture is lacquer. The lacquer tree is indigenous to Myanmar. When exposed to air, its sap becomes a viscous substance that can seal objects like bamboo or wooden wares, protecting them from water and insect damage. In China people have used another type of lacquer to coat and decorate wooden wares since before the beginning of the Common Era, but evidence of lacquer use in Myanmar only dates as far back as the Bagan period.[22]

One exquisitely lacquered object is the Buddhist offering vessel known as a *hsun-ok*. These containers are used to transport food to monasteries, as Buddhist monks in Myanmar only consume donated meals. Offering monastics rice, pickles, curries, soups and such has long been a key contribution that laypeople make to Buddhist institutions and an essential bond between those who have renounced worldly life and those in society who continue to raise families and work. Artisans produce these lacquer-coated objects as special repositories in the performance of such offerings. Two mid-nineteenth-century *hsun-ok* are made of split coiled bamboo that has been lacquered, covered in fine gold leaf and adorned with coloured glass in the shape of flowers and mythical lions (fig. 1.11). Details were produced with *thayo*, a lacquer putty. The top spires invoke the country's towering pagodas, bisected by a majestic *hintha*, or semi-divine bird, a Burmese version of the Indian *hamsa*. Lifted, the tops reveal bright red lacquered serving trays that are unlikely to have held much food. These impressive objects were probably intended for display.[23]

Lacquer is not limited to Buddhist communities. Its ubiquity reflects how cultural and artistic practices cross religious and ethnic lines that can be misunderstood as fixed and natural. Lacquer is found on everyday objects such as cups, bowls, trays for *lahpet* (the popular pickled tea-leaf condiment) and boxes for betel (the leaf-wrapped packets that are slowly chewed for their mild euphoric properties and prominent in social interaction). These common containers often begin as strips of bamboo that are coiled or woven and covered in layers of an increasingly refined and eventually coloured paste made of lacquer sap and ash (see fig. 2.26). The containers are then polished, engraved, coloured and, occasionally, painted. During the colonial period, lacquer was a cottage industry, and the government established a lacquer school at Bagan in 1925. Traders exported lacquerware to India, the United States and beyond and, under the military dictatorship starting in 1962, illegal exports were made via Thailand. In the late twentieth and early twenty-first centuries, Myanmar's lacquer industry has flourished domestically and enjoys a prime place in the tourism market, with visitors from all over the world purchasing souvenirs in famous lacquer-producing regions like Bagan.[24]

Ivory

Ivory is a hard white material from the tusks and teeth of animals, notably elephants in Burmese forests. Asian elephants are strong, dexterous and intelligent mammals that humans have captured for use and exploitation in transportation, warfare and construction, as well as for the purposes of displaying social status.[25] As mentioned above, Myanmar's teak industry has relied on the might and agility of elephants to harvest and move timber. In addition, the country's kings – influenced by Indian and Persian royal traditions – displayed captive elephants to communicate their power over the land, with white elephants being among the most prized royal possessions and a symbol of political legitimacy.[26]

In addition to their treatment as symbols of kingship and beasts of burden, elephants have also been targeted for their tusks, which people carve into decorative objects, items of use and gifts – from snakes and Buddhas to chess sets, large elaborate jars and pieces of furniture (see fig. 4.17). A carved elephant tusk from the Glasgow Museums collection features embossed silver mounts and is carved with scenes from the Vidhura Jataka, one of the ten great

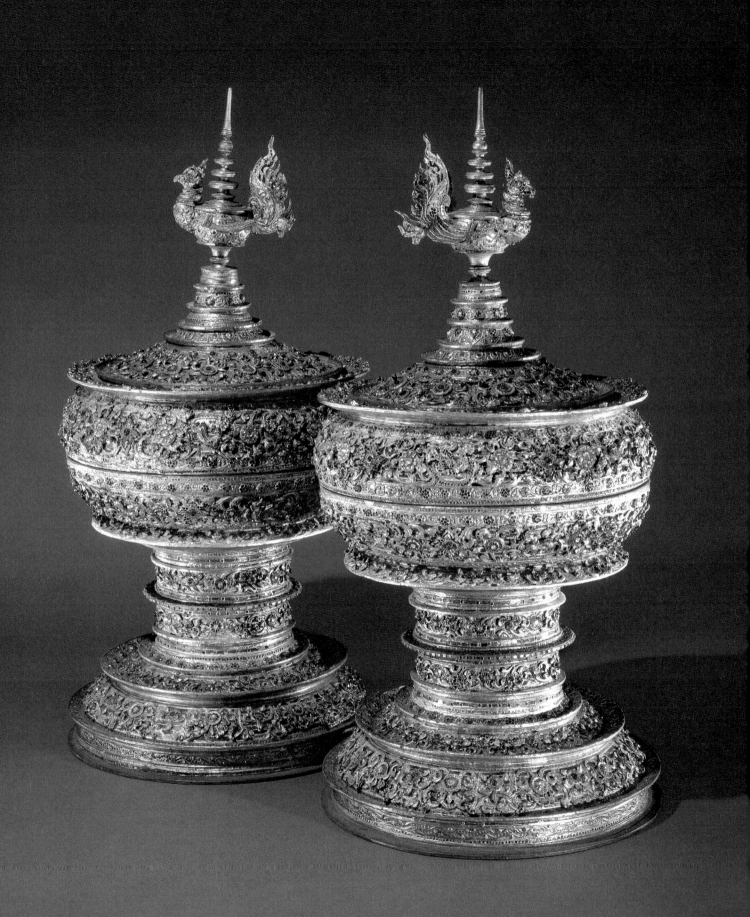

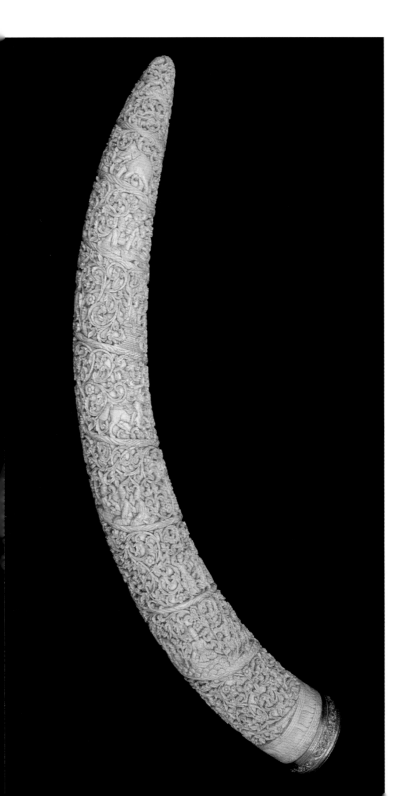

stories of the Buddha's previous lives in which he perfected the virtues necessary to become a Buddha (fig. 1.12). Most likely, it was purchased or commissioned by a wealthy family to donate to a Buddhist temple, thereby earning merit for the family so that their paths through multiple lifetimes, like the Buddha's path, would lead to wisdom and nirvana (with fortune and beauty along the way). While ivory has been crafted and traded in Myanmar for centuries, it appears to have picked up after King Mindon built the royal city of Mandalay in 1857 and sponsored workshops, including those dedicated to ivory carving. As with the other art forms that King Mindon sponsored, ivory carving often featured Buddhist imagery.[27] Today, the illegal trade in ivory remains widespread. The Asian elephant has been listed as endangered since 1986. Loopholes in Myanmar's legislation allow the tips of tusks, as well as tusks from government- and privately owned elephants that have died of natural causes, to be sold legally.[28]

Rice

Myanmar is a key exporter of rice, the most significant staple food in human history. This grass seed has fed more people over a longer time period than any other crop. It grows well in Myanmar's wetlands, as well as in its dry upland fields, and has been sustaining human life in the country for thousands of years. The country's literary traditions feature rice in their accounts of the origins of human society. Vernacular and classical stories of the world's first humans recount that when they began harvesting rice, they gave one-tenth of their harvest to the first king, Mahasammata. This story has been invoked to explain royal taxation practices, whereby the king is understood as the owner of the land who rightfully receives a portion of the resources extracted from it.[29] The rhythms of rice cultivation shape village life. The labour of sowing, harvesting, hulling and cooking rice makes for seasons of intensive co-operative work and times for celebration. Not only are humans and domesticated animals involved, but

gods and spirits are also called upon to help with harvests. A ceremonial rice measure (*kauk khauk te*) made by the lacquer master U Maung Htun from Kengtung (Kyaingtong), Shan states, conveys the cultural value of this seed (fig. 1.13). It was created in the first half of the twentieth century by weaving and lacquering split bamboo. The gilded *thayo* decoration features floral motifs, birds and couples whose musical instruments and clothing mark them out as from the four ethnic communities near Kengtung known as the Khun, Kaw, Khamu and Lahu.[30] These couples are separated by

four roundels with roosters and there are four sacred geese (*hintha* birds) on the vessel's feet.

Before the nineteenth century, rice cultivation was focused on production for local consumption and royal use via taxes;[31] southern and western regions such as Tenasserim (Tanintharyi) and Arakan also conducted significant business exporting rice. The earliest records of rice export describe sixteenth-century Mon kings in lower Myanmar authorising the shipment of rice from Pegu (Bago) to Malacca (Melaka, present-day west Malaysia) and Sumatran (now Indonesia)

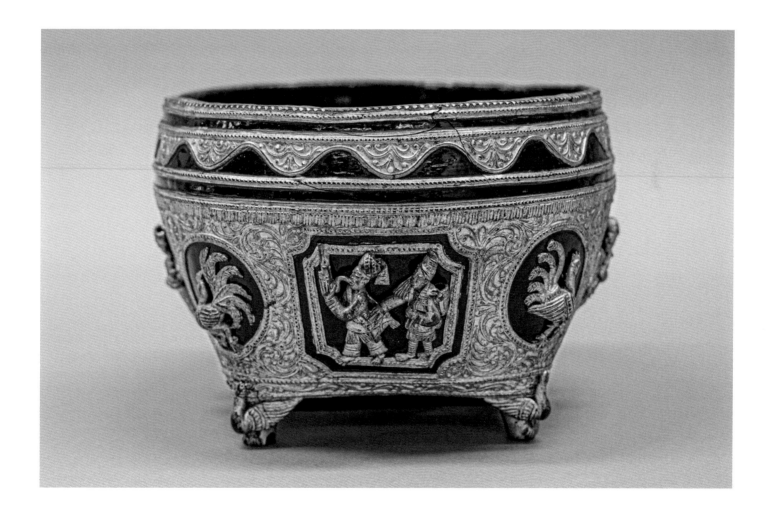

1.14
Oil worker's helmet, c. 1870s–90s.
Central Myanmar. Metal, possibly iron,
and glass. H. 34 cm, W. 20 cm, D. 20 cm.
Bankfield Museum, Calderdale Museum
Services, Halifax, GB.59. E.C.S. George
Collection, loaned to the museum in
1900, then given as a bequest in 1937.

and Dutch traders going to Arakan in the seventeenth century for rice and enslaved peoples.[32] Burmese kings in the eighteenth and nineteenth centuries restricted the outflow of rice to keep the staple for the central populations it depended on to maintain its large empire. After the First Anglo-Burmese War ended in 1826, British Lower Burma quickly became a major rice exporter. Industrialisation, urbanisation and population growth in other parts of the world – most significantly in the West – created a huge demand for rice. Large numbers of people from Upper Burma (central region) migrated south and worked in the rice industry. Their labour not only sent Burmese rice all over the world but also shifted economic power from central Burma (home to many royal capitals) down into the Irrawaddy Delta. The rice industry also drew migrant workers, possibly as many as a million, from other parts of British India, such as Bengal and Madras, where poverty forced people to seek work elsewhere. By the 1930s – as a result of arduous labour in malarial zones clearing jungles, draining land, building canals and dykes, and then growing and harvesting rice in the new paddy lands – over 90 per cent of cultivated land in Lower Burma was dedicated to rice,[33] and the region was the world's largest supplier to global markets.

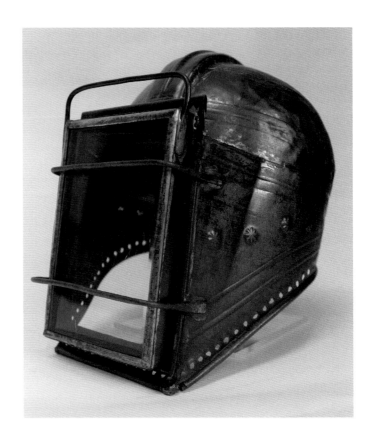

Oil

In addition to monopolies over the teak industry and gemstone mining, Burmese kings claimed monopolies over oil extraction. More than a decade after the Second Anglo-Burmese War (1852–3), King Mindon signed the Treaty for the Further Protection of Trade in October 1867. It established that only timber, precious stones and earth-oil required the Burmese king's authority to be taken, constraining his power in the face of the British advance.

Crude oil is formed through prolonged heat and pressure applied to dead organisms buried under sedimentary rock. This fossil fuel is recovered through drilling, after which it is refined and separated into products such as gasoline

and kerosene. Chinese records date Burmese oil wells to as far back as the thirteenth century, making the Burmese oil industry the oldest in Southeast Asia. After the British annexation of Upper Burma in 1886, the British-run Burmah Oil Company took over the industry. Like their royal predecessors, they maintained a near monopoly, with the colonial government rejecting applications for prospecting licences from competitors, including Shell Oil Company and the Colonial Oil Company of New Jersey. Burmah Oil Company quickly grew rich, selling kerosene in the Indian market, where it enjoyed tariff protections. In the period before the Second World War, oil was British Burma's most valuable export, next to rice. But with the Japanese forces on the brink of the Occupation, British

and Burmese authorities destroyed industrial infrastructure to prevent the energy supply from flowing to the Japanese army. Entire refineries, wells, drilling equipment and pumping systems were demolished.

Unlike sparkling gems and carved and lacquered wood, earth-oil, of course, has no overt aesthetic appeal. A rather severe oil worker's helmet from the late nineteenth century looks more like a prop from a dystopian film than a testament to the country's rich earth (fig. 1.14). The helmet displays a sturdy construction, and the large rectangular glass face pane tells of the dangers of drilling for fossil fuel. Images of similarly protected oil workers were represented on banknotes issued in the late 1980s (see fig. 8.14). While Myanmar's oil industry has yet to recover from the destruction of the Second World War, the country is emerging as one of Asia's major exporters of natural gas.[34]

Gold

With its gilded pagodas and Buddha statues, Myanmar's glittering landscape earned it the appellation 'the Golden Land' abroad ('Suvarnabhumi' in Sanskrit and 'Aurea Regio' in Latin). Gold is found in riverbed soil throughout the country. It is the most malleable of metals because of its unique arrangement of atoms. Its pliability and reflectiveness make it especially valuable to Buddhist communities in creating ritual objects understood to be charged with the Buddha's sacred power. Artisans take local and imported gold grains and hammer them into thin metal sheets, known as *shwe cha* in Burmese, that cover Buddha statues and pagodas throughout the land. By pounding pieces of gold for hours, specialists can create sheets thirty times thinner than human hair. Buddhist devotees make merit through the ritual application of these feathery, sparkling swatches to images and shrines to honour the Buddha and keep his teachings alive.

The most famous Buddha statue in the country, the Mahamuni Buddha, is distinguished by the dazzling gold leaf covering its 3.8-metre-tall form (fig. 1.15). Currently residing in Mandalay, this Buddha receives steady streams of visitors who purchase pieces of gold leaf from nearby workshops to add their own layer to this massive statue. Countless leaves have accumulated over time to encrust the Mahamuni Buddha in gold that is 15 centimetres thick in some places. This glittering, lumpy exterior characterises the seated Buddha image as much as the story of how it was made. That story tells of how a king in Arakan, a realm once situated on the country's western coast, cast a metal image of the Buddha that the Buddha himself then breathed on, infusing it with his power. For centuries, as kings have schemed and fought to possess this famous statue, pilgrims have sought it out to add their own bit of gold and, in the process, to experience the power of the Buddha. It was taken to central Burma after Arakan was annexed in 1784.

Like the Mahamuni Buddha, Myanmar's other celebrated Buddhist centres – the Golden Rock in Mon State, the Shwedagon stupa in Yangon, and the Phaung Daw Oo images on Inle Lake in Shan State – are also covered in gold. The Golden Rock, or Kyaiktiyo Pagoda, is said to have a relic of the Buddha's hair. This approximately 544-tonne granite boulder and the stupa on top of it in southern Myanmar have attracted waves of gold-leaf-bearing pilgrims since at least the nineteenth century, and stories narrating the journey of its Buddha relic have been told since at least the fifteenth. Perched at the top of Mount Kyaiktiyo, the massive shimmering round rock appears to be ever on the brink of rolling down the mountainside, as pictured here in a popular poster that would have been placed in a home shrine (fig. 1.16). Some accounts tell of how a king with superpowers chose the rock because its shape resembles the head of a hermit. Out of reverence to Buddhist ascetic practices, the king miraculously placed the rock in this unlikely spot, and it has remained balanced there because of the power of the Buddha's hair relic. Pilgrims seeking to honour the Buddha, to receive blessings of fame and wealth that the shrine is said to bestow, to revel in the spectacle of the place or, perhaps most likely, to enjoy some combination of these aims, climb up to the rock,

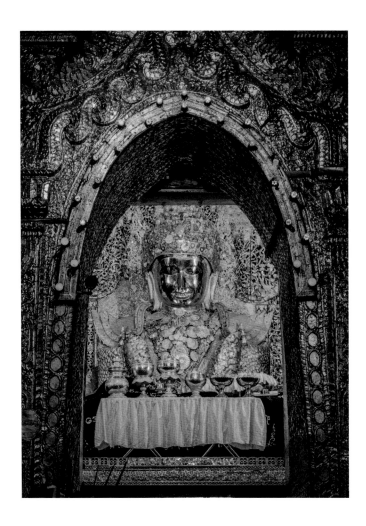

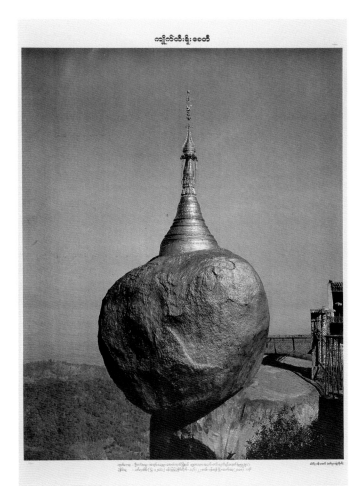

or are carried on stretchers if they are unable to climb up
themselves. Only men are allowed to touch the rock, so they
carry squares of gold leaf for themselves and their loved ones
to paste onto the boulder. The massive and distinctive shrine
sparkles with golden devotion from sunrise to sunset and even
at night in candlelight.[35]

The Shwedagon also glitters with gold leaf, attracting
devotees from around the world (fig. 1.17). Hairs of the
Buddha himself are also said to be enshrined in this
sparkling monument. Local traditions tell of two merchants
from Myanmar who were in India on business when they
came across the Buddha shortly after his enlightenment.
Impressed with the extraordinary being, they offered him
sweets and rice, his first meal after his glorious awakening
as a Buddha. In return, the Buddha shared some of his
wisdom, inspiring the merchants to take refuge in him and
his teachings. Before they left to return home, the Buddha
gave them eight hairs from his head, which the merchants
enshrined in their hometown of Yangon. The Shwedagon
is revered for having the first relics of the Buddha after his

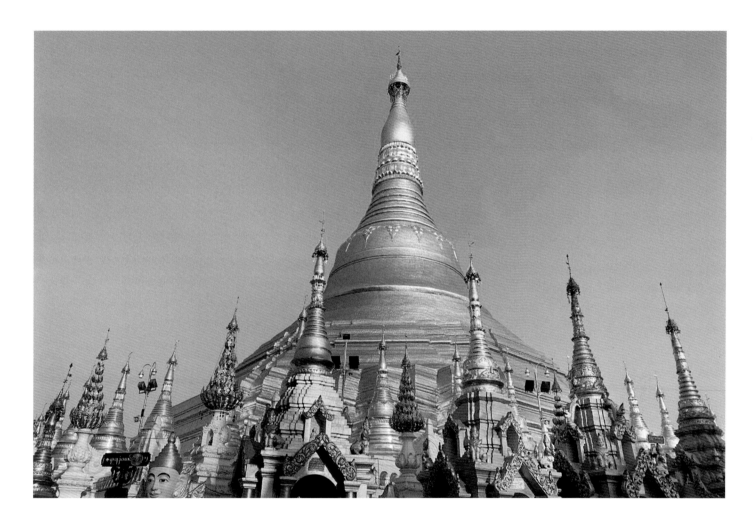

enlightenment, which are enshrined in the first Buddhist reliquary on earth by the first lay disciples. The many sponsors who have built up, maintained and renovated the shrine over the centuries have chosen gold leaf as the ideal finish for this most sacred site.

The Phaung Daw Oo monastery on Inle Lake in Shan State contains five highly sacred images. Over the years, pilgrims to the Phaung Daw Oo Buddhas, mainly coming from Shan and other local communities, have applied so much gold leaf to the images that in 2019 pagoda officials

had to ban the practice because the statues had become almost too heavy to participate in an annual festival in which they are moved to a special barge and processed around the lake.[36] The images are so encased in gold leaf that they no longer have any features. Replicas with added ears, possibly to hear people's prayers, are made for pilgrims to use in home shrines (fig. 1.18).

In 1858 the Scottish geographer and writer Henry Yule published *Narrative of the Mission to the Court of Ava*, a detailed and illustrated account of the Konbaung kingdom based

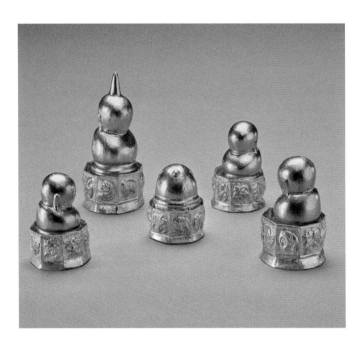

of the ruling elites in the local kingdoms and forged ties with principalities like those of the Shan and with foreign courts in influential places like Thailand and China.[38] Gold also became a form of diplomatic gift-giving by Burmese kings and later the British. For example, the British colonial government of India gifted a bowl to Yule in appreciation for the mission he undertook on behalf of the government of India to the court of Ava. This golden vessel depicts twelve signs of the zodiac (*ya thi*), created using a repoussé and chased technique (hammering the designs from the back of the gold piece and then from the front, pushing the outlines of raised shapes forwards to give them dimension). The base of the bowl is imprinted with a lion (*thein*). Such imagery was typical of gold and silver bowls and vessels of the time. Sparkling gifts, glittering jewellery and countless dazzling pagodas reflect how Burmese communities have long valued gold not just as a commodity but as a medium for celebrating the beautiful and the transcendent.

on his 1855 visit. In the book, Yule took note of the great importance of gold throughout the country. He wrote:

> Gold-leaf can be had in almost every tolerable bazaar or village in the country. Many of the poorer classes buy even single leaves, which they take with them to the pagoda on their moon-days, and attach either to the sacred building or to the Khyoung [monastery] adjoining. A considerable amount is also used in the preparation of jewellery, etc.[37]

Among the most significant pieces of gold jewellery among the elite were the earrings, bracelets and rings that Burmese sumptuary law granted to royalty and nobles. According to an 1868 manuscript illustrated by an artist named Nga Hmon, most queens received gem-studded gold earrings and bracelets, but only chief queens were allowed to wear gold anklets. These highly regimented and symbolic jewellery practices were part of an elaborate hierarchical system that minutely differentiated the status and power

Silver

Next to gold, silver is the most important precious metal found and traded in Myanmar. Silver's white lustre can take on a high polish, giving it an appealing finish for jewellery and tableware. In the precolonial period, it became especially important for the business of the kingdom when it was coined for currency (see figs 2.3–2.6). Pyu kings, whose realm flourished between the second century BCE and the ninth century CE, circulated silver coins from the fifth century CE onwards. In the early modern and modern periods, silver was also used to make letter cylinders to transport missives and many other objects like spittoons and receptacles. This bowl made by mastersmith Maung Shwe Yon in the late nineteenth century displays scenes from the Ramayana and various patterns, including the European acanthus leaf (fig. 1.19).

The possession of specific silver objects indicated rank, as royal courts governed such items through sumptuary laws and trade negotiations that required tribute payments from

surrounding polities and chiefdoms. For instance, the town of Hsawng Hsup in the Shan states paid tribute to the Burmese king every three years in the form of gold and silver flowers, a silver cup weighing five rupees, a pony and a bale of cloth.[39] Among the various peoples living in the highland areas, silver was used as adornment and tribute and as a means to store wealth. The Scottish journalist and colonial official in the Shan states James George Scott (the famous chronicler of Burmese life in the colonial period, who wrote under the pseudonym Shway Yoe) and his assistant John Percy Hardiman wrote in the early years of the twentieth century that silversmiths in Nam Kham (northern Shan states) made the huge silver bracelets worn by Shan-Chinese women and that many of the patterns used on silver in the region were similar to those produced in Chiang Mai (northern Thailand).[40]

Myanmar's most productively mined region for silver is in Bawdwin in northern Shan State, near the country's

northeastern border with China. In the early fifteenth century, Chinese miners began exploiting this deposit for silver, drawing on workers and expertise from Yunnan, which has a long and sophisticated mining history. The success of this mine led to a sizeable Chinese community in the region and is an example of the strong economic and cultural ties between northeast Myanmar and southwest China. The Chinese continued working the mine until the 1860s due to the Panthay Rebellion in Yunnan province in China, where many Chinese workers originated. Burma's last two kings, Mindon Min and Thibaw (r. 1878–85), took over the mine without much success.

After the British colonised the entire country, various people tried to revive mining in Bawdwin – including Herbert Hoover, a mining engineer before he was president of the United States. In 1906 the company Burma Mines was formed and began recovering silver, lead and zinc from

the huge slag heaps surrounding the Chinese-built mines, as shown on this 99 per cent pure silver ingot (fig. 1.20).[41] Burma Mines was a major mining operation for the global lead and silver markets between the First and Second World Wars. In 1965 Burma nationalised the mines, and in 2009 the government began selling rights to private companies.

Other resources

This chapter has surveyed Myanmar's most prized natural resources, from ancient amber, rubies and oil to modern teak and lacquer. Beyond its scope are more ordinary resources such as common stones and shells that have not commanded the same market value or hold on the global cultural imagination but have been similarly transformed into objects possessing powers worldly and otherworldly. Take, for example, the fascinating seashell letter the people of the southern coastal town of Myeik (Mergui) sent to the

Lieutenant-Governor of British Burma, Herbert Thirkell White, in 1907 (fig. 1.21). This object is made from molluscs but has been crafted as skilfully as the most spectacularly faceted gem. Its lustre recalls the countless pearls and other sea treasures that have sustained and employed Myanmar's coastal communities. With the text carefully printed on two silk leaves, the pages were bound with meticulous metalwork into the shell covers. Using poetic and obsequious language, the text from the people of Myeik appeals for funding for infrastructure projects such as road building, a steamship, access to a wireless telegraph, a clean water system and the construction of a hospital and a bilingual science school.[42]

Another marine resource was cowrie shells, which were imported from coastal regions to the northern regions of Myanmar and into Yunnan in southwestern China. They functioned as currency in many parts of South and Southeast Asia and the Pacific Islands. They indicated power, prestige and wealth when attached to clothing, as was also done with silver by many highland communities. Chin peoples in the

western highlands of Myanmar and northeastern India once used cowrie shells in these ways. Here, the cowries have been added to a vegetal fibre belt with a bone knife sheath attached (fig. 1.22). They would have revealed something of the financial capacity of the wearer, as well as signalling social rank.

Cotton, too, was a widely traded item in Myanmar, becoming a major cultivar in the dry zone from the fourteenth century and subsequently expanding into the Shan states. It was a major export item to China and Bengal and became the dominant material in clothing among the numerous groups populating the region.[43] Silk was imported from China to Myanmar, where it became the basis for various items or was used as a supplementary thread in weaving. One type of Chin ceremonial blanket called a *can-lo puan* combines cotton and silk, with the former composing the basic fabric and the latter used in creating the diamond-shaped *tial* pattern (fig. 1.23). Using the discontinuous supplementary-weft technique, the silk designs represent animals' and birds' eyes. *Can-lo puans* were worn by high-ranking men and could

only be woven by the wives of high-status men of the Zahau, Zotung and Mara Chin groups.

Like cowries and cotton, marble is a less well-known industry. Its pervasiveness, however, is represented in these market weights made from marble quarried in Mandalay and Sagaing divisions in central Myanmar (fig. 1.24). Such weights have been an important part of the extensive trade networks that crisscross the country, although they are usually made of cast metal. The stone weights shown here have been carved to resemble sea urchins, another reminder of the country's extensive coastline and many communities that depend on sea resources. Marble is used for a myriad of other products, too. From at least the early seventeenth century, artists used local marble to carve Buddha images of all sizes. The many shops lining the road from Mandalay to Amarapura selling marble Buddhas show that this industry is still strong today. As with the other extractive industries in Myanmar, like jade and amber, marble mining is dangerous, poorly paid and lacks basic health and safety protections.

People

As elsewhere, authorities in Myanmar have long viewed humans as an indispensable resource in building kingdoms, empires and the nation.[44] Alongside utopian visions of Buddhist realms filled with dedicated monastics, prosperous and protected citizens, and a noble lineage of righteous kings, there has also been a view that certain groups of people within and outside the country's spheres of influence can rightfully be forced to labour and even die for the country's greater prosperity and security.

In the late eighteenth and nineteenth centuries, the expansionist Konbaung empire forcibly relocated many tens of thousands of people to the central region, enslaving them through military excursions in nearby kingdoms and principalities, as can be seen in a *parabaik* (a paper book that

folds accordion-style) illustrating a royal procession during the reign of King Mindon (fig. 1.25). It depicts captive elites and artisans from neighbouring realms marching alongside princes from the central zone and the surrounding regions. Like other Southeast Asian powers, the Konbaung kingdom needed labourers, far more than land, to enrich and secure their realm. Among these captives were skilled artisans from culturally rich places like Ayutthaya in Thailand and Manipur in India. Through expansion and warfare, Konbaung kings captured highly specialised people, such as astrologers, manuscript makers, metal workers, elephant veterinarians and dancers.[45]

A hand-woven cotton map from around 1860 depicts the Maingnyaung region between the Chindwin and Mu Rivers in Upper Burma (now called the Sagaing region). It provides a picture of how populations and land were

managed and imagined in the decades before the British colonised the entire country (fig. 1.26). The unidentified Burmese artists who painted this square map framed three sides with winding blue rivers and the remaining side with an ochre mountain range. Neat brick rectangles indicate city walls with spaces for gates and city names written inside. Other labelled rectangles mark villages, with red boxes for those under Maingnyaung's jurisdiction and blue for those outside it. While the map mostly gives a top-down perspective, the artists drew structures such as pagodas and monasteries isometrically and with detail, drawing particular attention to these enlarged Buddhist landmarks. By the time this piece was created, Burmese map-makers had incorporated European techniques. Still, this depiction of Maingnyaung, with its colour-coded districting and attention to Buddhist place-making, is shaped by precolonial practices of taxation, jurisprudence and Buddhist architecture.[46] Conventions, such as rendering towns and cities to indicate their position in the social and political hierarchy through size, are historically tied to practices of surveying land and counting populations for taxation and military recruitment, such as the significant survey the Konbaung king Bodawpaya (r. 1782–1819) ordered in the 1780s.[47]

The natural resources discussed in this chapter conjure images of communities of labourers, artisans and merchants who have unearthed stones, collected forest treasures and searched seas to build homes, cities, kingdoms and nations. The astonishing breadth of materials reflects distinct ways that meaning has been found and made in this land. Today, as Myanmar dominates global markets for the rare earth heavy metals powering our smartphones and electric cars, the history of the labour and land practices used to extract related resources calls for a future of more equitable and environmental policies. Surely it is possible to appreciate the power of these objects to create communities and cross-cultural exchanges while also recognising the brutality in their histories.

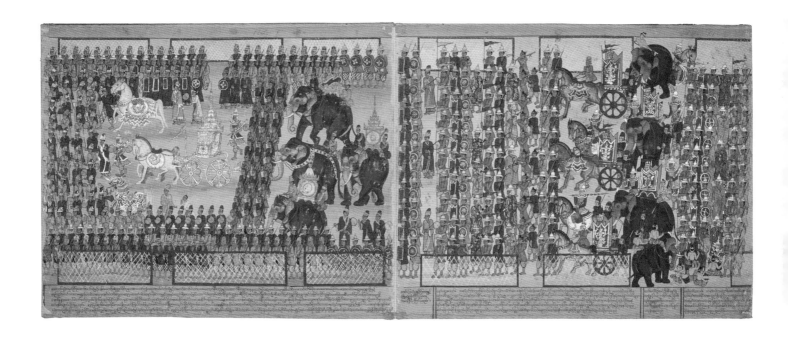

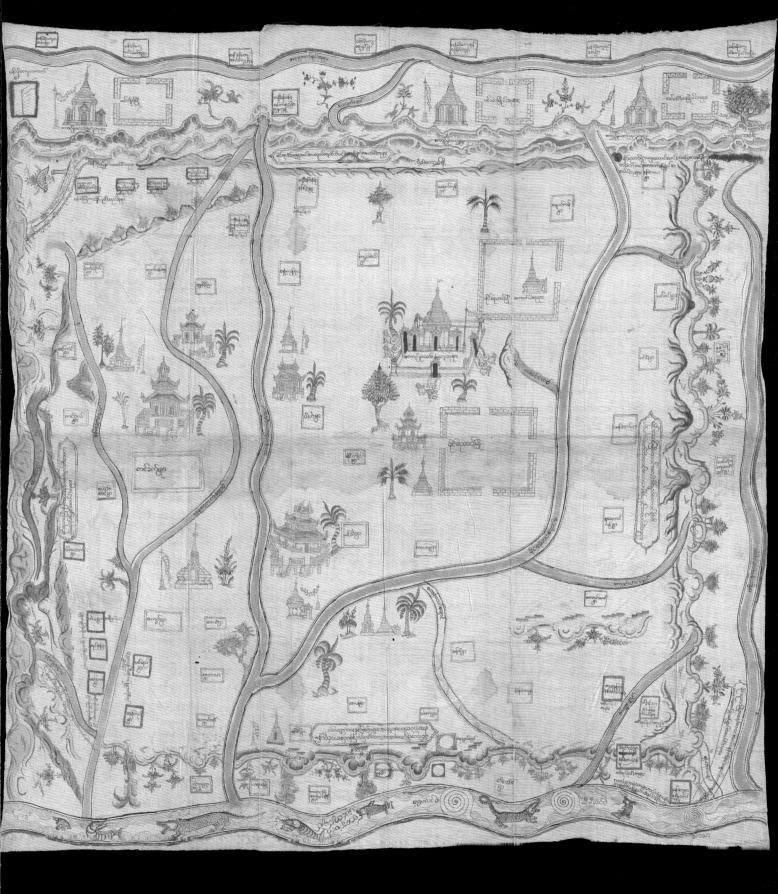

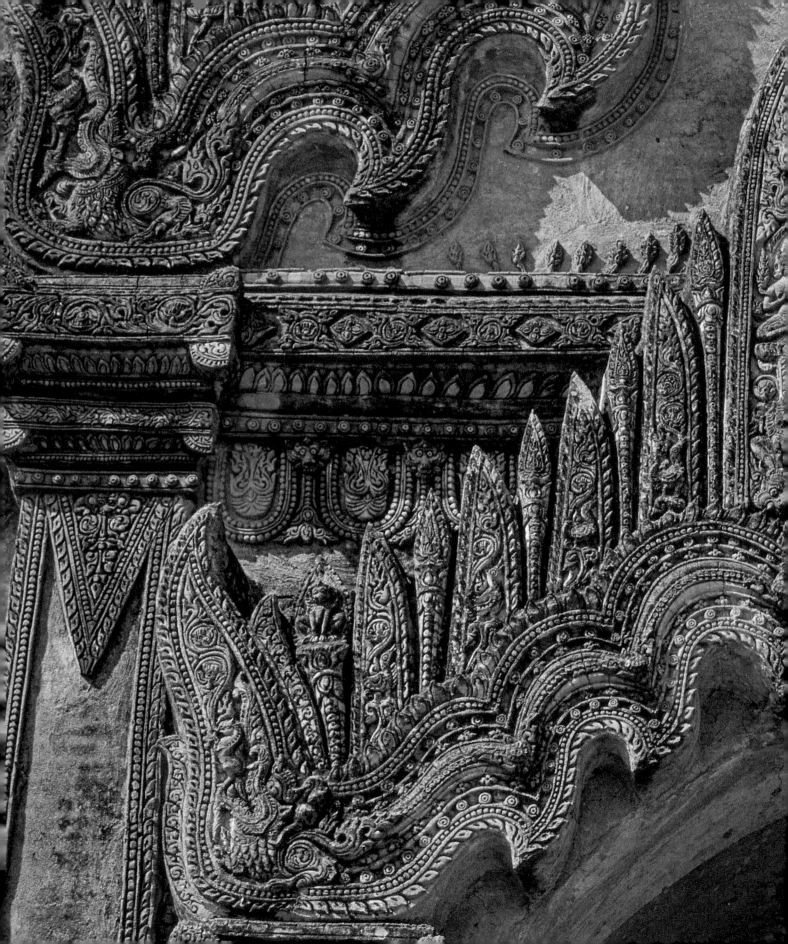

EARLY
KINGDOMS

THAW ZIN LATT, PYIET PHYO KYAW & ALEXANDRA GREEN

The kingdom of Bagan rose to prominence during the eleventh century, declining in the late thirteenth but remaining a religious centre until later times. It was called Arimaddanapura and Rammanadesa in contemporaneous Sri Lankan texts, mentioned as Tampadipa by the minister and monk Shin Disapramok during his diplomatic visit to the Chinese court of Kublai Khan in 1286, and labelled Tatthadesa by the Mons of lower Myanmar. In its own inscriptions, it was called Arimaddanapura or Pukam.[1] For nearly 250 years Bagan was a major Southeast Asian political and Buddhist centre, demonstrating dynamic exchanges, including of artistic and religious ideas, with the world around it. The name Bagan now refers to a vast plain covered with several thousand Buddhist sites along the Irrawaddy River (fig. 2.1). It was inscribed on the UNESCO World Heritage List in 2019 for its role as the centre of an early Buddhist empire, outstanding architecture and continuing Buddhist traditions.[2]

However, Bagan was not the first important historical site in the region: the Pyu peoples occupied central Myanmar before this. Although there have been fewer archaeological investigations in lower Myanmar, this is changing, and recent research indicates that there were substantial settlements and cities in the area. Similarly, the Arakan region saw the rise of the city of Dhanyawadi around the fourth century CE, Vesali in the sixth, and several cities in the Lemro River valley in the eleventh. There is little written material from these sites and what exists is written in Indic languages

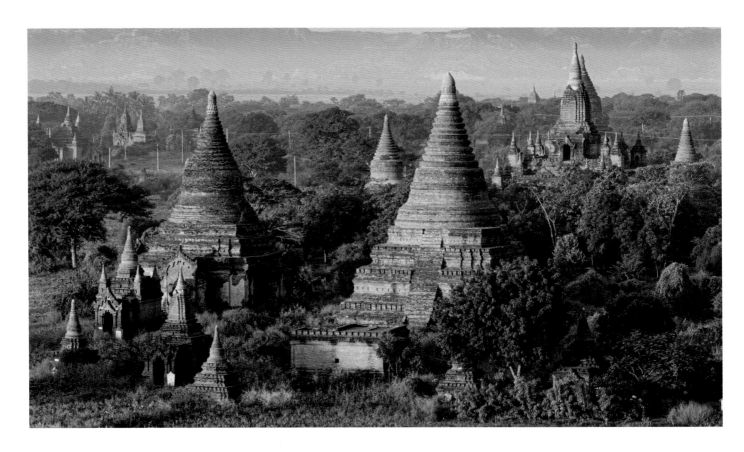

Previous pages
Hsinbyushin temple, Bagan, *c.* 1300.

2.1 *opposite*
The plain of Bagan.

2.2
Bawbawgyi stupa, Sri Ksetra,
c. 500–700 CE.

rather than local ones. This chapter focuses on Bagan rather than other sites in the region, but it should be noted that further investigation is necessary at locations across Myanmar to provide a clearer, more equitable picture of early polities.

The Pyu: predecessors of Bagan

Pyu is the name given to the people occupying sites in central Myanmar from about the second century BCE. Pyu peoples built upon Iron Age settlements and established several of the first urban centres in Southeast Asia, most famously at Sri Ksetra and Beikthano (see fig. 0.2) and Halin. As transregional interactions and trade routes between India

and Southeast Asia expanded from the first to the ninth century CE, the Pyu also increasingly participated in widening Hindu–Buddhist religious spheres. Cultural transmissions via trade carried rituals, social structures, written scripts, artistic styles and iconographical attributes around and beyond the region. Links with Indian kingdoms were strong, and Indian ideas were combined and augmented by regional ones. Evidence of connections with China, such as glass beads and records of embassies to the Chinese court, is also present. Cultures traversing east and west, north and south, transited through Myanmar from an early date.

There are extensive archaeological remains from the Pyu, including temples and Buddhist stupas (ritual mounds containing relics), finger-marked bricks and terracotta

2.3–2.6 *top to bottom*
Pyu coins with a bull, throne, rising sun, conch and *srivatsa* symbols, 700–900 CE.
Central Myanmar and Arakan. Silver. Weight 5.5–10 g, Diam. 2.2–3.2 cm. British
Museum, London, 1884,0510.1 (from Grindlay, a donor in the 1880s); 1921,1014.144
(previous owner Eyre, an early 20th-century coin collector; purchased from Spink
& Son Ltd); 1897,1201.1 (donated by the Government of Burma); 1882,0508.41
(donated by Lt-Gen. Sir Arthur Phayre, first commissioner of British Burma, 1862–7).

2.7
Plates with Buddhist texts, 400–600 CE.
Gold. Excavated at Maunggan, Sri
Ksetra. H. 3.2 cm, W. 25.3 cm (top);
H. 3.4 cm, W. 33 cm (bottom). British
Library, London, Or 5340 A and B.
Sent by Sir Frederic Fryer, Lt-Gov. of
Burma (1897–1903), to Dr Hultzsch for
transmission to the British Museum.

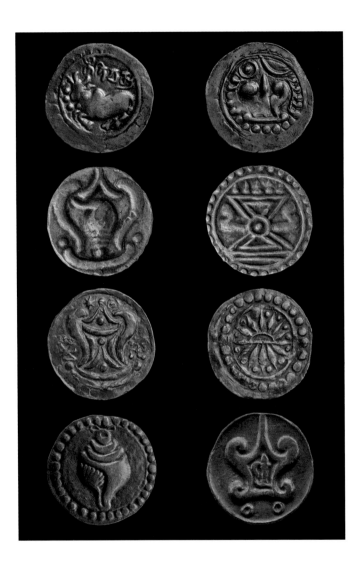

bulbous and globular-shaped stupas set upon round and octagonal terraces (fig. 2.2).

One of the cultural products of the Pyu was silver coinage. It was transported across mainland Southeast Asia and can be found in Arakan and lower Myanmar and at historical sites such as Nakhon Pathom and U Thong in Thailand and the port of Oc Eo in the Mekong Delta in southern Viet Nam. Pyu coins were minted in various denominations from the fifth to the ninth centuries CE, after which production declined and was not revived for several centuries.[3] The coins were circular with central imagery surrounded by dotting, a design also found in India and as far west as ancient Iran. They widely included Hindu and Buddhist subject matter also extant in India (figs 2.3–2.6): conches (symbolising purity and the spread of Buddhism), wheels (the spread of Buddhism), thrones (kingship), rising suns (propitiousness), dotting (an auspicious cosmic symbol) and the *srivatsa* (another auspicious image indicating divinity or greatness). The Pyu incorporated this material into the coins as symbols of religious kingship.

Early Indian scripts also arrived along trade and religious networks and were adapted for use with local languages, as can be seen in the archaeological find of two texts inscribed in Pyu script on gold plates dated to the fifth century CE at Sri Ksetra (fig. 2.7). The Pyu script is an adaptation of the southern Indian Pallava one. However, work on translating the language is still ongoing because it died out as the Pyu were absorbed into the Bagan kingdom. One of the last appearances of Pyu script features on the Myazedi quadrilateral inscription in Burmese, Pali, Mon and Pyu, which was erected by Prince Rajakumar in 1113 at Bagan and is sometimes called Myanmar's 'Rosetta Stone'.

Both gold plates feature Buddhist texts, including passages from the Abhidhamma Pitaka and text in praise of the Three Jewels of Buddhism (the Buddha, the *dhamma* (teachings, called *dharma* in Sanskrit) and the *sangha* (community of monks)). One text, the 'Ye Dhamma' verse, became widely used across many parts of the Buddhist world because it summarises the essence of the Buddha's teachings about

reliefs, and stone urns, images and inscriptions. City walls, building foundations and irrigation systems are also part of the record. Pyu stupas and monastic complexes show connections in shape and layout with the early Indian architecture of Nagarjunakonda and Amaravati, and later with northeastern Indian sites like Nalanda. Later Pyu stupas became more localised with the emergence of

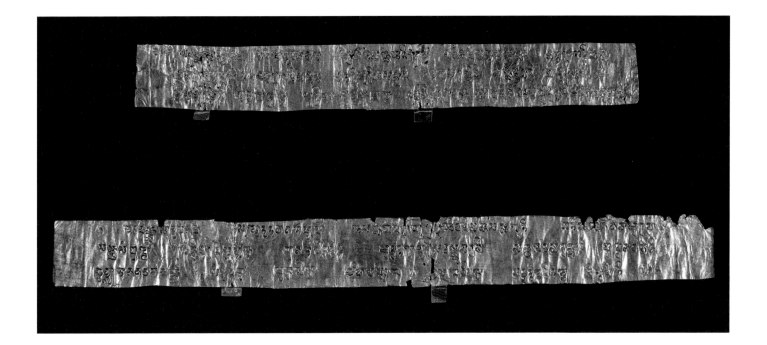

cause and effect and how to escape the suffering caused by the cycles of rebirth (*samsara*). (The 'Ye Dhamma' phrase became entrenched in the later Buddhist traditions of Bagan.) The Buddhism adopted by the Pyu included texts and practices from the Pali traditions of Sri Lanka and the Mahayana traditions from the north of India, as well as from the Himalayas and China. Mahayana Buddhist elements are also apparent in Pyu visual culture.

Among the most celebrated art forms from the city of Sri Ksetra are images of the Buddha flanked by two figures and bodhisattvas (spiritually advanced beings who postpone exiting the cycles of rebirth to help others to do so), who are features of the Mahayana. One such religious tablet displays the historical Buddha Gotama (also called Shakyamuni) in the centre, making the teaching gesture (*dhammacakka mudra*), with one of the Buddhas of the Past to the left in the gesture of enlightenment (*bhumisparsa mudra*) and the future Buddha Maitreya in royal robes to the right (fig. 2.8). All sit on lotus pedestals, a feature representing purity. The back was impressed with a leaf from the bodhi tree, the type under which the Buddha sat when he attained enlightenment. Two bodhisattvas – Avalokiteshvara and the future Buddha Maitreya – became particularly prominent in the Buddhist world of late-first-millennium Southeast Asia, including among the Pyu. Not only were such figures shown with the historical Buddha, but they were also represented individually. Sitting in royal ease, one image probably

represents the bodhisattva Maitreya, the next Buddha to be reborn on earth (fig. 2.9). Currently believed to be residing in Tusita Heaven, where all future Buddhas spend their penultimate life, he is shown richly adorned, as befits a deity.

The early richness of Pyu settlements and cities is attested by archaeological remains. Precisely what happened to the Pyu civilisation around the 900s CE is still unclear. Regardless of the means, by the late 1100s, Pyu remains were no longer distinct from those of the other peoples living along the central reaches of the Irrawaddy River.

The development of Bagan

Bagan is situated along a bend in the Irrawaddy River, where thousands of religious buildings were constructed over a 250-year period. While the river's course has altered over time, the place was a strategic location that provided access to the Chindwin River and the fertile agricultural districts at Kyaukse and Minbu in central Myanmar upstream and the Irrawaddy Delta and open seas to the south where traffic and transport from India, China and the region converged. Located in the central dry zone of the country, Bagan receives little monsoon rain in the middle of the year, followed by a dry, cool season. Starting around February, the temperature gets hotter, the weather even drier, and water must be obtained from sources such

as wells or the Irrawaddy River. Recent archaeological investigations have found a sophisticated water management infrastructure dating from the Bagan period.[4] Given the prolonged dry season, it was crucial to have access via the river to the agricultural production of the central region at Kyaukse and Minbu to sustain a growing local population that congregated around Bagan from its early origins until its political demise in the late thirteenth century.

The origins of the Burmans who came to prominence at Bagan in the eleventh century are still uncertain and subject to debate. They may have moved into Myanmar and absorbed the Pyu peoples in the ninth century CE, or they may have lived alongside the Pyu, resulting in the

merging of the groups, the rise of the Burmese language and the decline of the Pyu one.[5] Bagan's beginnings can be traced to a Pyu village, one of the legendary nineteen founding villages later described in Burmese histories.[6] According to these texts, Bagan was established in 107 CE by King Thamudarit, who united the settlements. However, it is not until much later, in 849 CE, that the construction of city walls by a King Pyinbya is described. The evidence for these early kings and settlements is still vague. It is only in the eleventh century, during the reign of the first historical king, Anawrahta (r. 1044–77), that extensive archaeological material in the form of stone inscriptions, sculpture, bas-reliefs, inscribed tablets, paintings and monuments develops at Bagan. Construction accelerated over time and, while only a few monuments were built during the eleventh and early twelfth centuries, there were thousands by the late thirteenth century.

The impetus for the surge in construction was religion, but not that of its neighbours. Nearly all India's kings were Hindu by the eleventh century, and the Song dynasty emperors of China had abandoned Buddhism in favour of Daoism and Confucianism. Islam was advancing from central Asia into northern Pakistan, which had previously been Buddhist territory, and would soon reach India, in some instances driving Buddhists to migrate elsewhere. Tantric (Vajrayana) Buddhism persisted in the Himalayas and Tibet. Although Bagan was in contact with the Himalayan regions and northeastern India, as well as China, it turned towards Sri Lanka, a centre for Theravada Buddhism that was based on Pali-language texts.

Bagan in the Buddhist world

Despite Bagan's position in the central dry zone of the region, it was an active participant in regional trends and religious networks, as indicated by its remaining inscriptions and Burmese chronicles, as well as Sri Lankan and Indian inscriptions and texts and Chinese annals. Dynamic trade and religious networks traversed vast distances from China and the Himalayas to northern and southern India, Thailand and Sri Lanka, as well as around the region that comprises Myanmar today. These links emerge visibly in architectural forms, artistic styles, the arrangement of imagery, patterns and motifs, and the representation of narratives at Bagan. As Bagan became a Buddhist epicentre, its kings adopted the title of *cakkavatti* (universal monarch), connecting their position as ruler with Buddhist doctrine and philosophy.

Sri Lanka

Myanmar and Sri Lanka have had prominent political and religious connections since the Bagan period. For instance, Burmese histories note that King Anawrahta sent a mission to Sri Lanka to acquire a tooth relic of the Buddha.[7] Although this event is not mentioned in Sri Lankan texts, Burmese ones describe how the tooth relic replicas sent by Sri Lankan king Vijayabahu I (r. 1055–1110) were encased in four monuments marking the corner boundaries of Bagan – the Shwezigon, Tuyin Taung, Lawkananda and Tangyi Taung stupas. A Sri Lankan historical text, the *Culavamsa*, does mention connections to Bagan, including King Vijayabahu's request for Bagan's assistance in defeating the Indian Chola dynasty in the 1060s.[8] In response, Sri Lanka apparently received ships with merchandise.[9] Vijayabahu I also sent a religious mission to Bagan in 1071, requesting educated Buddhist monks to help purify the Sri Lankan *sangha*, which had become corrupt, by hosting reordination ceremonies.[10] King Vijayabahu II (r. 1186–7) sent a letter to King Narapati Sithu (r. 1174–1210) of Bagan, stating a desire to maintain friendly relations to help the *sangha* flourish.[11] Named monks who travelled to Sri Lanka are known, such as Chapata, who returned to Bagan in 1181 after spending ten years abroad. Similar exchanges continued intermittently throughout the Bagan period.[12]

Interestingly, despite religious exchanges with Sri Lanka, there is little visual evidence of such connections at Bagan

compared with the quantity of imagery associated with several regions of India. One exception is the Hpet-leik stupas, which display the first 497 out of 550 *jataka* stories (tales of the Buddha's previous lives) in an order associated with Sri Lanka and the remainder in an order associated with the Mon of lower Myanmar, which Bagan attacked in 1057. However, few of the many stupas at Bagan display Sri Lankan elements, such as a bulbous bell-shaped section, a square *harmika* (box-form developed from a fence on top of the bell portion), separate finial of layered umbrellas, or a platform resting on the backs of a row of elephants. One of the few examples with an overt connection to Sri Lankan styles is the massive Setanagyi, the construction of which was patronised by King Nadaungmya (r. 1211–*c*. 1230/31, also known as Htilominlo) (fig. 2.10).[13] The stupa displays Sri Lankan features in combination with Burmese-style terracing set with miniature temples at the corners.

Events associated with Sri Lanka were occasionally represented in wall paintings, too. For example, the paintings in the Myinkaba Kubyaukgyi temple (*c*. 1113), built by Prince Rajakumar, and the Thetkyamuni temple (*c*. 1200–1300) display such material as scenes from the Sri Lankan *Mahavamsa* text.[14] Also represented are the coronations of Sri Lankan kings, the life of Sri Lankan king Dutthagamani (r. second or first century BCE), the monk Sanghamitta transporting to Sri Lanka a branch of the bodhi tree under which the Buddha became enlightened, and Buddhist councils ensuring the integrity of the scriptures, including the one held in the first century BCE in Sri Lanka.[15] Although the content is associated with Sri Lanka, the settings and imagery are in keeping stylistically with Bagan art of the time.

India: Bodh Gaya

Thousands of religious structures were erected across a 104-square-kilometre plain during Bagan's building boom, which drew Indian artists and artisans to the kingdom.

2.10
The Setanagyi stupa, early 1200s.
Bagan.

2.11
Tablet with a Mon inscription, late
1000s. Bodh Gaya, Bihar State,
India. Clay. H. 10.7 cm, W. 10.3 cm,
D. 1.7 cm. British Museum, London,
1887,0717.82. Donated by Maj.-Gen. Sir
Alexander Cunningham, founding head
of the Archaeological Survey of India
(1870–85), in 1887.

2.12
Photographic print of the Burmese
inscription at Bodh Gaya, late 1800s.
Bodh Gaya. Paper. H. 22.8 cm,
W. 20 cm. British Museum, London,
1897,0528,0.26.a. Donated by
Maj.-Gen. Sir Alexander Cunningham
in 1897.

Although it has been assumed that ideas flowed outwards
from India and were absorbed by Bagan, the situation
was much more complex. Bagan participated actively
alongside India's communities in creating a Buddhist and
artistic world. From the eleventh century, Bagan had a
particularly strong connection with Bodh Gaya in northern
India, the site of the Buddha's enlightenment and the great
Mahabodhi temple commemorating it. Burmese and Mon
inscribed materials have been found there. A religious tablet
with impressed Buddhist imagery, possibly dating to the
late eleventh century, has an Old Mon inscription incised
on the lower edge, which indicates that the maker came
from Myanmar, possibly Bagan, since the language was still
common on inscriptions there at the time (fig. 2.11). Because
the inscription was added while the clay was wet, most
likely the tablet was made at Bodh Gaya, indicating the
presence of Mon-speaking pilgrims from an early date.

Bagan monarchs sent delegations to repair and donate
offerings at the Mahabodhi temple at Bodh Gaya to show
their devotion to the Buddha and demonstrate their status as
dhammarajas, righteous Buddhist kings. Kyansittha (r. 1084–1113)
is the first king of Bagan to record sending a repair team to
Bodh Gaya, detailing in the Shwesandaw inscription of the
late eleventh century that he dispatched a ship with numerous

precious jewels for the temple's renovation, and in the vicinity of the temple bought lands to donate, had lakes dug, constructed irrigation works and a dam, regularly had lights, music and theatrical performances offered to the Buddha, and renovated monuments built by King Dhammasoka (Indian emperor Ashoka, r. c. 268–232 BCE).[16] Another inscription, a nineteen-line Burmese text found at Bodh Gaya, recorded repairs to the temple led by two Burmese Buddhist monks between 1295 and 1298 CE, after completion of which land, bonded people and cattle were dedicated to the temple for its support.[17] This inscription is also important because it records previous royal missions to Bodh Gaya. A copy held in the British Museum was made when the inscription was found during archaeological work at the site by Alexander Cunningham, director of the Archaeological Survey of India, in the late nineteenth century (fig. 2.12).

Yet, the royal embassies to the site of the Buddha's enlightenment were not the only pilgrims from Bagan and the regions around it. Courtiers and commoners also sponsored such journeys, as records of financial contributions towards joint ventures attest.[18] Ritual objects such as clay religious tablets were made at Bodh Gaya, and some were brought back and enshrined in temples and stupas in Myanmar. Such offerings are an aspect of Buddhism that focuses strongly on acts of donation as a path towards good future rebirths and the eventual attainment of enlightenment, the goal of all Buddhists. Donations were and are made to generate merit and good karma, and the Three Jewels of Buddhism are believed to be maintained through these acts of devotion (karmatic Buddhism).

The Mahabodhi temple at Bodh Gaya was also of relevance at Bagan too. After another embassy to Bodh

2.13
The Mahabodhi temple, Bagan, built in
the early 1200s.

2.14
Tablet impressed with a figure of
Buddha under a Mahabodhi temple-
style superstructure, *c.* 1200–1300.
Bagan. Terracotta. H. 15.5 cm,
W. 12.5 cm, D. 5 cm. British Museum,
London, 1896,0314.15. Collected by
Rodway Swinhoe, a lawyer in British
Burma from 1888 to 1927; donated by
Sir Augustus Wollaston Franks in 1896.

Gaya was sent by King Nadaungmya in the early thirteenth
century, a full-sized replica of the Mahabodhi temple was
constructed in a central position within Bagan's city walls in
1216 (fig. 2.13). The temple's outer walls are covered in niches
containing Buddha images, a feature common in Mahayana
and Vajrayana (Tantric) temples at the time.[19] The temple's
shape also became a standard architectural format at Bagan
from the early thirteenth century, although a few earlier
examples exist.[20]

While there are numerous architectural forms at Bagan,
an early common element was the *sikhara*, which means
'mountain peak' in Sanskrit and refers to the curving,
layered superstructure atop temples. The superstructure
of the Mahabodhi temple at Bodh Gaya, however, had a
pyramidal shape, and this form replaced the curved *sikhara*
at Bagan in the thirteenth century. It is visible at several
surviving temples. It also appears on clay religious tablets
with an image of the Buddha seated under the pyramidal
form of Bodh Gaya's temple instead of a *sikhara*. Here,
the Mahabodhi superstructure is clearly visible above
the Buddha seated with legs, pendant and hands in the
teaching gesture (fig. 2.14). The surrounding stupas could
refer to the tens of thousands of stupas reputedly erected
by Emperor Ashoka of the Indian Mauryan dynasty, who
was considered a model Buddhist king. In addition to
being illustrated on tablets, there were miniature three-
dimensional replicas of the Mahabodhi temple, usually
made of stone, which have been found at Bagan and
Arakan, as well as in the Himalayas and India itself.

Pala India and Bagan: Buddha images

From roughly the eighth to the twelfth centuries, artistic
production flourished in northeast India in a style that can
be seen from the Himalayas to Myanmar and Indonesia,
which only declined when Muslim incursions caused people
to flee to other Buddhist centres, including Bagan. The art
forms of the Indian Pala era (eighth to the twelfth centuries)
are closely linked with those at Bagan from the eleventh

century, with aspects lasting into the nineteenth century in
Myanmar. Not only were narratives and designs carried
around the region, but also art styles and the expression
of religious concepts. Early Buddhist images at Bagan
from the eleventh and twelfth centuries exhibit strong links
with northeastern India in the folds of the robe, the broad
shoulders and narrow waist, the shape of the face and the
pointed chin, the arch of the eyebrows and the pursed lips,
as seen here (fig. 2.15). The transition to a Burmese aesthetic
came in the late twelfth and thirteenth centuries when
Buddha images became squatter with a short neck, rounder
with softer limbs, and also featured a slight smile.

A number of hand gestures, representing different
moments or actions in the Buddha's life, were produced in
the early Bagan period. However, by the mid- to late twelfth
century, the gesture marking the Buddha's enlightenment
(*bhumisparsa mudra*) had become predominant. In this position,
the Buddha's right hand touches the ground to call the earth
goddess to witness the good deeds he performed throughout
his innumerable previous lives. The moment occurred when
Mara, the god of earthly desires, and his army attacked,
trying to prevent the Buddha-to-be's enlightenment. When
Mara was defeated by the overwhelming evidence, the
Buddha-to-be was free to continue meditating and achieved
enlightenment, thereby becoming a Buddha, at dawn. The
gesture references the site of the enlightenment – Bodh
Gaya – demonstrating the growing importance of that
event, and therefore that place, as a result of the increasing
ritual emphasis on the historical Buddha, Gotama, around
the region.[21] The wide distribution of this enlightenment
iconography – *bhumisparsa mudra* – became common among
communities that shared this religious focus.

In the eleventh and twelfth centuries, standing images of
the Buddha bedecked with crowns and necklaces were also
part of the Pala phenomenon.[22] These were often replicated
in wood in Myanmar, mainly during the fourteenth and
fifteenth centuries (fig. 2.16). In Myanmar, these images
were shown with the right hand facing palm-out in the
wish-granting gesture and the left against the chest.

2.16
Standing crowned Buddha image,
1300–1500. Central Myanmar. Wood,
gold and lacquer. H. 114 cm, W. 23.4 cm,
D. 3.7 cm. British Museum, London,
1981,0611.1. Purchased from Bruce
L. Miller in 1981 via the Brooke Sewell
Permanent Fund.

The crown relates to Pala examples in its several high leaf-like points, but the inclusion of a high central protuberance does not, nor do the extensive ribbons to each side. The figure's round face and short neck likewise display its central Myanmar origins. Not only did such images show the bond between an earthly monarch and the Buddha, but the adornment further linked the Buddha with the height of spirituality – Buddhahood. As the king was at the apex of lay society, so the crowned Buddha was presented as being at the zenith of the spiritual realm.[23] While the crowned Buddha image became one of the most commonly produced in succeeding centuries, examples from the seventeenth to the early nineteenth centuries were shown seated in the gesture of enlightenment, testifying to its enduring importance (see figs 3.20–3.21).

Buddhist narratives

Starting in the eleventh century, narrative imagery became prominent at Bagan. At this time, such imagery was often a mix of the different branches of Buddhism, drawing on various texts about the life of the Buddha from the *Nidanakatha*, associated with Pali-language scriptures, to the Sanskrit *Lalitavistara* common in northern regions, including China and the Himalayas. The illustrated stories at Bagan rapidly focused upon three significant elements – the *jataka* tales of the Buddha's previous lives, the final life of the historical Buddha, and the twenty-eight Buddhas of the Past – coming to prominence at Bagan in that order. While to some extent the imagery can be traced to the Pala style of the Buddhist world or Sri Lanka, it is also related to the development of Buddhism at Bagan with its focus on donation.[24]

The 550 *jatakas* functioned as a means to understand the Buddhist law of cause and effect, whereby good or bad actions have a good or bad result in a future life and, in doing so, they promoted karmatic Buddhism. While the use of these particular stories may be associated with King Anawrahta's attack on Thaton in lower Myanmar

2.17
Plaque depicting the Kalabahu *jataka*
(no. 329 of the 550 tales), Mingalazedi
stupa, *c.* 1274. Bagan. Glazed terracotta.

2.18
Jataka stories painted in the corridor
of the Myinkaba Kubyaukgyi temple,
Bagan, 1113.

in 1057, when people and Buddhist texts were brought back to Bagan, the fact that they were also popular in Sri Lanka suggests that the importance of these tales was a regional phenomenon. At Bagan, the *jataka* tales are first seen in rectangular clay plaques set into the interior walls of the Hpet-leik temples (early to mid-eleventh century); the plaques are numbered and identified in Pali using Mon script. After this, plaque design changed to a green-glazed square. These were surrounded by a dotted border, with a space for a caption below the imagery. This became a fixed format for the depiction of *jataka* stories found in both architectural ceramics and interior wall paintings (figs 2.17–2.18). One plaque or painted square was associated with each of the 550 *jataka* stories, except for the ten great tales in which the Buddha-to-be perfected the ten virtues necessary for attaining enlightenment and nirvana. These lengthy and complex stories were represented over several squares.

The design of the plaques has precedents. The beading can be seen on architectural plaques produced earlier by the Pyu and people living in lower Myanmar, and the imagery

relates to contemporaneous examples found in northeast India. The standardisation lasted into the nineteenth century, appearing on ceramic and stone plaques affixed to temple and stupa exteriors. The later plaques were not only used to represent the *jataka* tales, but they also included events from the life of the Buddha and the history of the *sangha*. Particularly famous examples come from King Bodawpaya's (r. 1782–1819) Mingun temple just north of the then capital at Amarapura in 1790. Never completed, it was to be set with plaques resembling Bagan-period examples except for the glaze colour, the wheel-shape of the beading (reminders of the Buddha's teachings, the wheel of the law) and the inclusion of a wider range of events and imagery. Such plaques were also found at other nineteenth-century sites (fig. 2.19). This example shows the Third Buddhist council organised by Emperor Ashoka around 250 BCE to ensure the accuracy of the scriptures. The plaques were part of an efflorescence of Bagan-style art that occurred in the late eighteenth to the mid-nineteenth centuries.

The story of the historical Buddha Gotama's final life appeared at an early stage at Bagan, though slightly

2.19
Plaque showing the Third Buddhist council, early 1800s. Wuntho, central Myanmar. Glazed earthenware. H. 24 cm, W. 24 cm, D. 3.7 cm. British Museum, London, 1894,0719.4. Donated by Lt-Col. Sir Richard Carnac Temple (1850–1931), colonial administrator and scholar of India and Burma, in 1894.

2.20
Tablet with the eight great events of
the Buddha's life, 1200–1300. Bagan.
Terracotta. H. 16.5 cm, W. 11.8 cm,
D. 4.5 cm. British Museum, London,
1899,1016.1. Donated by Lt. Dobson
in 1899.

later than the *jatakas*.[25] At some Burmese temples, scenes of the Buddha's life were arranged in combination with sculpted figures of the Buddha in niches, but his life events rapidly became condensed into eight scenes: his birth; his enlightenment; his first sermon; his descent from Indra's palace in Tavatimsa Heaven after preaching to his mother who had been reborn there; the taming of the maddened Nalagiri elephant; the retreat to the Parileyya forest; the

performance of the twin miracles; and his *parinirvana* when he died and exited the cycles of rebirth (fig. 2.20). In this format, the eight great events were sometimes represented around a sculpted main image as part of wall paintings. However, they were more commonly found on clay and stone tablets in a standardised format, with the enlightenment as the central event, the *parinirvana* directly above it, and the six remaining events arranged to each side. The adoption of the eight great events to display the Buddha's life at Bagan also emerged from trends in the Buddhist world more generally. In India, for example, Pala art from the tenth century onwards incorporated the eight great events from the Buddha's life into various materials, such as black schist stone stelas, reliefs, dolomite plaques and illustrated palm-leaf manuscripts.

The eight great events not only display the structure of the Buddha's life – birth, death and enlightenment – but also point towards the triumph of his teachings, as the remaining five scenes are associated with the instruction of others. As such, the events also present a paradigm for the lives of other Buddhas. Because the eight great events were each associated with a specific location in India, they became a major focus for pilgrimages, with Buddhists coming from afar to pay homage, creating another means for the development of transregional connections and exchanges.[26] Occasionally, the eight great events were represented together with the seven stations. These were positions around the bodhi tree where the Buddha sat, stood, walked and meditated during the seven weeks immediately after his enlightenment. Like the eight great events, the seven stations were developed into a 'mini' pilgrimage as the practitioner walked around the site of the Buddha's enlightenment. This layout was particularly replicated at temples in lower Myanmar and northern Thailand in the fifteenth century (see fig. 3.25).

At Bagan, the night of the enlightenment was occasionally elaborated visually. For example, the attack of Mara's army was represented in greater detail at the Ananda temple (*c.* 1100) and the Wetkyi-in Kubyaukgyi (*c.* thirteenth century). At the former, it was replicated on green-glazed

2.21
Tablet with the Buddhas of the Past
and the historical Buddha, 1100–1300.
Terracotta. H. 19.5 cm, W. 14.2 cm,
D. 3.8 cm. British Museum, London,
1947,0208.2. Donated by Cmdr. A.A.
Rundle in 1947.

plaques that were set around the outside of the temple and, at the latter, it was depicted in paintings on either side of the sculpted main image. Expanding the enlightenment sequence beyond the representation of the Buddha in *bhumisparsa mudra* at Bagan reinforced the centrality of the Buddha's great achievement.

Another element of Gotama Buddha's biography appears in representations of Buddhas of the Past. The historical Buddha is merely one in a long line of Buddhas (the term means 'awakened being'), with further Buddhas to come (the next being Maitreya). The theme of the previous Buddhas can be found at numerous sites in India, from the fifth-century CE Ajanta caves to Pala-period India, although groups of four, five, seven and eight Buddhas were typically displayed. At Bagan, the imagery of these Buddhas not only served to emphasise the Buddha's lineage but was also another element in homage to the historical Buddha Gotama. Bagan adopted a standardised series of twenty-eight Buddhas by combining stories of twenty-five Buddhas from the *Buddhavamsa* in the Pali scriptures[27] with another three probably from a Sri Lankan text called *Sotatthaki*.[28] These Buddhas were believed to have made prophecies of Buddhahood to the future Gotama Buddha during his previous lives. As with the life of the Buddha, these Buddhas were represented in paintings, sculptures and religious tablets. One tablet displays thirty Buddha images, two stupas surrounded by a beaded border and an illegible inscription at the base (fig. 2.21). The twenty-eight Buddhas are shown in a small size, while the two representations of Gotama are larger to emphasise him. He is represented in the lower centre to indicate his great significance, and he is the central image at the top to indicate that he too is part of the lineage of Buddhas. The growing prominence of the twenty-eight Buddhas came to be linked with royal propaganda. The status and wealth of Bagan kings were believed to be evidence of their sufficient positive karma from previous lives to warrant being reborn as earthly kings. This suggested that they too were worthy to receive prophecies about their future spiritual status.[29] Being a good and righteous ruler

therefore indicated the possibility of a future final rebirth, attainment of enlightenment and Buddhahood, and a final release from suffering and the cycles of rebirth.

Buddhism, Brahmanism and Hinduism

Initial evidence for Brahmanical (Hindu) imagery in Myanmar dates to the fifth to the tenth centuries CE in cities

2.22
Relief sculpture of Brahma in Nanpaya
temple, Bagan, c. 1050–1100.

2.23
Relief panel with an image of the deity
Brahma, probably from Myebontha temple,
Bagan, 1100–1200. Grey sandstone with
traces of yellow pigment. H. 30.5 cm,
W. 22.2 cm (base), D. 12 cm. Victoria and
Albert Museum, London, IM.39-1917.
Collected by the zoologist Dr John Anderson
(1833–1900), who worked in India and Burma;
bequeathed by his wife, Grace Anderson.

like Thaton in lower Myanmar and Sri Ksetra, one of
the major Pyu cities. At Bagan, an early representation
of Hindu deities in a Buddhist context occurs at the
Abe-yadana temple, which is thought to have been built
around 1090 by Abe-yadana, one of King Kyansittha's
queen consorts, who apparently came from Bengal. In the
temple, paintings of Hindu deities such as Brahma, Indra,
Vishnu and Shiva on their animal mounts sit alongside
Mahayana images of bodhisattvas and Theravada material
of the life of the Buddha, including Mara's attack and
defeat, the Buddha's enlightenment and the *jataka* stories.[30]

Hindu deities were gradually incorporated into Burmese
religious and court traditions, as well as the Burmese spirit
(*nat*) tradition. *Nats* are unnamed spirits occupying natural
features of the landscape or named individuals (such as the
goddess Saraswati, a *nat* in Myanmar and a Hindu deity in
India) who are propitiated to ensure good luck and success
(see fig. 7.2).[31] However, two deities came to be of particular
importance in the Buddhist context – Indra (*Sakka*; *Thagya*)
and Brahma. Not only are they important devotees of the
Buddha, but they are also thought to have participated
in major events of the Buddha's life, including his birth
and his renunciation of worldly life when he departed
the palace, cut his hair and commenced life as a monk.
Indra was lord of Tavatimsa Heaven, whose palace was
a model for the construction of Burmese kings' palaces,
including the nineteenth-century Mandalay Palace. Indra
also recorded people's good and bad deeds that determined
the state of their future lives as part of karmatic Buddhist
practice. Buddhist practitioners interpreted Brahma as a
prominent devotee of the Buddha, as seen in the stone relief
sculptures at the Nanpaya temple (*c.* 1050–1100) (fig. 2.22).
At the Myebontha temple (*c.* 1100–1200) stone sculptures of
Brahma with three of his four faces visible and his hands
in *anjali mudra*, the gesture of homage, were embedded into
the throne of the main images (fig. 2.23). The curving shape
of the eyes and the pursed lips follow contemporary Bagan
conventions associated with the reign of King Kyansittha
and the early twelfth century.

Because kingship in Myanmar was not inherited through
the first-born son, competition for the throne was frequent.
Kings justified claims to the throne in part through
genealogies and narratives of previous lives linked with
'Hindu' deities. For instance, King Kyansittha claimed a
personal connection with Brahma and Vishnu. During his
reign, he erected at least twenty Mon-language inscriptions
in Bagan, Pyay (near Sri Ksetra in central Myanmar) and
the vicinity of Thaton in southeastern lower Myanmar that

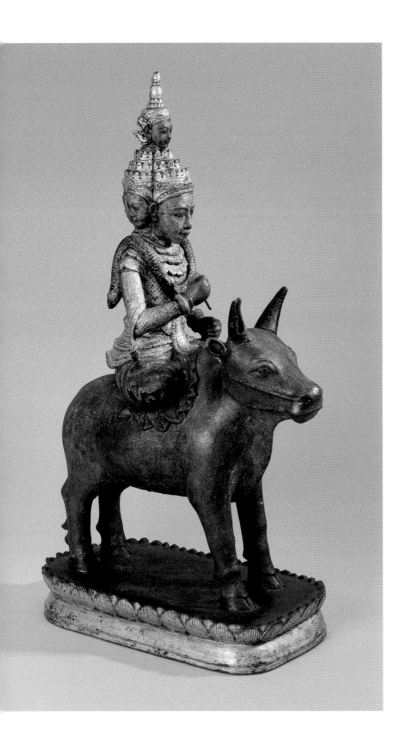

documented his biography and the construction of a new palace. In lines 13 to 47 of the inscription at Shwezigon stupa at Bagan, he claimed that the Buddha prophesied to him in a previous life that he would become a Bagan monarch in the future, that in one of his previous lives he had been reborn as Brahma and that he had also been the hermit Vishnu who established the ancient Pyu city of Sri Ksetra with the help of the gods.[32] In making such claims for his previous lives, Kyansittha established his connections with powerful entities (including the Buddha) and the historical landscape, revealing his good karma and demonstrating his suitability to be king.

A complex system of court rituals also emerged during the Bagan period. Of Indian, Arakan and Manipuri origins, Hindu brahmins (*ponna* in Burmese) were a vital part of Bagan courts, performing essential royal rituals and selecting auspicious times for state tasks such as the establishment of capital cities, initiating military campaigns, and royal and Buddha image consecrations, as indicated by the inscriptions of Kyansittha and other kings. For instance, King Narapati (r. 1501–27) constructed a new palace in 1510, accompanied by rituals associated with Parameshvara (Shiva), Brahma and the gods of the nine planets, which were organised by the court *ponna*.[33] Such elements were also part of King Mindon's (r. 1853–78) construction of Mandalay Palace in 1857.[34] Wooden sculptures of deities were produced for the court as part of ritual activities. One example of Shiva mounted on his bull Nandi, which was probably produced for the court at Mandalay in the mid- to late nineteenth century, has five heads representing his control over the five elements and five directions (the cardinal directions plus the centre) (fig. 2.24). Images were honoured and their presence was required to maintain stability, prosperity and the king's legitimacy. *Ponna* and their objects and rituals associated with Brahmanical elements therefore remained an essential part of court activities until the end of the monarchy at the hands of the British in 1885 (see p. 84).[35]

China

By the late thirteenth century, Bagan's kings could no longer keep control of the kingdom. There were complex reasons for the decline, ranging from the cumulative donations of land to the *sangha*, which then remained tax-free in perpetuity and reduced the tax base, to ecological pressure from increasing deforestation, to a series of weak kings and invasions by the Mongols via southwestern China. In the late thirteenth and early fourteenth centuries, there were three attacks on the kingdom of Bagan by the Mongols, adding to the demands made on the resources of the state and society.[36] In 1271 China sent envoys to Bagan to affirm the kingdom's tributary status but received no response. Reacting to rising tensions with China and realising the importance of good relations, King Narathihapade (r. 1256–87) sent his minister Shin Disapramok on a diplomatic mission in 1284.[37] Although the mission successfully convinced Kublai Khan (r. 1264–94) that Bagan's glory was its religion rather than its military prowess – a feat commemorated in an inscription erected by Disapramok upon his return[38] – Bagan was unable to remain integrated, and other cities took the opportunity to proclaim separate status.

Compared to Bagan's links with northeast India, there is limited visual evidence of interaction with China from the Pyu and Bagan periods. In earlier times, the Pyu not only paid tribute to the Chinese courts but were also mentioned in Chinese annals, and some Chinese Buddhist imagery occurs in religious tablets found at Sri Ksetra.[39] The focus during the Bagan period was primarily on the Buddhist centres of Sri Lanka and northeastern India, so there are comparatively few Chinese references. Yet, a number of sites, such as the Kyansittha U-min cave temple (eleventh century) and the Thambula and Nandamannya temples (thirteenth century), have wall paintings that display figures wearing what appear to be Chinese textiles, clothing and hairstyles.[40] The few Chinese links may result from the fact that Indians played major roles in the production of art at Bagan, reflecting the kingdom's importance in the Buddhist world – it also provided a haven to Indians fleeing the decline of Buddhism, instigated in part by the expanding power of the Delhi Sultanate founded in 1206. This suggests that, when making religious donations, Buddhist connections and imagery associated with the Buddhist world were paramount. Remaining art forms from Bagan therefore do not necessarily represent the full extent of the kingdom's interactions with the world around it.

The continuity of Bagan art

The art of Bagan did not end with its political fortunes. As mentioned, particular elements became part of ongoing artistic production into the nineteenth century. Besides the plaques and Brahmanical imagery, textile patterns were another prominent feature that persisted. Few textiles remain from the Bagan period, the largest being a painting on cloth found rolled up inside a Buddha image at one of the many temples on the Bagan plain. It displays the same layout and subject matter as many wall paintings and shows figures sumptuously dressed in what may have been Indian trade textiles. Such textiles were also replicated in paintings on the walls and ceilings of Bagan's many temples, both as patterning framing the imagery and as clothing worn by the people being represented,[41] a phenomenon that occurred elsewhere, as seen in contemporaneous Indian manuscripts and later Sri Lankan wall paintings. The practice of painting temples to look as if they were hung with textiles indicates that sometimes textiles themselves were hung in religious and other spaces. Furthermore, the use of textiles or replica textiles in temples reveals their prestige since they were considered sufficiently valuable to adorn sacred spaces. This practice continued in Myanmar into the early nineteenth century in wall paintings.[42] The polygonal, circular, rhomboid and striped patterns stuffed with lines, dots, waves and floral designs, as well as a layout in bands or fields of designs, were adapted for use on a variety of art forms, including religious ones, such as *kammawasa*

manuscripts from the nineteenth and twentieth centuries
(fig. 2.25). Made of lacquer over varying materials like cloth
or metal, such manuscripts contain excerpts from the Vinaya
portion of the Buddhist scriptures that establish monastic
rules of conduct, including procedures for ordination. Using
the *shwezawa* gold-leaf technique, the covers and pages of
kammawasa manuscripts were decorated with various types of
imagery, with Indian *patola* textile patterns being particularly
common. These include animals and birds in a geometric
shape, lotus pools, repeat patterns in the centre field, and
borders and end panels with bands of geometric shapes
and the zig-zag *tumpal* pattern, as seen in this example. Yet,
everyday utensils, such as lacquer betel boxes, were also
embellished with trade textile patterns (fig. 2.26). Betel is a
flowering plant native to Southeast Asia, and the chewing of
betel leaves was common across the region, where it was an
important part of social interactions and rituals. Boxes were
made to hold the necessary ingredients and paraphernalia,
including the nut itself, leaf wrappers, lime paste, nut
cutters and miniature boxes for the paste, and this example
is decorated with an interlocking circle design that was a
known textile pattern during the Bagan period but can also
be seen in Indian stone sculpture from the first century BCE.

Even after Bagan declined as the political capital in the late
thirteenth century, this vast plain remained an important
Buddhist centre with significant royal patronage and public
pilgrimage. Despite regional insecurities as the country
descended into various wars, new religious buildings
were still being erected. One of the largest libraries in
Myanmar was constructed there in the fifteenth century.[43]

Construction almost ceased between the late fifteenth
and seventeenth centuries as the political centres shifted
from Ava (Inwa) to Toungoo, Bago (Pegu) and back to
Ava. After the establishment of the Konbaung dynasty in
1752, however, there was another flurry of construction,
demonstrating Bagan's continued importance to Buddhism
in Myanmar.

In the 1990s, following major damage caused by a
strong earthquake in 1975, the military regime restored and
reconstructed many of Bagan's monuments. Rebuilding
was carried out on old foundations, sometimes transforming
ruins into whole new temples. In opposition to the basic
principles of heritage conservation, the regime and
responsible officials tried to reconstruct all the monuments.
Senior officials argued that it was to promote a nationally
identified patriotism and asked for religious donations from
people across the country to carry out the meritorious
work of reconstructing sacred sites. While their efforts
acknowledged Bagan's artistic and cultural importance,
the work often obscured original features, and the addition
of heavy cement to ancient brick structures caused further
major damage during the most recent earthquake in 2016.
Despite these modern interventions, Bagan was included
on the UNESCO World Heritage List in 2019. The listing
criteria acknowledged the global significance of Bagan's
art and architecture, representing the world's largest
concentration of Buddhist merit-making efforts. UNESCO
also recognised Bagan as the birthplace of long-lasting
Burmese Buddhist rituals, such as temple festivals, and as
an important centre of Buddhism around the region for
several hundred years.

2.25
Kammawasa manuscript, *c.* 1800–20.
Lacquer over textile. H. 9 cm, W. 53 cm.
Royal Asiatic Society of Great Britain
and Ireland, RAS Burmese 1 (5).
Probably donated by Robert Fullerton
between 1828 and 1831.

2.26
Betel box, *c.* 1890s–1930s. Central
Myanmar. Lacquer and bamboo.
H. 18.5 cm, Diam. 21.5 cm. British
Museum, London, 1998,0723.30.
Purchased from Madame Thair;
donated by Ralph H. Isaacs (director
of the British Council, Myanmar) and
Ruth Isaacs in 1998.

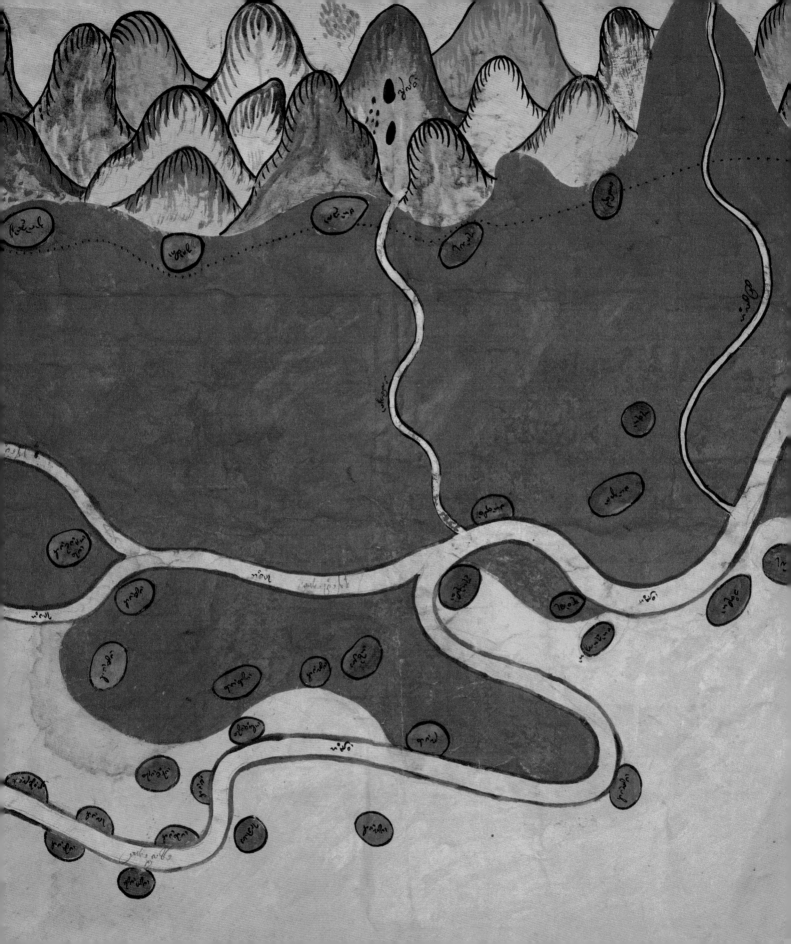

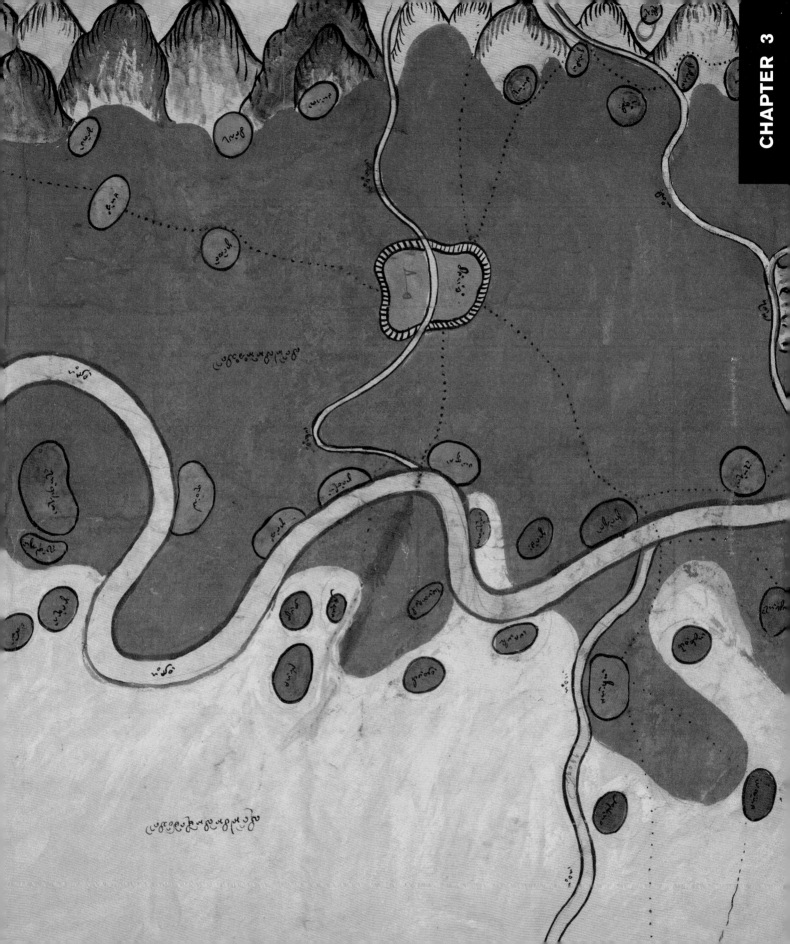

STATES AND NETWORKS: EXPANSION AND CONTRACTION, 1500–1900

ALEXANDRA GREEN

After the decline of the polities at Dhanyawadi, Vesali and the Lemro valley in Arakan, Bagan in the central zone and Thaton in the south, other political centres arose. These included Pinya and Inwa (also known as Ava) in the central area by the Irrawaddy River; Mrauk U, a polity in Arakan connected with the Bay of Bengal trade networks; and Hanthawaddy (also known as Bago/Pegu), an inland port kingdom in lower Myanmar. In the eastern regions (now Shan and Kachin States), numerous Shan principalities, such as Mohnyin, Mo-ne and Kengtung (Kyaingtong), competed for power. In the upland regions between state territories there were chiefdoms linked to one another through kinship and marital alliances and trade networks that developed into complex social hierarchies spread across large areas.

Such political multiplicity was characteristic of precolonial political structures in mainland Southeast Asia, where there were no borders defining territories. Instead, there were fluid lines and spheres of influence, and political control substantially depended on personal loyalties. The multiple centres interacted with one another and with regions further afield in military, political, religious and social capacities. This chapter examines cross-cultural exchanges among the political entities based in central Myanmar, Arakan, Hanthawaddy, the Shan states and the highland regions, as well as surrounding kingdoms, and how these are expressed in the production of art and material cultures. The movement of people, techniques, ideas and art forms occurred through warfare, trade and religious exchanges, resulting in the adaptation of patterns and designs, stories, languages, architecture and currency into local idioms. The extensive interactions of the period are not only detailed in texts but are visible in the objects discussed in this chapter. Material objects and artistic productions – including manuscripts, maps, religious images, musical instruments, coins, silver items, textiles, ceramics and weapons – record the complex politics of the regions through their forms, patterns, designs and uses.

The kingdoms of central Myanmar

The political sway of kingdoms based in central Myanmar (with their capitals variously at Ava, Toungoo, Amarapura and Mandalay) waxed and waned over 250 years until the Konbaung dynasty (1752–1885) was curtailed by the First Anglo-Burmese War of 1824–6. Twice the kingdoms briefly expanded to become the two largest empires in mainland Southeast Asia, stretching from the territories of Assam and Manipur (now in India) in the west to Thailand and Laos in the east and down the Thai-Malay peninsula.

After the decline of Bagan, several polities grew in strength, with the city of Ava becoming the most powerful. It was in the late fifteenth century that Toungoo, a provincial area in its sphere of influence to the south, grew in power, but it was not until Ava was defeated in 1527 by Mohnyin that substantial expansion was possible. Toungoo's political influence began with King Tabinshwehti (r. 1531–50). He conquered the various centres of authority in the lower region, including Hanthawaddy, Pathein and Mottama (Martaban). Tabinshwehti proved unable to move into Mrauk U in Arakan to the west under King Minbin (r. 1531–53) or the central Thai kingdom of Ayutthaya. After a brief hiatus following Tabinshwehti's early death, Bayinnaung (r. 1551–81) assumed the throne, and it was under him that the central Burmese Toungoo dynasty expanded to its largest size.

Bayinnaung built a multi-ethnic army that included Portuguese mercenaries and Mon and Shan peoples, among others, demonstrating that patronage pre-empted ethnicity and religion. He also proceeded to take the central region, the Shan states, Manipur, Chiang Mai (now northern Thailand), Vientiane (now Laos) and eventually Ayutthaya (central Thailand) in 1564 – carrying off the royal family as hostages – and invaded Ayutthaya again in 1569 following a revolt there. In 1568 he subdued the Sipsong Panna region (now part of Yunnan province in China), requiring tribute and deporting people to central Myanmar.[1] He kept his capital at Bago in lower Myanmar in part because the sixteenth century was a time of burgeoning trade through

the Bay of Bengal. However, this zenith was short-lived; after Bayinnaung's death in 1581, there was a protracted political crisis and Bago was ravaged by the neighbouring states of Arakan and Ayutthaya. The largest mainland Southeast Asian empire had disintegrated.

A smaller polity, later named the Restored Toungoo dynasty (1599–1752), reconstituted itself in the central region at Ava and set about reconquering the various parts of the empire. The Shan areas were subdued or brought into alliances and, by the mid-seventeenth century, Hanthawaddy and its rebellions were quelled and Chiang Mai retaken. Conflict arose again upon the collapse of the Ming dynasty (1368–1644) when one of the claimants to the Chinese throne took refuge in Myanmar, and Qing dynasty incursions between 1659 and 1662 sought to extradite the fugitive prince. However, the late seventeenth and early eighteenth centuries saw far more serious disruptions as Ava's power declined steadily due to internal factionalism and external attacks, finally collapsing in 1752.

The Konbaung dynasty, founded by King Alaungpaya, emerged in central Myanmar from the remnants of the Restored Toungoo dynasty. The decline of the mid-eighteenth century was only a temporary downturn in the central region's general trend towards consolidation and the expansion of its religious, linguistic and material practices.[2] Konbaung kings brought Manipur and Assam under their control; renewed the hold on northern Thailand briefly; destroyed the kingdom of Ayutthaya; tightened hegemony over the Shan princes; and engaged with the numerous chiefdoms and networks in the northern and highland areas beyond direct control.

Three major instances of military expansion and colonisation had highly visible impacts on the production of art and material culture in central Myanmar. These were the attacks on Ayutthaya in the 1560s and 1767; the approximately 200-year-long colonisation of Lan Na (northern Thailand) from the late sixteenth to the late eighteenth century; and the attacks on Manipur beginning in 1758, culminating with the Seven Year Devastation (1819–26)

when the population of Manipur was substantially relocated to central Myanmar. In each instance, the forcible movement of populations resulted in the emergence of new stories, artistic techniques and motifs, fashionable dress, games, ritual practices, forms of community integration and so forth, and it is to these transitions that the chapter now turns.

Ayutthaya

The relocation of people was once a standard part of warfare in many parts of Southeast Asia, and Myanmar's historical chronicles record this fact. In describing the attack on Ayutthaya in 1767, which utterly destroyed the city, the *Glass Palace Chronicle*, compiled at the Konbaung court at Amarapura between 1829 and 1832, records the people whom the Burmese encountered once they entered the city, including

> musicians and dancers, carpenters, carvers, turners, black-smiths, gold and silver smiths, copper-smiths and braziers, masons, decorators with natural and artificial flowers, painters both in ordinary colours and illuminated with gold and bright material, workers of marquetry, lapidaries, barbers, persons skilled in incantations, charms, and magic; persons skilled in the cure of the diseases of elephants and ponies; breakers and trainers of ponies; weavers and workers of gold and silver threads; and persons skilled in the culinary art.[3]

As the army returned home, many of these people were taken with them and resettled in central Myanmar. As a result of the relocation of so many skilled people from Ayutthaya, the kingdom was enriched by numerous elements of Thai art and material culture. This ranged from stories and religious practices to artistic techniques, patterns and court dress.

Thai theatrical troupes particularly impressed the Konbaung court. Their fame spread around the country to the extent that the diplomat Michael Symes, who worked

for the East India Company and led an embassy from the Governor General of India to King Bodawpaya's court in 1795, wrote of a performance at Bago:

> The theatre was the open court, splendidly illuminated by lamps and torches. … The performance began immediately on our arrival, and far excelled any Indian drama I had ever seen. The dialogue was spirited … the action animated, without being extravagant, and the dresses of the principal performers were showy and becoming. I was told that the best actors were natives of Siam [central Thailand].[4]

Thai (Burmese: 'Yodaya') performers were also incorporated into the pageantry associated with the display of state power.[5] Numerous manuscripts record court processions that include a group of Thai performers, demonstrating their role in the king's entourage and court and indicating the extent of the king's conquests and hence his power.[6] In one paper manuscript (*parabaik*) (fig. 3.1), the players wear Thai theatrical dress, some with masks on top of their heads and others as mythical creatures, and are labelled according to their performances – 'Yodaya aka' (Thai dance) and 'Yodaya adi' (Thai music).

Thai theatrical costumes, based on Thai court dress, were also appreciated by the Konbaung court. Several elements were adapted into a new type of formal court dress, including features such as the cloud collar, epaulette-like additions to jackets and elaborate swag elements worn like an apron at the front of the outfit. These changes were due to the fact that Konbaung court workshops comprised a variety of artisans (this was the case during earlier times too), and after 1767 these included Thais, some of whom specialised in gold and silver thread embroidery.[7]

At court, clothing was governed by sumptuary laws that allocated the shape, colour, materials and decoration that each rank was allowed to use. There were various state robes reserved for royals and other members of the elite, as well as those coming to pay tribute.[8] The sumptuous robe of one of King Mindon's (r. 1853–78) queens displays the sartorial prescriptions for her rank (fig. 3.2). The outfit would have been worn over a skirt-cloth, and its parts include the jacket with flaring sleeves, winged shoulder ornaments modelled on the Thai *kranok* flame pattern, a belt, the swag-like apron and a combined collar and front panel.[9] The green velvet displays extensive Indian silver and gilt embroidery embellishments. While there is evidence of embroidery and a partiality for flaring hems and cuffs on court textiles prior to the late eighteenth century, the wing-like projections and the ornate fall of the front panel are an elaboration of Thai theatrical costumes, demonstrating their impact on the Konbaung court of this period. Formal robes with similar elements were worn by other ranks too, and people coming to present tribute were also required to wear such dress, as seen in this photograph of the *saopha* (*sawbwa* in Burmese) of Yawnghwe in the Shan states and his wife (fig. 3.3).

Similarly, a ceremonial military outfit of the highest rank was composed of a velvet jacket, breast and back plates and a cloud collar that would have been worn over a man's skirt-cloth called a *pasoe*. The various components of the jacket were decorated with floral and geometric motifs around the edges and shoulders in gold embroidery, adapted from Indian work, with sequins, couched gold thread and bells (fig. 3.4).[10] The jacket was made specifically for a minister of the interior (*atwin-wun*) and could not be worn by any other rank. Yet, the cloud collar was a modification of Thai theatrical examples, and the Thais had adapted it from the collar of Chinese court robes.[11]

The new elements of formal court dress also appeared on Buddha images. Because there was a close connection between kingship and Buddhism – seen in the king's role as a *cakkavatti* (universal monarch) responsible for the spread and defence of Buddhism, his position in maintaining the purity of the *sangha* (community of monks) and the belief that he was a future Buddha – Buddha images were often shown adorned with crowns, royal insignia and jewellery in the fashion of the times, starting in at least the Bagan period. As a result of the sacking of Ayutthaya in 1767, adornments changed from a pronged crown with extensive ribbons flaring

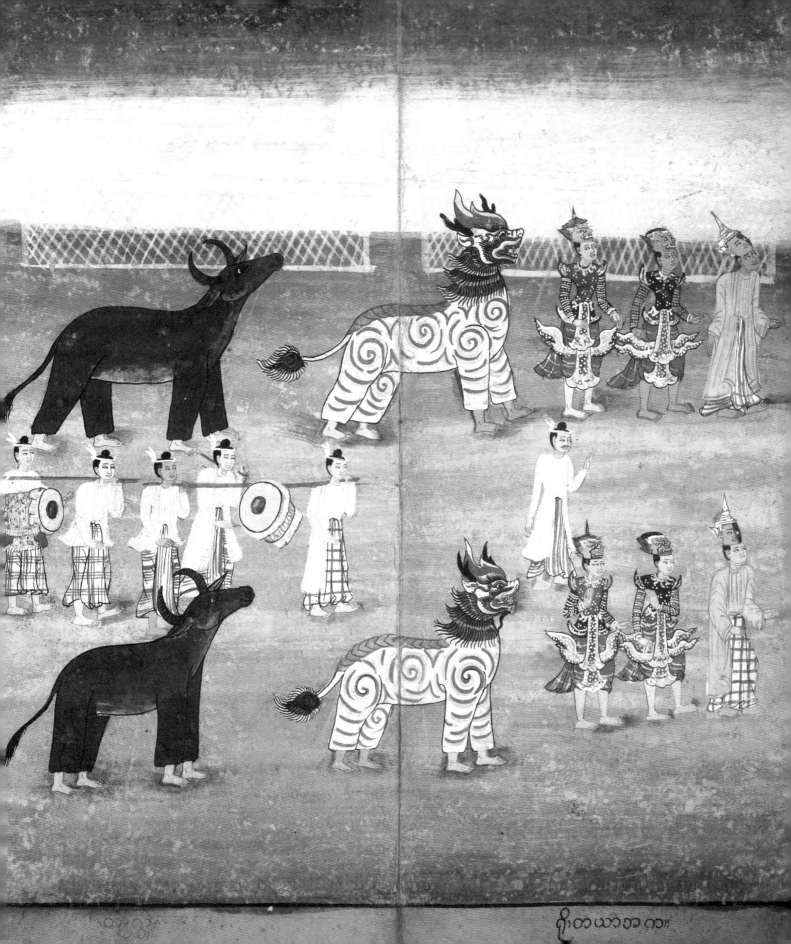

ရှိတယာဘကာ

3.2
Queen's robe of state, *c.* 1860–78. Mandalay. Velvet, tinsel, satin, gold braid, lace, silver-gilt wire, sequins, bamboo and cotton. H. 160 cm, W. 95 cm. Victoria and Albert Museum, London, IM.45-1912. Purchased by divisional judge Mr L.M. Parlett in the early 20th century; acquired by the Victoria and Albert Museum in 1912.

3.3
Philip Klier, *Sawbwa* of Yawnghwe (Shan states) and his wife in formal dress to attend the court at Mandalay, early 1880s. Photographic print. Published in Charles Crosthwaite, *The Pacification of Burma*, 1912.

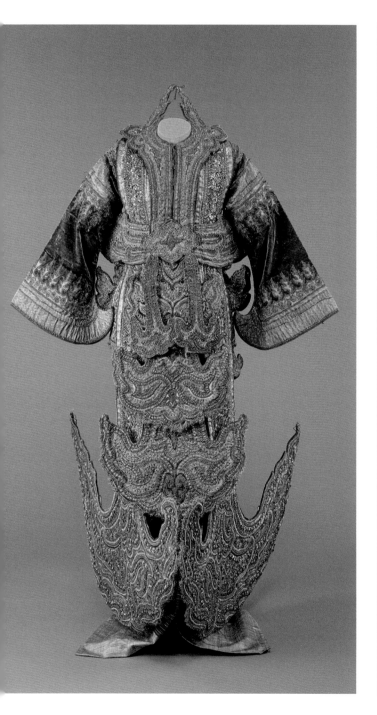

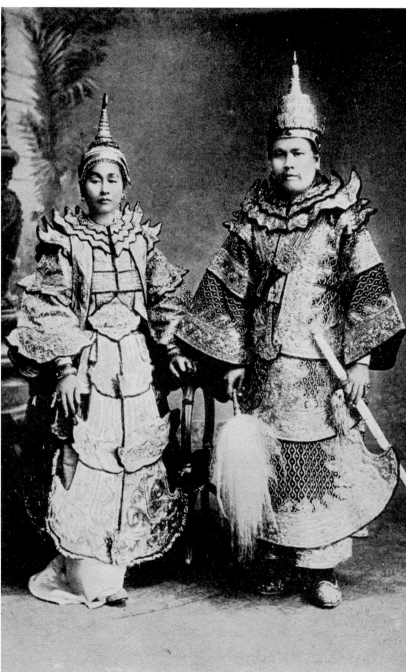

3.4
Minister's military court jacket, *c.* 1853–85. Mandalay. Green and plum velvet, gold embroidery, sequins, bamboo, cotton, gilt wire and brocade. H. 170 cm, W. 80 cm. Victoria and Albert Museum, London, IM.44-1912. Purchased by divisional judge Mr L.M. Parlett in the early 20th century; acquired by the Victoria and Albert Museum in 1912.

3.5
Crowned Buddha image, *c.* 1850–85. Central Myanmar or Shan states. Wood, glass, gold and lacquer. H. 82.5 cm, W. 30 cm. British Museum, London, 1919,0717.1. Purchased in 1919 from Rev. William Kidd, a Presbyterian pastor in Rangoon from 1881 to 1887.

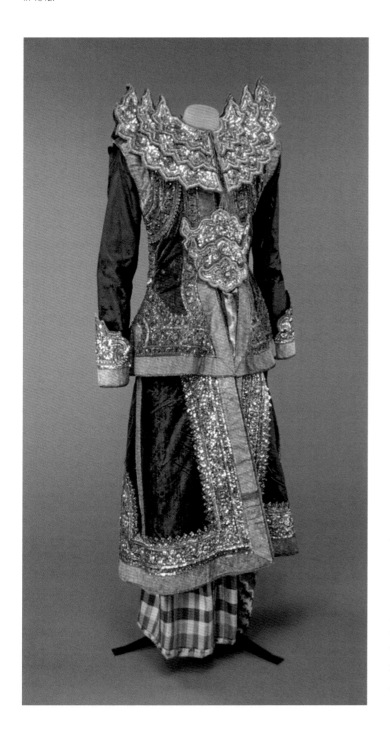

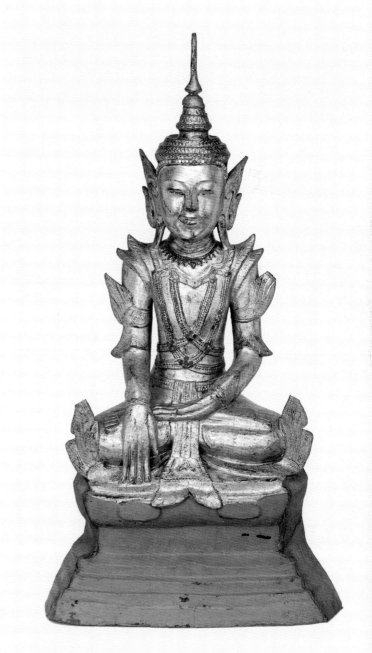

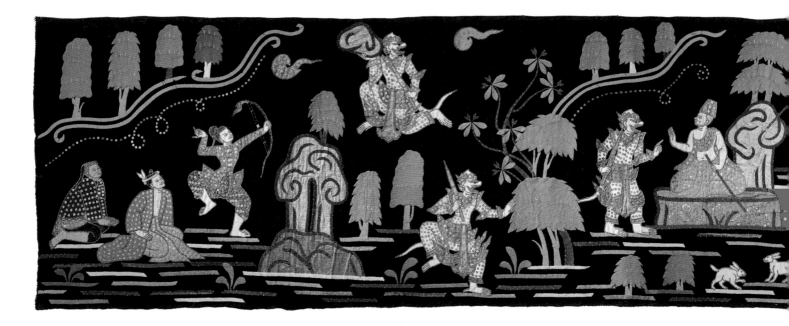

to each side, smooth robes and necklaces hanging in a
loop to a more pronounced display of Ayutthayan elements,
including a Thai-style crown with a broad base surmounted
by a stupa-like form with a tapering finial, as seen here
(fig. 3.5). The crown's flanges are pointed above the ears and
curve up behind them in a flame shape. The Buddha's robes
are likewise adorned with wing-like elements at the knees,
cuffs, elbows and shoulders, all visible on Thai imagery from
the seventeenth and eighteenth centuries.[12]

Not only did Thai theatre impact performance styles,
costumes, dress and music, but the popularity of the Thai
troupes was also such that the crown prince established a
royal committee to translate plays from central and northern
Thailand in 1789.[13] The story that took the Konbaung
kingdom by storm was the epic Ramayana narrative. It is
a tale of how Prince Rama sought and recaptured his wife,
Princess Sita, after she had been abducted by the demon
Ravana and taken to his island kingdom of Lanka. The
prince was aided by his brother Lakshmana and the white
monkey Hanuman together with a monkey army. Although

wall paintings suggest that the Ramayana was known
from the twelfth century, it was only in the late eighteenth
century, after the arrival of the Thai troupes (the story was a
major part of their repertoire), that it became a key feature
of Burmese theatre and storytelling, too. It was not just
performed at court; itinerant troupes carried it around the
country, making elite culture visible outside the capital.[14]
The popularity of the story is indicated by its display in
numerous art forms, including manuscripts, wood carvings,
stone reliefs, silver wares and *shwe-chi-doe* wall hangings (also
known as *kalaga*).

First described by the Portuguese missionary Sebastião
Manrique in 1603 as a tapestry cloth covered with gold
embroidered flowers and gems that hung as a wall within
a pavilion,[15] *shwe-chi-doe* of the late nineteenth century
were panels of fabric appliquéd to a velvet or thick cotton
ground adorned with gold and silver wrapped threads and
sequins. Long, thin panels were hung in eaves, while wider
examples functioned as hangings and room dividers. *Shwe-chi-doe* usually illustrate tales of the Buddha's previous lives

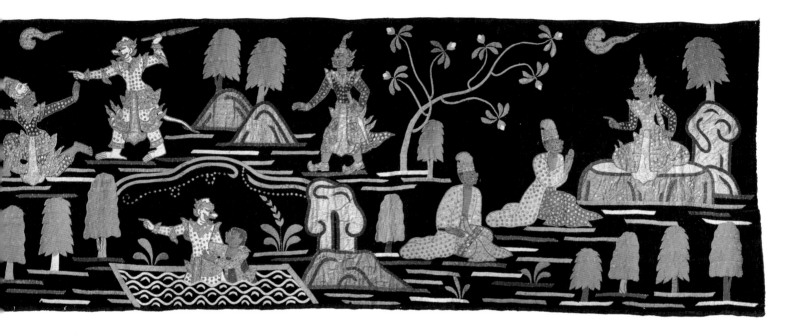

(*jatakas*), animals, the zodiac, court scenes or episodes from the Ramayana,[16] with the latter often depicted over several textiles in order to include the many popular scenes of the lengthy narrative. In this early twentieth-century example, the imagery focuses on events associated with Hanuman, the white monkey, and the demon-king Ravana and his minions (fig. 3.6). The figure with the bow is Prince Rama.

The interactions between Thai and Burmese artists were not limited to the courts, however. Trade, monastic exchanges and the movement of people had an impact on design, too. For example, northern and central Thai patterns are visible on silver-wrapped Buddha images. For those unable to afford silver in Myanmar as well as parts of Thailand, Buddha images were made inexpensively from resin and wrapped in impressed silver or silver-coloured metal foil (fig. 3.7). Typical features of Buddha images from the late eighteenth and first half of the nineteenth centuries include such elements as fitted robes, high arched eyebrows, earlobes touching the shoulders and a large tapering finial. A throne with a narrow waist was also common. Many

examples, some found along the border with Thailand,[17] also display central Thai-style decorative patterns consisting of leaf shapes filled with a foliate-flame motif. This is the same motif found in Konbaung court dress, and it is also present in lacquer decoration and textiles, as well as other art forms.[18]

The Thai foliate-flame motif also appears on the leaves of an unusual *kammawasa* manuscript from the late eighteenth or first half of the nineteenth century (fig. 3.8). This type of Buddhist manuscript was once composed of lacquered pieces of cloth, metal or ivory with black lacquer letters in the 'tamarind seed' square script with gold leaf imagery and patterns around the text. Usually commissioned for donation to a monastery by laypeople, such manuscripts contain texts from the Vinaya Pitaka, scriptures that relate to the ordination of monks, the donation of monks' robes and monastic rituals. This example uses the Burmese lacquer format, but the lettering and patterns are made of inlaid mother-of-pearl, a common form of embellishment from central Thailand.

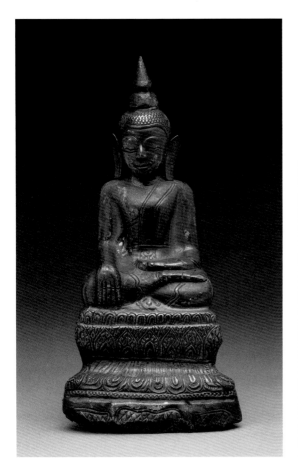

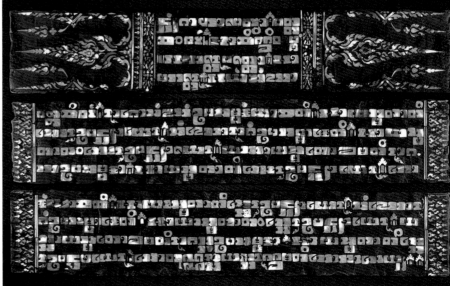

3.7
Buddha image, *c.* 1770–1899. Resin
and silver. H. 21.6 cm, W. 10.8 cm,
D. 7.1 cm. British Museum, London,
1925,0606.1. Donated by Miss M.G.
Tylor in 1925.

3.8
Kammawasa manuscript with Japanese
brocade wrapper, *c.* 1770–1850.
Probably central or lower Myanmar.
Mother-of-pearl, lacquer and cloth.
H. 10 cm, W. 54.5 cm (each page). The
British Library, London, Add MS 23939.
Purchased at a Sotheby's auction
in 1860.

The combination of techniques and patterns suggests that the *kammawasa* was made by a Thai artist who had been relocated from Ayutthaya to central Myanmar in 1767 or a descendant trained in the technique.

Lan Na

Toungoo and Konbaung kings colonised Lan Na (now northern Thailand) for more than 200 years from the late sixteenth to the late eighteenth century. Initially, Lan Na was left as a semi-autonomous state, but during the eighteenth century there was greater direct control, with Burmese rulers substituted for local ones. Even after the loss of the region in the late eighteenth century, Konbaung incursions continued until the 1820s. Numerous people were relocated from Lan Na into Myanmar, given land, assigned to hereditary groups, settled in artisanal quarters, placed in specific occupations and so forth. The lengthy occupation of Lan Na and the limited material remains before the eighteenth century mean that teasing out the new ideas,

stories and techniques brought into central Myanmar by the captives and refugees at the different times is difficult, but there are some prominent examples, including decorative patterns and novel episodes in the life of the Buddha.

The main pattern that is seen in both regions is a dense floral patterning. Called *zinme*, the Burmese name for Lan Na, it is found on lacquer objects and was also replicated on textiles in a layout that resembles Indian trade textiles (*patola*) and central Thai textiles.[19] For example, this betel box has been incised with a very dense *zinme* floral pattern in red (fig. 3.9). Although this example was probably produced in Thailand, the shape and size of the box, as well as the colouring, pattern and the incised production method, all demonstrate the strong links between central Myanmar and Lan Na.

In addition to patterns and designs, oral literature from Lan Na also had an impact on the art found in central Myanmar. Certain episodes from the story of the life of the Buddha found in a Lan Na text called the *Pathamasambodhi*, which are not in written Buddhist texts from Myanmar,

became particularly prevalent in central Burmese art. Most likely, the new narratives were brought orally by people who were relocated to central Myanmar, where they were integrated with other narratives of the life of the Buddha and subsequently portrayed in various artistic forms.[20] The most prevalent was the representation of the earth goddess wringing her hair, whereupon all the water that the Buddha in previous lives had poured on the ground to mark his good deeds gushed forth. Occurring on the eve of the Buddha's enlightenment, the flood overwhelmed the army of demons attacking him and left him free to become an awakened being (a Buddha). Besides being illustrated in narratives of the life of the Buddha, the earth goddess was also integrated with a pillar that symbolised the spread of Buddhism.

The practice of raising pillars originated in India in the third century BCE, but among Buddhists in Myanmar it was adapted into a form called a *tagundaing*, which was represented large-scale in temple compounds and in small form for use inside temples (fig. 3.10). In this example, as on many other *tagundaing*, the earth goddess, in small scale, is shown out of narrative context at its base, emphasising the centrality of the Buddha's enlightenment to Buddhists in Myanmar and also marking the good deeds of donors to the religion.

Manipur

Similar processes of cultural transfer occurred with Manipur, a mountainous region part of present-day northeast India that was once an independent kingdom. Its relations with the Toungoo and Konbaung dynasties in central Myanmar varied from diplomacy – such as the mission from the Restored Toungoo court at Ava in 1704 that led to a Manipuri princess being sent as a bride to the Burmese king in 1705 – to raids and warfare. The first glimpse of Manipuri society when it consisted of animist clans comes in part through Shan chronicles and local texts of the fifteenth century. By the seventeenth century Manipur became increasingly Hinduised and centralised. Islam, too, was present – another development of the seventeenth century. It was under an invigorated king, Gharib Newaz (r. 1709–51), that early raids for captives and loot shifted towards territorial expansion, and in the 1730s Manipur instigated a series of destructive incursions into central Myanmar.[21] After Gharib Newaz's assassination, the political situation destabilised, and in 1758 the Konbaung dynasty king Alaungpaya marched into Manipur. A map that belonged to Henry Burney (a British army officer who served as a diplomat for the East India Company and envoy to the Konbaung court between 1829 and 1837) shows Alaungpaya's campaign against Manipur (fig. 3.11).[22] The map, with cities and towns marked as squares, is not topographically accurate, but it gives a good sense of the region and marks the campaign route in yellow dots,

3.10
Tagundaing (standard), 1850–99.
Central or lower Myanmar. Wood,
lacquer, glass and gold. H. 185.8 cm,
W. 32 cm, D. 22 cm. British Museum,
London, 1915,1020.1. Bequeathed by
Mary Sale, who acquired the objects in
Britain in the late 19th or early
20th century.

3.11
Copy of a map of King Alaungpaya's
military campaign against Manipur in
1758–9, c. 1829–32. Probably Ava,
central Myanmar. Paper. H. 35 cm,
W. 50 cm. Cambridge University Library,
RCMS 65/9/9, Henry Burney papers.
Presented by M. d'Arblay Burney
in 1921.

validating Alaungpaya's military success and therefore
claims to Manipur as part of his realm.[23]

Alaungpaya's campaign of 1758 was not the only one
launched against Manipur. King Hsinbyushin (r. 1763–
76) attacked again in the 1760s, and King Bodawpaya
(r. 1782–1819) renewed hostilities in the 1790s. Between
1819 and 1826, which Manipuris remember as the Seven
Year Devastation, King Bagyidaw (r. 1819–37) ordered the
military to occupy the region once again. Many people were
slaughtered during these campaigns or forcibly relocated
to central Myanmar, where their descendants, called
Kathe, remain today.[24] As was common practice, resettled
Manipuris were incorporated by being assigned land, status
and jobs within local society. Their positions ranged from
cultivators to members of the court, and their presence
impacted such things as religious rituals and activities, the
military and textiles.

Hindu ritual specialists known as brahmins were
incorporated into the court. Called *ponna* in Myanmar,
brahmins had been part of regional courts from at least
the eleventh century and probably earlier, and by the mid-
eighteenth century they had become a distinct social class
linked to Buddhist monarchy. Father Sangermano, a Jesuit
priest who resided in Myanmar between 1783 and 1806,
wrote that 'all is regulated by the opinions of the Brahmins,
so that not even the king shall presume to take any step
without their advice'.[25] They were involved in determining
auspicious times for particular activities, the recitation of
protective chants, and astrology. They made offerings to
astrological bodies, such as the planets, as well as to *nat*
spirits and deities, acted as royal counsellors and were part
of kings' consecration ceremonies.[26] The *ponna* taken from
Manipur in the late 1750s were augmented by the *ponna*
brought from Arakan in 1784, creating a community of
relocated peoples and their descendants essential for the
royal court. In Konbaung Myanmar they were represented
dressed in white in royal scenes in manuscripts of the life of
the Buddha and manuscripts of court activities where they
were portrayed pulling the royal couple's carriage, holding

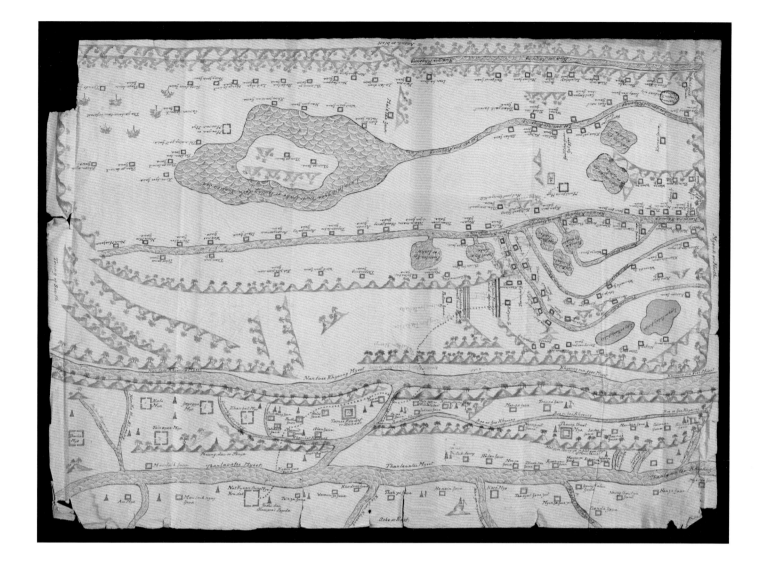

umbrellas of rank, fans or musical instruments (see fig. 3.1), and carrying palanquins (covered litters).

Polo became a standard part of court entertainment in the early nineteenth century as a result of the incorporation of the Manipuri cavalry into the Konbaung one. The equestrian skills of Manipuri men were well known at the time, and it made them desirable around the region. During his 1795 embassy to the Konbaung court, Symes wrote that 'All the troopers in the king's service are natives of Cassay [Kathe; Manipur], who are much better horsemen than the Birmans.'[27] The Kathe cavalry was given an elite status, though its members were tattooed to mark their rank and prevent escape.[28] While polo was known at central Burmese courts before the arrival of the Manipuri cavalry, it was repopularised in King Bagyidaw's reign and

often illustrated in manuscripts of courtly life (fig. 3.12).[29] Equestrian events like horse races, polo and military displays were particularly associated with the month of Pyatho (January), part of the cool dry season when warfare was possible. Following defeat in the First Anglo-Burmese War in 1826, warfare declined, and polo became a way to display and maintain military prowess.

When the Manipuris were resettled around the capital city of Ava, and later Amarapura, some began work in the area's textile (particularly silk) industry.[30] Manipur had been a source of textiles and silk in regional trade since the seventeenth century.[31] It also produced tapestry weave, a time-intensive technique that seems to have become popular in Myanmar around the late eighteenth century with the production of silk *luntaya acheik* textiles that

3.12

Manuscript (*parabaik*) illustrating courtiers
playing polo, *c*. 1830s–99. Mandalay.
Gouache and paper. H. 41.6 cm, W. 18.8 cm
(each page). Wellcome Collection, London,
727619i / 47114i. Purchased from Steven's
auction house, London on 22 October 1918
(lot 72a); a tag identified a previous owner as
C.B. Jarvis Edwards, Mandalay, 1 May 1893.

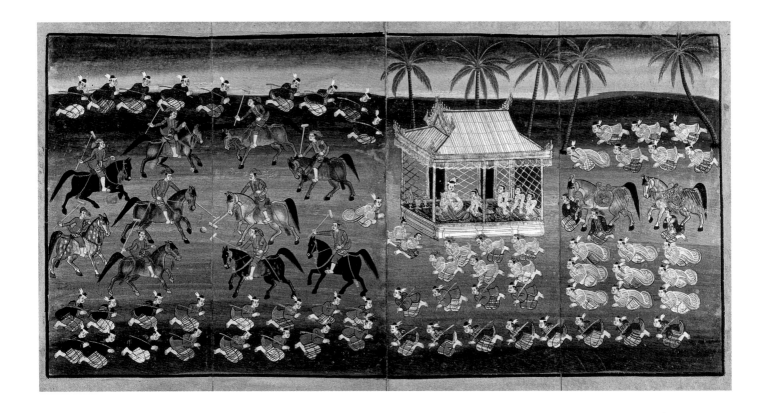

display horizontal wavy designs (fig. 3.13).[32] Tapestry weave
textiles are made by tying the warp yarns to the loom and
interlacing them with weft threads that do not stretch all
the way across the warps; instead, the wefts move back and
forth across a small area to create sections of colour. Only a
few centimetres can be woven in a day because the process
is so complex.

There is debate, which may never be resolved, as
to whether the tapestry technique was introduced into
Myanmar from Manipur or China but, most likely, tapestry
weave arrived from multiple directions. Besides the extensive
interactions with China, there were direct connections
between China and Manipur, with Chinese people present
in Manipur by the mid-fifteenth century, as local texts
demonstrate. A community of Chinese in a Kabaw valley

town (today in northwestern Myanmar) governed by a
Shan chief was raided repeatedly by the Manipuris in the
sixteenth and seventeenth centuries, with Chinese captives
resettled in the Manipur valley.[33] There were trade routes
between China and Manipur via the Kabaw valley from at
least the beginning of the seventeenth century and probably
earlier. All these factors suggest multiple routes by which
weaving techniques could have circulated in the region.

The tapestry-weave *luntaya acheik* textiles display bold
serpentine, zig-zag and interlocking cable patterns
accompanied by narrower foliate tendrils and creepers in
the surrounding spaces set against a horizontally striped
ground. This results in a complex interplay of colour and
form.[34] While wavy and zig-zag lines have been a standard
part of Burmese art for a long time, the complex *acheik*

3.13

Luntaya acheik patterned skirt-cloth
(detail), *c.* 1890–1930. Probably
Amarapura, central British Burma.
Silk and cotton. H. 116 cm, W. 114 cm.
British Museum, London, 2007,3013.2.
Purchased in 2007 from Krishna at
Chaupal dealers, New Delhi.

patterning only emerged in the late eighteenth century, as
evidenced by wall paintings of the period. Although at first
glance the *acheik* design does not resemble those of Manipuri
textiles, on further inspection some features resemble
Manipuri design elements, including S-forms, hooks and
curves, and a bold main pattern from which spring thinner
subsidiary foliate designs.[35] This mixture of elements
suggests that various sources have been drawn together
to create something novel.[36] The arrival of people from
Manipur and their presence in central Myanmar's textile
industry was one such spur that gave rise to *luntaya acheik*
patterns and tapestry weave in the late eighteenth century.

Muslim communities

The Muslim communities in Myanmar are substantial
and long-standing, with periodic population influxes into
the nineteenth century. The British encouraged Indians,
including Muslims, to settle in British Burma during the
colonial period (1826–1948), and Muslims fleeing the unrest
caused by the Panthay Rebellion (1856–73) in southwestern
China further augmented this population.[37] Yet, there were
Muslim communities in many parts of Myanmar prior
to the colonial period. Some were traders in the coastal
ports, and others were relocated peoples from Arakan
and Manipur. The Muslim presence in Manipur appears
to have originated with the capture and resettlement of
Bengali Muslims in the first decade of the sixteenth century,
alongside Muslim migration into Manipur, and it was these
people who were relocated again into central Myanmar
starting in the late 1750s.[38] Other Muslim Burmese were
descendants of a Burmese raid on Arakan in 1707 when
Muslim soldiers were captured and resettled.[39] There were
also Indian Muslim mercenaries in the Arakan and Toungoo
dynasty royal services from at least the sixteenth century.[40]
By 1855 Henry Yule, British envoy to the court, described a
thriving community of many thousands in the capital city of
Amarapura in central Myanmar. He noted the large number
of Muslim eunuchs, courtiers and members of the royal

bodyguard, as well as the fact that King Mindon allowed
the Muslim community to build mosques and to practise
their own religion, and that many prominent Muslims were
jewellers and ruby traders, some acting as brokers for the
king.[41] Yule particularly mentions their different origins,
ranging from Muslims from India and the Middle Eastern
world who had been in the region for several centuries to
captives from Arakan, Manipur and Cachar (now part of
Assam, India) and local Burmese converts.[42]

Despite the clear presence of Muslims in the various
kingdoms of Myanmar, little of their art and material
culture has been collected or studied, partially because
(as also noted by Yule) they largely assimilated with the
Burman majority in language, dress and other ways.[43]
This is exemplified by an ornate Qur'an box and stand
decorated in a typical central Burmese style called *hman-
si shwe-cha* (fig. 3.14). The technique involves setting glass
inlays into lacquer putty (*thayo*) designs and the gilding

Qur'an box and stand, *c.* 1870s–1920s.
Lacquer, *thayo* (lacquer putty), glass and
wood. H. 25 cm, W. 33 cm, D. 33 cm
(box); H. 17 cm, W. 45 cm, D. 45 cm
(stand). Asian Civilisations Museum,
Singapore, 1996-02182. Purchased
from Yonok Treasure, River City,
Bangkok in 1996.

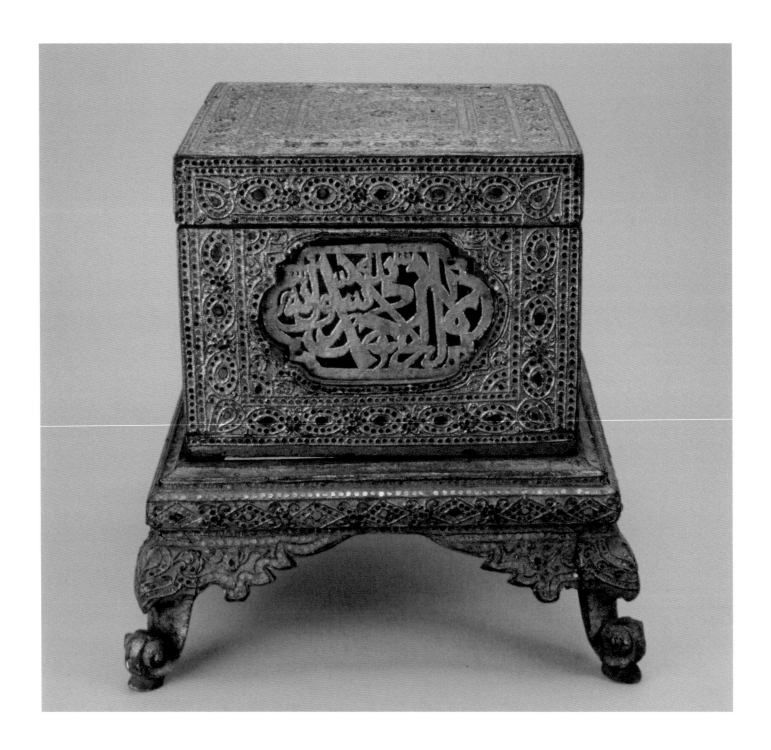

of a substrate, in this case a lacquered wood ground. That this box is for a Muslim community is indicated by the cartouches on each side containing the Shahada, the Islamic profession of faith.

The kingdoms of Arakan

Rakhine State is situated on the western littoral of Myanmar today, but the area was once home to a series of independent, wealthy polities. The first evidence of a kingdom there dates to about the fourth century CE under Buddhist kings at Dhanyawadi. Around the sixth century CE a new capital at Vesali emerged, and the people there are known to have been in contact with the Pyu peoples in central Myanmar, India and regions as far afield as Cambodia. From the eleventh to the fifteenth centuries, there was a series of small city-states in the Lemro River valley, and these were followed by the rise of a kingdom based at the city of Mrauk U in the 1430s. Mrauk U was in a strategic position to control the Kaladan and Lemro River valleys, as well as parts of the Bay of Bengal, and it engaged with local Christian Portuguese and Bengali Muslim communities, as well as other Buddhist and Hindu states in the region, including the occasional payment of tribute to the court in central Myanmar. Arakan expanded and reached its zenith in the sixteenth and early seventeenth centuries before declining in the mid- to late seventeenth and eighteenth centuries. In 1784 the region was conquered by the Konbaung king, Bodawpaya, annexed by the British in 1826, and was included as part of modern Myanmar in 1948.

At its height Mrauk U was an important political and commercial centre on the Bay of Bengal. A Portuguese priest, Father Sebastião Manrique, provided a description in the early seventeenth century, saying,

> the City of Arracan … must have contained one hundred and sixty thousand inhabitants, excluding foreign merchants, of whom there was a great influx owing to the large number

of ships trading with this port from Bengala [Bengal], Masulipattam [on the east coast of India], Tenasserim [Tanintharyi, lower Myanmar], Martaban [Mottama, lower Myanmar], Achem [Aceh on Sumatra] and Jacatara [Jakarta, Java]. There were other foreigners also, some being merchants and some soldiers, the latter being enlisted on salaries, and were, as I have said, Portuguese, Pegus [Bago, lower Myanmar], Burmese and Mogors. Besides these there were many Christians of Japanese, Bengali, and other nationalities.[44]

Later, a Dutch surgeon named Wouter Schouten published written and illustrated information about Arakan and the city of Mrauk U in his 1676 travel writings (fig. 3.15). Despite Schouten's accurate descriptions of local natural features, such as the strong riverine tides and the curves of the river leading to Mrauk U, the city is stereotypically illustrated with images that owe more to fantastic European ideas of Asia than Arakan itself. The picture thus gives a sense of Mrauk U's wealth and grandeur rather than providing a reliable portrait of the city.[45]

Because of its strategic location, Arakan was active in trading networks. Although customs duties, royal monopolies and overseas trade were an important source of revenue for its rulers, duty was periodically waived. Manrique wrote of festivities arranged by King Sirisudhammaraja (r. 1622–38, also known as Min Hari and Salim Shah II) in 1635 when 'The Court was full of men from various foreign countries whom the exemption from all duties on merchandise, granted in such times of festivity, had induced to assemble there.'[46] He went on to list the people as coming from nearby countries like Bengal, Bago and Mottama, but also further afield, such as from Thailand, Champa (now southern Viet Nam), Cambodia, the Maldives, Indian kingdoms, Java, Sumatra and Makassar (now Sulawesi, Indonesia). Despite these instances of free-trade, tax on trade was the norm, and examples of permits issued by the court remain.

Upon translation, two permits in the British Library, one in Burmese and the other in Persian (written in Arabic

3.15
Wouter Schouten, *D'Conincklycke hoofstadt Arrakan*, 1708 (reprinted posthumously). Paper. Printed in Amsterdam, published by Andries van Damme. H. 24.6 cm, W. 47 cm. British Museum, London, 2022,7039.1. Purchased in 2022 from The Prints Collector, Amsterdam via the Brooke Sewell Permanent Fund.

3.16 *opposite top*
Burmese permit giving permission to trade from the King of Arakan, 1728. Arakan. Palm leaf. H. 5.5 cm, W. 92 cm. The British Library, London, Sloane MS 4098. Permit ceased to be used when the king was assassinated in 1731; collected by Sir Hans Sloane (1660–1753) and purchased at his death by the 1753 Act of Parliament that established the British Museum.

3.17 *opposite bottom*
A Persian *farmān* (decree) giving permission to trade from the King of Arakan, 1728. Arakan. Paper, cloth and wax. H. 38.5 cm, W. 32 cm. The British Library, London, Sloane MS 3259. Collected by Sir Hans Sloane (1660–1753).

script), were found to be the same (figs 3.16–3.17). They were issued by Sanda Wizaya (r. 1710–31, also known as Thoungnyo) in 1728 to an Armenian merchant named Khwajeh Georgin in Chennaipattana (Chennai, India), giving him permission to trade in Mrauk U. The king's round seal is affixed to both, as well as to the Persian letter's cloth envelope and paper wrapper.[47] Diplomatic correspondence with the Portuguese king encouraged traders to use Arakan's ports, and in 1610 the Dutch were given permission to build a trading post.[48] Trade involved the export of rice, as well as cloth, gems, elephants and spices. Arakan was also notorious in the region for its raids for people along the Bengal coast during the sixteenth and seventeenth centuries. The captured people were forced to work locally or were transported to India and the eastern Indonesian archipelago to provide labour for the spice trade.[49]

Using the wealth generated by ocean trade, Arakan employed mercenaries from all over the region, including central and lower Myanmar, India, Japan and Portugal.[50] It became militarily strong in particular through its connections with the local Portuguese and Portuguese (Luso)-Asian communities. In the sixteenth century the powerful King Minbin employed Portuguese mercenaries and military advisers to strengthen his navy.[51] Arakan was able to repulse invasions, such as one by King Tabinshwehti of the Toungoo dynasty in central Myanmar in 1546–7 that ended with a diplomatic resolution, and another one by the Portuguese based in Goa (now in India) in 1615 that ended with their heavy defeat. Arakan was also expansionist itself. It was in almost continual conflict with the Muslim Sultanate of Bengal and the neighbouring Hindu kingdom of Tripura. In 1578 the port of Chittagong (in present-day

Amarapura, as well as the bronze images, which remain there today. Brahmins and numerous other people were also relocated to the central region. After the annexation, the cultural homogenisation of Arakan with that of central Myanmar was promoted by the Amarapura court,[54] and historical treatises, such as the *Glass Palace Chronicle*, described Arakan as if it had always been a dependant of Myanmar, therefore marginalising its distinct history and downplaying its differences from the central region.

Yet, Arakan was a unique culture forged in part through its extensive contacts with other cultures across all echelons of society, including the court. This is visible in Arakanese coinage, for example. Arakan's kings used Bengali coinage with Persian inscriptions in the fourteenth and fifteenth centuries, but by the sixteenth century they started to issue their own Bengali-style coins. From the 1580s until 1635, coins like this one (fig. 3.19) were minted with inscriptions in three languages – Bengali, Persian and Arakanese. Additionally, several kings from the late fifteenth to the mid-seventeenth century used a Muslim-style name. The king who issued this coin was known as both Manh Khamon and Dhammaraja Hussain, the latter a combination of a Buddhist title and a Muslim name. However, Muslim names were rarely used in either Arakan or Bengal and their presence on the coins therefore indicates that the coins were mostly used for trade. The multilingual coins were a means of sending messages about the king's power and sovereignty across trading networks.[55] Indeed, the text on this example states that the king is lord of the white and red elephants. These animals were a sign of royalty associated with political and spiritual power and therefore a strong symbol with which to promote the ruler of Arakan.

In religious spheres, Arakan was in contact with Buddhist Sri Lanka from at least the eighth century CE. Additionally, it provided a refuge for Buddhists after the Muslim conquest of Bengal at the end of the twelfth century (and it did the same for a Mughal prince, Shah Shuja, fleeing the Emperor Aurangzeb in 1660).[56] A mission came from Sri Lanka in the sixteenth century, and in the seventeenth, the Dutch,

Bangladesh) and the surrounding areas came under its control, which lasted until 1666.[52] To the east, in 1595–9 Arakan attacked Bago in lower Myanmar, an area controlled by the Toungoo dynasty of central Myanmar at the time, and this contributed to Toungoo's collapse. Arakan deported several thousand households from Bago, as well as many goods and objects, including some large bronze images (fig. 3.18) that had been seized from Ayutthaya by King Bayinnaung during his campaigns in the 1560s and which had been acquired from Cambodia by Ayutthaya during its raids on the Khmer empire based at Angkor in the 1430s.

Although the seventeenth century was a period of strength and wealth for Arakan (it was about twice the size of present-day Rakhine State),[53] its decline began late in the same century, and in 1784 it was annexed by the Konbaung dynasty. Among other things, the royal library was sent to

in a bid to prevent Portuguese Catholicism from spreading, assisted Buddhist monks from Arakan with travelling to Sri Lanka. Buddhist scriptures were imported from Sri Lanka, and Sri Lankan embassies arrived in 1693, 1696 and 1697, testifying to Arakan's importance within the Buddhist world. Furthermore, Arakan's Mahamuni Buddha image was considered to be one of the most sacred representations, and legends described how it was a replica of the Buddha himself, made when he visited the kingdom (see fig. 1.15). People came to Arakan as pilgrims, made offerings and contributed to the upkeep of the shrine. They commissioned replicas of the Mahamuni Buddha image until it was captured in 1784 and removed to Amarapura in central Myanmar, where it remains a major pilgrimage site.

Buddha images produced in Arakan reveal the breadth of the region's religious interactions. Given the importance

of Sri Lanka to Southeast Asian Buddhism generally, it is not surprising that Sri Lankan bronze images have been found in Arakan. In the fifteenth century a new Buddha type shows links with northern Thailand. A later Ayutthayan influence arose due to the fact that the people brought back from Bago at the end of the 1590s included Ayutthayans relocated to Bago by the Toungoo Myanmar campaigns in the 1560s (and their descendants). However, the best-known Arakan image type emerged in the fifteenth century. Called Yongle after the Chinese Ming dynasty emperor (r. 1402–24), the new style of crowned Buddha image showed strong links to Chinese and Tibetan art forms. Despite Tibetan records indicating exchanges between Bengali, Arakanese and Tibetan monks, the Mahayana and Tantric Buddhisms of China and Tibet were not adopted in Arakan, even though elements of the Buddha images were. Stylistically,

3.18
The Angkorian bronzes on display at the Mahamuni temple, Mandalay.

3.19
Coin (*tanka*) issued by Dhammaraja Hussain, 1612–22. Arakan. Silver. Diam. 2.9 cm, Weight 10.1 g. British Museum, London, 1882,0508.4. Donated by Lt-Gen. Sir Arthur Phayre, first commissioner of British Burma (1862–7).

Kingdoms in lower Myanmar

Lower Myanmar, which is associated with the Mon peoples, has long been inhabited. In ancient times the peoples of the region maintained substantial contact with the Pyu in central Myanmar (see chapter 2) and the Dvaravati culture of central Thailand during the late first millennium. Although lower Myanmar was drawn into the kingdom of Bagan's political orbit by King Anawrahta (r. 1044–77), its port cities along the coast during this early period were geopolitically and economically part of the maritime world of the Bay of Bengal. When the Mongols made incursions into northern Myanmar in the late thirteenth century, the ports of Mottama (Martaban) and Bago took advantage of the unstable situation to assert their independence. The two struggled for supremacy of the coastal region, and Mottama won under the leadership of Wareru (r. 1287–96), a man supposedly of Shan or Mon origin.[58] The new polity, called Ramannya and later Hanthawaddy (which is also called Bago after the capital shifted to that city), was acknowledged by China and had links with the Thai kingdom of Sukhothai. Historical texts from northern Thailand describe Wareru eloping with one of the Sukhothai king's daughters, an act that eventually saw Wareru awarded with a white elephant, a symbol of royalty, and a new status allowing him to claim rulership over Mottama as a vassal of Sukhothai. While this story may not be accurate in detail, it reveals the intimate political relations between Thailand and the polities of lower Myanmar at the time.

By the mid-fourteenth century under King Binnya U (r. 1348–84), the centre of power shifted from Mottama to the city of Bago,[59] with its advantageous geographical position on a fertile rice plain with two rivers, the Sittang and the Bago, providing access to the hinterlands and through them northern and central Thailand and China, as well as the Bay of Bengal. From this location, kings fended off attacks by armies from Lan Na (northern Thailand) and central Myanmar in the fourteenth and fifteenth centuries, while engaging in trade. Bago functioned as an entrepôt,

Arakan's Yongle-type Buddha images follow the Himalayan and Chinese formats, displaying a shawl draped over both shoulders, five-leaved crowns with an elaborate central headdress and extensions that curve upwards behind the ears, plug earrings and two necklaces, one shorter and elaborate and the other less embellished and falling in a curving line to the navel (fig. 3.20). A pot holding the elixir of life is usually held in the lap, either with one hand when the image is making the gesture of enlightenment or with two when the gesture of meditation is indicated.[57] The style persisted with variations for approximately four centuries and had an impact on Buddha images particularly in central Myanmar, the Shan states and kingdom of Hanthawaddy, which display similar necklaces and other pieces of jewellery (fig. 3.21). However, these representations are stylistically distinct from the Arakanese examples and merely incorporate the jewellery and pot into the local idiom.

3.20
Crowned figure of the Buddha, *c.* 1500–
1699. Arakan. Bronze. H. 24.7 cm,
W. 15.3 cm, D. 7.8 cm. British Museum,
London, FBInd.16. Collected by Carl
Alfred Bock while travelling in Southeast
Asia in the 1880s; bequeathed by Sir
Augustus Wollaston Franks.

3.21
Crowned figure of the Buddha, 1600–
1799. Central Myanmar or the Shan
states. Bronze. H. 53.7 cm, W. 25.5 cm,
D. 23.7 cm. British Museum, London,
1969,0211.1. Purchased from Berkeley
Galleries in 1969 via the Brooke Sewell
Permanent Fund.

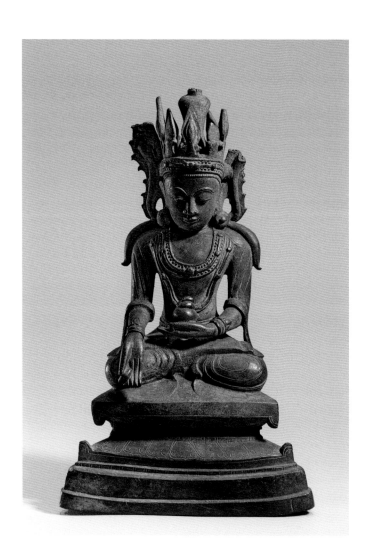

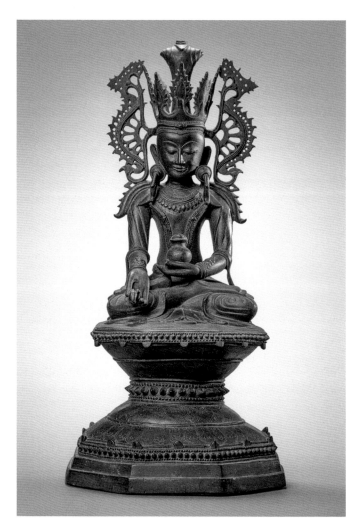

dealing with products from the interior such as gems, teak for shipbuilding, sugar and other commodities. In the fifteenth and sixteenth centuries and into the nineteenth century, it exported rice around the Bay of Bengal as part of expanding production and trade networks. Cotton cultivation also spread in the central dry zone, becoming the basis for regional trade and one of the major exports sent overland to China and by sea to Bengal.[60] Some of the cotton returned

to Bago in the form of fine Indian cloths, which were then distributed through market networks inland. From the late sixteenth century, lower Myanmar's trade networks also included the growing European and Japanese markets. Its cities, particularly the ports of Bago, Pathein and Mottama, developed into centres filled with Muslim and Hindu traders, as well as Portuguese, Armenian, Persian, Abyssinian, Venetian, Jewish, Southeast Asian and other local merchants.

One of the products for which lower Myanmar was renowned was ceramics, particularly Martaban jars, the large glazed storage containers with broad shoulders tapering to a narrower foot, named after the kilns near Mottama. Used on ships trading around the region and to the Middle East, the jars were first mentioned by Ibn Battuta, an Arab visitor to Mottama in 1350. The Portuguese adventurer Duarte Barbosa commented in the early sixteenth century that their colour was prized by 'Moors' who exported them.[61] However, Mottama was not the only place in lower Myanmar that produced ceramics. Major kilns have been found at Twante near Yangon (Rangoon), which were in use from the fifteenth and sixteenth centuries onwards. These produced storage jars, as well as bowls, dishes, plates, bottles and pots, usually with minimal geometric or abstract designs and a crackled celadon green glaze that ranged from a light colour to a yellowish olive one, as seen in this example, rather than the deep brown favoured at Mottama (fig. 3.22).[62]

Because of its prime location and access to resources, the kingdom of Hanthawaddy was attacked repeatedly by other polities in the region. However, it saw a century of peace from the mid-fifteenth to the mid-sixteenth century. During this time, in a rare instance, a woman, Shin Saw Bu, ascended the throne. Her reign lasted from 1453 to 1472, and she was succeeded by King Dhammazedi (r. 1472–92), a former Buddhist monk. Together, the two reigns have come to be viewed as a golden age. Under Dhammazedi, the kingdom became a centre for Theravada Buddhist orthodoxy and developed strong ties with Sri Lanka. Between 1476 and 1479 he erected inscriptions commemorating the reformation of the local *sangha* in the Sri Lankan Mahavihara tradition, a distinct group that adhered strictly to scriptures written in the Pali language. Monks came from neighbouring regions to be ordained in the newly constructed Kalyani ordination hall. Testifying to the wealth of Hanthawaddy and its religious connections is a gold reliquary in the shape of a stupa (a ritual burial mound containing relics) that was excavated with other gold items near the east side of the Shwedagon stupa in present-day Yangon (fig. 3.23). Dating to the fifteenth century, it demonstrates the enhanced links with Sri Lanka, particularly through the inclusion of the *harmika* (a square enclosure on top of a stupa from which rises the central pillar, umbrellas and finial), which was common on Sri Lankan stupas but fell out of use in the Burmese region in the late eleventh century.

Hanthawaddy's position as a strong independent maritime power in the fifteenth and sixteenth centuries was short-lived. It was captured piecemeal by the Toungoo dynasty of central Myanmar in the 1530s and 1540s. During King Bayinnaung's reign, Bago became the capital city of central and lower Myanmar, transforming Hanthawaddy from a maritime kingdom to a land-based empire.[63] This situation lasted until the late 1590s when Arakan in the west conquered, sacked and burned Bago, deporting people and goods. The Toungoo dynasty's other major rival, Ayutthaya, made similar incursions into Bago and other parts of lower Myanmar from the east. After 1599 the king of Arakan left the Portuguese mercenary and warlord Filipe de Brito e Nicote in charge of the port of Than Lyin (Syriam) near present-day Yangon, and in the first decade of the seventeenth century de Brito used the opportunity to take control of the port for himself.[64] He was eventually captured by the restored and resurgent Toungoo dynasty and executed in 1613, and the Portuguese community was relocated to central Myanmar. There they were often employed as mercenaries and guards, and their descendants merged with the local population. The presence of the Portuguese was recorded in texts, and in wall paintings they are shown in city guardhouses wearing large black European-style hats (fig. 3.24). A result of this campaign was the removal of the Portuguese as a player in coastal politics and trade, and it marked a decline in their political presence in Southeast Asia generally.

Peace did not last long. Bago rose against the Restored Toungoo dynasty in 1634, but the Toungoo king Thalun (r. 1629–48) suppressed it and moved the population north

3.22
Storage jar, *c.* 1400–1600. Twante,
lower Myanmar. Glazed stoneware.
H. 39 cm, Diam. 44 cm (max.). British
Museum, London, 1997,1004.1.
Collected in Myanmar, purchased in
1997 through Tom White MBE, funded
by the Brooke Sewell Permanent Fund.

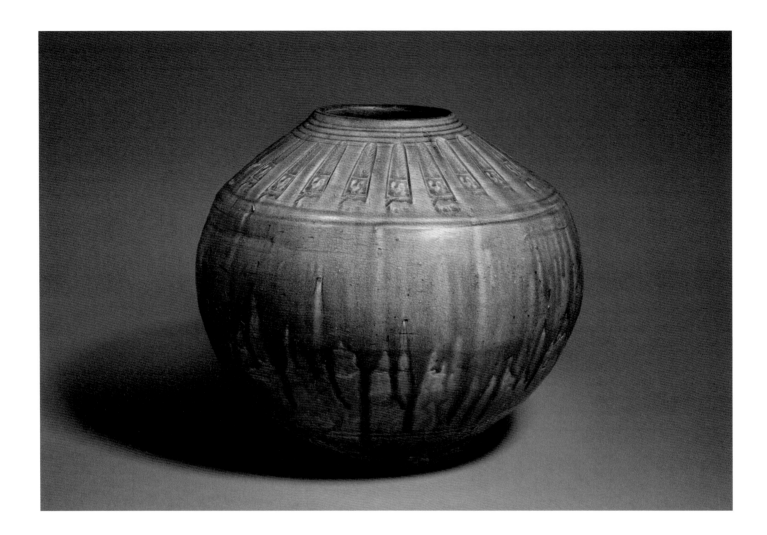

to Ava in the central region. By the mid-eighteenth century, however, Bago was resurgent, and it attacked the Restored Toungoo dynasty in central Myanmar in 1740, finally capturing Ava in 1752 and relocating that court and its material goods, including administrative records and the library, to Bago. Success was again short-lived, however, as King Alaungpaya, founder of the Konbaung dynasty, reconquered the central and lower regions by 1757. The Bago area remained part of the Konbaung empire until

it was annexed piecemeal by the British in the First and Second Anglo-Burmese Wars of 1824–6 and 1852–3.[65]

The extensive warfare had several effects. During the seventeenth century, for example, the wars and the relocation of peoples depopulated Bago, a situation from which it took a century to recover. Another less recognised effect of a depleted population and the removals of the courts was to limit the production of historical chronicles from the point of view of the Hanthawaddy kingdom. Writing histories

3.23
Reliquary, c. 1400–99. Yangon. Gold.
H. 34.3 cm, Diam. 30 cm (max.). Victoria
and Albert Museum, London, IS.02755.
Excavated in 1855.

was promoted at the courts, particularly in the eighteenth and nineteenth centuries, but because Hanthawaddy and the city of Bago were subsumed under the courts in central Myanmar repeatedly, few of its records remain. The kingdoms are therefore primarily seen from the outside in writings from Ayutthaya, the Toungoo and Konbaung courts and Arakan, among others, where it was viewed as either an enemy or a vassal state.[66] However, Hanthawaddy was a highly connected polity, and its interactions can be seen in the material culture of the area, ranging from religious imagery to manuscripts and musical instruments.

Religious connections are evident in a rectangular architectural plaque that would have once been set into the wall of the Shwegugyi at Bago (fifteenth century) (fig. 3.25). Displaying two monstrous creatures, the plaque is one of a large group that represented Mara's army, which attacked the Buddha-to-be on the eve of his awakening, querying his worthiness to become a Buddha and attempting to prevent his enlightenment. Similar plaques of Mara's army have also been found at Bagan from the twelfth and thirteenth centuries, particularly at the Ananda temple (c. 1105) and the Mingalazedi stupa (c. 1274), although these are square in design and covered in a green glaze (see fig. 2.17). In Hanthawaddy, the rectangular plaques are glazed a light green, with the creatures covered in darker green and brown glazes. The plaques from the Shwegugyi were part of King Dhammazedi's extensive construction programme in the 1470s, which included the famous Kalyani ordination hall.

Dhammazedi's buildings included a replica of the seven stations occupied by the Buddha during the seven weeks following his enlightenment. This grouping is of particular importance to the region since it is tied up with the establishment of the sacred Shwedagon stupa in Yangon. The story relates how, at the end of the Buddha's seven weeks of meditation near the site of enlightenment, two Mon brothers paid homage to him and received hair relics in return, which they reputedly enshrined in the Shwedagon. The plaques therefore mark the eve of the Buddha's awakening and the start of the seven-week

period and, in this particular instance, as the Mon are connected with the Hanthawaddy kingdom, the plaques also link the narrative with the local majority group. The layout of the Bago temple site was not original, however. The use of the narrative of the Buddha's enlightenment connects the Shwegugyi with the site of the enlightenment at the Mahabodhi temple at Bodh Gaya in India, the Mahabodhi's replica at Bagan built in 1216, and Wat Chet Yot temple in Chiang Mai in Lan Na that was constructed

3.24
Detail of a Portuguese man (seated, centre, wearing a black hat) from a wall painting in the Monywe complex at Salingyi, central Myanmar, 1770s–1810.

3.25
Plaque with two creatures from Mara's army, c. 1479. Shwegugyi temple, Bago. Glazed pottery. H. 51 cm, W. 36.9 cm, D. 12 cm. British Museum, London, 1965,1217.1. Donated by Cyril Newman, who fought in Burma in the Second World War, receiving a Burma Star medal.

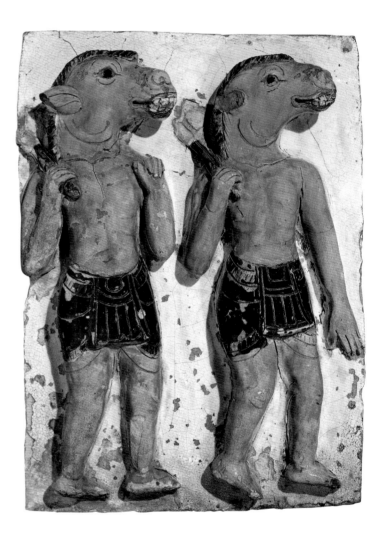

in the early 1400s and which also emphasises the seven stations. This group of buildings suggests, if not direct links between the regions, at least connections with circulating Buddhist ideas.[67]

There are few Buddha images from lower Myanmar that date from prior to the seventeenth century. Extant examples are usually made of wood, which could account for their poor survival rates. As seen here (fig. 3.26), composite elements fused into a unique local style – a disproportionately large head, crown, hands and feet, small torso, narrow close-set eyes, high arched eyebrows that merge with the line of the nose and a slightly smiling mouth.[68] The crown is also typical of the region, consisting of five layers surrounded by stylised lotuses. Some elements were adapted and can be found in the Shan states as well. Features that are shared around the region include the lotus bud finial – also common on Buddha images from central Myanmar from around the seventeenth century – plug earrings, fingers of the same length, the waisted

throne shape and the use of the gesture of enlightenment that became the standard hand position from about the fourteenth century. The ribbons to each side of the crown are another regular feature of crowned images in Myanmar; however, the solid and vertical arrangement was more typically found in the Mon and Shan regions. The upturned epaulettes are known from Mon images of the seventeenth century,[69] but they are also found in central Thailand and may relate to the relocation of people from

3.26
Crowned Buddha image, *c.* 1700–99.
Possibly Mawlamyine, lower Myanmar.
Wood, gold and lacquer. H. 94.3 cm,
W. 29.9 cm, D. 19.8 cm. British Museum,
London, 1880.251. Acquired from the
India Museum, London, when it closed
in 1879.

Ayutthaya in the mid-sixteenth century. Finally, the shape of the necklace that dangles to the waist replicates the necklaces found on the Chinese and Himalayan Yongle style of jewellery adapted in Mrauk U (see fig. 3.20).[70]

Hanthawaddy and central Thailand also shared beliefs and art forms. For example, this divination *parabaik* from the late eighteenth or early nineteenth century is made from white paper and is similar to those found in central Thailand (fig. 3.27). Divination was popular across the region, and divination manuals are one of the main types of central Thai manuscripts that survive today, a testimony to the extensiveness of their production. While there are different types of divination manual, one of the most commonly used is the Chinese twelve-year animal cycle. In such manuscripts the year itself is portrayed as a person next to a tree (also emblematic of the year), and there are four forms of the year's animal, each corresponding to a three-month period. The text summarises the chief characteristics of people born during these times.[71] The use of the Mon language for this manuscript's text, in conjunction with a central Thai format and iconography popular from at least the eighteenth century, indicates that it most likely originated in the Bago region or among Mon peoples resident in central Thailand.[72]

A crocodile-shaped zither reveals further wide-ranging connections. Associated now with the Mon peoples, who call it the *kyam*, the crocodile zither was apparently once used by the ancient Pyu peoples who performed at the Chinese imperial court. The zither is extant in other parts of Southeast Asia, too. However, the crocodile shape is primarily found in lower Myanmar, central Thailand and Cambodia. While in Thailand and Cambodia the instruments are both called 'crocodile' (*chake* and *krapeu*, respectively), their forms are highly stylised. Only in lower Myanmar do the instruments resemble crocodiles explicitly. The crocodile-form zither was used in musical ensembles, and it was popularly collected, as seen in museums around the UK. One was gifted as part of an ensemble to Queen Victoria by the residents of 'Margai' (probably Mergui [Myeik]) upon her Golden Jubilee celebration in 1887.

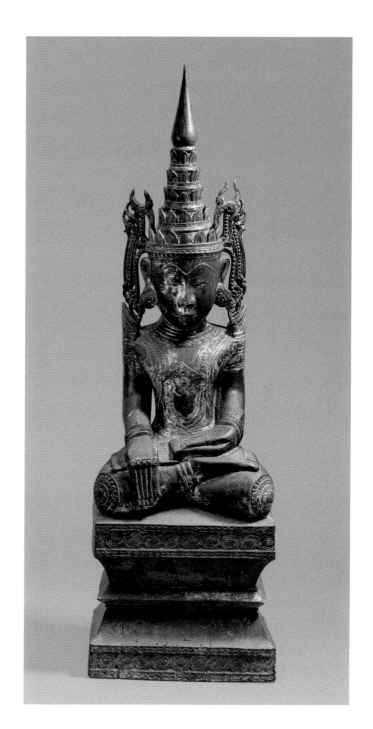

3.27
Divination manual, 1750–1820. Probably
lower Myanmar. Paper, lacquer, watercolour,
ink and gilt. H. 42 cm, W. 16 cm (each page).
The British Library, London, OR 14532.
Acquired by Mr Stewart, the medical officer
attached to a British mission to the court in
1827. Purchased by the British Library from
the Royal Society of Edinburgh in 1989.

A gilded and glass-inlaid example (now missing the strings that
would have been plucked) came to the British Museum after
being displayed at the Paris World Exposition in 1900 (fig. 3.28).

Shan states

There were once Shan principalities of varying sizes and
strengths across northwestern, northeastern and eastern

Myanmar, as well as in northern Thailand and southwestern
China. The vast areas once controlled by Shan rulers known
as *saohpas* (Burmese: *sawbwa*) are rugged yet populated
landscapes of mountains and upland plateaus intersected
by valleys and narrow river gorges. While wetland rice is
grown in the valleys, Shan regions also produced numerous
other crops like cotton, indigo, tea and teak, as well as being
a source of precious metals and gems.[73] Different peoples,
including the many varying groups of Shan (also known as
Tai), Karen, Wa and Kachin, occupied the region (and still
do today), interacting through extensive kinship and trade
networks, regular markets held in towns and villages, and
warfare. While the Shan principalities received tributes from
communities around them, they also entered at varying
times into tributary relationships with courts in Manipur,
central Myanmar, Lan Na and China. Typically, tribute was
sometimes paid to more than one place at the same time.

Shan states appear to have first developed in the twelfth
and thirteenth centuries. Early records indicate that around
the late thirteenth century, when Mongol power in Yunnan
was declining, the Maw Shan principality was established
along the upper reaches of the Nam Mao (Burmese:
Shweli) River. Although the new state repulsed a Mongol
incursion in the 1340s, it sent a mission to the Yuan Chinese
court in 1355.[74] The states of Mohnyin and Mogaung
established themselves as independent from Maw Shan in
1399. Histories from central Myanmar claim that Mohnyin
was subject to the courts of central Myanmar until the
1470s, although Chinese sources indicate that such control
was nominal and sporadic.[75] Mohnyin used its access to
amber and jade resources to expand, and joined forces with
Manipur and Mogaung to conquer three Shan principalities
in the Kabaw valley, which were then divided among the
conquerors. Sawlon (r. *c.* 1500–33), the ruler of Mohnyin,
sacked Ava, the capital of central Myanmar, in 1527, putting
his son on the throne, a situation that continued for a further
two reigns. Mohnyin supported the Shan state of Hsenwi
(east of Mohnyin) when Mongmit – another Shan state that
was wealthy due to its mines and had links with ocean-going

3.28
Zither in the form of a crocodile,
c. 1860s–90s. Probably lower Burma.
Wood, lacquer, glass, metal, gold and
animal gut. H. 15.5 cm, W. 106 cm,
D. 25.5 cm (max.). British Museum,
As1901,0605.29. Donated to the
museum in 1901 by the Indian Section,
Paris Exhibition 1900 Committee.

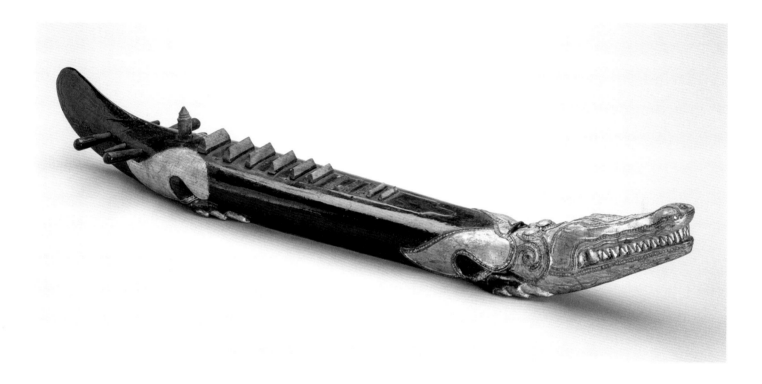

trade in the Bay of Bengal – started expanding. Hsipaw and Yawnghwe were two other Shan principalities that had close relations with the courts in central Myanmar, resulting in substantial cultural and religious similarities.[76] Further east was the state of Kengtung (Kyaingtong). With a ruling house dating back to the thirteenth century, it paid tribute to Lan Na's Chiang Mai until the sixteenth century.[77]

Although at times the states formed alliances with each other or the court in central Myanmar – such as when they helped repulse Chinese invasions in the fifteenth century – hostilities between the Shan states were otherwise a relatively frequent occurrence. This situation continued into the sixteenth century, after which warfare with the Toungoo and Konbaung dynasties of central Myanmar reduced their military capacity. Many of the battles were efforts to control the region's plentiful natural resources. The strategic location of the major trading hub at Bhamo (present-day Kachin State)

became a focus for struggles to control trade routes stretching from Manipur and Bengal to the eastern Shan states, Yunnan and beyond.[78] Bhamo had been controlled by Hsenwi from the mid-fourteenth century but was taken by Mongmit in the fifteenth and then by Mohnyin in 1494. Control of the Shan states by Toungoo gradually developed from the second half of the sixteenth century with King Bayinnaung's conquests. As Toungoo exploited the mines in the Shan regions, its kings were termed the 'master' of gem and amber mines and were declared to have a royal monopoly on amber and gold in 1597. As a result of these losses, the Shan principalities were deprived of their economic resources and went into decline.[79] The deportation of people to central Myanmar from the states and conscription into the Toungoo and later Konbaung militaries further depleted the region, a situation that resulted in the Shan states being less prosperous and populated in the nineteenth century than they were in the sixteenth.[80]

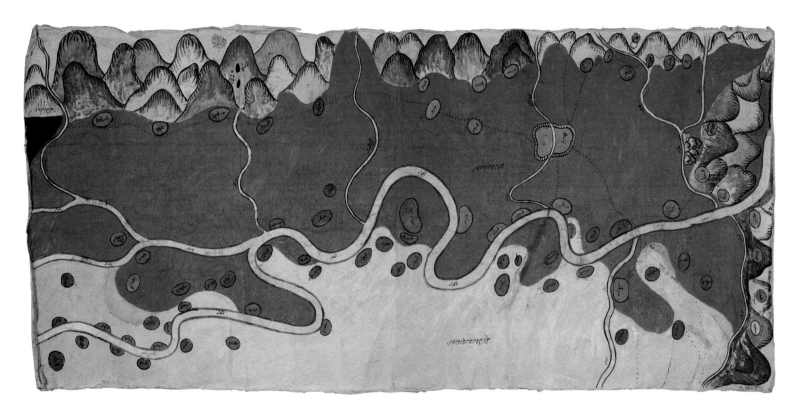

Political interactions were not always confined to warfare
and control of resources. Diplomacy also played a role in the
cross-cultural activities of the Shan principalities. Chronicles
record treaties with powerful Kachin groups, with the Kachin
attending Shan ceremonies.[81] Marriage alliances with the
nobility of the courts of Lan Na, Lan Xang and other
kingdoms in present-day Laos, Sipsong Panna in Yunnan, and
central Myanmar were also important means of extending
political influence. Shan princesses became consorts or
ladies-in-waiting at various courts,[82] and rulers of the Shan
principalities often displayed their wives from different
regional groups in the traditional clothing of their homelands
to demonstrate the extent of their political connections.[83]
Shan princes were also kept at the central Burmese courts to
ensure the states did not rebel.[84] With the Shan states under

their control, central Burmese kings promoted their cultural,
administrative and religious agendas in the region. For
example, the Burmese system of weights and measurements
was introduced in the second half of the sixteenth century,[85]
and at the same time King Bayinnaung sent monastic
missions with orthodox Buddhist texts to preach and ensure
that rulers promoted the correct religious ideas.[86]

Shan principalities once spread across a vast territory,
from today's northern Myanmar and Shan State to Yunnan
province in China, Thailand and Laos. Maps sometimes
depict this complexity, though few remain from before the
late eighteenth century.[87] A number of maps of the Shan
states were in the collection of James Scott, a colonial
official assigned to the region in 1886. He was responsible
for gathering information, including about disputed borders,

3.30

Shan skirt, *c.* 1870–90. Shan states.
Cotton, velvet, silk and gold wrapped
fibre. L. 90 cm, W. 72 cm. Bankfield
Museum, Calderdale Museum Services,
Halifax, 1955.44. E.C.S. George
Collection, loaned to the museum in
1900, then given as a bequest in 1937.

with the assistance of local clerks. One such map on Shan paper shows an area of about 122 square kilometres along the Nam Mao River (fig. 3.29). Three Shan states are identified – the red territory is part of Namkham State, the black is Selan and the yellow Mong Mao. Villages and hamlets are shown as green ovals, standard for Shan maps,[88] with ink labels providing the names. The relationships between the border, the river and village locations are clearly shown. It has been suggested that the map was produced in either 1888 – when the British were trying to settle disputes among the Shan principalities in order to arrange clear borders – or in 1898–9 when the area was surveyed by British, Shan and Chinese authorities to determine where the new hard borders should lie.[89] Prior to the late 1880s Namkham had been largely independent and Selan had been under its sway; after 1888 they were part of the Hsenwi administrative division (now in Myanmar) established by the British,[90] and Mong Mao became part of Yunnan Province in China.

Chinese records of trade dating to the Ming dynasty (1368–1644) describe various routes into the region with such commodities as salt, tea and silk exported to the Shan states and central and lower Myanmar and cotton imported to China. Such sources indicate that there were several main routes from Yunnan that passed through areas controlled by Shan polities, with some extending down to the coast. Other routes traversed Lan Na and Lan Xang. Trade was brisk from the fourteenth century onwards,[91] and itinerant traders brought goods from China, Myanmar's kingdoms, Lan Na, India and other places to sell at inland markets across the region. These markets linked the Shan states with global trade from an early date. Textiles from the nineteenth and twentieth centuries testify particularly to the richness of trade around the region. Shan men once wore home-woven wide cotton trousers, headcloths and loose shirts, while women dressed in striped skirt-cloths, shoulder-cloths and Chinese-style jackets. These items of clothing could be adorned with a wide variety of trimmings, as well as pieces of imported cloth and novel patterns. One example is this skirt, which combines European chemically

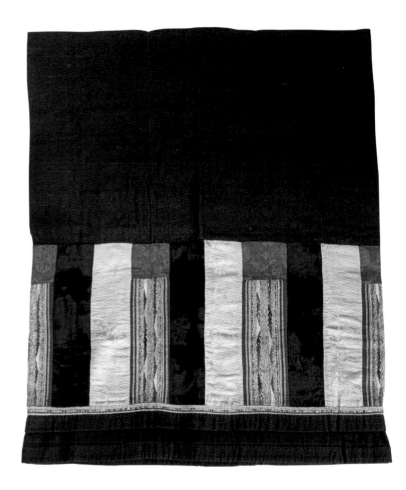

dyed velvet and European cotton with local black cotton and red and yellow Chinese silk (fig. 3.30).[92] The arrangement of three sections of cloth – lower, upper and a mid-panel with vertical stripes – has been reported as originating among the northeastern Shans along the Chinese border, although it is now worn in many other regions, too.[93] Another type of skirt for a wealthy woman is made of black cotton edged with black velvet and a decorated central panel consisting of three sections, the largest of which comprises multicoloured supplementary weft patterns of diamonds, key-frets,

3.31 *and detail, right*
Skirt, 1870s–80s. Shan states. Cotton,
silk, gilt thread and metal sequins.
L. 94 cm, W. 70 cm. Brighton & Hove
Museums, WA508311. Collected
by William Nisbett, a British army
soldier, in the 1880s; donated by his
granddaughter Janet Browne.

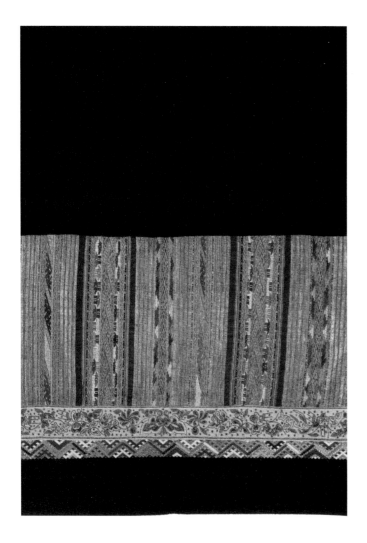

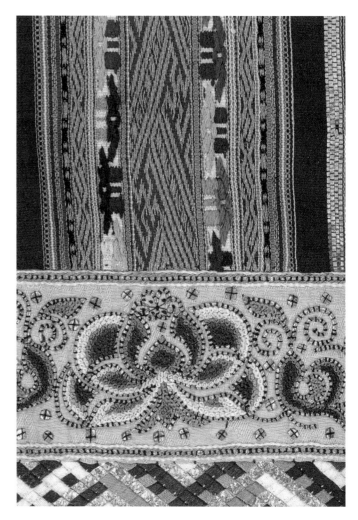

triangles and other geometric shapes in cotton, silk and
gold threads (fig. 3.31). The mid-section is of silk brocade, a
sumptuous cloth extensively made in China, displaying floral
and animal imagery interspersed with gold-coloured sequins.
The third part displays interleaved ribbons and pieces of
gilded leather that form a raised, basket-weave-like polychrome
panel, a typical decorative format on elite Shan textiles. The
supplementary weft patterns and the striping, as seen on these

two skirts, were popular among the Tai peoples who have
lived in the broad swathe of territory from the Shan states
into Sipsong Panna in Yunnan, Lan Na and northern Laos.

Also worn in the Shan states were knee-length men's
robes with long sleeves and a button-down front. These may
have been influenced by Indian robes, as a group of Shan
saohpas visited India during the Delhi Durbar celebrating
the coronation of King Edward VII in 1903, and this type

3.32
Coat, *c.* 1900–30. Shan states. Silk and
cotton. L. 127 cm, W. 149 cm (including
sleeves). James Henry Green Collection,
Brighton & Hove Museums, G125.
Loaned to the museum by the estate of
Colonel James Henry Green in 1992.

of robe became particularly popular in the 1920s.[94] While
the visit to India may have stimulated the later popularity of
such coats, an example dating from before the 1903 durbar
exists in the Pitt Rivers Museum in Oxford, suggesting that
such a style was known prior to the twentieth-century visit.[95]
This example is made of Chinese silk and patterned with
popular European designs of East Asian buildings set among
landscapes (fig. 3.32). The overall shape resembles the robes of
Indian rulers, but the buttons are in a Chinese style and the
lapels and sleeves are in a European fashion. The styling of
the coat may be a further adaptation for European women's
wear, probably by the collector James Henry Green. Such
a wide combination of features demonstrates the extent to
which the Shan states have been a major crossroads.

Silver was mined at a number of sites in the Shan states,
the most famous being Bawdwin, which was managed by
Chinese specialists from about the fifteenth century until
the 1860s. Workers came from around the region. Shan
silver objects likewise exhibit characteristics of the region's
extensive interactions. Pieces were produced as bowls,
boxes and cups, as well as daggers and swords, and tribute
included silver objects in the shape of bowls, model trees
and, according to the *Gazetteer of Upper Burma and the Shan
States*, shoes.[96] A narrow repertoire of imagery and designs
is used, including low relief on the sides of objects and high
relief on lids, as well as floral and geometric shapes, thick
brackets, large bead-like motifs and geometric spaces or
cartouches filled with animals. Particularly popular were
the eight-days-of-the-week motif (Wednesday is divided
into two 'days') and the zodiac, themes that were also
prevalent in central Myanmar, as noted by Yule when
he visited Amarapura and the local silversmiths' quarter,
and as is seen in this silver bowl (fig. 3.33).[97] Some features
relate to Lan Na silver, such as the high-relief curled rosette
motif found on the lids of boxes, while the high-relief
animal figures on boxes can also be seen on silver found
in Manipur in the nineteenth century (fig. 3.34).[98] Silver
dha-lwe (ceremonial swords), typically decorated in an
elaborate fashion, were made in the Shan states[99] as well as

3.33
Bowl, 1895. Shan states. Silver.
H. 20.1 cm, Diam. 23.8 cm. Honeybill
Collection. Purchased from Mata-Hari
Traditional Arts and Antiques, Singapore
in 2013.

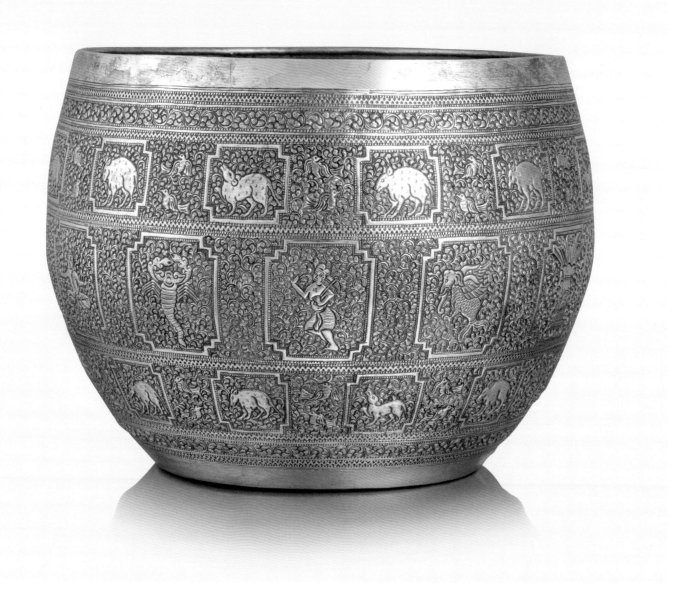

3.34 *below*
Covered box, *c.*1870s–1910. Shan
states. Silver. H. 11.2 cm, Diam. 11.8 cm.
Honeybill Collection. Purchased from
Mata-Hari Traditional Arts and Antiques,
Singapore in 2012.

3.35 *right*
Sword (*dha-lwe*), *c.* 1870–80s.
Central British Burma or the Shan
states. Silver and steel. L. 101.5 cm,
W. 6.4 cm, D. 6.4 cm. Honeybill
Collection. Purchased from Michael
Backman Ltd. in 2012.

3.36 *below*
Dagger with ivory handle, *c.* 1870s.
Probably the Shan states. Steel and
ivory. L. 52.5 cm, W. 4.4 cm. National
Museums Scotland, Edinburgh, 1891.59.
Purchased from A. Dowell's auction
house, Edinburgh on 30 April 1891.

in central Myanmar (fig. 3.35). Here, the hilt is embellished
with floral motifs, while characters from the Ramayana
epic are contained in cusped cartouches surrounded by
floral arabesques on the sheath. Over time, such swords
were incorporated into the formal dress of some Kachin
communities,[100] as noted by a missionary who commented
that Shan swords were the ones primarily used by Kachin
peoples living south of the Myitkyina and Mogaung areas.[101]

Silver was also used for daggers and knives, some of
which had beautifully decorated hilts of ivory, silver or
niello work. While Burmese carvers sometimes used ivory
imported from India or Africa, the majority came from the
Shan states.[102] In the late eighteenth and early nineteenth
centuries ivory was used for regalia, sword and dagger hilts,
manuscripts and boxes, among other things, and regional
rulers gave such items as gifts.[103] Although commonly

associated with, and used in, the Shan states, many ivory hilts were made in central and lower Myanmar, with Mandalay, Yangon, Mawlamyine (Moulmein), Pathein and Pyinmana the primary carving centres. Usually produced in detailed high relief, imagery ranged from Buddhist themes to images of the monkey Hanuman and demonic figures, the latter seen on this dagger (fig. 3.36). Such creatures were considered protective of the bearer.

Highland regions

The highlands of Myanmar encompass great human and linguistic diversity and complex social environments. Consisting substantially of present-day Kachin, Chin, Kayah and Kayin States, as well as part of Sagaing Division, these highlands were once not part of any state, although they interacted with lowland, valley-based kingdoms. Far from being political vacuums and empty border worlds, as often described during the British colonial period, the highland regions display complex and tangled interactions and should not be dismissed because of their differences from state-based civilisations. The marginalisation of highland peoples occurred in the nineteenth century partly because the exotic materials they specialised in supplying to lowland states became less important to the global economy or were monopolised by colonial companies engaged in the extraction of resources. Additionally, narrow state-based views of what constituted 'civilisation', coupled with the expansion of colonial control, further led to the demise of the power exercised by highland peoples. Many highland cultures had extensive oral literature rather than a written one and, because of a lowland emphasis on texts, this further contributed to the elimination of highland groups in contemporary and later historical accounts of the region. As anthropologists Jelle Wouters and Michael Heneise write, understanding such polities 'requires seeing highland communities not as reactive, reactionary, rebelling, derivative, or as "lagging behind" [but] ... as worldmakers and enactors and repositories of their own visions and versions of sociopolitical life, both past and present'.[104]

Part of the marginalisation of highland peoples can be seen in the simplifying terminology applied to them during colonial times. For example, the term Kahkyen, used initially by Burmese and Shan officials to refer to the Jinghpaw, was later adapted by the British to become the name Kachin, used in reference to several groups – the Jinghpaw, Zaiwa, Lisu, Nung-Rawang, Lashi/Lachik and Lawngwaw/Maru/Lhaovo and their subgroups – who were among the numerous peoples living in the northern areas.[105] The name Kachin is standardly used today by the groups themselves, as well as outsiders. However, historically, among themselves the groups aligned according to networks based on lineage, marital and kinship groups and flexibly embraced diversity. For instance, Jinghpaw networks extend from present-day Assam in India, across northern Myanmar, and into Yunnan and northern Shan State, and communities now also exist in northern Thailand. Due to the complexity of the highland regions and based upon the availability of their material culture in museums, this discussion focuses on the Kachin groups.

The highlands' forested mountainous terrain, segmented by narrow valleys and deep river gorges, is in part responsible for the diversity of the region, as well as making it difficult to implement state-based control. The few strategic passes across the difficult landscape gave local communities considerable power and, although the Konbaung, Qing (China) and Chakri (Thai) dynasties and the British described the region as beyond the edge of civilisation, it was in fact highly politically organised around three main routes of travel. This gave the peoples living in the highlands opportunities, from early times, to interact extensively with the various cultures, states, principalities and chiefdoms around them through trade and diplomatic activity. The highlands' historical importance as a region of transitions and networks connecting peoples across vast distances is still insufficiently understood.

The political power and influence of Kachin elites in the highlands partially resulted from their control of the entrances and exits to mountain passes, enabling them to affect movement and therefore trade and diplomatic exchanges across the region. For example, the routes that crossed Kachin land were under the control of local chiefs, whose management of the region was tacitly accepted by the surrounding polities and states, as well as local officials and elites. The chiefs would travel to meeting places across the region and into Yunnan to negotiate the price and logistics for passages through their territories. As recorded when Colonel Edward Sladen and later Colonel Horace Browne travelled from central Myanmar into Yunnan, local elites controlled logistical arrangements from the quantity of bags (plus contents) to the supply and number of animals, as well as charging a price for protection and transport.[106] Later, in the 1870s, Kachin chiefs and their agents travelled to Mandalay, Rangoon and Calcutta (Kolkata) to work with the Konbaung court and to understand the British better, and King Mindon sent emissaries to the Kachin chiefs, too.[107] Intercultural knowledge and communication, as well as the ability to negotiate across cultures, were crucial factors in being successful among communities that lived in the areas between states.[108] Leaders displayed authority in part by indicating the extent of their connections. This kind of amalgamation of multicultural strands is visually evident in a photograph of Nga Lang La, a powerful Hkahku Kachin chief (*duwa*) who controlled territory near the northern Putao area (fig. 3.37).[109] Photographed by Colonel James Henry Green in the 1920s, the *duwa* deliberately wears a Chinese court robe,[110] a Chinese helmet that was held in place by his Hkahku turban, and a Burmese man's skirt-cloth, and he smokes a silver pipe probably from the Shan area.[111] In this way, he demonstrated the broad extent of his political networks and therefore power.

Markets were an important point of interaction. Itinerant traders brought goods to sell at regularly occurring local and larger-scale markets, to which people from different communities travelled, sometimes across long distances. The markets, some of which rotated around villages and towns on a five-day basis, ranged from smaller ones to provincial markets that functioned as collection and distribution centres, and major centres specialising in the sale of local, regional and maritime goods and imports from the Indian Ocean network via the Bay of Bengal and land-based systems.[112] Trade with Yunnan via caravans of mules and horses included, among other products, jade, silver, sugar, salt, gems and cotton. Cowrie shells, some from the Maldives, came via Bengal and the Naga peoples of Assam (see fig. 1.22).[113] Chinese silk was imported, as were silver from Yunnan and trade textiles from India.[114] Because of this system, areas considered remote today were once highly connected, rapidly receiving goods from many thousands of miles away.

Local cultures absorbed goods and materials from far afield. Technologies, production techniques and patterns, such as those on Indian trade textiles, also left their mark on Kachin objects. For instance, a bamboo container is decorated with floral and geometric patterning, some of which replicates Indian trade textile patterns (fig. 3.38). Such containers were used to hold knives or Chinese-style folding fans, among other things.

In addition to trade and markets, the mines were another major draw to the region. Sapphires, emeralds, rubies, semi-precious stones, jade and gold were mined in the highlands. In the north, Kachin chiefs controlled lands with mines that were important economically for the peoples of the region. Chiefs allocated mining rights to kinship groups, ensuring that the economic benefits were distributed widely, and surrounding courts and states did not question land rights in these regions.[115] People came from afar to work in the mines, and there is evidence of a Chinese presence from at least the fifteenth century and possibly earlier.[116] Chinese communities also developed in such places as the Kabaw valley and the Shan states.

Through contact with the Chinese, the Kachins learned to make gunpowder and use guns at an early date,[117] developing a reputation for raids and fierce defence of

3.37
James Henry Green, Kachin *duwa*
Nga Lang La, 1920s. Kachin Hills.
Photographic print. H. 12 cm, W. 16.5 cm.
Brighton & Hove Museums, James
Henry Green Collection, no. 0166.

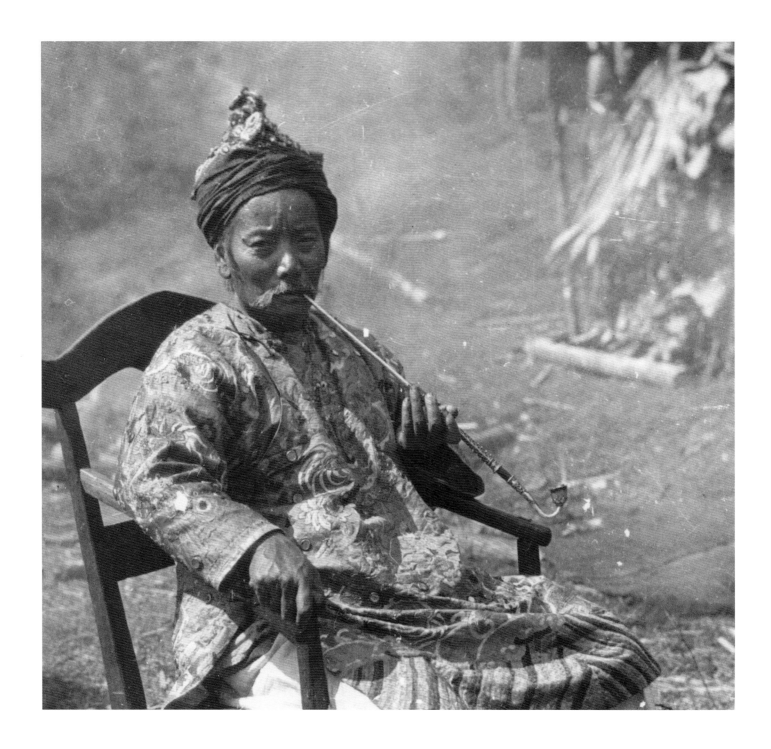

3.38
Container, early 1860s. Kachin region.
Bamboo. H. 27.5 cm, Diam. 2.9 cm.
British Museum, London, As.7132.
Donated by Col. Sir Edward Bosc Sladen
in 1871; probably collected during his
mission to find a route into China via
Bhamo in 1868.

territory among surrounding communities. Ammunition
pouches were often collected by colonial explorers in
the highland regions. One example was acquired by the
aforementioned Captain, later Colonel, Sladen on his
journey from Mandalay to Yunnan through Bhamo in 1868
to explore the possibility of trade with China via Myanmar
(fig. 3.39).

Prior to the nineteenth century, Kachin literature and
history was recorded orally (much of which has now been
lost through the strife of the twentieth century), so it is only
from the late eighteenth century in the written records of
others that Kachin history, particularly that of the Jinghpaw,
comes into sharper view. During this time, the Jinghpaw
group took advantage of the decline of the Ahom kingdom
in Assam to expand into that region (where they became
known as the Singpho). This was to relieve the population
pressure around the Mali and Nmai Rivers in today's
Kachin State. People also migrated eastwards into Yunnan
and the Shan states because warfare between Myanmar and
China in the late eighteenth century, which also involved
the Shan states, had reduced the states' control of the
regions. Despite the wide distribution of people, networks
of relationships resulted in periodic transregional unity
for common political purposes. For instance, Jinghpaw-
Singpho men from as far afield as Yunnan assisted Burmese
forces when they attacked the weak Ahom court in Assam
in 1821.[118]

As Jinghpaw-Singpho populations expanded into Assam
in the early nineteenth century, they came into contact
with the British East India Company. Attuned to political
winds, Singpho leaders wrote to, or met with, Company
officials, offering support in return for land rights, such
as one letter sent by chief Bisa Gam in April 1825 to
Lieutenant Neufville, who was camped near land that
the Ahom ruler Chandrakanta Singha had recognised as
being under Bisa Gam's jurisdiction.[119] Despite such efforts,
strengthening British intervention in the Assam area saw
Kachin peoples across the region suffer the loss of political
influence as well as reduced access to lands. The drawing

3.39
Ammunition pouch, early 1860s. Kachin region. Rattan and cotton. H. 10.6 cm, W. 9 cm (excluding string). British Museum, London, As.7133. Donated by Col. Sir Edward Bosc Sladen in 1871; probably collected during his mission to find a route into China via Bhamo in 1868.

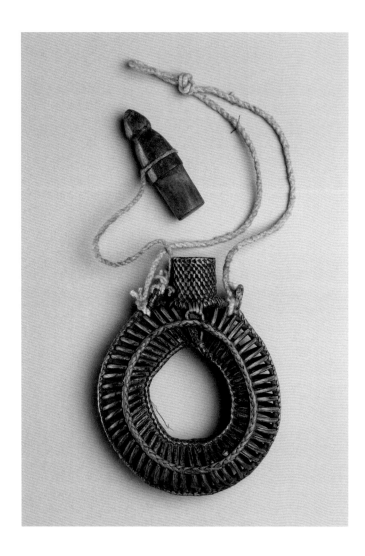

disrupted, and the nineteenth-century upheavals in China generally led to a drop in trade with China and Japan, the main consumers of jade and other gems.[120] Combined with British land restrictions to the west, the result was substantial economic hardship among the Kachins generally, and among those living in the mine regions and along trade routes in particular. One consequence of the economic problems was an uprising against the British in 1843 that involved a unified effort by Jinghpaw-Singpho peoples from across the region,[121] demonstrating the extent of such connections.

The Panthay Rebellion in Yunnan (1856–73) further disrupted trade and sent many Muslims into Kachin areas. Kachin elites engaged with the Panthay leaders until the Qing dynasty crushed the attempted secession. The unrest had the further result of the substantial movement of a number of groups, such as the Lisu, into what were then Jinghpaw regions. The Jinghpaw to some extent assimilated these various people and formed alliances with non-Jinghpaw groups – trends that also occurred among other Kachin groups across the region, producing a degree of social and political integration that helped set the stage for twentieth-century arguments for a pan-Kachin identity.[122]

The diversity and interconnectedness of the region, as well as the way in which fashion changes over time, are clearly demonstrated in Kachin textiles. Some styles and techniques were shared across a number of groups, in particular the diamond-shaped 'mother pattern' woven with supplementary weft yarns vertically along the side of a textile, which was generally associated with weaving competence. However, it is often difficult to determine which group or subgroup produced which designs, as many parts of Kachin State have been subject to extensive migration and, more recently, displacement. The primary materials were once regionally grown cotton and wool with some use of silk from China and locally grown hemp and, from the late nineteenth century, synthetics from Europe (see chapter 5). Silver pieces, coins (often British Indian rupees), seeds, orchid fibres, cowrie shells (via Bengal and

of boundaries between Manipur and Myanmar after the First Anglo-Burmese War also diminished Kachin control of trade routes to the west, causing impoverishment. The economic situation for Kachin groups in northern Myanmar and Yunnan deteriorated further after the outbreak of the First Opium War between Britain and China in 1839. The major trade route from the northern regions through Yunnan to Canton (Guangzhou) was

3.40

Kachin bag, *c.* 1930s. Kachin region. Cotton, metal, glass beads, silver and seeds. L. 61 cm, W. 28 cm. Brighton & Hove Museums, WAG 000001. Collected by Col. James Henry Green, who documented Kachin communities while recruiting for the Burma Rifles and mapping the northern regions, 1918–34.

the Naga peoples to the west), pompoms, tassels, porcelain buttons (from China) and sequins (produced in central Myanmar, among other places) contribute to the rich appearance of many textiles and other objects. The most common colours are red, black and yellow. James Henry Green noted that some groups preferred more sombre colours, such as the Hkahku Kachins, whereas others, like those living in the Nmai region, appreciated bright ones.[123]

Outfits could include waist and leg bands, necklaces, earplugs and headcloths. Bags were once a common part of Kachin dress, although designs and appliquéd elements varied substantially. A commonly collected bag type was probably produced by Htingnai Jinghpaw Kachin. It displays numerous silver elements, lengths of white beads ending in pompoms, seeds and a curtain of red cotton ribbons that hides the body of the bag covered in multicoloured supplementary weft patterns (fig. 3.40). The woven cotton pieces with fringes and beading tied to the strap are also occasionally part of Htingnai bags. Long red fringes were not exclusively found among the Htingnai. Lawngwaw and Zaiwa Kachins also used them, as did soldiers recruited into the Indian Army from the late nineteenth century onwards. It may be because they were associated with soldiers, as well as the fact that they were consequently produced in large numbers, that so many of these bags are now in Western museum collections.[124]

Jinghpaw and Jinghpaw subgroup textiles were most commonly collected by Westerners, which may reflect the dominant political status that those communities came to hold locally by the late nineteenth and early twentieth centuries. Skirt-cloths like the example seen here were popular to collect because of their stunning appearance (fig. 3.41). Made of cotton and wool, they consist of red and black sections joined together and patterned with continuous and discontinuous supplementary weft and twill weaving. The vertical supplementary weft stripes, filled with varied designs that would appear around the lower edge when worn, were once woven by some Jinghpaw, including Hkauri Jinghpaw communities from

3.41
Skirt-cloth (*labu*) (detail), 1910s–1933. Kachin region. Wool and cotton. L. 188 cm, W. 71 cm. British Museum, London, As1992,01.5. Collected by Lt-Col. W. Thyne of the military police before his departure from Burma in 1934; donated by his daughter, Anne Smith, in 1992.

southeastern Kachin State or northern Shan State. Such stripes are now associated with Lachik Kachins, who live in the same region. Likewise, the narrow horizontal stripes across the black section are also found on textiles woven by Lawngwaw Kachin women from similar areas.[125]

Further evidence of interconnectedness is visible on textiles from Lhaovo (Maru) communities living in northeastern Kachin State (fig. 3.42). While supplementary weft yarns and an appreciation for the colour red are in common with many other Kachin groups, the Lhaovo also incorporated indigo stripes into their textiles, as can also be seen on textiles from Black Lisu communities of the northern part of Kachin State. This jacket typically combines striped fabric for the sleeves and an upper section with red and blue continuous supplementary weft yarns in a twill weave and discontinuous supplementary weft patterns in the lower two-thirds. The red yarns may include dog hair.

The Nung-Rawang were once the most remote Kachin group, living in the Upper Nmai Hka River valley in the far north. Because of the cold weather in the region, blankets wrapped around the upper body were part of everyday wear. Some were made of undyed, tufted hemp dotted with red and blue spots and X motifs (fig. 3.43). In this example, the mid-section has blue, red and black zig-zag bands, as well as patterns of red, black, blue and yellow lozenge forms, possibly incorporating dog hair. The end sections consist of a red supplementary weft interspersed with dark stripes. Tufting, which made blankets better able to retain heat, is used and, unsurprisingly, was worn on the inside, with only the plainer back of the cloth visible. The use of zig-zags, a red supplementary weft section and the diamond-shaped 'mother pattern' is in keeping with the textiles of other Kachin groups.

Despite the waxing and waning in the fortunes of these various political centres and systems over the sixteenth to nineteenth centuries, the trend across the region, in keeping with global developments,[126] was one of gradual consolidation into larger units. Thus, after 200 years of control by the Toungoo and Konbaung dynasties of central

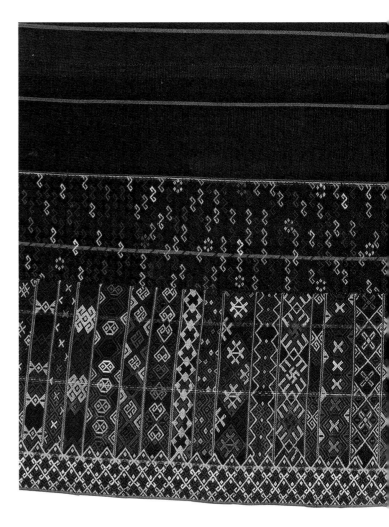

Myanmar, Lan Na reasserted its independence in the late eighteenth century, only to be subsumed by the Chakri dynasty of central Thailand in the nineteenth. Gained only in the late eighteenth and early nineteenth centuries by the Konbaung kings, Manipur and the Ahom kingdom of Assam were lost to the British in the First Anglo-Burmese War. Although the connections of the kingdoms of Hanthawaddy and central Myanmar have been couched

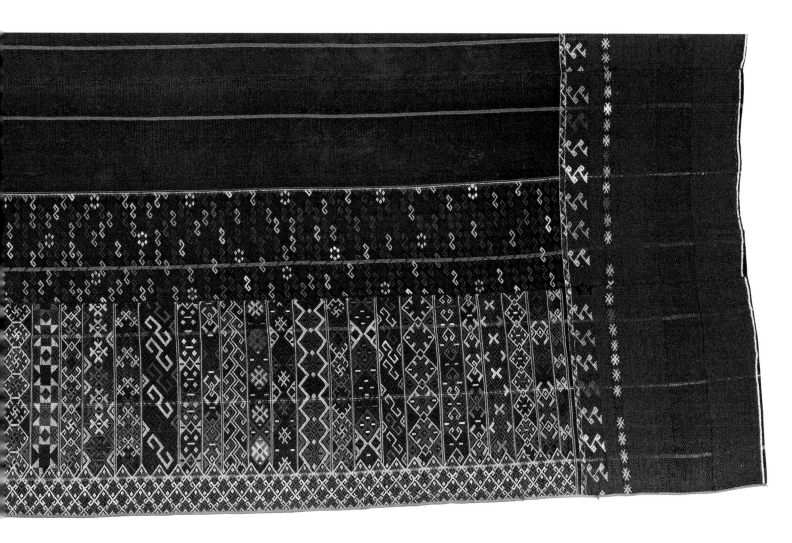

in terms of ethnic rivalry between the Burmans and the Mons – an idea still prevalent in Myanmar today – they were, in historian Michael Aung-Thwin's assessment, 'dualistic and symbiotic', interacting with, and contributing to, each other.[127] Exchanges between the kingdoms of Arakan and those based in central Myanmar varied from warfare to tribute payments and diplomatic engagement but were much less integrative than between lower and

central Myanmar because Arakan looked to its west and north and the Bay of Bengal first and foremost. Only after annexation did the 'Burmanisation' of Arakan begin. The Shan principalities remained in tributary relationships to the Konbaung court until the 1880s, as well as maintaining connections with Lan Na, Kachins and other groups. Tribute relationships between Kachin peoples and the central Burmese courts were never particularly strong, but

the Konbaung court worked to build closer connections as British control expanded during the nineteenth century. Eventually, the Kachins were marginalised by the British, who viewed them as politically irrelevant and culturally primitive, and were bypassed when improvements in communications technology meant that their historic roles as managers of non-state spaces became obsolete.[128] The Kachins and other highland groups were also prevented from traditional regional interactions and migrations as the highland areas were divided by modern borders established by surrounding states. Such events spurred disparate yet related peoples of the highlands to form alliances and associations and, in some instances, to amalgamate.

These histories are recorded in written texts and oral material from across the region, but objects reveal them, too. However, cross-cultural engagement does not have to be viewed generically as something that happens to people evenly across an area. As the objects in this

chapter demonstrate, interactions range from courts to individuals to specific areas, classes and groups of people. Therefore, we see the popularisation of the game of polo at the central Konbaung court after the incorporation of the Manipuri cavalry into the Burmese equivalent in the late eighteenth and early nineteenth centuries; the long-standing production of ceramic storage jars for use on trading ships in lower Myanmar; a wide variety of Buddha images in Arakan based on extensive religious connections from the Himalayas to Sri Lanka; and the rapid arrival and popularisation of synthetic dyes in highland areas, including the Shan states, through extant trade networks in the second half of the nineteenth century, to be paired with local materials and Chinese silk that had long been an imported commodity. The impact shows local agency: ideas, techniques, patterns, designs and materials were adopted, adapted, incorporated, developed and shaped creatively by locals exploring, engaging with and affecting the world around them.

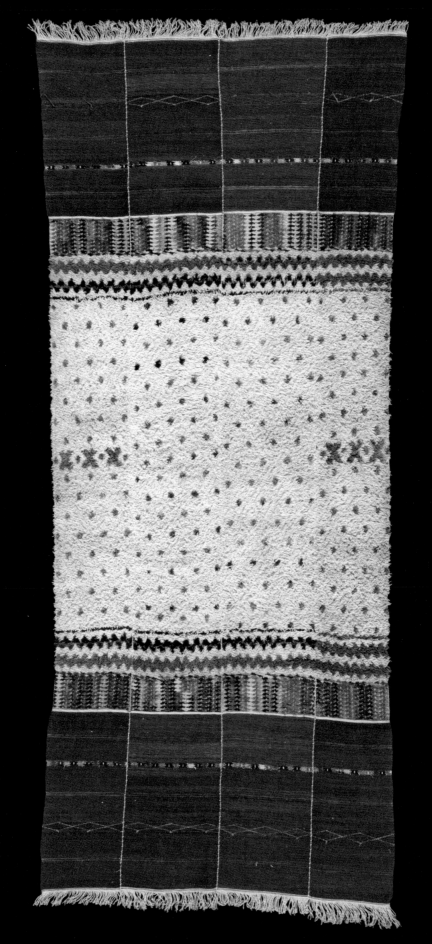

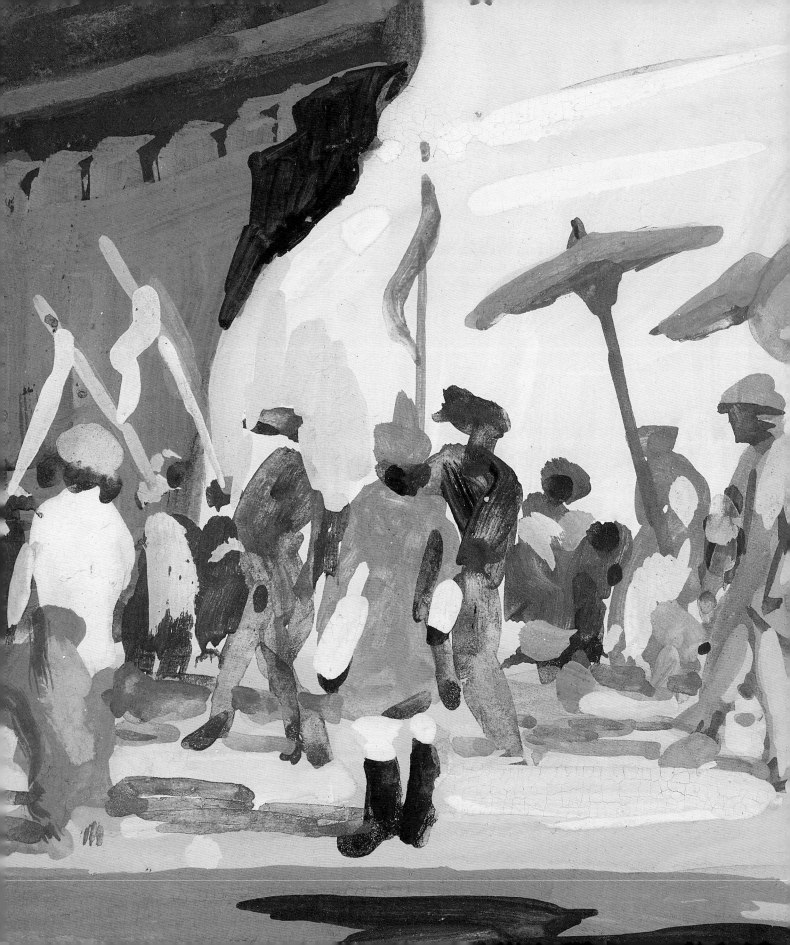

THE BRITISH COLONIAL PERIOD, 1826–1948

ALEXANDRA GREEN

The British colonial period of Burmese history has been described as a time of 'order without meaning' by the historian Michael Aung-Thwin.[1] The complete transformation of social, political and religious structures into new and alien systems in the regions under direct rule and lesser changes in those governed by indirect rule created efficiency for the extraction of resources and the import of new ones but caused severe cultural confusion. Many of the alterations are visible in material remains, as the works in this chapter – such as new patterns on silver objects and collections of textiles from highland groups – demonstrate. Yet, like those of the preceding centuries, the objects produced during the nineteenth and first half of the twentieth centuries demonstrate a ready engagement with new ideas – from subversive cartoons to painting styles – and the Burmese understanding of the power of objects in political discourse. Some of the changes set the stage for the challenges the nation state faced after gaining independence in 1948. This chapter does not address the effects of colonisation in detail – such as its impact on day-to-day lives, administrative structures and the nationalist movement – but instead focuses on objects, providing an alternative perspective on the colonial experiences of the region.

The three Anglo-Burmese wars

Divergent notions of state boundaries and borderlands had been a recurring source of tension between the British East India Company (EIC), which administrated the Cox's Bazar area of present-day Bangladesh, and the Konbaung dynasty based in the central area. Konbaung Myanmar had conquered Arakan in 1784 and subsequently occupied and colonised the formerly independent kingdom. For decades Arakanese rebels and bandits sought refuge in the British territory. Burmese forces maintained the right to pursue rebels wherever they fled, while the EIC considered these acts provocative violations of British sovereign territory. Finally, on 5 March 1824 the EIC declared war on Myanmar. The bitter fighting lasted nearly two years, with General Thado Maha Bandula (1782–1825) leading the Burmese forces and General Archibald Campbell (1769–1843) commanding the EIC troops. Eventually, the Burmese were defeated, signing the Treaty of Yandabo on 24 February 1826. The treaty stipulated that the Burmese were to pay £1,000,000 in silver, a tremendous sum at the time, as well as to sign a commercial treaty, cease warring with Thailand and house a British Resident at the court in Amarapura. Furthermore, they had to cede Arakan, Tenasserim (Tanintharyi), Manipur and parts of Assam to the British (fig. 4.1). Burma's colonial period had begun.

The first war incurred huge costs and losses for both sides. On the British side, large numbers of troops, both British and Indian, had lost their lives, and expenses had drained the coffers. Numerous soldiers in the Burmese army also died, and the treaty was devastatingly expensive for the Burmese, especially with the loss of revenue from its former territories. Arakan was merged with the colonial Presidency of Bengal, and Tenasserim came under the administration of Penang (now part of Malaysia). Additionally, when the British withdrew from the areas left to the Burmese, there were revolts by officials, non-Burman communities and other local groups against returning royals, who struggled to regain control over resources, revenue and territory.[2] In the northern regions, the war damaged highland networks, cut trade routes and shrank towns dependent on both.[3]

The Second Anglo-Burmese War (1852–3) ostensibly began after two British ships were fined for non-payment of customs duties by the Burmese governor of Rangoon (Yangon) in December 1851. Lord Dalhousie (1812–1860), the British Governor General of India, demanded that the fines be cancelled and a new Burmese official be installed, exerting pressure on Konbaung Myanmar by dispatching two Royal Navy ships commanded by Commodore Lambert (1795–1869). Lambert exceeded his orders and blockaded the port, leading Dalhousie to launch a pre-emptive strike

4.1

Map of the British annexation of Burma.
The borders illustrated are not an exact
representation.

and demand payment of one million rupees. The British
took control of the remaining part of Lower Myanmar,
transforming what territory remained under the Konbaung
dynasty court based at Amarapura into a landlocked
country. The war resulted in the overthrow of King Pagan
(r. 1846–53) by his half-brother, Mindon (r. 1853–78). Mindon
refused to sign any treaty that formally ceded territory and
halted hostilities. The British subsequently consolidated the
Arakan, Pegu (Bago) and Tenasserim areas into a single
province of India in the early 1860s.

Under King Mindon there were administrative reforms
in 1872–3, and some Western technologies were adopted.
However, these efforts angered conservative factions at court.
Although their attempted coup against Mindon in 1866
failed, they hampered fiscal and structural changes during
the reign of Mindon's successor, Thibaw (r. 1878–85), as
relations with Britain deteriorated.

After 1852 Myanmar under Konbaung control experienced
economic challenges caused in part by the loss of the coastal
regions and British trade restrictions, with Burmese workers
migrating to British Burma in search of better economic
opportunities. Moreover, political turmoil emerged in the
Kachin Hills to the north, and a powerful commercial faction
in Rangoon, Calcutta (Kolkata) and London pushed the
British government towards full annexation of the remaining
portion of Myanmar. Against this backdrop, Burmese–
French negotiations in the early 1880s raised concerns that
the French could use the Konbaung kingdom as a base to
threaten the security of British India's northeastern frontier.
The pretext for full annexation arose when the Burmese
government fined the Bombay Burmah Trading Company
for logging outside its contractually stipulated area. Among
the demands issued by the British India government in
Calcutta were the cancellation of the fine and the transfer of
foreign policy decisions to its authority. Although the Burmese
agreed to most of the stipulations, they refused to relinquish
sovereignty, and the British, regarding King Thibaw as a
tyrant, launched an attack in November 1885. By this time,
Britain's advances in military technology due to the Industrial

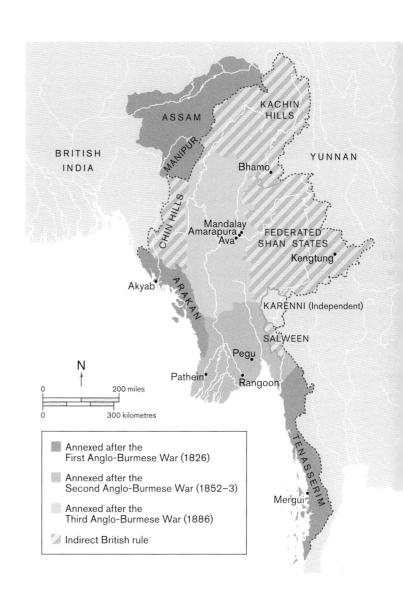

Revolution, coupled with factionalism at the Burmese court,
brought the war to a swift conclusion. Thibaw was deposed
and exiled to the city of Ratnagiri near Bombay (Mumbai) in
India, where he remained until his death at age 57 in 1916.

On 1 January 1886 the British government officially
declared the annexation of Konbaung Myanmar, and it was

4.2

Seated Buddha image, c. 1790–1824.
Probably central Myanmar. Lacquer,
wood, gold, textile, shell and *thayo*
(lacquer putty). H. 180 cm, W. 127.5 cm
(at base), D. 90 cm. British Museum,
London, 1826,0211.1. Acquired by Captain
Frederick Marryat (1792–1848) during
the First Anglo-Burmese War of 1824–6;
donated to the British Museum in 1826.

conflicts, the British implemented 'indirect rule' in the Shan
states, Chin and Kachin Hills, and other highland areas,
while designating the Karenni region as 'ungoverned' and
leaving it to the control of autonomous rulers. Under the
'indirect' system, local rulers and chiefs were allowed to retain
their positions of authority, with the British maintaining civil
order and managing foreign affairs, revenue, and resource
extraction. For instance, in the Shan states, *saohpas* (rulers)
were to administer their territories in conjunction with British
commissioners, superintendents and state judges as part of
the Shan State Council. Local chiefs were the means through
whom the colonial government exerted control. Such men
received gold medals to indicate their authority and enhance
their local status (see fig. 7.12). Despite this apparent control
on paper, it took many years of intense fighting and repression
for the British to 'pacify' the region. This lasted into the 1890s
in many areas and, in parts of the highlands, it continued into
the 1930s. Some areas only came under 'British control' as
borders were drawn around them on maps.

The acquisition of objects

The three Anglo-Burmese Wars resulted in significant looting
and the acquisition of objects. Some of the earliest Burmese
items in the British Museum came from Captain Frederick
Marryat, who amassed a collection of 173 items during the First
Anglo-Burmese War (1824–6). Marryat offered his collection to
the Museum, having reportedly spent nearly £2,000 gathering
the material. In return, he asked to be made a hereditary life
trustee of the Museum, saying, 'When it is considered that
there will never be another opportunity of obtaining the same
and that no collection of this kind exists in any other museum,
I do not think that I am very exorbitant in my demands.'[5] His
request was rejected and the collection was ultimately dispersed
to unknown locations. Marryat had already given two objects
to the museum, a large lacquer seated Buddha image (fig. 4.2)
and a stone sculpture of the Buddha's footprint acquired
during the war. The Buddha image belongs to a type found

incorporated as a province of British India, coming under
the control of a colonial Indian bureaucracy. This new
administrative arrangement proved disorienting for the
agrarian regions of Burma, which had been accustomed to
a system of governance centred around kingship and village
headmen.[4] Initially, the British considered placing a prince
on the Burmese throne under a British protectorate, but
this idea was soon discarded. Instead, the monarchy, the
Hluttaw (royal governing body), nobility and other political
and social institutions were abolished in favour of direct
rule and a parliamentary regime was established. In a
decision that would later contribute to post-independence

BURMA TO MYANMAR

4.3
Lacquer box with hinged lid, *c.* 1852.
Central or lower British Burma. Wood,
lacquer and gold. H. 10.5 cm, W. 43.4 cm,
D. 28.2 cm. British Museum, London,
2002,0204.1. Purchased from Jill
Morley Smith in 2002; funded by the
Brooke Sewell Permanent Fund.

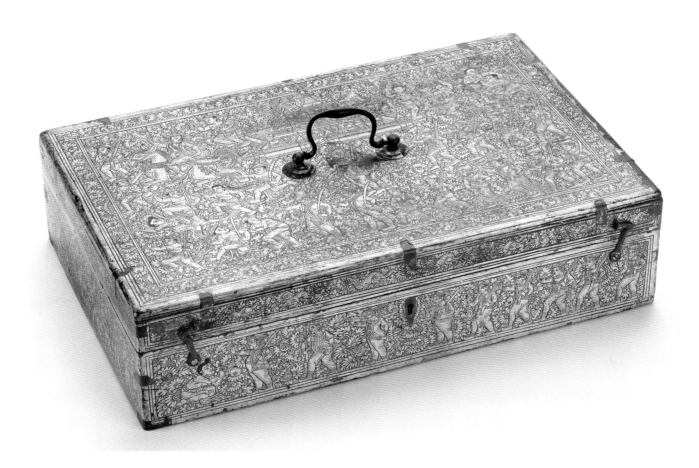

in the Shan states but often produced in the area around
Shwebo (north of Amarapura, Mandalay and Ava). They
were for sale in the Shan states from around the seventeenth
century.[6] The lengthy bulbous finial aside, the ruffled robes,
the fillet separating the forehead from the hair, and the
myrobalan (a medicinal fruit) offered to the viewer in the
figure's right hand were part of a new repertoire of Buddha
images that developed in the early nineteenth century. Their
presence therefore suggests that the image may have been
new or recently produced when obtained by Marryat.

Other collections, though not as extensive as Marryat's,
were formed as more British people began to settle in
British Burma after the second war in 1852–3. Yet, although
substantial quantities of Burmese material now reside in
British collections, in the late nineteenth and early twentieth
centuries British officials followed the latest collecting
practices and kept historical objects, such as Bagan-period
stone sculptures, in the country or sent them to the regional
headquarters in Calcutta.[7] The British also started to
commission the production of artworks, objects of use and
commemorative pieces, while Burmese craftsmen began
creating objects for a new clientele. For instance, this
box with European-style metal hinges, handle and lock
is decorated in the Burmese *shwezawa* technique of gold

4.4

Manuscript of King Thibaw being taken
into exile, 1886–94. Probably Mandalay.
Paper. H. 41 cm, W. 18 cm (each page).
The British Library, London, Or 14963,
fol. 1r. Purchased from Sam Fogg,
previously in the Stokesay Court sale
(1994), collected by Herbert Allcroft on
his visit to British Burma in 1894–5.

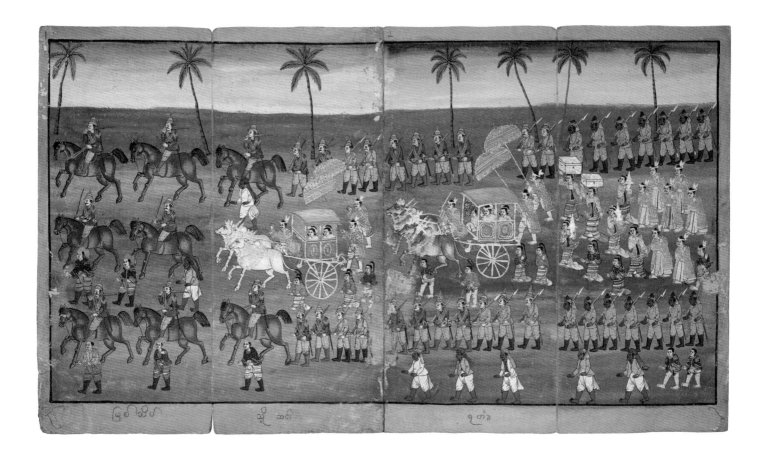

decoration on black lacquer (fig. 4.3). Tentatively linked to
the Second Anglo-Burmese War based on the depiction
of the soldiers' uniforms, the imagery on the box portrays
British troops with cannons putting Burmese fighters
to flight. The third war in 1885 had a profound impact
on the arts in British Burma, as will be discussed, but it
also prompted the production of numerous manuscripts
depicting King Thibaw's departure into exile (fig. 4.4).
That some of these manuscripts still exist in various museums
and libraries in the UK and Ireland suggests their popularity.
They vary in quality, but all show the king and queen in a
bullock-drawn carriage surrounded by British soldiers and
cavalry, some of whom are identified as Indian by their skin

colour, and followed by members of the royal retinue and
court on foot. The extent to which the manuscripts were
commemorative from the Burmese perspective or intended
to symbolise British triumph remains unclear.[8]

Following the looting and burning of the palace as
well as the destruction of the royal library in Mandalay
in November and December 1885, former members of
the Konbaung court sought to salvage and preserve royal
records and manuscripts. Literati and administrators,
who had previously worked to restructure the kingdom
to prevent its colonisation, now dedicated themselves to
ensuring that information about it was not lost forever.
Their preservation work continued for decades, with many

Manuscript showing the designs of
things in daily use in the Golden Palace,
1894. Probably Mandalay. Paper.
H. 48.5 cm, W. 21.5 cm (each page).
The British Library, London, MSS
Burmese 199, fols 48r–50r. Purchased
from Rev. A.D. Cope in 1912.

materials, including royal chronicles and legal texts, being
reproduced in printed form. In particular, U Tin, an
assistant minister, rescued thirty-five cartloads of materials
from the palace and compiled this wealth of information
into a lengthy compendium titled *The Royal Administration of
Burma*, which was published in the 1930s.[9] While the advent
of printing technology led to the decline of palm-leaf and
paper manuscripts in the early twentieth century, the older
forms of documentation were not completely discarded. The
production of white paper manuscripts (*parabaik*) continued
in the colonial period and formed part of the preservation
efforts. An example is this 1894 manuscript, which provides
visual descriptions of the objects, practices and peoples
at the late Konbaung dynasty court (fig. 4.5). It illustrates
such varied things as sumptuary law regulations governing
clothing, hairstyles, bells, weaponry, royal regalia and
religious paraphernalia and practices. It also depicts deities
and *nat* spirits, including Shiva, known as Paramithwa *nat*
(see fig. 2.24), members of the court, foreign delegations and
visitors (Chinese, Indian, Thai, European, etc.), as well as
non-native animals. Through these images, the manuscript
serves as a testament to the interactions of the Konbaung
court with the world around it. Despite efforts to preserve
such material, the loss of so many records about the
precolonial Burmese court, governance and administration
has left a significant gap in our understanding of its history.

Religion: Buddhism, Islam and Christianity

The deposition of Burma's king not only resulted in political
upheaval but also had far-reaching social and religious
ramifications. Before 1885 royal support for the Buddhist
faith and its institutions extended even to those regions
annexed by the British. In a climate of weakening political
control, displays of piety and acts of charity played a
crucial role in bolstering the king's legitimacy. To this end,
in the late 1850s King Mindon constructed a new capital
city, Mandalay, that symbolically represented a Buddhist

4.6
Standing Buddha offering a myrobalan
fruit, c. 1850–99. Probably central
British Burma. Wood, lacquer, gold and
glass. H. 100 cm, W. 46 cm, D. 19 cm.
British Museum, London, 1923,0305.1.
Donated by Mrs Ballantine in 1923,
collected by Capt. James Edgar
Ballantine of the Irrawaddy Flotilla
Company.

sanctuary capable of extending its protective powers even to former royal subjects residing in annexed areas. This was a change from previous royal construction projects in which the primary goal was to reproduce the cosmic order visually.[10] Furthermore, in 1871 King Mindon hosted a Buddhist synod (religious assembly) for monks, including from British-held regions, Siam (Thailand) and Sri Lanka. At the same time, he replaced the *hti* finial on top of the most sacred Burmese site, the Shwedagon stupa in Rangoon (see fig. 1.17), despite its location within British-controlled territory. These major events were complemented by various other actions, such as the prohibition of hunting animals along the lower Chindwin River, reflecting the king's religious obligations to safeguard living beings.[11]

However, after 1885, with the monarchy no longer fulfilling its role as the primary promoter and protector of Buddhism, religious and social dynamics underwent substantial changes. When the Supreme Patriarch of the Sangha (the leader of the Buddhist religion in Burma) died in 1895, the absence of a successor appointment resulted in factionalism and religious disputes. Buddhism and kingship had been deeply intertwined and mutually reinforcing for more than a millennium, and the dissolution of the latter, combined with the British policy of non-intervention in religious affairs, transformed how the Burmese engaged with Buddhism.[12] One such shift came from the teachings of the monk Ledi Sayadaw, who advocated the practice of meditation and mindfulness for all, not solely monks. His teachings spread to India and eventually the Western world, becoming the source of the modern mindfulness movement.[13]

Yet, the nineteenth century was also a period of change within the world of Theravada Buddhism itself, both inside and outside Burma. Earlier trends of religious centralisation and increasing orthodoxy, with strict interpretations of the Pali Canon and close adherence to the rules of self-discipline, accelerated. These developments were not unique to Burma but also occurred concurrently in Sri Lanka, Thailand and elsewhere.[14] In keeping with the increasing orthodoxy of the time, there was a major

4.7

Reclining Buddha image, *c.* 1850–90.
Central or lower British Burma. Bronze
and glass. H. 18.9 cm, W. 68.6 cm,
D. 30.7 cm. British Museum, London,
1891,0225.1. Purchased from Joseph
Aggas in 1891.

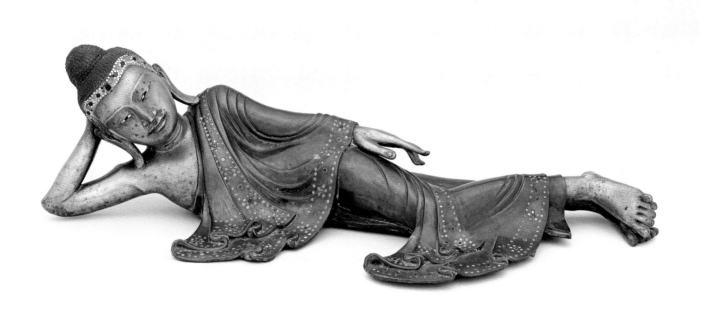

shift in the stylistic representation of the robes, features, hand gestures and body positions of Buddha images. In Burma, elaborate ribbons and ornate thrones were phased out in favour of a more naturalistic depiction known as the Mandalay type (figs 4.6–4.7). These images displayed full faces with relatively straight eyebrows, with the elongated earlobes remaining as a vestige of the heavy earrings worn during the Buddha's early life as a prince. A thick decorated fillet separated the forehead from the hair, and the *ushnisha* (cranial bump), symbolising the Buddha's wisdom, took on a large rounded form without a finial. The robes were no longer smooth but were portrayed with extensive folds edged with inlaid coloured glass or gems. Some of these images depicted the Buddha offering the devotee a myrobalan, symbolising the healing powers of his teachings. Prior to the nineteenth century, seated images predominated, but during this period of innovation, standing and reclining postures became more

prevalent, alluding to events in the Buddha's life beyond his awakening.[15]

Buddhism also became an arena of resistance against British rule. At Buddhist sites, it is the custom to remove shoes as a sign of respect. However, from the outset of colonial rule in 1826, the British authorities declared that they would not adhere to this practice, partly due to the presence of military troops stationed at such locations, such as the Shwedagon in Rangoon. An aquatint from a series illustrating the First Anglo-Burmese War by British lieutenant Joseph Moore depicts a soldier in military attire, wearing boots, standing in front of a Buddha image at the Shwedagon (fig. 4.8). Although most religious temples and stupas were returned to Burmese management by the 1890s, the Burmese tolerated the footwear practices of Westerners until the early twentieth century when Buddhist monks began challenging individuals wearing shoes at sacred sites. Signs indicating that Europeans were exempt from removing

Drawn by J.Moore. Pub.d Nov.y 1st 1805 by Kingsbury & C.o Leadenhall Street and Tho.s Ost, 10 Ludgate Hill London. Engraved by G.Vivar.

Inside View of the GOLD TEMPLE *on the Terrace of the* GREAT DAGON PAGODA *at* RANGOON.

their shoes gradually disappeared. Under pressure from the press and nationalists, the British colonial government finally agreed to eliminate the Western exemption in 1919. While the 'shoe question' was couched within the broader context of defending Buddhism and preserving the integrity of the Buddha's teachings, for nationalists British concessions came to symbolise the erosion of colonial control.[16]

Most Westerners disdained the practices of contemporary Buddhism. However, their interest in texts and written materials led to the collection of Buddhist books and manuscripts, often with the assistance of missionaries. The focus was on acquiring what was considered to be the 'original' Buddhism, free from what they perceived as the 'corrupted' practices of the present. In Burma, paper

(*parabaik*), palm-leaf (*pei-sa*) and lacquered (*kammawasa*) manuscripts were collected in considerable quantities. One exceptional *kammawasa* is beautifully wrapped in a regionally printed cotton cloth and bound with a locally produced binding tape (*sazigyo*) that is inscribed with religious texts and images. Dated to 1792, the manuscript's first and last pages are covered in intricate designs based on Indian trade textile patterns in gold leaf (fig. 4.9). Its arrival in Britain shortly after its production testifies to the European interest in Burmese Buddhist manuscripts.

However, alongside Buddhism, there were other religions present in Burma, including Islam, Judaism, Hinduism, Christianity and animism. During his reign, King Mindon made efforts to promote religious tolerance. For instance, he

4.8 *opposite*
George Hunt after Joseph Moore, *Inside View of the Gold Temple on the Terrace of the Great Dagon Pagoda at Rangoon*, 1825. Hand-coloured aquatint with etching. H. 33 cm, W. 42.6 cm. British Museum, London, 1872,0608.208. Published by Thomas Clay in London; purchased from Nathaniel Thomas Wetherell in 1872.

4.9
Kammawasa manuscript and Indian textile wrapper, 1792. Central or lower Myanmar. Lacquer, gold, cotton, wood and bamboo. H. 9.5 cm, W. 54 cm. Royal Asiatic Society of Great Britain and Ireland, Burmese 86. Acquired in the 19th century, donor unknown.

allowed the construction of mosques in Mandalay during the 1860s and even donated a resthouse to Mecca.[17] He also sent letters to the Ottoman empire in the late 1850s and late 1860s, with one dated to 1869, still preserved in the Ottoman archives, expressing a desire to foster friendly relations between the two nations. When a chief minister and leading reformer, the Kinwun Mingyi U Kaung, was sent on a mission to Europe in 1872, he stopped in the Middle East and received a warm welcome from the Ottoman viceroy in Cairo.[18] King Mindon also granted permission and sometimes paid for the construction of Christian churches and schools, though restrictions remained on the distribution of Christian tracts and active conversion of Buddhists. These permissions were partly aimed at securing political

assistance from the missionaries, and in 1857 an American Baptist named Dr Kincade was sent on a diplomatic trip to meet with President Buchanan of the United States. However, such diplomatic efforts generally failed to gather support for Burma against British encroachment.

Christian missionaries had been visiting Myanmar since the seventeenth century, but the first sustained effort came from the Americans Ann and Adoniram Judson, who arrived in Rangoon in July 1813. While Christianity, in its Catholic, Anglican or Protestant forms, never gained much popularity among Buddhists, certain groups such as the Kachin, Karen and Chin responded with greater enthusiasm. Yet, conversions among many of these communities accelerated substantially only after the churches came under local control

following the expulsion of foreign missionaries in 1966. The translation of the Bible into vernacular languages played a vital role in facilitating conversions, with Adoniram Judson producing the first Burmese version of the Bible in 1834 and a Burmese–English dictionary that was nearly complete at the time of his death in 1850. Mission schools were also established to promote Christianity by providing a Western education that would help students navigate the colonial environment and advance themselves. The American mission was instrumental in developing scripts for several Southeast Asian languages, such as the Sgaw Karen script devised by

the American Baptist missionary Jonathan Wade in 1832, the Asho Chin script in 1865 by the Pwo Karen mission and the Jinghpaw Kachin script in 1877 by the Baptist Josiah Nelson and Karen evangelists.[19] This led to the publication of Bibles and other religious and secular materials, with missionaries importing printing presses and developing suitable typefaces to produce religious literature in these languages. The American Mission Press, established by Judson in Rangoon in 1816, published the Bible, catechisms, dictionaries, school textbooks and the *Maulmein Almanac and Directory*.[20] One publication utilising the newly established Karen script was the 1843 New Testament printed by the Karen Mission Press, which had been established in Tavoy (Dawei) (fig. 4.10). A Sgaw Karen hymn book was published in Moulmein (Mawlamyine) in 1845. The missionaries were pleased with the conversion rates among the region's non-Buddhist peoples. However, while sharing a religion with the colonial regime empowered these communities, it also further divided them from Burman Buddhists, which became a contributing factor to post-independence strife.[21]

New materials, designs and patterns across the region

As noted earlier, King Mindon made significant efforts to modernise and strengthen his kingdom by introducing reforms in political institutions, military capabilities, communication systems and industrial development. His aim was to align Konbaung Myanmar with European systems so as to prevent its demise.[22] In material terms, Mindon ordered the establishment of a number of factories in the Mandalay area during the late 1850s and early 1860s. These factories produced such items as lac (a natural dye from an insect), cutch (a tree extract used in food production and dyeing), sugar, cotton, indigo, glass and silk.[23] In addition, new sawmills, rice and sugar mills, an iron foundry, an arsenal and a mint were established.[24] To oversee these developments, new governmental positions were created, such as the minister of glass factories, known

4.11
Glass mosaic surround, *c.* 1870s–90s.
Wood, lacquer and glass. H. 180 cm,
W. 127 cm, D. 13.5 cm. Russell-Cotes
Art Gallery & Museum, Bournemouth,
T11.7.2005.15. Unknown acquisition
date, likely to be the late 19th or early
20th century when Merton Russell-
Cotes built East Cliff House for his wife
and they assembled the contents.

as 'Pangyet Wun'. Burmese students, mostly the sons of noble families, were sent abroad to receive training in various technologies such as iron and glassworking. In 1872–3, the Kinwun Mingyi U Kaung travelled to Europe with other members of the court, visiting France, Italy and Britain, including Scotland, Ireland and the industrial north, where the entourage visited factories, among other sites. Foreign engineers, architects and other experts were also employed in Mandalay. Unfortunately, many of these endeavours cost vast sums of money without yielding significant returns.[25]

However, the focus on technological advancements had cultural implications. Glass mosaics, for instance, replaced wall paintings in temples and religious complexes, and became a standard inlay material on the new Mandalay-style Buddha images as well as on large lacquer items ranging from clothes containers (*bi-it*) to *sadaik* (the chests used to store manuscripts in monastic libraries), *hsun-ok* offering vessels and Qur'an boxes (see fig. 3.14). Glass mosaics were also used to embellish elaborate surrounds, as can be seen in this example (fig. 4.11). Typically attached to a monk's raised preaching plinth or placed behind a Buddha image, this surround is made of lacquered and gilded wood and inlaid with pieces of clear and red glass mirrors and cut red glass. The geometric arrangements of the glass mosaic replicate floral Indian trade textile patterns and the flame-like foliate design known in Thailand and Myanmar since the Bagan period, which experienced a resurgence in popularity in Burmese art after the sacking of Ayutthaya in 1767.

Other new materials included synthetic dyes and fibres, which began to replace cotton, bast fibres and natural dyes such as indigo, madder and gamboge (see chapter 5) during the latter half of the nineteenth century. These new materials reached highland regions through a network of rotating markets among a cluster of towns, where each village had its own market day, carefully planned to avoid clashing with nearby villages and towns. People from varying ethnic groups from the surrounding areas would gather at these markets, exchanging goods, information and

news.[26] In this way, new materials and techniques diffused rapidly throughout the region, indicating that areas now considered remote were once closely integrated with global trade. Silver too moved around, as it was widely used for jewellery and sewn onto clothing by various communities across Asia as a means to store and display wealth. With the British presence in Burma, silver coins from British India started circulating in the region. This necklace that once belonged to a Chin woman is made of eighty-eight quarter-rupee coins issued by the British Indian government between 1910 and 1936 (fig. 4.12). Each coin, which bears the

4.12
Necklace with quarter-rupee coins,
c. 1910–36. Chin Hills. Silver, wool and
cotton. L. 77.5 cm. British Museum,
London, As1948,07.21. Acquired by
David Hay-Neave, a captain in the Indian
army during the Second World War;
donated in 1948.

and coarse muslins come from India ... Kachins can buy the cheap red German flannel which ornament their jackets ... German silks and velvets, shirts and woven undergarments, knitted caps for children ... all these articles, and many others, made, manufactured, and exported from Germany, fill the Shan markets and pass through the country in the packs of merchants on their way to Yün-nan.[27]

As European goods increasingly filled the Burmese market, small-scale producers struggled to compete with the imports. In 1907 E.N. Bell commented on the plight of blacksmiths in Burma, noting their poor prospects when confronted with foreign products. Bell emphasised that 'the individualistic arts that aim at utility alone cannot survive like those of the silversmith or wood carver where the individuality of the artist counts for something'.[28]

When King Thibaw was deposed in 1885 and the royal court and elite were abolished, the primary patronage of literature, music and various forms of artistic production ceased to exist. Consequently, artists had to seek alternative markets for their creations. This shift was partly encouraged by the emergence of a new clientele and increased exposure to the diverse range of goods available through the British empire's networks. It was also a result of the British emphasis on arts and industry, which led to the participation of Burmese artists in international exhibitions and world fairs, including the Calcutta Exhibition of 1883, the Colonial and Indian Exhibition in London in 1886, the Paris World Exposition of 1900, the Delhi Durbar in honour of King Edward VII in 1903, and the British Empire Exhibition at Wembley, London, in 1924. For these exhibitions, a collection of materials considered representative of various provinces of the empire was sent, ranging from architectural samples, silverwork, textiles and utilitarian items to raw materials such as gems and timber. From 1883 into the early twentieth century, the responsibility for co-ordinating exhibits was given to H.L. Tilly, who wrote several books and articles on Burmese art, including *Glass Mosaics of Burma* (1901), *Silverwork of Burma* (1902) and *Wood-Carving of Burma* (1903).

image of King George V, is made of 91.7 per cent pure silver and weighs 2.92 grams for a total of about 256 grams.

Manufactured goods traversed large distances along these market routes. Despite the British colonial presence, many goods in the early twentieth century originated in Germany and other countries, to the point where anthropologist and author Leslie Milne complained that:

There are practically no articles of British manufacture in the country districts of the Northern Shan States ... Shoes and matches come from Japan ... Silks for embroidery, tinsel-thread, small porcelain bowls, copper cooking-pots, and brass lamps ... are of Chinese manufacture. Cotton goods

Local exhibitions and competitions were also established by Tilly in 1885 and continued until the 1930s, showcasing silverwork, ivory carving, wood carving and other arts, and shifting to include raw materials over time. In 1913 Tilly wrote:

A competition for all the craftsmen in Burma is held annually in Rangoon and prizes are only given to exhibits of Burmese design, good work obtaining a ready sale there at very good prices. The workmen are graded, so that every man competes with his equals and has a chance. The prize-winners are promoted into the next higher grade after each competition. The Provincial Art Competition is now firmly established, and anyone who requires really good Burmese work can obtain it by writing to the officer in charge. The influence so exerted is felt all over the country, for many of the Municipalities help the local men to compete and send them to Rangoon to learn what they can. Moreover, most of the curio shops in Rangoon employ the same workmen and occasionally compete themselves, so that the artistic standard is much higher than is generally the case.[29]

The curio shops mentioned by Tilly sprang up all over the country from an early date, as did foreign and later Burmese workshops for all types of goods. S. Oppenheimer

4.14
Ewer and stand, *c.* 1834. Central or lower
Myanmar. Silver. H. 35 cm, W. 26 cm (ewer,
without handle); H. 4.2 cm, Diam. 34 cm
(stand). The Royal Collection / HM King
Charles III, RCIN 2403175. Presented
by Lord William Bentinck to William IV
in 1836.

& Co. was founded in 1885, dealing in a range of goods
from military equipment to iron and brass wares and
wine. S.C. Coombes Company Ltd advertised itself in part
as a manufacturing silversmith, while P. Orr and Sons
were jewellers and silversmiths. One of the most famous
silversmiths was Maung Shwe Yon (d. 1889), whose three
sons followed him into the trade, opening a shop at 29
Godwin Road in Rangoon in the late nineteenth century.
Other companies contributing to the availability of goods
on the market included Burma Industries Ltd and travel
photographer Felice Beato, who opened two stores selling
Burmese arts and crafts in the late 1880s, one in Rangoon
and the other in Mandalay (see fig. 0.5).

Such shops in Burma sold a range of objects from
brushes, visiting-card cases, whist boxes, napkin-rings and
menu holders to small containers, cutlery and bowls.[30]
Models, fans and furniture were also popular. Some objects
were manufactured elsewhere, imported, and decorated
in Burma, as with this painted fan (fig. 4.13). The fan
features a Japanese painted landscape on one side, while
the other side depicts scenes from the Vessantara Jataka,
one of the tales of the Buddha's previous lives that tells the
story of Prince Vessantara, who perfected the virtue of
generosity on his long path to Buddhahood. The layout of
episodes from the story in two strips follows long-standing
Burmese conventions for organising narratives, as seen in
manuscripts and wall paintings.[31] Although the folding
shape of fans originated in East Asia and was adopted by
Europeans in the sixteenth century, it was not widely used
in Burma until the colonial period, when it was primarily
produced for foreign consumption.

Silver was an important facet of European consumerism
and display in the nineteenth and early twentieth centuries,
and Burmese silver was readily acquired. The increased
demand for it brought about changes in Burmese silver
production. For example, in 1836 Lord William Bentinck
presented William IV with this Burmese silver ewer and
stand (fig. 4.14). The ewer is covered with dense geometric
and floral patterns, with cartouches containing the twelve

signs of the zodiac encircling its middle, a typical design
arrangement at the time, as noted by Henry Yule during his
visit to Burma in 1855.[32] The stand, with its European-style
paw feet, displays similar floral, animal and geometric
patterning surrounding a central medallion with the British
royal coat of arms. The low relief was a characteristic feature
of early nineteenth-century Burmese silverwork. However,
apparently due to European demand, high-relief imagery
emerged in the 1860s and became increasingly pronounced
from the 1870s onwards.[33] Cast three-dimensional figures
also became common. Elaborate centrepieces and
presentation plates were regularly produced for Europeans,
evident from the numerous examples in public and private
collections today. Some of these pieces were created for
competitions associated with international exhibitions, such
as the Delhi Durbar, where several Burmese silversmiths
received recognition for their work, including Maung Yin
Maung (awarded first prize with a gold medal for a silver

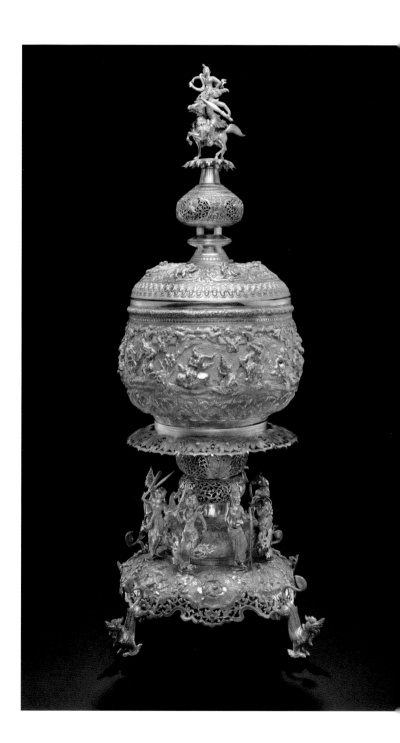

4.15
Maung Yin Maung, Table centrepiece
with scenes from the Ramayana,
c. 1890–1910. Rangoon (Yangon).
Silver. H.80 cm, Diam. 29.5 cm (max.).
Victoria and Albert Museum, London,
IS.19-1971. Bequest from Mrs C.C.
Jeffery in 1971.

centrepiece), Maung Po Kin (awarded first prize with a
silver medal for a bowl) and Maung Kyi Maung (awarded
second prize with a silver medal for a bowl and stand).[34]
Large platters embellished with extensive decoration and
elaborate covered bowls and boxes with domed footed
stands, baluster stems and claw feet were European features
that became recognisable elements of Burmese design for
the Western market (fig. 4.15).

From the late nineteenth century, silverwork in Burma
blended Burmese and European motifs and imagery.
Common Burmese elements included lotus patterns,
narrative scenes from the Ramayana epic and Buddhist
jataka tales, and decorative borders comprised of floral and
geometric bands of varying widths. Depictions of hunting big
game, such as lions, tigers, boar and deer, on horseback or
elephant-back with local assistance – a major pastime during
colonial times – were also common in art catering to British
tastes (fig. 4.16). However, the main European contribution
in terms of patterns was the acanthus. Found in ancient
Greek art and widely used in European art, the acanthus is
typically depicted as a serrated leaf, but in Burma it became
a popular basis for extensive invention.[35] The circulation of
such imagery in the central and southern regions occurred
through various channels, including copybooks, publications
like Tilly's (who claimed that his book on silverwork aimed
to assist Burmese silversmiths and that many used it in
translation), and opportunities to observe other works
through exhibitions and competitions.[36] Additionally, the
promotion of artists by colonial officials played a role in
dispersing new patterns and design arrangements.

Innovation was not limited to silver production but
extended to a variety of goods as well. European-style
furniture was crafted to cater to both foreign and local
markets. Reputedly made for King Thibaw in the 1880s,
this ivory chair, now housed at the World Museum,
Liverpool, exemplifies this trend (fig. 4.17). The chair
features a backrest and arms, a form that only became
prevalent in Burma during the colonial period. It is
intricately carved in high relief with the floral tendrils

4.16
Presentation plate with hunting scenes,
c. 1890–1910s. Probably lower British
Burma. Silver. Diam. 56 cm. Honeybill
Collection. Purchased from Michael
Backman Ltd in 2014.

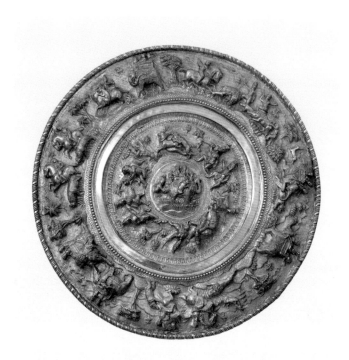

commonly seen in Burmese wood carving and which were also illustrated on silver and lacquer objects.

Over time, new elements became part of what the British considered traditional Burmese silver design. American anthropologist Bernard Cohn wrote: 'The power to define the nature of the past and establish priorities in the creation of a monumental record of a civilisation, and to propound canons of taste, are among the most significant instrumentalities of rulership.'[37] Colonial writings, such as Tilly's volumes, demonstrated attempts to guide the products of Burmese artists and craftsmen. Alongside the expansion of cultural control, there was a strong commercial aspect to these new creations, as can be seen in the annual reports of the Superintendent of Cottage Industries (Burma), where W. Grahame wrote:

It would be a great advantage to the Province if there were some dépôt in Rangoon where well-finished articles could be kept for inspection and purchase, as well as raw products and articles in various stages of completion. Not only would this benefit Burmese Craftsmen, but would be a boon to Visitors who often do not know where to go to learn what art handicrafts are obtainable. From time to time also Visitors come who are interested in art handicrafts from a commercial point of view, and might do something to develop trade in such articles if they could see a fairly comprehensive collection of articles in a short time, and could also learn something of how they are made.[38]

It was important that Burmese art and other productions aligned with international trade systems. In the annual Department of Cottage Industries reports, there was a section titled 'Important Industrial Enquiries' filled with such information as the following:

The Punjab asked for a set of lacquer articles as samples … the Star Trading Company, Bombay enquired about the Handloom Factories in Burma … a cabinet of figures representing (1) a scene from the old Burmese Court showing the dresses and manners of that time, and (2) scenes of present day life showing modern dress and manners, was sent to a prominent gentleman in Washington (D.C.), U.S.A. These figures were made by a Burmese Princess, a granddaughter of King Mindon, which enhanced the interest of the collection. … About £100 worth of samples of Burmese artware sent to some five dealers in Australia, in response to orders received. … A number of Burmese and Shan articles were sent to a firm in Singapore in compliance with a requisition.[39]

The focus of the Burmese Department of Cottage Industries was upon textiles, ceramics and lacquer, with the Saunders Weaving Institute established in Amarapura in 1914, as well as textile schools in Sagu and Myinmu from the 1920s, and the Government Lacquer School at Bagan in 1923.[40] Various pottery initiatives took place in Pyinmana,

4.17
Carved ivory chair, c. 1880–5. Probably Mandalay. Ivory and fabric. H. 92 cm, W. 59 cm, D. 61 cm. National Museums Liverpool, World Museum, 56.115. Probably taken from Mandalay Palace; acquired from a Rangoon merchant by Dr Barnardo, who sold it at a Red Cross auction in 1892; purchased by Mr MacAndrew; sold for the Red Cross through Christie's in 1914 to benefit the war effort and purchased by Mr MacAndrew's son; donated for safekeeping in 1941 to the Natural History Museum, London, which gave it to the Liverpool Museum later in the Second World War.

Shwegu, Gyogon and Loilem (Shan State), including efforts to get Burmese ceramicists to replicate ancient Greek pottery.[41] In the 1928 annual cottage industry report, it was recorded that the Deputy Commissioner of Bassein (Pathein) had sought advice on improving ceramic production methods and developing an export trade for locally made umbrellas.[42] The suitability of Mergui sand for glassmaking led to the establishment of a glass factory in 1925, with the assistance of a Japanese expert.[43] While outlets were sought for Burmese silk, it was not as popular as other goods. Burmese products can still be found today in markets in India, the UK and other parts of the world, serving as mementos of such colonial craft and industry projects.

Burmese lacquer proved popular in the international market, and it was recommended in the 1925 annual cottage industry report that any patterns or designs that could make the wares more attractive to outside markets should be adopted.[44] Lacquer samples from Chiang Mai in northern Thailand were brought to the Bagan school, and the workers adopted the patterns, although not the colours, except for a silver grey, and by 1925, numerous items featured such leafy scroll designs. According to the report, these introductions aimed to improve design and finish, secure better prices and access a wider market.[45] Another notable development was the introduction of signed pieces, reflecting the importance of authorship in Western contexts. This addition helped make lacquer, silver and other products more appealing to the Western market.

The British lack of interest in Burmese art for reasons beyond commercial and monetary value is partially visible in their archaeological and museum work. It was not until 1899 that an archaeology department was founded, and there was no government-funded major museum dedicated to the preservation and display of Burmese art.[46] Instead, site museums like those in Pyay and Bagan were created to house archaeological materials unearthed during excavations. The establishment of a school of art and music did not occur until 1930, further highlighting the limited support for artistic endeavours. Consequently, monastery

4.18
Ko Bo Yu, Tiffin food box, c. 1900–39.
Kyaukka, Sagaing region. Lacquer and
wood. H. 32.6 cm, Diam. 14.1 cm. British
Museum, London, 1998,0723.221.
Donated by Ralph H. Isaacs (director
of the British Council, Myanmar) and
Ruth Isaacs in 1998; acquired in Yangon
in 1993.

collections, formed over generations through donations, became the primary sites for the preservation of some aspects of Burmese art and may prove to have played a crucial role in safeguarding cultural heritage through the turbulent nineteenth, twentieth and twenty-first centuries.

Ethnicity, new communities and the census

From 1862 Rangoon emerged as the administrative centre of British Burma. Serving as a major export point, the city experienced a rapid influx of merchants and labourers from various British colonies and beyond. The scale of immigration was so vast that it reportedly surpassed that of New York City. While in 1872, two-thirds of Rangoon's population was Burmese, by 1937 this ratio had reversed, with non-Burmese residents comprising two-thirds of the city's population. Most of the immigrants came from southeastern India and southeastern China.[47] While some arrived as temporary labourers, others settled permanently but maintained ties to their home regions.

The British actively encouraged immigration, as they viewed the Burmans as backward, lazy and commercially incompetent and found it preferable to employ immigrant labourers who would not only accept lower wages compared to their Burmese counterparts but often already possessed skills acquired through interactions with British systems in their home countries. Eventually, the Chinese community came to dominate the construction industry and gold trade, Brahmin Hindus found employment in the financial departments of British companies, Tamils secured clerical positions, and individuals from various regions of India laboured in fields, mills and transportation. British Indian companies already established in South Asia expanded into the newly formed Burmese province.[48] The commercial and political dominance by foreigners, especially in Rangoon, is evident in a 1910 publication listing Rangoon companies, where proprietors are primarily Indian, British and Chinese, with only a few Burmans.[49]

Although Indians and Chinese had been present in Myanmar for long periods, some as traders and miners, their numbers before the British arrived were relatively small. The rapid expansion of these communities during the colonial period spurred Burmese artists and craftsmen to develop specific goods catering to their needs. For instance, tiered tiffin boxes – a design originating in India to facilitate the transportation of home-cooked meals to workplaces – began to be produced at Burmese lacquer centres.[50] This example, made in Kyaukka in central Burma, is of a sturdy red and black lacquer (fig. 4.18). Eventually, these containers were adopted by Burmese workers, too. Yet, goods produced for the Indian

4.19
Plate depicting M.K. 'Mahatma' Gandhi,
1930s. Central or lower British Burma.
Bamboo, lacquer and gold. H. 1.5 cm,
Diam. 15.2 cm. British Museum, London,
2001,0612.1. Purchased from Joss
Graham Oriental Textiles in 2001.

community were not only practical. After Mahatma Gandhi's visit to Burma in 1929, when it was still part of British India, a series of *shwezawa* plates was created, some featuring Tamil inscriptions of Gandhi's aphorisms, commemorating the event (fig. 4.19). Lacquer objects also depicted the portrait of Pandit Nehru, India's first prime minister, after he visited Burma.

The British reliance on Indians in administrative roles, and the promotion of Indians as well as communities such as the Karen and Kachin in defence, marginalised the Buddhist Burman community and fuelled a sense of disenfranchisement.[51] In 1930 anti-Indian riots erupted, resulting in the loss of hundreds of lives. The influx of diverse populations from various parts of Asia and Europe, many of whom did not practise Buddhism, also led in the early twentieth century to the association of anti-colonialism with the preservation of Burman culture and Buddhism and the developments of new concepts of ethnicity. The British policy of privileging access to power and economic opportunities to some groups – particularly the local Karen, Kachin and Chin, in addition to Indians – resulted in the emergence of a nationalism based on Buddhism and Burman ethnicity versus non-Buddhists and other ethnicities. Rivalry stemming from ethnicity and religion was not a major feature of Burmese societies historically.

While King Alaungpaya (r. 1752–60), the founder of the Konbaung dynasty, had employed the idea of shared ethnic identity as a rallying cry to bring together disparate regions into a single kingdom, this notion was not based on blood ties but on cultural practices, language, religion and other criteria that flexibly allowed for assimilation.[52] As historian Michael Charney has written: 'In many spheres of Burmese life, identities and identifications that were fluid, syncretic, multiple, or even undefined were common. Whether in terms of religion, ethnicity, or culture, it was not unusual for an individual or a group to change their self-identifications in different contexts.'[53] For instance, when King Bagyidaw (r. 1819–37) learned that some Burmans had been converted to Christianity by Adoniram Judson, he asked, 'Are they real Burmans? Do they dress like other

Burmans?'[54] The reverse could also be true. Individuals who dressed as Burmans and spoke Burmese did not necessarily view themselves as such if their ancestry traced back to the various populations relocated during times of war.[55]

Ethnicity was therefore not rigid, and its interpretation differed significantly from the exclusive perspective of Europeans. In particular, it was not a method of structuring inclusion or exclusion in local societies. With the advent of colonialism, this situation began to change due to several factors. How Burma was ruled during the colonial period emphasised the divisions between the different parts of what now constitutes modern Myanmar. Upper and Lower Burma and Arakan were ruled directly by British colonial administrative structures. In contrast, the hill regions were ruled 'indirectly', allowing local rulers to retain power under the condition of signing treaties, paying tribute

4.20
Album depicting hill groups and animals
from eastern Burma, *c.* 1900–10.
Probably Kengtung (Kyaingtong), Shan
states. Paper. H. 34 cm, W. 22 cm
(page). Cambridge University Library,
Scott LL4.153. Given to J.G. Scott,
superintendent of the northern Shan
states, before 1910 by the *saohpa* of
Kengtung. Donated to the library in 1934.

to the British, adhering to specific British standards of
governance, and granting the British rights over forests
and minerals. The majority of the Shan, Chin, Karenni and
Kachin regions were ruled as semi-autonomous areas
that were financially and administratively separate from
British Burma. These territorial divisions were reinforced
by European scholarship on Burmese history, which
reinterpreted historical conflicts and power struggles
as ethnic strife between the Mons, Shans, Burmans,
Arakanese and so forth.[56] The situation was further
solidified through the implementation of a census by the
British colonial authorities.

While the royal courts had conducted surveys of their
lands for tax and mobilisation purposes, the British census,
initiated in 1872 and carried out approximately every ten
years from 1881 to 1931, recorded detailed information about
people, ranging from occupation to language, religion and
ethnicity.[57] However, the reliance on single, unqualified
answers in censuses resulted in an inaccurate portrayal of
the country, as many individuals had multiple occupations,
among other complexities. Moreover, it divided people based
on generalised notions of ethnicity, overlooking the intricate
and multifaceted relationships among Karen, Kachin, Chin,
Karenni, Burmans and other groups. The categorisations
imposed by the census were based on misunderstood
Indigenous sources, new European linguistic theories and
the foreign idea of a rigid connection between people
and territory. These simplifications failed to capture the
dynamic nature of language, dress, customs and the frequent
migration of individuals when leaders opportunistically
expanded their spheres of influence. As James Henry Green
wrote in the 1931 census:

> Some of the races or tribes in Burma change their language
> almost as often as they change their clothes. Languages are
> changed by conquest, by absorption, by isolation and by a
> general tendency to adopt the language of a neighbour who
> is considered to belong to a more powerful, more numerous,
> or more advanced race or tribe.[58]

Furthermore, the census did not differentiate among the
diverse historical backgrounds of the individuals classified as
Burman-Buddhist, despite many being descendants of captives
and migrants from surrounding regions such as Ayutthaya,
Lan Na, Vientiane (Lan Xang, now Laos), Arakan, Sipsong
Panna in Yunnan (China), the Shan regions and so forth.[59]

4.21

Maung Nyun (attrib.), Figures,
mid-1940s. Mongnai, Shan states.
Wood. H. 16.8–17 cm, W. 5.7–6.5 cm,
D. 6.5–7.4 cm. British Museum, London,
2022,3020.1–13. Acquired by Reginald
Dorman-Smith while governor of
Burma (1941–6); donated to the Royal
Hampshire Regiment Museum in 1975;
donated to the British Museum in 2022.

With the dissolution of the social hierarchy encapsulated by the royal family, nobility and elite in 1885, colonial Burma became a 'rural, egalitarian society' characterised by new divisions based on ethnicity rather than class.[60]

Portraying people

One of the main ways that ethnicity was ascribed during the colonial period was through the classification of clothing, often based on missionary descriptions. Missionaries and others amassed extensive collections of textiles, which were displayed in world fairs and deposited in museums.[61] The ethnicisation of Burma found artistic representation in wooden figures, painted books and photography, all elements of the material culture of empire. Books portrayed the multitude of ethnic groups within the region in new, simplified categories. Such images usually portrayed a man and a woman, occasionally accompanied by a child, labelled

with their ethnic name, sometimes in multiple languages.[62] Their attire was shown in moderate detail, and they were sometimes depicted holding or using artefacts associated with their cultural practices. These albums of peoples were not only made for British consumption but were also occasionally exchanged as gifts, such as this volume given by the *saohpa* of Kengtung in the Shan states to J.G. Scott, the British superintendent for the northern Shan states (fig. 4.20).

The standardisation of ethnic groups was also reflected in the sale of small wooden figures in curio shops. Beato's mail-order catalogues served as a means of distributing the newly essentialised and pigeonholed categories of the local peoples. For example, one of his 1903 catalogues advertises: 'Wooden carved and painted figures of Burmans, Shans, Kachins, Hpoongies [monks], Nun, Burmese Officer, Soldier and King Theebaw, and Soopayalat [Thibaw's wife], 9 inches high. Price Rs. 3 each' (see fig. 0.7 for a similar page). Such figures were a means of capturing a sense of the country and people for a Western audience, as

4.22 *left*
Carte de visite showing a Burmese carpenter,
photographed by August Sachtler, *c.* 1865. Printed by
C. Dammann. Hamburg, Germany. Paper. H. 10.1 cm,
W. 6.3 cm. British Museum, London, Oc,A3.98.

4.23 *below*
D.A. Ahuja, Postcard showing a Burmese woman rolling
cheroots, 1900–20. Rangoon (Yangon). Printed paper.
H. 8.8 cm, W. 13.7 cm. British Museum, London,
EPH-ME.5022. Purchased from Bella Bennett, a
postcard dealer, in 2015.

4.24 *opposite*
Tray with *wunthanu* patriotic inscription,
1920s–30s. Lacquer and bamboo.
Diam. 45.7 cm. British Museum, London,
1999,0301.2. Purchased via the Brooke
Sewell Permanent Fund in 1999 from
Elephant House, a Bangkok-based
Burmese lacquer shop run by Cherie
Aung Khin.

A Burmese Woman making Cigars.

can be observed with the examples collected by Reginald
Dorman-Smith, the governor of Burma from 1941 to 1946
(fig. 4.21). In this collection, each figure is labelled with the
name of the ethnic group in Burmese and sometimes
the gender of the person. They include a Chinese-Shan
woman, a Kachin woman, a Red Karen man and woman,
a Palaung woman, a Taungthu woman, a tattooed
drummer and a Padaung woman, among others. Some
artists gained recognition for their skills in carving such
pieces. The curator at the Royal Hampshire Regiment
Museum, who received the set in the 1970s, thought these
examples might have been produced out of teak by master
carver Maung Nyun from Mongnai of the Shan states,
though little is known of him.[63] Some of the concepts
expressed by such figures were adopted locally, and these
stereotyped images were still being made in the early
twenty-first century.[64]

Photography also played a crucial role in documenting
various aspects of colonial Burma, ranging from ethnicity
to occupation. Initially used as a tool of colonial expansion,
the state employed photographers to capture images of life
in Burma as it came under British control. This included
military expeditions, with Willoughby Wallace Hooper,
a colonel of the 7th Madras Light Cavalry, recording
the British advance to capture Mandalay in 1885, for
example. Private photographers also arrived, with many
establishing studios in Rangoon and other locations in
Lower Burma. 1865 saw the arrival of J. Jackson and Philip
Klier – the latter a German photographer whose images
were popularised through postcards and in books about
Burma, including Tilly's publications. Beato arrived in
1887. Photographic studios from India, like Bourne &
Shepherd, established themselves in Burma in the 1870s,
while other foreign-owned enterprises opened in cities
such as Maymyo (Pwin Oo Lwin), Bassein (Pathein)
and Moulmein (Mawlamyine).[65] The Burmese court in
Mandalay even had its own studio, supervised by a French
photographer.[66] Japanese photographic companies and

souvenir shops, including Nikko and Fuji Studios, arrived in the first decade of the twentieth century, and D.A. Ahuja, a photographer of Indian descent, established a studio employing both Indian and Burmese assistants and technicians that lasted until the early 1960s. Out of Ahuja's business emerged one of the earliest Burman-operated studios, London Art, which was in evidence by 1915 and had connections with Ohn Maung, one of the founders of Burmese cinema.[67]

In the second half of the nineteenth century, photography became a market commodity, with studio shots presenting Burma as picturesque and exotic rather than a lived reality.[68] Such images were circulated as cartes de visite and, in the early twentieth century, as postcards, which had recently been developed. Photographs of people usually aimed not to document individuals but to establish them as representatives of broader categories or identity groups.[69] Images portrayed various occupations, Burmese women, ethnic groups, and landscapes and monuments. For instance, this carte de visite with a posed image of a Burmese carpenter with a handsaw and a pickaxe next to a sawhorse exemplifies this trend (fig. 4.22). Similarly, this postcard, produced by Ahuja's studio and depicting a Burmese woman rolling fat cheroots, points both to the ubiquity of such scenes and the British fascination with the fact that local women smoked (fig. 4.23).

With the development of anthropology as a discipline and as photographic equipment became easier to operate, photography became a tool for ethnographic documentation, serving as another form of colonial engagement between the ruling power and the local populations. The collection of James Henry Green's photographs, captured during his work in the Kachin Hills between 1918 and the early 1930s, exemplifies this dynamic (see chapter 7).[70] Green's photographs oscillate between dehumanising portrayals of semi-nude or nude 'scientific types' and more informal images that reflect his knowledge of, and sympathy for, the subjects.[71] Much of his work can be considered 'salvage' photography, an attempt to document and preserve what he perceived as cultures at risk of being eroded through contact with the British empire and Christian missionaries.[72]

Yet, objects and imagery also became a site of resistance. The Burmese struggle for independence gained momentum during the 1920s, particularly with the Wunthanu movement, which prioritised traditional values to demonstrate patriotism and reject foreign influences. Village associations actively promoted the boycott of British textiles, cigarettes, candles made by the British-owned Burmah Oil Company and other imported goods in favour of locally made alternatives such as homemade cloth and cheroots. Exhibitions showcasing local products were

4.25
Saya Nyo, Painting of U Wi, the first
Burmese governor of Thayetmyo,
early 20th century. Cotton and paper.
H. 60.9 cm, W. 56 cm. Acquired by
Pansodan Gallery, Yangon, from the
governor's descendants in 2008.

organised to foster greater self-reliance. Those who did not comply with the boycott, as well as moneylenders and collaborators with the British, all faced social ostracism and potential mistreatment.[73] This lacquer tray, depicting a battle scene from the Mahajanaka Jataka, one of the Buddha's previous lives, announces in an inscription on the reverse, 'The silver gong is struck to proclaim that using this product will safeguard the race and national identity' (fig. 4.24). Dated to the 1920s to 1930s, this tray exemplifies how, as mentioned earlier, the pursuit of independence and the establishment of the nation state became intertwined with notions of ethnic and religious identity at an early stage. It further symbolises a collective Burman effort to preserve and assert a distinct cultural and religious heritage as a form of resistance against colonial authority.

Painting

The introduction of photography sparked the emergence of a hybrid form of portrait painting. Among the most popular subjects were family portraits, depicting a group of individuals wearing Konbaung-period clothing, seated on chairs or cushions, and directly facing the viewer.[74] The figures occupy most of the space or provide the main focal point, marking a significant shift in painting style. These images not only replicated the studio-posed figural groups found in photography but could also incorporate photographs into the artwork itself as collages, typically featuring the faces of subjects. A black-and-white photograph would be lightly overpainted to merge with the rest of the painting. Produced in limited quantities for a relatively brief period, from the 1890s to the 1930s, these paintings were eventually supplanted by an increasing number of Western-style watercolours and oil paintings. In this example, the artist Saya Nyo portrays U Wi, the first Burmese governor of the town of Thayetmyo, as a man of importance. U Wi is dressed in a green and white *longyi* and white shirt with a fur-lined jacket over his shoulders

and sits in a high-backed rattan chair (fig. 4.25). Adjacent to him, his turban (*gaung baung*), an important part of Burmese dress, rests atop a stack of books on a table. Also on the table are cheroots (with a matchbox) and a circular box containing betel paraphernalia, both customary offerings extended to guests as a gesture of hospitality. On the floor is a rug adorned with floral patterns – a European import – and on it stands a white English bulldog. This celebratory image combines British and Burmese elements, symbolising the rise of a new Burmese elite educated in Britain or at local schools that provided a European education. Such an education made it possible to become part of the colonial administration, and this painting of U Wi reveals the increasing presence of Burmese individuals in senior positions in the early twentieth century.

Burmese painters began to engage with European forms in the late nineteenth century, using images of paintings depicted in books, and later on postcards, to learn Western techniques. In 1913 a group of British officials and Burmese artists founded the Burma Art Club, and some Burmese artists were formally trained there. However, it was not until the 1920s that two artists, U Ba Nyan (1897–1945) and U Ba Zaw (1891–1942), received sponsorship to travel to London for formal training at the Royal College of Art (RCA). While U Ba Zaw completed the course at the RCA, working primarily with watercolours, U Ba Nyan departed after a year and apprenticed with the artist Frank Spenlove-Spenlove. He also learned from Sir Frank Brangwyn, a British muralist, and embarked on travels across Europe. His work was chosen to represent modern Burmese art at the 1924 Empire Exhibition in Wembley.

Upon returning to Burma in 1930, both artists had an impact on the local art scene. U Ba Zaw established himself in Mandalay, while U Ba Nyan became influential in Rangoon, resulting in distinct technical variations between artists from Rangoon and Mandalay.[75] They trained a new generation of artists, such as Saya Saung (1898–1952) and U Ngwe Gaing (1901–1967). The early works of these artists often depicted Burmese subjects through Western

ဆရာညို

D...AWN.B:.MG.NYO

4.26
U Ba Nyan, *Untitled (sailing ships)*, 1930.
Rangoon (Yangon). Gouache on paper.
H. 10.2 cm, W. 5.7 cm. British Museum,
London, 2022,3022.4. Purchased via the
Brooke Sewell Permanent Fund in 2022
from the descendants of Maurice Collis,
who acquired it at a banquet hosted by
the Mayor of Rangoon in 1930.

4.27
U Ba Nyan, *Untitled (Government
House, Mandalay)*, 1931. Mandalay.
Tempera on paper. H. 8.3 cm,
W. 10.8 cm. British Museum, London
2022,3022.1. Purchased via the Brooke
Sewell Permanent Fund in 2022 from
the descendants of Maurice Collis, who
acquired it from the artist in 1931.

forms, or combined techniques to portray local landscapes, genre scenes, religious buildings and portraits. U Ba Nyan's artistic style, for example, emphasised oil and gouache techniques, particularly employing a textured impasto often applied with a spatula. His painting of sailing ships exemplifies these approaches (fig. 4.26). In this 1931 untitled piece (fig. 4.27), the figure at the centre of the painting is Sir Charles Innes, governor of Burma between 1927 and 1932, emerging from the gates of Mandalay Palace. The palace was turned into a military cantonment and renamed Fort Dufferin (after the then-viceroy of India) by the British in 1886, and it became the seat of colonial government in Mandalay. (The Allies bombed and destroyed the palace during the Second World War when the Japanese used it as a supply depot.)

Following U Ba Nyan's return to Burma, the acting governor, Sir Joseph Maung Gyi, granted permission for a solo exhibition of his artworks to be held at Government House in Rangoon. According to the acting governor's own writings, it was Maurice Collis, the district magistrate of Rangoon, who had proposed the idea. The exhibition was a way to deflect from the fact that it was a difficult time in Burma. The global economic downturn of the Great Depression had devastated the value of export commodities, particularly rice, one of Burma's chief exports. Amid this economic turmoil, the Saya San revolt erupted in 1930 and lasted until 1932. Saya San (1876–1931), a traditional medical practitioner from a rural background, had been invited by the General Council of Burmese Associations in 1925 to investigate rural issues. After witnessing the impoverished conditions of the Burmese countryside under colonial rule, Saya San and his commission reported the mistreatment of cultivators. When their report was ignored, Saya San proposed actions against the colonial government, including non-violent resistance to colonial taxes and laws restricting the collection of bamboo and wood. These proposals caused rifts within the General Council, and Saya San resigned and started to plan an armed uprising. Following the rejection of a farmers' petition to the colonial government to delay the collection of taxes due to plummeting rice prices, the revolt began in December 1930. Despite Saya San's capture and execution in 1931, the revolt persisted until 1932.[76] As a result, Collis wrote that the Burman acting governor was delighted with the proposal to host an exhibition of U Ba Nyan's paintings because 'it gave him an opportunity of flattering the rising national spirit without annoying the three gentlemen [British civil servants] who were salaried to restrain him. An encouragement of the arts could hardly be held against him.'[77]

Before the 1931 exhibition at Government House, U Ba Nyan had been invited to create individual paintings for the menus of the mayor of Rangoon's banquet in 1930. Collis kept several of these paintings, attaching white painted card surrounds and noting their origins on the back. Typical of early painting forms, these images give an impressionistic view of Burma's people, places and scenery. U Ba Nyan's solo exhibition and growing fame also drew him into the

politics of art. There was a call for an organisation of painters beyond the scope of the Burma Art Club, which operated in English, and U Ba Nyan and Collis supported the founding of the Burmese Artists' and Handicraftsmen's Association, with U Ba Nyan becoming the vice-chairman. The group only lasted a short time but, before its demise in 1936, it sponsored various exhibitions, quite an innovation in the Burmese art world. U Ba Nyan mounted several other shows, including another one at Government House, Rangoon, in 1934. Until the outbreak of the Second World War, he worked at the Teachers' Training College in Rangoon. During the Japanese Occupation, he returned to teaching at the college and was appointed the principal of the newly established Institute of Art.[78]

Newspapers, advertisements, film and cartoons

In the 1830s imported English-language newspapers began to appear in Burma, followed by locally produced English-language newspapers in the 1840s, first in Moulmein and later in Rangoon. However, it was not until the second half of the nineteenth century that Burmese-language newspapers and publications started to emerge. The Burma Herald Press, established in 1868 by H. Ahee, a Sino-Burmese, in Lower Burma, was the first to publish Burmese-language material, including legal texts, religious tracts and Burmese plays. King Mindon invited him to establish a royal printing press in Mandalay in 1864 and subsequently a Burmese newspaper in the early 1870s, known as the *Mandalay Gazette* in English,

to present Burmese perspectives on events in both Upper and Lower Burma.[79] From the 1870s onwards, there was a substantial expansion of printing. Philip H. Ripley, son of a British army captain and a woman possibly of Burmese-Armenian heritage, founded Hanthawaddy Press in Rangoon in 1897. During Ripley's time in Britain in the mid-1890s, he had purchased a type foundry while learning the printing trade. Hanthawaddy Press published works in English, Burmese and Tamil, and famously produced a complete set of the Tipitaka, the Buddhist Canon, in thirty-eight volumes, as well as engaging in bookbinding and engraving.[80] Its periodicals and newspapers included the English *Rangoon Advertiser* and the Burmese *Hanthawaddy Weekly Review*, which provided general news, commercial information and translations of material from English-language sources like Reuters.[81] With such extensive production, Hanthawaddy Press became the leading publisher in Burma in the early twentieth century.

The introduction of modern printing technologies led to an explosion of printed materials, in part because of Burma's high literacy rate that allowed for large readerships. As Burma became further drawn into the British empire, there was tremendous commercial expansion, the development of infrastructure (such as railways, communications systems, irrigation and banking), increased agricultural production of rice, cotton, tobacco, wheat and tea, and extensive extraction of oil and teak. British and other firms moved into the Burmese market, encouraging a new consumerism and Western ideas. Books and newspapers from across the empire, Western clothing and other goods, international food and drink (including alcohol) and cigarettes all became readily available and were promoted through advertising posters. Many artists, including well-respected figures like U Ba Nyan and U Ngwe Gaing, produced commercial art for advertisements promoting the new goods and services

4.28 *opposite left*
Poster for Nestlé and Anglo-Swiss
Condensed Milk Company with artwork
by U Ngwe Gaing, *c.* 1935. Probably
Rangoon. Paper. H. 82 cm, W. 57 cm.
Collection of John Randall, Books of Asia.

4.29 *opposite right*
Poster advertising Sunlight soap with
artwork by U Ba Nyan, 1930s. Probably
Rangoon. Paper. H. 71 cm, W. 52 cm.
Collection of John Randall, Books
of Asia.

4.30
Front cover of the *British Burma Film
Pictorial Magazine*, vol. 1, no. 12, 1938.
Probably Rangoon. Paper. H. 27.5 cm,
W. 22.5 cm. Collection of Pansodan
Gallery, Yangon.

available in the country. U Ngwe Gaing, for example, created various posters, including for films, in the 1930s such as this advertisement for Nestlé's condensed milk that evokes Western stereotypes of Asian women (fig. 4.28). Artists also drew upon nationalistic imagery, as seen in this advertisement for Sunlight soap depicting a dashing General Maha Bandula, the Burmese military leader killed in the First Anglo-Burmese War, against a backdrop of wartime triumph with a soap box in the foreground (fig. 4.29). The use of the general, who had led the Burmese in a stiff resistance against the British, shows that historical figures were part of creating an appealing message to the Burmese. It also suggests that advertising artwork could provide space for subversive messaging about resistance to colonial rule.

Graphic and design skills were also used in the magazine and comic book industry, as well as in supporting the nascent film industry. Formerly prevailing types of entertainment – such as puppet shows and travelling theatrical troupes performing episodes from the Ramayana or *jataka* stories of the Buddha's previous lives accompanied by musical ensembles – gave way to new forms, particularly cinema, during the 1920s and 1930s. Initially, the Burmese film industry collaborated with Indian film companies and needed censor approval under the Cinematograph Act of British India. However, Burmese film studios like A1, Bandoola, Yan Kyi Aung and British Burma soon emerged, initially producing short documentaries followed by biographies, folk tales, love stories, Buddhist narratives and eventually political and nationalist documentaries and films.[82]

The first Burmese feature film was *Metta hnint Thuya* (*Love and Liquor*, 1920), directed by U Ohn Maung, who had worked at Ahuja's photographic studio as an assistant and is considered to be the father of Burmese cinema. Notably, some activists in the nationalist Do Bama A-si-a-yone (We Burman) organisation who later became prominent figures – such as Aung San (who negotiated Burmese independence from the British and was the father of Aung San Suu Kyi) and U Nu (prime minister of independent Burma in the

1950s) – also ventured into political filmmaking.[83] After gaining independence from Britain in 1948 and as challenges to central governmental sovereignty and authority arose, the film industry was encouraged to produce films that promoted patriotism and cross-ethnic unity, albeit through a Burman-majority and Buddhist lens, as the independent Union of Burma was supposed to be grounded in ethnic pluralism.[84]

Film magazines, cinema storybooks, song sheets, records and record sleeves and advertising, as well as merchandising, emerged as part of the burgeoning exploration of new media.[85] The example here is a magazine of the British Burma Film Society (fig. 4.30).

4.31 *top*
U Bagale, *That Loin Cloth*,
12 September 1931. Published in the
Rangoon Times.

4.32 *bottom*
U Bagale, *It's a Long Way to Home-Rule*,
1933.

Its cover depicts two actors in Greek-style dress, while the
contents feature film plots and discussions about filmmaking,
but also nationalist calls against Indians living in Burma.
As with advertising, artists and designers became integral to
the production of materials associated with cinema and the
entertainment industry.

One of the other new media that developed in the early
1910s was cartooning. This was initially taught at the
Burma Art Club by Martin Jones, a deputy minister of the
Railway Department.[86] Alongside painting, many artists
were drawn to this art form, and cartooning soon gained
significant recognition in Burma.[87] The two prominent
figures in the field in the first half of the twentieth century
were the Muslim-Burmese U Bagale (1892–1945) – an
actor (he performed in *Love and Liquor*), film producer,
advertising director at the Myanmar Aswe Department
Store and comedian – and U Ba Gyan (1902–1953), a
painter, photographer and writer.[88] Cartooning was an ideal
medium for them to comment on the tumultuous events of
the early twentieth century.

Particularly contentious politics developed in British
Burma when, in 1917, Lord Montagu, the Secretary
of State for India, suggested the possibility of self-
government in India and spearheaded a report that led
to the Government of India Act of 1919. The Burmese
assumed that, as a part of British India, they would have
the same rights, but the British thought the Burmese were
unprepared for self-rule, educationally and politically,
and only extended the provisions of the Act to Burma in
1923 after massive unrest. At this time, the British granted
greater concessions than those given to India, including
equality for women and a broader general franchise.
However, these did not apply to the hill regions, as the
British and often the inhabitants of those areas opposed
integration with the Burmese state. Instead, the Chin and
Kachin Hills, the Karenni and Salween region and the
Shan states were combined under a new administrative
entity called the Burma Frontier Service and were
excluded from the constitutional changes.[89]

During the struggle over the Act, Burmese political leaders became divided between those who opposed co-operation with the government and those who wanted to fight for their rights within the system. In 1931–2 a Burma Roundtable Conference was held in London to discuss constitutional reforms, particularly the separation of Burma from India. Subsequent elections in 1932 resulted in victory for the anti-separationists, as many viewed the separation as a British plan to exclude Burma from further political reforms and even impose permanent rule. Nevertheless, the British passed the 1935 India and Burma Act and, after elections in 1936, Burma formally separated from India in 1937. The first premier of Burma, Dr Ba Maw, governed under the Burma Office of the Secretary for State of India and Burma.

One of U Bagale's responses to the transformations of the time was to satirise them in cartoons, published in newspapers and magazines such as the *Rangoon Times* and the Burmese-produced *Review of London*. For instance, he mocked the British for being shocked by Gandhi wearing a loin cloth during an official visit to London, while also demonstrating the difficulties caused by the trade depression of the 1930s and exposing European hypocrisy, exemplified by the clothing that European women chose to wear at the time (fig. 4.31). His wit also targeted the excessive infighting among Burmese political parties over constitutional change and whether separation from India would slow or advance progress towards independence. Improvising on a traditional Burmese saying that when two buffaloes fight it is the grass that gets hurt, one of his cartoons depicts two buffaloes representing the rival parties ('this party' and 'that party') at loggerheads (fig. 4.32). The innocent country, symbolised by the grass, is the victim of the conflict, questioning Burma's ability to rule itself and whether the parties were fighting for the benefit of the country or out of jealousy.

Similarly, U Ba Gyan drew cartoons critiquing political, social and economic issues, from human frailties to governmental mismanagement. Besides contributing

to daily newspapers and periodicals, he created the first Burmese comic book and cartoon films in the mid-1930s. His work was highly regarded, and he was posthumously honoured with the Alinga Kyaw Swa, the highest title awarded to artists in Burma, in 1954. In this example (fig. 4.33), he depicts the perception of many Burmese that the British were shirking their responsibility for the state of the country – which had suffered immense financial and physical damage during the Second World War – when they departed in 1948. This cartoon makes this explicit by portraying a British man bidding farewell to a Burmese family and instructing them to take good care of their children, named 'Finance', 'Debt' and 'Reconstruction'. The war and the Japanese Occupation had hastened Burmese independence, but it came at a tremendous cost.

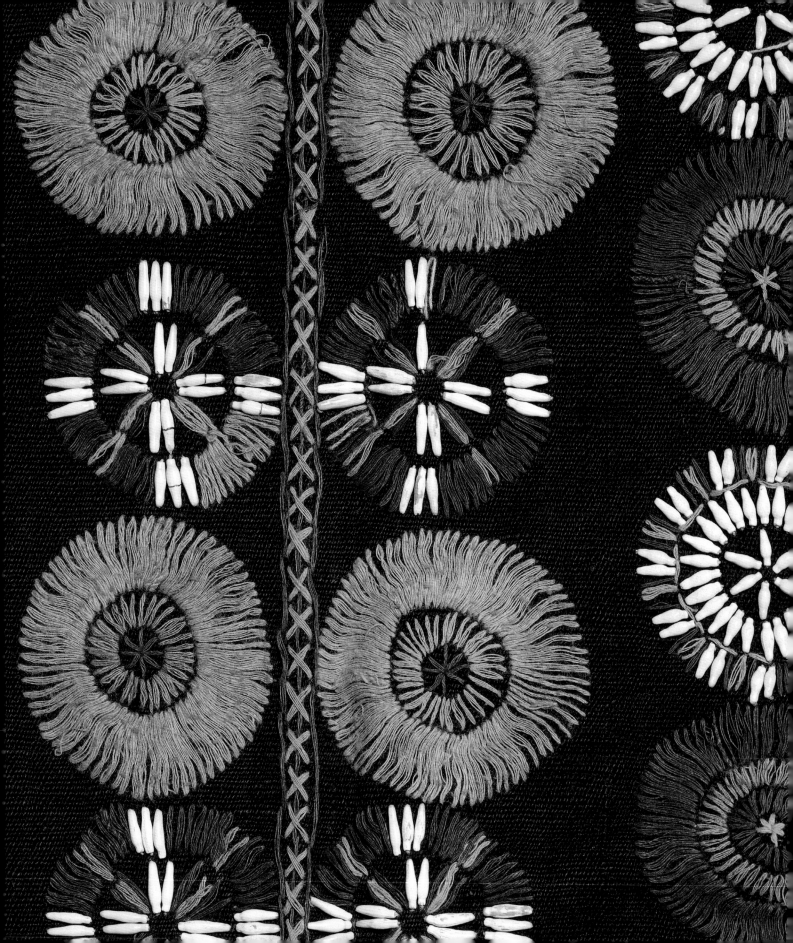

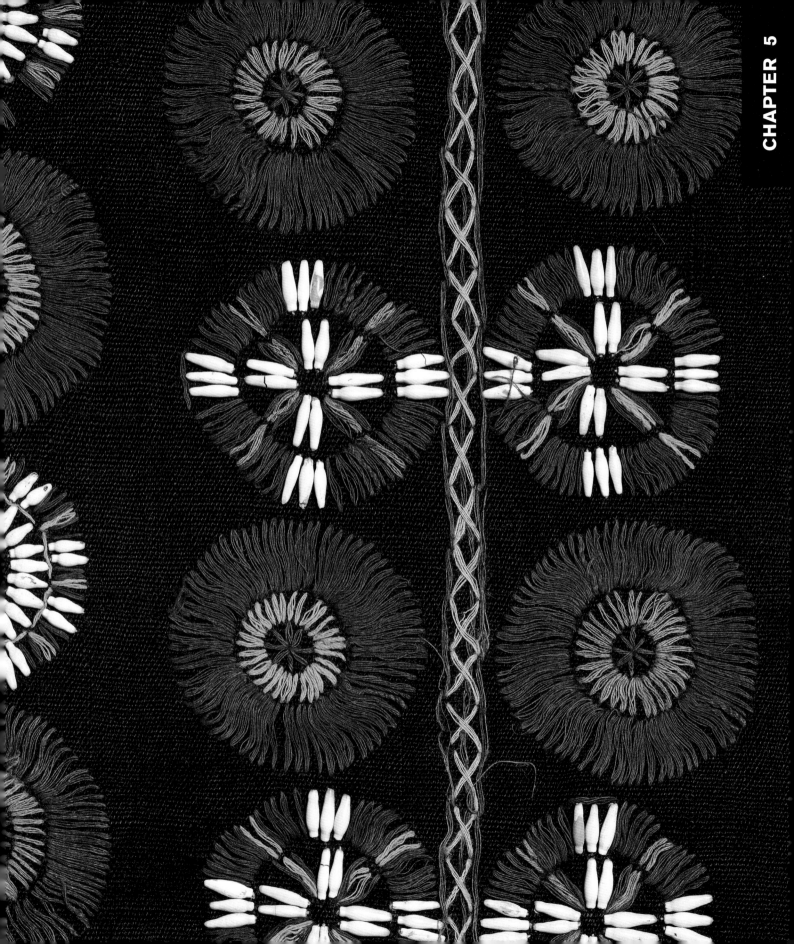

KAREN TEXTILES: EARLY SYNTHETIC DYEING PRACTICES

DIEGO TAMBURINI, CAROLINE CARTWRIGHT, JOANNE DYER
& ALEXANDRA GREEN

The ethnolinguistic label 'Karenic' covers an extensive range of different peoples, often only subjectively associated, who live in Shan, Kayin (Karen) and Kayah (Karenni) States, along the Tanintharyi (Tenasserim) coast in lower Myanmar and in the Irrawaddy, Sittaing and Salween delta regions, as well as in Thailand. Diaspora communities are growing in the United Kingdom, United States and other countries. Karenic peoples are also called 'Karen', sometimes referring to the whole Karenic family and sometimes to specific subgroups. Karen peoples in Myanmar include the Pwo, Sgaw and Karenni groups. Under the Pwo come the Pwo group, who primarily live in the Irrawaddy Delta, and the Pa-O, who are mainly in Shan State and the Thaton region of lower Myanmar. The Sgaw group includes the Sgaw Karen, living in Karen State, and the Paku Karen, who primarily live in southwest Karenni State. The Kayah, Kayaw (Bre) and Kayan have been considered part of the Karenni group, with the Kayaw and Kayan encompassing numerous other subgroups. Despite these seemingly clear distinctions, it is impossible to define Karen peoples neatly, since migration, intermarriage and village networks, interconnected market systems and trade routes have guaranteed long histories of interaction and exchange. In the highland regions of Myanmar, home to many Karen peoples, ethnicity is viewed very differently from European forms of categorisation. Many current classifications only came into being in the nineteenth century due to colonial descriptions, the imposition of the British census, missionary work and scholarly analyses. They do not necessarily reflect how the locals viewed themselves within their own cultural frameworks.[1]

Karen peoples have primarily been described and researched as part of the history of Christian missionary work by American Baptists, Italian Roman Catholics and Anglicans. Much less attention has been given to their oral histories and representations in the chronicles and records of surrounding states.[2] The rise of Karen literacy, with the production of several Karen scripts prompted by missionaries in the nineteenth century, became an important impetus towards the emergence of Karen nationalism during the colonial period.[3] In 1881 the Karen National Association (KNA) was formed by Karen Baptists who wanted to represent the interests of Karen-speaking communities and make claims to the British for a nation of their own, separate from the Burman majority.[4] The KNA initially had a limited impact because many groups did not view it as relating to them, partly because Christian Karens comprised only a small percentage of all Karens, with most following Buddhism and animist religious practices.

In typical 'divide and rule' fashion, the British recruited Karen men into specific units in the colonial army that were used to suppress anti-British rebellions in the mostly Burman Buddhist central region.[5] Additionally, as the Burma Independence Army, in a bid for independence, allied with the Japanese initially in the Second World War, ethnic Burmans often found themselves fighting against the Karens, who continued to support the British (see fig. 6.10). Both sides were grouped together in a single country by the departing British in 1948, but this longer colonial and military history made harmony difficult.

Shortly after independence, the Karen National Liberation Army, the armed wing of the Karen National Union (KNU), launched a formidable challenge to the newly formed democratic government under prime minister U Nu, as an independent state was sought. At the same time, the Karenni National Progressive Party (KNPP) and its armed section were fighting for a separate independent Karenni State.

Despite the armed resistance to Burman-led governments over the decades, splits have occurred within the Karen and Karenni fronts, such as in 1994 when a group of Buddhist Karen soldiers left the predominantly Christian-led KNU and formed the Democratic Karen Buddhist Army. While a KNU ceasefire was negotiated with the Myanmar government as part of the so-called National Ceasefire in 2015 (though this did not also include the KNPP), hostilities have resumed since the military coup toppled the elected government in February 2021. Over the long history of conflict, hundreds of thousands of Karen have been displaced, particularly in the 1980s and 1990s, with many

fleeing to Thailand, where there are large refugee camps in the northwest.

Karen textiles

The fighting in the twentieth and twenty-first centuries and the deprivations inflicted by the Burmese Way to Socialism (see p. 208) have led to a scarcity of resources as well as a displacement of populations that have severely disrupted the production and preservation of Karen cultural objects. However, textiles are still widely produced and preserved. Weaving still happens in refugee camps to retain links to the past and as confirmation of identity. Such clothing is today primarily used for special events, and inexpensive imitation batik prints and t-shirts are generally worn on a daily basis.[6] Refugee camps have also brought distant and dispersed Karen groups into closer contact, resulting in changes to clothing. One particularly visible response to persecution and fighting has been an effort to create a pan-Karen culture. This movement has generated new, pan-Karen 'traditional outfits' for men and women.[7]

The devastation of the Second World War and the subsequent ongoing civil wars with the central Burmese government have resulted in the loss of much material culture. As a result, missionary and other collections formed over the past 200 years have become important records of Karen history. Most items in collections are Paku, Pwo or Sgaw Karen, with fewer from the Karenni groups. Karen textiles were frequently collected for several reasons: they were visually captivating and easily transportable objects; they formed part of nineteenth-century ethnic identifications by non-Indigenous people; and alterations to clothing, particularly in the creation of outfits that covered more of the body, were often linked to Christian conversion and thereby indicated the success of missionary work.[8] Because of their preservation in collections, the study of textiles is one of the main remaining avenues of historical investigation into Karen material cultures. For example,

the scientific analysis of dyes, fibres, weaving and dyeing techniques and patterning reveals the trade and cultural networks within which Karen peoples operated during the nineteenth century and, by extrapolation, earlier times. Dye and fibre innovations were incorporated into clothing quite rapidly. Market systems created networks of exchange points that facilitated the diffusion of innovation across urban and rural areas and large regions from present-day coastal, eastern and northern Myanmar, northeast India, Yunnan and China, Thailand and Malaysia.[9] Alterations to nineteenth- and early twentieth-century textiles therefore also provide information about fashion and market changes as Myanmar became connected with the British empire. However, trends in textile production change over time. For instance, work by the anthropologist Sandra Dudley among Karen refugees in Thai camps indicates that tunics heavily decorated with *Coix* seeds (see figs 5.1 and 5.9) were once popularly produced in Burmese Karen regions but, by the late twentieth century, had become dominant among Karen groups in Thailand instead, an indicator of textile ideas spreading between distant communities.[10]

Early textile-making and materials

Customarily, only women are involved in textile-making operations, including preparing threads, dyeing, and weaving on backstrap (body-tension) looms. Textiles are most commonly warp-faced tabby (plain) weaves. Warps sometimes end in tassels or pompoms, while continuous and discontinuous supplementary weft yarns are used to develop complex patterning. Warp *ikat* is another regular feature, especially on women's skirts, where the mythologically related python design marks a woman's impressive weaving ability. Embroidery is another standard element, often including Job's tears seeds (*Coix lacryma-jobi*), and so is the incorporation of appliquéd pieces of red cloth. Such decorations on shirts, headdresses and skirt-cloths are usually reserved for married women among

Sgaw and Pwo people; unmarried women and girls once wore simple shift dresses.[11]

Early Karen textiles were made of cotton (*Gossypium* species (sp.)) and occasionally silk, although hemp (*Cannabis sativa*) and wool were sometimes used as well.[12] The once predominant natural dyes in the region were mainly sourced from local plants. The most common red dye was extracted from the root bark of the *Morinda citrifolia* plant, although some other plant species were also used.[13] Lac dye, obtained from the *Kerria lacca* insect, was also a natural source of red colour.[14] Natural yellow dyes used by the Karen peoples include turmeric (*Curcuma longa*), gamboge (*Garcinia* sp.), jackfruit (*Artocarpus heterophyllus*) wood and bark, mango (*Mangifera indica*) leaves, and cockspur thorn (*Maclura cochinchinensis*).[15] Blue was usually obtained from indigo-producing plants, such as *Indigofera tinctoria*, grown and traded around the region.[16]

Mordanting and fixing methods were often used in natural dyeing practices to enhance the colour and fastness of certain dyes. Mordants are substances used to treat the fibres and contain metal ions that act as a bridge between the fibres and the dyes, therefore strengthening the bond and making the colours more stable. Common mordants, for example aluminium or iron, are found in the form of salts, such as alum or ferrous sulphate. Vegetable sources of mordants such as tannins exist as well. They are a category of molecules that can be extracted from various plants, fruits and seeds and are commonly used to obtain dark colours.[17] Mordanting methods have a long and variable history in Myanmar, including adding earth or ash to the dye bath, using aluminium-rich leaves (*Symplocos* sp.), and burying the cotton yarns underground or treating them with oil before dyeing.[18]

Synthetic materials

With the industrialisation of textile-making in Europe, an abundance of new materials became available in the second half of the nineteenth century. Synthetic dyes represent one of the most important categories of such materials, and their introduction from Europe to Asia is an understudied topic.[19] Myanmar was subject to considerable Western influence from the early nineteenth century. As the East India Company became the leading supplier of trade goods to the area following colonisation, these new products became available in Myanmar. Tremendous transformations occurred in this period and evidence exists that scientific advances and technological developments in Europe impacted Myanmar's textiles and other art forms.[20] As the year of discovery of most synthetic dyes is documented, these molecules can be used as dating tools to establish the earliest possible date for the production of a textile, therefore potentially yielding important information to interpret the chronological changes in Karen textile practices. Moreover, little in-depth scientific work on textiles made by Myanmar's minoritised communities has been undertaken. A 2016 study of six Chin and Karen textiles dated to 1890–1930 is the only scientific report on this topic, showing that synthetic red dyes, such as fuchsin, synthetic alizarin and rhodamine B, were used at that time.[21]

This chapter presents the results of a study of six Karen textiles undertaken by the Scientific Research Department at the British Museum, which aimed to investigate the changes in textile production over the nineteenth century and identify light-sensitive dyes to develop appropriate display conditions. According to their attribution dates, the six textiles span the 1830s to the early 1900s. They include tunics, skirts and a headcloth and represent a broad colour palette and a wide variety of production techniques (tabby weave, embroidery, *ikat*, etc.). Chosen for their temporal spread across the early colonial period and the advent of synthetic dyes and fibres, the selection should not be considered representative of Karen textile production overall, particularly given the geographic distribution of Karen peoples and their varying levels of access to new materials. Instead, it is an initial foray into the topic of synthetic materials in Myanmar.

Scientific methods for the study of dyes and fibres

Several investigative techniques were used in the analysis of the six Karen textiles.[22] The initial stage of the investigation included a visual examination of the textiles using digital microscopy to investigate the weaving of the textiles and other details to identify colour nuances, possible mixtures of dyes and fading. These observations were followed by broadband multispectral imaging (MSI) and fibre-optic reflectance spectroscopy (FORS), both of which use the reflection or, in certain MSI techniques, light absorption and emission from an object to understand the materials from which it is made. Some of the colourants could already be identified at this stage, and their distribution could be mapped on the surface of the textile (see figs 5.4, 5.12 and 5.14). The information obtained by MSI and FORS guided strategic sampling during which a small number of samples (approximately 0.5 cm of thread) was taken from each colour of the textiles.

The samples were investigated by optical microscopy (OM) under visible and ultraviolet light (UVL) and by scanning electron microscopy – energy-dispersive X-ray spectroscopy (SEM-EDX). By producing highly detailed images at high magnification, SEM enabled fibre identification and the evaluation of possible degradation of the fibres (see figs 5.5, 5.8 and 5.10). Additionally, the use of inorganic mordants, for example aluminium or iron, can be inferred from the EDX detector. Finally, the samples underwent extraction of the dye molecules from the fibres using a specific mixture of solvents. Once the molecules were in solution, liquid chromatography (HPLC) was adopted to identify the molecules one by one. This technique provided the exact identification of the dyes at the molecular level. The scientific methods used in this study are detailed in the appendix (p. 244). The results of this multi-analytical approach are summarised in Table 2 (p. 246), with the most relevant observations highlighted in the following paragraphs.

The textiles

An early tunic

This tunic shirt was collected in the Tenasserim region of lower Myanmar for its extensive use of two species of Job's tears (*Coix* sp.) seeds and presented to the Botanical Department of the British Museum in 1844. It is a beautifully produced part of a Pwo Karen woman's outfit made of two strips of dark blue tabby weave cotton cloth joined along the lengths but leaving spaces for the head and arms (fig. 5.1). The base fabric is left plain in the upper third and is heavily embellished over the remainder with red, yellow and light green embroidery threads in stem and running stitches, as well as stars and zig-zags formed from *Coix* seeds. The five rows of patterning of the lower third are interspersed with appliquéd red cotton bands that extend beyond the borders of the tunic as a thick 'fringe'.

The *Coix* seeds are attached to the base by undyed cotton threads. Two different types of seed are indeed present, one with an elongated shape and one with a rounder shape (fig. 5.2). The very dark blue colour of the base textile was obtained by using indigo and tannins. Unfortunately, the exact plant sources of both indigo and tannins are often very difficult to identify, even with sophisticated scientific methods, and this was the case here. The embroidery threads were dyed with *Morinda citrifolia* (red), gamboge (yellow) and indigo (light green). The horizontal appliquéd bands were also dyed with *Morinda* red and found to be particularly rich in aluminium. Aluminium mordanting is needed to dye with *Morinda* red, but such a high level of aluminium is rarely detected on fibres. This might point towards the use of a vegetable aluminium-rich mordant, such as the leaves of the *Symplocos* sp. plant,[23] rather than the mineral mordant alum. Overall, the results reveal a completely natural palette, with gamboge being particularly interesting because this dye is often mentioned as an early source of yellow for Southeast Asian textiles,[24] but this is the first evidence of its actual use on a historical textile. The attribution date for this tunic

5.1
Tunic (*hse*), *c.* 1830–40. Pwo Karen,
Tenasserim region, lower Myanmar. Cotton
and *Coix* seeds. L. 77 cm, W. 69 cm.
British Museum, London, As1979,Q.101.
Donated by I.D.V. Packman in 1844.

5.2
Details of the two types of *Coix* seeds
used in the embroidery of the tunic,
As1979,Q.101.

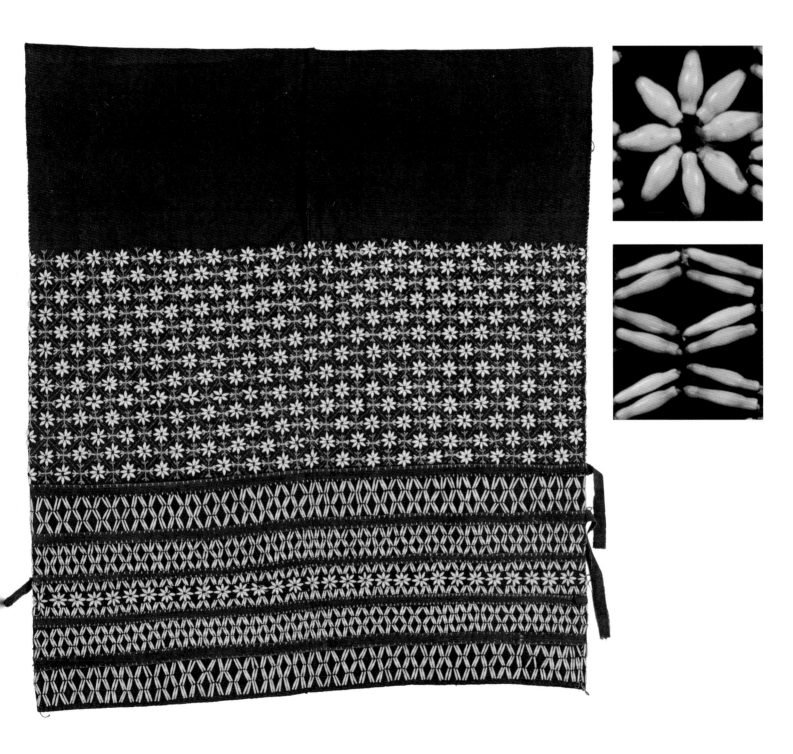

5.3
Skirt-cloth (*ni*), before 1870. Karen
regions or lower Myanmar. Cotton
and silk. L. 114 cm, W. 71 cm. British
Museum, London, As.7765. Donated
by Augustus Wollaston Franks in 1872,
who probably acquired it from the dealer
William Wareham.

5.4 *top*
Left: VIS image of As.7765.
Right: UVL image of As.7765. The
UVL image shows the Chinese cork
tree (*Phellodendron chinense*) dye with
strong luminescence properties in two
vertical stripes, and the presence of
turmeric (*Curcuma longa*) – showing
weaker luminescence – in the other
yellow areas.

5.5 *bottom*
Left: details of the decorative pattern
on As.7765, showing yellow, green and
pink vertical threads made of silk. Upper
right: SEM image of the yellow thread
(silk dyed with Chinese cork tree). Lower
right: SEM image of a red weft (cotton
dyed with *Morinda* red).

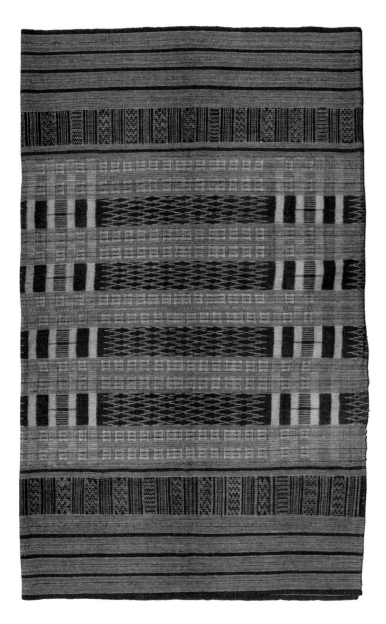

shirt is around 1830–40, making it probably the earliest Karen textile in the British Museum collection. That it was exclusively dyed with local natural dyes supports an early production date for this textile.

An early skirt-cloth

Produced by a Sgaw Karen woman, this exceptional skirt-cloth (*ni*) is formed of two mirror-image pieces of warp-faced cotton cloth joined together (fig. 5.3). The upper and lower edges display four sections of horizontal warp stripes in red, blue, yellow and white. These are followed by short vertical bands of stripes alternating with sections of zig-zags woven with a discontinuous supplementary weft technique in red, yellow, white, green and dark blue-black. The four red and white warp *ikat* panels of the central section alternate with five sections of warp stripes and discontinuous supplementary weft patterns in geometric shapes. While discontinuous supplementary weft is not an unusual technique on bags and shirts among Karen pieces, its use on skirt-cloths is relatively rare.[25]

The *ikat* sections, as seen here, are usually composed of repeated rhomboid, diamond or rectangular patterns, representing a design called 'python skin' commonly found on Sgaw Karen textiles, particularly skirt-cloths. The design originated with a myth about how the Karen woman Naw Mu E was kidnapped and taken by a python to its lair. Rescued by her husband, she ever after wove the pattern, either, according to different versions of the story, to show contempt for the serpent or because it required her to do so.[26]

Turmeric (*Curcuma longa*) was used in the yellow horizontal bands and yellow supplementary wefts, whereas *Morinda* yellow mixed with indigo was used in the green supplementary weft details. Interestingly, another type of yellow dye was found in only two of the vertical stripes. This was identified as the dye extracted from the bark of the Chinese cork tree (*Phellodendron chinense*), which is a typical Chinese dye,[27] with the characteristic of emitting a bright yellow fluorescence under UV light.[28] This feature enabled

it to be distinguished from the other yellow areas under UV light (fig. 5.4). Additionally, the threads in these two vertical stripes are made of silk, strengthening the hypothesis of a Chinese origin.

All red areas were dyed with *Morinda* red; however, lac dye was identified in some bright pink details (also visible in fig. 5.4). This dye, extracted from a resinous secretion of the *Kerria lacca* insect, is a natural source of red in Myanmar. Still, it is likely to be historically imported from India or China.[29] Again indicating a possible Chinese connection, the bright pink threads were also found to be made of silk (fig. 5.5). With indigo being the dye used in all blue and green details, this textile was completely coloured with natural dyes, supporting a pre-1870s attribution date. The combination of cotton and silk, as well as the exquisite, intricate decoration, also mark this piece as particularly special.

A skirt-cloth from the early 1880s with an unusual synthetic colourant

A Sgaw Karen piece, this warp-faced cotton skirt-cloth (fig. 5.6) comprises numerous warp stripes of varying widths in blue, red, orange and green yarns, as well as four wide python skin panels and four narrow undulating lines in blue and white warp *ikat*. Indigo and *Morinda* red were identified as the dyes used for the blue and red areas, respectively. The bright orange and green colours contained a particular type of non-plant-derived colourant, referred to as 'chrome yellow' (lead chromate or lead bichromate) (fig. 5.7). In this colouring process, yellow particles form directly on the fibres by a chemical reaction. Developed in Europe in the 1820s, the process is similar to applying a mordant rather than a dye. The fibres are first immersed in a solution of lead salt, with the lead ions linking to the fibres. Secondly, a potassium chromate solution is applied to the fibres. The chromate reacts with the lead ions, and the yellow lead chromate particles are formed, as emphasised in SEM images showing the distribution of such particles (fig. 5.8). If the fibres are then treated in an alkaline bath, the yellow particles become

5.6
Skirt-cloth (*ni*), before 1886, probably
1870s–early 80s. Possibly Shan states.
Cotton. L. 89 cm, W. 73 cm. British
Museum, London, As1919,0717.200.
Purchased in 1919 from Rev. William
Kidd, who was a Presbyterian pastor in
Rangoon (1881–7).

5.7 *top*
Three details of the textile weaving and
high-magnification images of the bright
green and orange threads from the
skirt-cloth, As1919,0717.200.

5.8 *bottom*
SEM image of an orange sample
from As1919,0717.200, showing
the presence of inorganic particles
(appearing as bright spots) distributed
on the cotton fibres coloured with the
'chrome yellow' dyeing method.

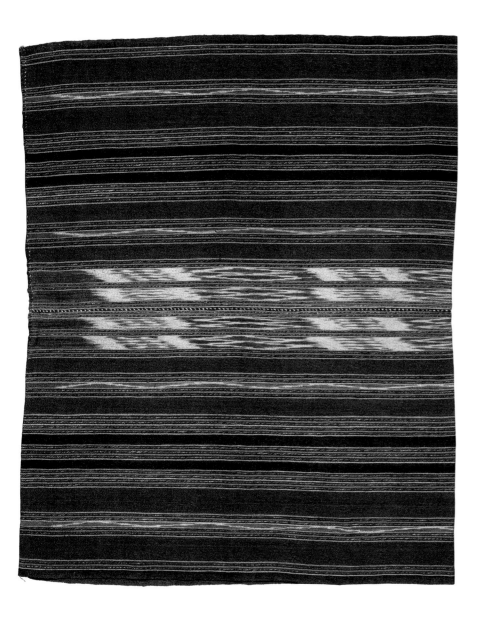

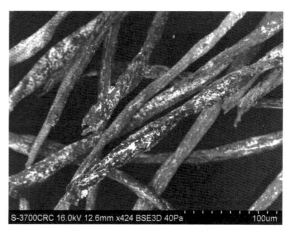

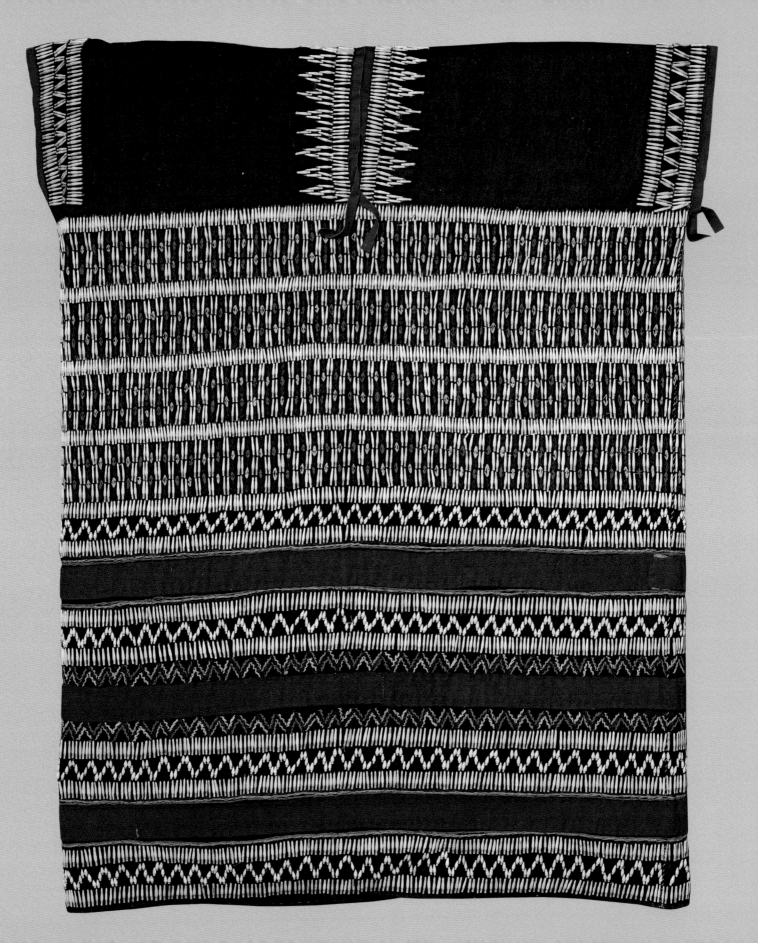

more orange in colour. Although the method is described in nineteenth-century dyeing manuals,[30] little evidence for the use of chrome yellow in historical textiles has been reported so far.[31] In the green and orange threads of this textile, chrome yellow is overdyed with blue (indigo) and red (*Morinda* red), respectively. This is an interesting observation. If these cotton threads had been dyed in Europe and imported, the red colour would probably be from madder (*Rubia tinctorum*), cochineal (*Dactylopius coccus*) or brazilwood (*Paubrasilia echinata*), which were common natural dyes used in Europe at that time, and not from *Morinda citrifolia*, which is used locally in Southeast Asia and not in Europe. It therefore seems likely that either the cotton threads were received from Europe already dyed with chrome yellow and were then overdyed by Karen dyers with local red and blue dyes or that the technology of dyeing with chrome yellow had reached Myanmar at the time of production of this textile.[32]

A tunic with materials imported from Europe

Likely a Pwo Karen woman's shirt, this exceptionally rich example displays dense patterning with two types of *Coix* seeds, including around the arm and neck holes (fig. 5.9). The seeds are interspersed with embroidered zig-zags, lines and geometric shapes in coloured yarns, using chain and cross stitching. Narrow red felted wool stripes line the arm and neck holes with three broad ones around the lower half of the garment. The base textile of the jacket is blue (indigo) cotton decorated with red (lac dye), green (chrome yellow and indigo), orange (chrome yellow and lac dye) and white (undyed) cotton embroidery threads. The felt is dyed with a mixture of lac dye, cochineal and young fustic (*Cotinus coggygria*), mordanted with tin (fig. 5.10). Tin mordanting was a common practice in Europe and was used to confer brightness to red colours.[33] Cochineal and young fustic were commonly used European dyes in the nineteenth century. The felt was stitched with a pink cotton thread also dyed with cochineal. These observations, in combination with the use of wool, which was not common in Karen textiles,

suggest that this red felt was dyed in Europe and exported to Myanmar, possibly in the early 1860s. As the acquisition information of this textile places its production date before 1863, it is particularly interesting to observe that the chrome yellow dyeing method, abundantly found here, was used before the introduction of synthetic dyes, as described in dyeing manuals.[34]

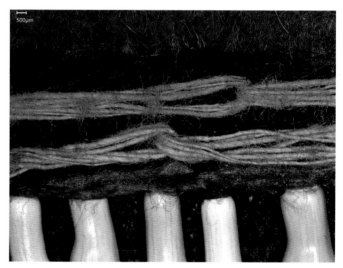

5.11
Tunic (*hse*), *c.* 1880s–1920. Karen
regions or northern Thailand. Cotton and
Coix seeds. L. 75 cm, W. 84 cm. British
Museum, London, As1966,01.481.
Purchased from the Church Missionary
Society in 1966.

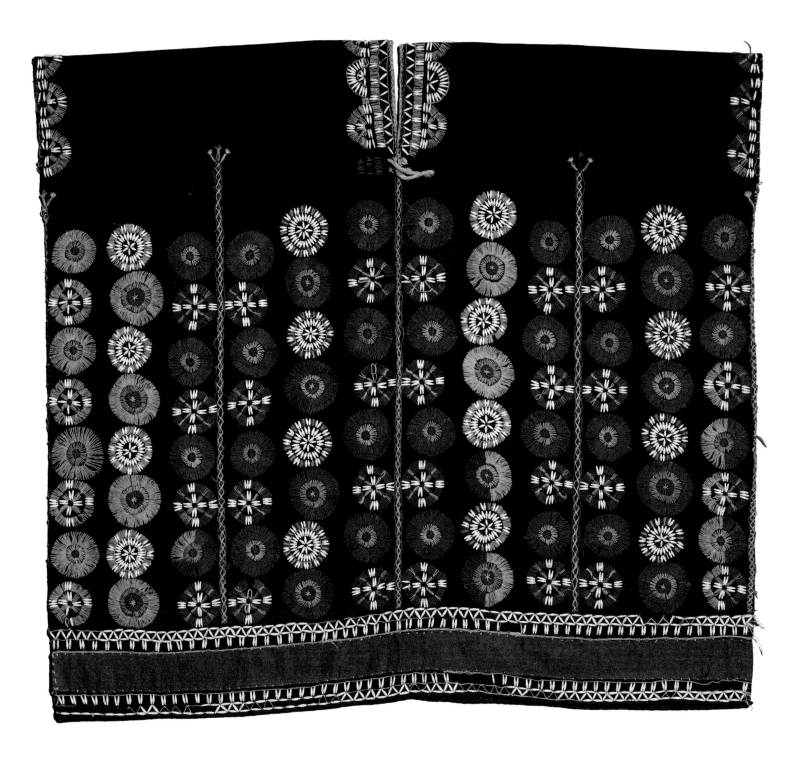

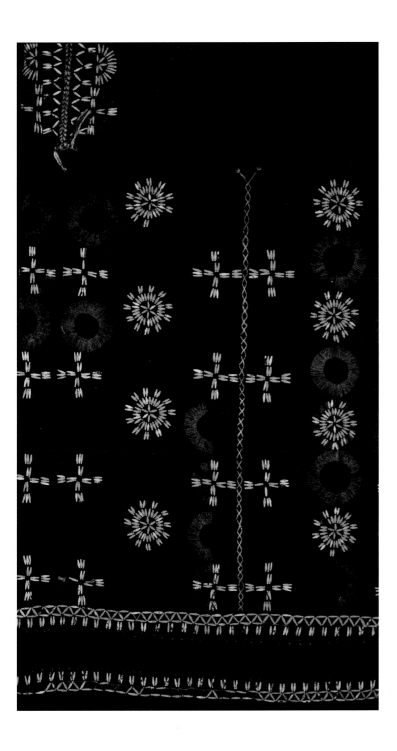

A tunic with a possible Thai connection

This tunic was probably produced by a Pwo Karen woman (fig. 5.11), as it was among the Pwo and the Paku Karen that shirts were embroidered with geometric or naturalistic designs.[35] The designs differ from other Pwo examples (see figs 5.1 and 5.9), suggesting that it comes from a different area (the Pwo also lived in Thailand) or a new fashion associated with a later date. This is partially corroborated by the fact that the reduced number of seeds and extensive, circular embroidery were features of tunics produced by Karens in Thailand in the twentieth century. The tunic is made of black cotton embroidered with yellow, red, green and orange or beige cross, stem and chain stitches, as well as Job's tears seeds of the elongated type, to produce numerous circles set into sections separated by narrow vertical stripes. Embroidery and seeds also mark the edges of the holes for the neck and arms, and around the lower edge is a loosely woven red cotton band that extends beyond the width of the shirt. It is flanked by bands of seeds arranged vertically and in a triangular pattern. The attribution date (*c.* 1880s–1920) is relatively late and in agreement with the detection of synthetic dyes. Synthetic alizarin was identified in all red areas. This dye was developed in 1868 to replicate the natural molecule alizarin present in madder roots.

In the light green vertical embroidery, the natural yellow dye turmeric was found mixed with the synthetic dye diamond green B, which was discovered in 1877. As turmeric emits yellow luminescence under UV light, these green threads could be distinguished from the other green threads in the textile (fig. 5.12), which were dyed with indigo and chrome yellow. These green colours are particularly interesting, as they are obtained by mixing two dyes, despite pure synthetic greens being available at this time. In fact, diamond green B is a green dye, but it can retain quite a blue shade if the dye bath conditions are not ideal. This could explain the presence of turmeric to counterbalance the blueness of this dye and may be indicative of the experiments that dyers were performing with newly available colours to obtain the desired shades. It is interesting to find the chrome yellow again, as some texts

5.13
Woman's headcloth (*hko peu ki*),
c. 1890s. Karen regions. Cotton and
felted wool. L. 140 cm (including fringes),
W. 30 cm. British Museum, London,
As1901,0318.217. Donated in 1901 by
the Indian Section, Paris Exhibition 1900
Committee.

report that this dyeing method was quickly abandoned when
synthetic yellow dyes became available.[36] The results from
this textile seem to contradict this and suggest that chrome
yellow continued to be used alongside synthetic dyes for a
longer period than previously suspected. The black used for
the ground is also synthetic, as is the orange/beige dye used
in the embroidery. Unfortunately, these dyes could not be fully
identified. Still, they appear to belong to a class of colourants
referred to as ingrain colours that were commercialised in
1887 and used for a relatively short period. This result is again
in line with the textile's relatively late production date.

A headcloth with synthetic dyes

Collected for the Paris Exposition of 1900, this piece, along
with many other textiles from Myanmar, was donated to the
British Museum in 1901 by the India Section of the Exhibition
Committee (fig. 5.13). Although initially identified as a Paku
Karen man's waistcloth, this is more likely to be a woman's
headcloth (*hko peu ki*). Made of white cotton warp-faced cloth,
each end is elaborately embellished with pink, dark red, green
and dark green felted wool geometric designs in continuous and
discontinuous supplementary weft techniques. Warp-twined
cotton fringes are interspersed with wool-wrapped fringes
that end in pompoms. Carefully kept as heirloom objects, such
headcloths were placed on a bride's head at her wedding.[37]

 All the colours of this headcloth were obtained with
synthetic dyes, probably attesting to it being the most
recently produced textile in this study. Upon initial, non-
invasive inspection, certain dyes were suspected due to their
characteristic emissions under UV light (fig. 5.14) and other
specific properties, such as distinctive FORS spectra. The
two shades of pink (bright and salmon) were obtained with a
mixture of rhodamine B (pink/red) and auramine O (yellow).
Dark red was obtained using the dye orange I with a chrome
mordant. The emerald green was a mixture of diamond
green G and naphthol yellow S. The dark blue details contain
crystal violet. The identification of the dyes in the light
and dark green areas was more challenging, pointing to the

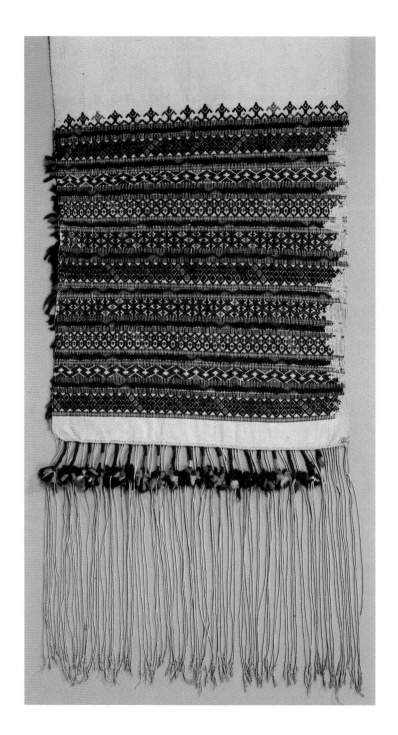

5.14
Left: VIS image of As1901,0318.217.
Right: UVL image of As1901,0318.217.
The UVL image shows the luminescence
of rhodamine B.

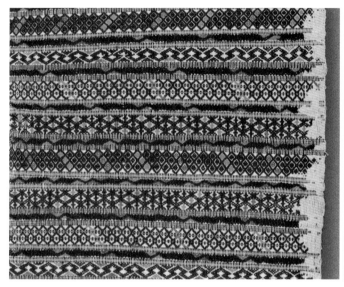

presence of mixtures of synthetic dyes. As the dates of the first syntheses of these dyes are known (Table 2, p. 246), the results show that this textile was produced in the 1890s at the earliest, in agreement with its attribution date.

Conclusions

This overview of the dyes and fibres of six Karen textiles from the British Museum's collection reveals a dynamic textile-making scenario that evolved over the nineteenth century. There is now much more information about the adoption of synthetic dyes and fibres and the availability of such materials across large parts of Myanmar. The natural dyes, such as red from *Morinda citrifolia* and the lac insect, yellow from gamboge and turmeric, and blue from indigo, were all found on the older textiles (figs 5.1 and 5.3), supporting their relatively early attribution dates. Silk threads imported from China were also found on fig. 5.3, showing extensive trade connections related to textile production. Evidence from Chinese sources indicates that these links are many centuries old.

Mixtures of natural and synthetic dyes, including synthetic alizarin and various aniline dyes, were identified in the other textiles that represent a transitional and experimental phase, which encompasses the use of rarely found threads dyed with the 'chrome yellow' colourant in three (figs 5.6, 5.9 and 5.11) out of the six textiles investigated. This is the first scientific evidence of the use of this dyeing method, which is discussed in European literature as rarely used and not particularly successful. The fact that evidence of its use comes from non-European textiles adds value to this remarkable observation. It constitutes a basis for further research into the commercial trade of threads dyed with this method. Clear evidence for the inclusion of European materials in Karen textile-making also comes from the presence of felted wool in fig. 5.9, dyed with such colourants as cochineal and young fustic that were not commonly used in Myanmar. These materials, therefore, highlight the influx of European goods into Myanmar in the second half of the nineteenth century, in tandem with the expansion of European and mainly British trade networks into the region and increasing colonial control.

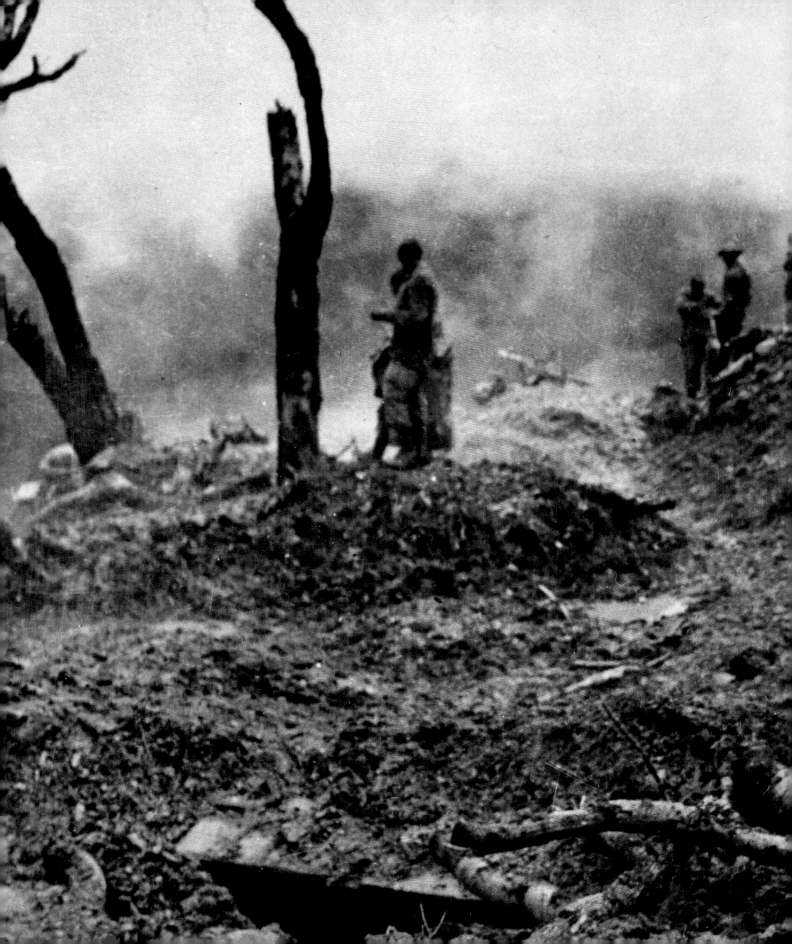

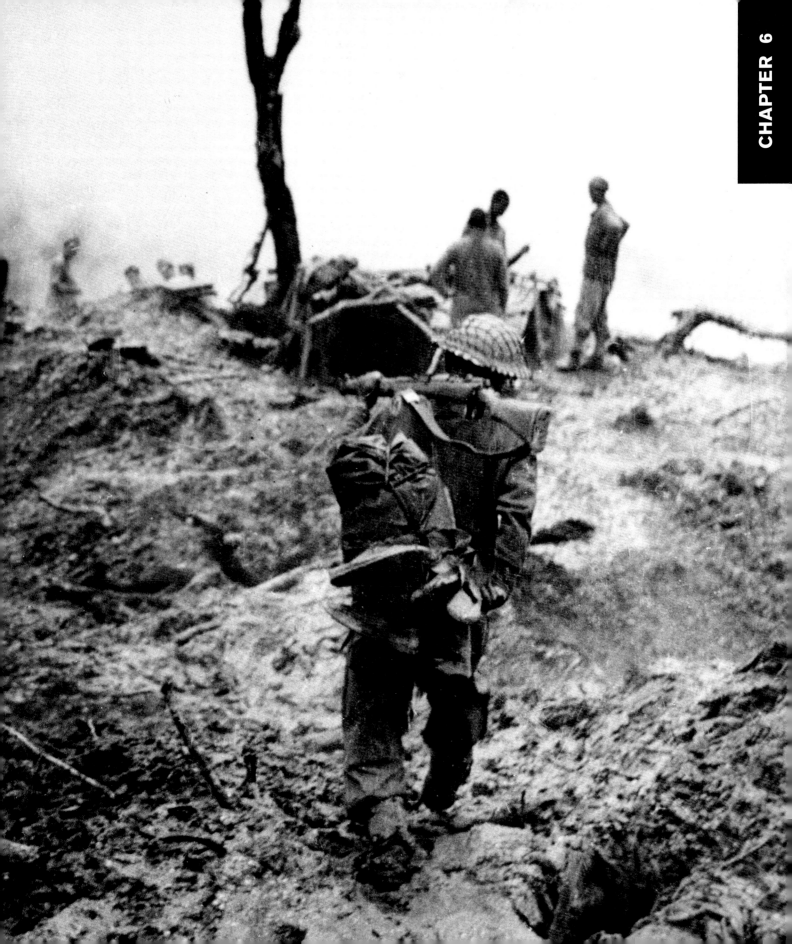

MYANMAR IN THE SECOND WORLD WAR

MAITRII AUNG-THWIN & ARTHUR SWAN YE TUN

At the start of the Second World War, Rangoon (Yangon) was already a global city. Its establishment as a key port and capital of British Burma transformed it from a religious pilgrimage site into a cosmopolitan and globally interconnected urban centre. Rangoon served as a financial, commercial and administrative hub for a network of cities across the British empire and as an international node within the broader Indian Ocean. Located in the Irrawaddy Delta, Rangoon was a gateway to Burma's interior resources, the overland trade networks with southern and southwestern China, and the various trans-Asian maritime networks that stretched across the Bay of Bengal and the Straits of Malacca.

Rangoon's strategic location attracted foreign communities of merchants, bankers, lawyers, developers, railway engineers, clerks, priests, shopkeepers, labourers and hoteliers. Scottish, English, Irish, Armenian and Jewish people were among the many European and other communities residing in British Burma. Asian immigrant communities from South and East Asia also migrated to British Burma to profit from the resource-extraction sector as brokers, professionals, moneylenders and labourers, roles critical to the rice, timber, oil and mineral economies. The Japanese set up banking and business houses, barbershops, photography studios, massage parlours and other smaller businesses. They were also hired as advisers to boost Burma's technological capacity – for example, a Japanese expert was hired by a glass factory in Mergui (Myeik).[1] Imperial Japan had already established colonies in Manchuria, Korea and Taiwan, and local Japanese in Rangoon most likely kept them apprised of British Burma's potential.

An International Students' Institute was established in 1935 to promote cultural contact between Burma and Japan. Burmese people went to Japan to learn how to industrialise craft skills, particularly textile production – the Burmese textile industry had declined from the 1930s as it could not compete with cheap imports from Japan. The lacquer industry also developed connections with Japan, including after the war when the second head of the Government Lacquer School was sent as a state scholar to Japan. Upon his return, he introduced several new techniques, including marbled lacquer (*Japan yun*), which became widely used in the second half of the twentieth century.[2] The *Japan yun* technique layers gold, silver or aluminium powder or paint between coats of brown lacquer, which are then abraded to reveal the gold or silver and brown in broadly geometric patterns, as seen on this circular box (fig. 6.1).

Local Burmese sentiment towards the influx of European and Asian communities and goods into British Burma varied. Minority groups – who benefited from the British economy and education system and had favoured political status – welcomed foreign investment and personnel. In contrast, nationalist groups representing the Burman majority regarded foreigners and the socio-economic changes they brought with them as a threat to the country. By the eve of the Second World War, politicians representing these local constituencies were embroiled in an internal struggle against one another over the country's future (see fig. 4.32), a situation that the invading Japanese would eventually exploit.

The Japanese empire and invasion

Events in Burma during the Second World War can be understood in the context of the Japanese empire and the Asian response to European imperialism. The expansion of Japanese influence in Asia began with the First Sino-Japanese War, leading to Japan's territorial acquisition of Taiwan from China in 1895. Japan's defeat of Russia in 1905, its annexation of Korea in 1910 and its expansion into Manchuria in the Second Sino-Japanese War (1937–45) demonstrated that Japan could modernise and compete as an equal to European colonial empires. In the decades before the Second World War, monks and student activists from Burma, such as U Ottama (1879–1939) and Aung San (1915–1947), travelled to Japan for ideological, organisational

Previous pages
Men of the 10th Gurkha Rifles clearing
enemy positions on 'Scraggy Hill',
1944. National Army Museum, London,
NAM 1998-01-154-5.

6.1
Circular box and lid made by Tun
Handicrafts, early 1990s. New Bagan.
Bamboo, lacquer and gold powder.
H. 4.5 cm, Diam. 16 cm. British Museum,
London, 1996,0501.44. Purchased new
in 1996.

and military training. The generation of Burmese
politicians, activists and civil servants who co-operated
with the Japanese during the Second World War sought
independence from Britain and saw Japan as a path to
this end. The competition for power among these various
stakeholders with different visions for Burma's future would
last well into the postcolonial period.

Geographically, Burma was in a critical position for
wartime strategists. Nestled at the junction of India, China
and mainland Southeast Asia, the British colony provided
important access to the Bay of Bengal and the Gulf of
Thailand. Japanese military planners regarded Burma as
a potential base for the invasion of India, the heart of the
British empire in Asia. In December 1941, Japan launched
bomb attacks on Pearl Harbor in Honolulu, Hawaii, and
on British-held Singapore and Manila, stunning both

US and British authorities and anti-colonial nationalist
groups across the world. In Burma it was understood
that the Japanese would target the country next. Bomb
shelters, rationing and other civic defence measures
were implemented to prepare for the ensuing invasion.
Air-bombing raids on Burma began mid- to late December
1941, causing nearly 2,000 deaths in Rangoon and
destroying much of the city's infrastructure.

The Japanese entered British Burma via Tenasserim
(Tanintharyi) in the south, having moved their troops
quickly through Thailand following their occupation of
British Malaya (the set of states on the Malay peninsula,
including the island of Singapore). Thailand, an ally of
Japan, served as a launching point for the Japanese to
co-ordinate and deploy its ground troops into British
Burma. Aided by the Burma Independence Army (BIA),

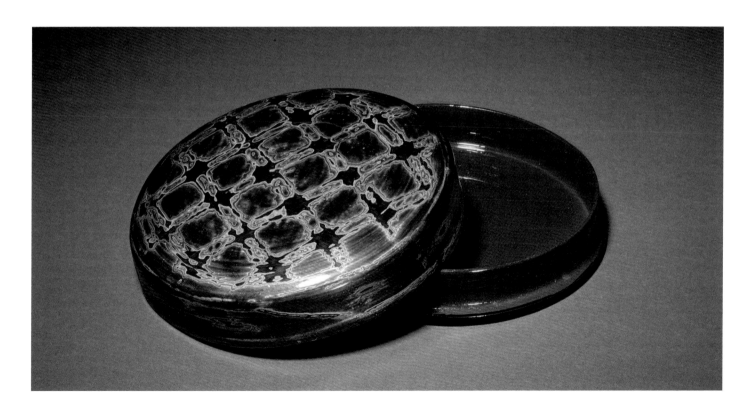

the Thai Phayap Army and the Indian National Army (former British-Indian units that collaborated with the Japanese), the Japanese moved quickly to overtake British positions in Moulmein (Mawlamyine). Despite concerted attempts by the Chinese Army (British allies) and the United States air force to assist British-Indian troops defending British Burma in the south and northeast, the Japanese moved into key positions, cutting Lower Burma off from the rest of the country. Having returned from Japan, Colonel Aung San was keen to secure independence for his country and in December 1941, he helped form the BIA to fight against the British. When word reached British authorities that Aung San's army and Japanese troops had entered British Burma from the south at Tavoy (Dawei) in January 1942, an evacuation order was given, and Rangoon quickly emptied, with most European, Indian and Anglo-Burmese communities affiliated with the colonial administration fleeing to India. Army units were readied for fighting, and the Japanese encountered fierce resistance. British units in Burma were issued with detailed maps to aid escape from enemy territory if they were shot down or captured and held prisoner. The maps were printed on silk because the material was easily concealed, silent when in use and durable. On this example (fig. 6.2), one side of the silk depicts Upper Burma and the other shows the central region. It was issued to Private E. Dexter, who was part of the Chindits, special long-range deployment units named after the Burmese word for lion (*chinthe*) that were dropped 250 miles behind Japanese lines in 1944.

Local reactions to the Japanese and the BIA

The sudden retreat of the colonial administration after the Japanese invasion in 1942 sent shockwaves across Burmese society, especially in urban centres. Not only were day-to-day services no longer in operation, but there were no municipal personnel to administer the basic services and needs for those communities who stayed behind. Government officials fled their posts, leaving the inhabitants of the psychiatric hospital and jails, as well as the animals in the zoo, to fend for themselves. Food, electricity and water were in short supply, and transport, logistical and communication infrastructure was deliberately destroyed by the retreating British. On their own initiative, *thakins* (members of the Dobama A-si-a-yone or We Burman Association) among the BIA established their own administrative presence at district centres to fill the gap, replacing British-appointed headmen and officials with members from their own ranks. However, these local administrative units were not linked to Japanese administrators based in the cities, further complicating the ability of people to get the supplies of day-to-day goods they required. Moreover, the BIA became less popular when they started competing locally for essentials. Without direct supplies from the Japanese, the BIA resorted to living off the land and looting local villages, further depleting material goods and removing prized possessions.

Different communities in Burma had various reactions to the Japanese and the BIA. Hard-line Burmese nationalists welcomed the Japanese and the BIA, regarded as liberators. Imprisoned student activists and politicians who favoured a path towards independence were eventually released by the Japanese and thrust into positions of influence. Many were thrilled by the rumours that thirty of their own (including Aung San), later known as the 'Thirty Comrades', had successfully contacted the Japanese and formed part of the invasion force. While the BIA and the Japanese were initially welcomed by many who questioned British rule, most of the population remained apolitical, focusing on the challenges of surviving the dire consequences of war. To complicate matters, many in the BIA were distrustful of the Japanese and wary of their military police – the Kempeitai – who were prone to execute anyone suspected of anti-Japanese sentiments. Communist sympathisers, whom the Japanese regarded as security threats, armed themselves in preparation for likely persecution. Others were suspicious of the BIA, which had arrived under the support of another

6.2
Map of northern Burma, early 1940s.
Probably Britain or India. Synthetic
silk-like material. H. 56.1 cm, W. 70 cm.
Imperial War Museum, London,
EPH 4012.

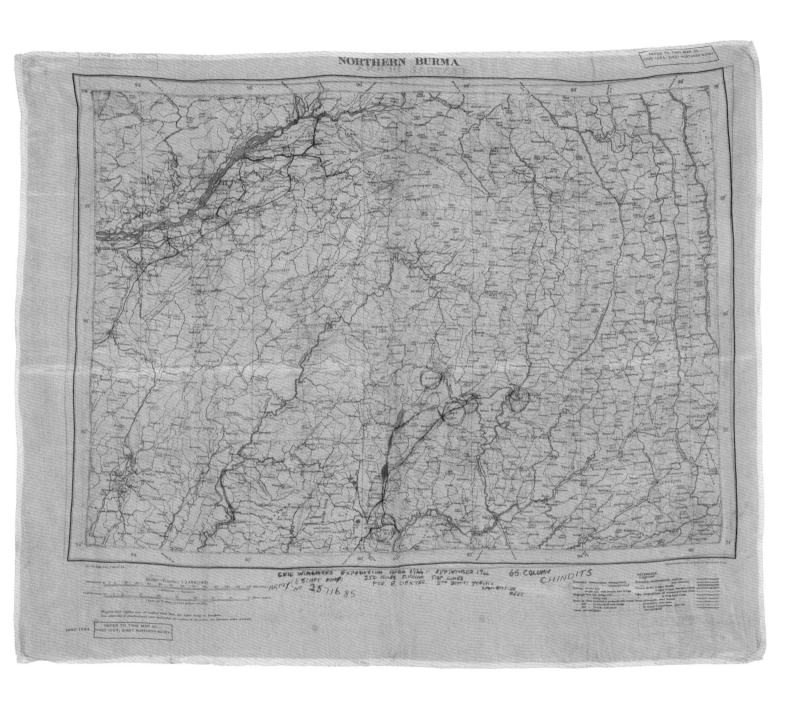

6.3
Karen bag (*hteu*), 1930s. Dali Forest
Reserve near Moulmein (Mawlamyine).
Cotton and wool. L. 115 cm, W. 25.5 cm.
British Museum, London, As 1954,04.3.
Given to Ian Abbey by a village headman
named U Tai Paw; donated by Abbey
in 1954.

imperialistic power and whose membership included trigger-happy radicals, criminals and activists with little connection to, or sympathy for, their local communities.

British sympathisers, often minority groups who had benefited from the colonial system, kept a low profile for fear of being arrested by overzealous nationalists or Japanese agents. Their support for the British can be seen in surviving examples of gifts. Embellished with continuous and discontinuous supplementary weft threads, twined fringes and pompoms, this bag in the British Museum collection was given to the donor, a British soldier, by U Tai Paw, a headman of a village directly east of Moulmein (Mawlamyine) in the Dali Forest Reserve (fig. 6.3). Among Karen peoples, bags were presented ceremonially as gifts to show respect and esteem to visitors and elders.[3] The villages in the region were Baptist, Buddhist and animist, with this bag coming from a Buddhist one. However, the power vacuum left behind by the British caused many minority peoples to feel jeopardised and concerned about the safety of their communities. Japanese persecution against pro-British communities was real, but the threat coming from local anti-colonial nationalists was considered even greater because of the perceived favouritism these minorities enjoyed under the British. During the war, minorities and Burmans often fought on different sides. Many of the disbanded pro-British military units, comprising mainly Karen and other minorities, returned to their homes with their weapons, preparing to defend themselves against an attack from the BIA that finally came in May and June of 1942.[4] The arming of the countryside during the Second World War and the infighting among different communities would have significant political consequences in post-war Myanmar.

The Japanese Occupation

Two weeks after the British evacuated in March 1942, the Japanese established a Japanese Military Administration to manage the affairs of the former colony. Nominal powers

were eventually transferred to a provisional government under Japanese supervision on 1 August 1942, when independence was formally declared by members of an anti-colonial, pro-Japanese nationalist group called the Freedom Bloc. Led by Dr Ba Maw (1893–1977), a former premier with strong anti-British credentials, the new provisional government brought different political actors together from the ranks of the Freedom Bloc, *thakins* and other nationalist groups. This arrangement enabled local politicians, whose own ambitions aligned with Japanese wartime economic and security interests, to step into the political vacuum left by the British. Ruling indirectly through these elites allowed the Japanese to establish administrative policies that increased Japan's access to Burma's natural resources, which were critical to the war effort. For the Burmese, co-operation with the Japanese was predicated on the promise of independence.

Under Japanese oversight, Ba Maw's administration drafted a plan to establish a new cabinet, political structure and economic strategy to meet wartime demands. Presenting their case to the public in patriotic terms, the leadership equated co-operation with the Japanese to attaining independence. A committee drafted a new constitution defining the government's limited powers and outlining regional administrative integration.[5] The new government also unveiled a plan to concentrate labour and land resources to support the war effort via a National Labour Service Bureau and established a central bank. Occupation currency was issued, ranging from one quarter to 100 rupee notes, printed with Japanese and English text with local imagery, including the Ananda temple at Bagan (figs 6.4–6.7). Japanese financial institutions, companies and other banks within the imperial system also set up branches in occupied Burma to support the new system. Japanese firms took over businesses owned by the British and other Europeans but left Asian-owned businesses alone so long as they recognised Japanese authority and production demands. As a result, the economy soon became dominated by Japanese monopolies.

Life for most local communities was extremely difficult during the Occupation. Areas outside immediate military control were rife with lawlessness, as neither the Japanese nor the BIA could suppress roving bands of thugs and thieves. Gasoline for local use was scarce, while Japanese companies dominated railways and rivercraft. Rice, fish, salt, onions and cooking oil – basic needs – were in short supply because of a broken distribution system and the drastic reduction of overseas trade. Half of the cattle population (used for transport, beef and leather) was lost to disease, negatively affecting the rice crop, which dropped well below 50 per cent of its normal production levels. Japanese authorities encouraged cultivators to grow food crops in great demand and provided incentives for new fibre crops. However, poor agricultural conditions, the lack of Indian labour that had contributed to production under the British, and public safety issues created crises in critical sectors that worsened the overall economic downturn.[6]

The situation became more difficult when local communities at the village level were conscripted for menial labour services on military infrastructure, taking vital labour away from the already weakened agricultural sector. In particular, the Japanese needed an overland supply route as they could not risk transporting troops and supplies by sea because of Allied submarine attacks. Therefore, they decided to build a railway link between Burma and Siam (Thailand). The construction of the Siam–Burma Railway required a massive labour force. About 250,000 people, including Burmese, labourers from other parts of Asia and prisoners of war, were forced to work on the infamous project (often called the 'Death Railway'). Running from Thanbyuzayat near Moulmein in Lower Burma to Ban Pong near Bangkok, the railway crossed approximately 420 kilometres of thick jungle and mountainous terrain bisected by rivers and canyons (fig. 6.8). The urgent need to secure the Japanese supply routes resulted in exceptionally harsh conditions; people were forced to work up to eighteen hours a day and inadequate and contaminated food and water supplies resulted in massive numbers of deaths from disease

6.4–6.7 *opposite*
Various denominations of Japanese Occupation money, 1942–5. Paper. H. 5.1–8.1 cm, W. 10.6–16.9 cm. British Museum, London, CIB,EA.104 (donated by the ifs School of Finance); 2006,0405.42 (bequeathed by Andrew Frederick Wiseman); 1996,0217.2489 (purchased from a collector); 1992,0405.1 (donated by Mrs Wilkins).

6.8
Australian and British POWs and Asian labourers laying track on the 'Death Railway', *c.* 1943. Ronsi. Photograph. Australian War Memorial, Canberra, P00406.034.

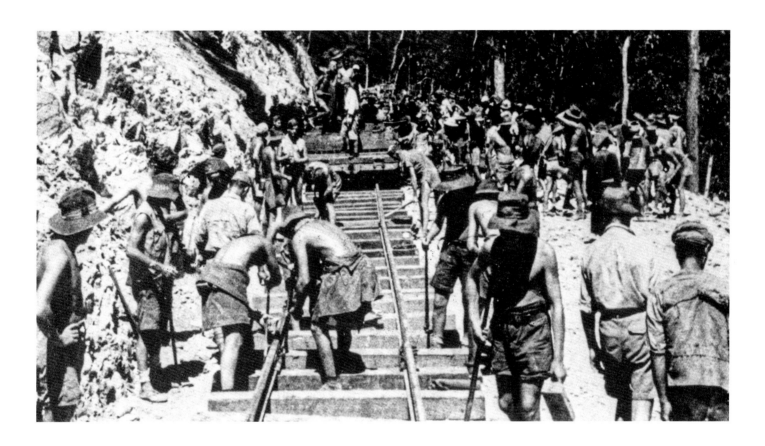

and starvation. More than a third of civilian labourers (approximately 90,000 people) and some 12,000 Allied prisoners died from the horrendous conditions.

During the Occupation, the desecration of Buddhist temples and sacred objects, as well as acts of disrespect towards monks by Japanese military personnel, created public resentment. The Japanese political authorities became aware of their unpopularity. They attempted to alter their public image by renewing ties via trans-Asian cultural links and educational programmes and through the support and promotion of Burmese culture more generally. The East Asia Youth League mobilised Burmese youths of both Burman and other ethnic groups to improve infrastructure and public works. A Greater East Asia

Buddhist Conference convened in Tokyo in November 1943 to showcase Japan's commitments to pan-Asian religions. After the Botataung Pagoda in Rangoon was destroyed by Allied bombing in 1943, a replica was built in Japan as part of this broader cultural diplomacy. These efforts, however, did little to change the public's growing negative sentiment towards the new occupiers, its puppet government and the lack of effective policies to deal with the challenges of war.

Under the new quasi-independent government, the Japanese encouraged the Burmese to promote local cultural forms, languages and histories as part of a broader 'Asia for the Asians' campaign to demote the prestige of British/European influences – yet at the same time, this was an era of devastation for local arts and cultures.

An Institute of Art was established in 1943 to train Burmese artists, particularly in producing military images and propaganda art, enabling the development of commercial and design skills. At the same time, artistic production was severely curtailed, and no exhibitions were allowed.[7] The Japanese Occupation also halted the Burmese film industry. There were few calls for the production of arts and crafts as the country scrambled to grow adequate quantities of food in the chaos and lawlessness of war, and families were forced to sell possessions, such as silver items and jewellery, to purchase essential goods. Many artisanal traditions ceased during the war and were not revived afterwards, such as the production of paper manuscripts (*parabaik*) or the construction of carved wooden monasteries.[8] Government schools for textiles, lacquer and so forth closed as resources were drained from the country to provide for the Japanese war machine. As armies repeatedly advanced and retreated across the landscape, the destruction of cities, villages and cultural sites by foreign powers was tremendous. For example, the British bombed the royal palace at Mandalay in 1945 when the Japanese used it as a headquarters. When the Bernard Free Library in Rangoon was bombed, invaluable manuscripts, inscriptions and works of art were destroyed.[9]

Division among nationalists, and military manoeuvres

Internal divisions plagued Ba Maw's government, continuing rivalries that characterised the nationalist movement during British rule. Even though Aung San was appointed Minister of Defence, other *thakins* complained about being left out of Ba Maw's government. At the same time, anyone with communist and socialist leanings was excluded by default due to their perceived ideological differences from the Japanese. Other political stakeholders, especially those who felt more comfortable under British rule, considered the entire administration under Ba Maw inadequate, ill-trained and unable to guarantee their political future.

Ba Maw and others close to him began to see that the Japanese had little intention of ceding power to an independent Burmese leadership. Therefore, Aung San and his allies began to make secret efforts to contact the British in India. Because the Japanese War Office allowed Aung San and his newly formed Burma National Army (BNA) to work in the field with limited oversight from Japanese Command, it was possible to form secretly the Anti-Fascist Organisation (AFO) – an alliance of socialists, communists, ethnic resistance fighters, BNA soldiers and community leaders – to fight against the Japanese Occupation. This coalition of anti-Japanese fighters would evolve into the Anti-Fascist People's Freedom League (AFPFL), a loose alliance of stakeholders (civilian and military) who would become the dominant organisation representing 'Burmese' interests to the British after the war. Communication was soon established with Lord Louis Mountbatten, the British admiral leading the Southeast Asia Command.

The BNA and other fighters were accepted as an Allied force that would fight alongside Mountbatten against the Japanese in 1944. The combined Burma forces were renamed the Patriotic Burmese Forces (PBF). When the Allies mounted several operations to retake Burma in early 1945, the Burmese attacked unsuspecting Japanese patrols, supply lines and other assets. The decisive moment came in the battles of Meiktila and Mandalay, where the British successfully pushed the Japanese out of Upper Burma. On 28 March the PBF revolted against the Japanese army and struck their stragglers and supply lines from behind. By May 1945, Rangoon had been recaptured by the British.

Chinese, Americans, Indians, Kachins, Karens, East Africans, British and Gurkha troops participated in the highly destructive battles to oust the Japanese, who were supported lightly by the Thais. One photograph shows Gurkhas marching past the Shwesandaw stupa in Prome (Pyay) en route south in the battle to recapture Rangoon in 1945 (fig. 6.9).[10] A Union flag rolled up in a silver presentation box was gifted to King George VI to celebrate

6.9
Gurkhas of the British Army march past
a Buddhist site, Prome (Pyay), May 1945.
Associated Press.

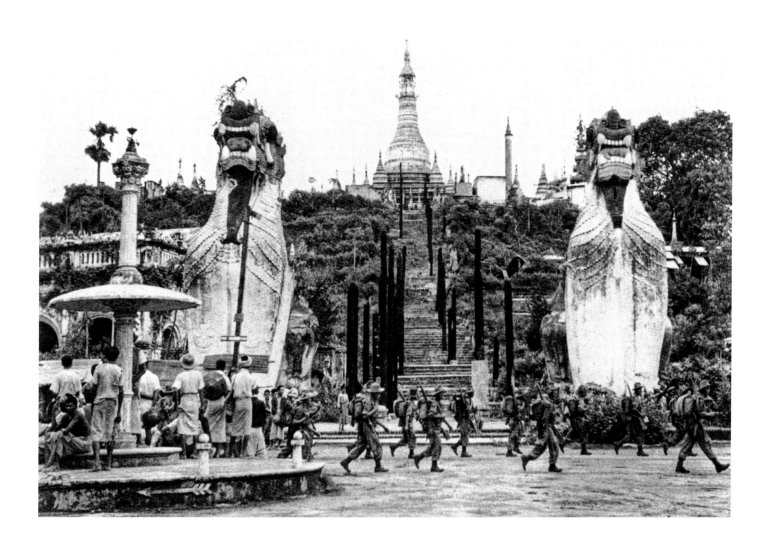

the liberation of the town of Bassein (Pathein) (fig. 6.10).
The flag was the one hoisted over Bassein when it was
captured from the Japanese on 12 May 1945 by troops led
by Major San Po Thin. At the time of the gifting, it was
recorded that Karens had hidden the flag in a grandfather
clock during the Occupation. The flag was felt to be a
source of encouragement during the war. The pro-British
sentiment is clearly expressed by the inscription on this silver
box, which says:

The Union Jack
Hoisted Bassein 12th May 1945
Presented to His Gracious Majesty King George VI
by his humble subjects the Bassein Karens

In May 1945 the British government created the Burma
Star medal to reward those British and Commonwealth
troops who served in Burma between 11 December 1941
and 2 September 1945. This example of a Burma Star was

6.10
Union flag in silver presentation box,
1945. Bassein (Pathein), lower Myanmar.
Cotton and silver. H. 15.5 cm, W. 30.6 cm,
D. 12.2 cm. The Royal Collection / HM
King Charles III, RCIN 70200. Presented
to King George VI by Rev. J.W. Baldwin
on 7 February 1947.

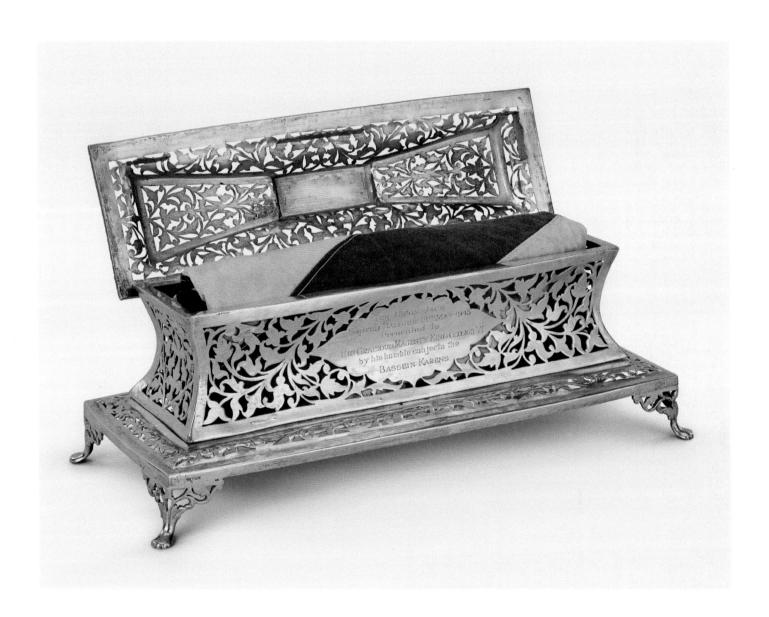

awarded to Ramchandrabahadur Ghale, who also received the Indian Distinguished Service Medal for actions in Burma in July 1944 (fig. 6.11). The medal displays the title of the award with the royal cypher GRI VI (George Regent Imperator the Sixth) surmounted by a crown. The ribbon further identifies the medal with a red centre (the British Army) flanked by orange (the sun) and blue stripes (British naval forces). In addition to being presented to those serving in Burma, the medal was also given to those who participated in specific events in China, Hong Kong, Malaya and Sumatra.

6.11

Burma Star of Ramchandrabahadur Ghale of the 3rd Battalion, 3rd Gurkha Rifles, 1945. Britain. Silk and copper zinc alloy. H. 10 cm, W. 4 cm. Gurkha Museum, Winchester, 2000.09.143. Donated by the Friends of the Gurkha Museum in 2000; probably purchased at auction.

Post-war Myanmar

The surrender of Japan in August 1945 signalled the end of one of the most critical chapters in Myanmar's colonial and postcolonial history. The war brought about the collapse of the colonial state and the rise of the first national army, which would play a significant but controversial role in the future development of the nation state. Aung San and his coalition of anti-Japanese forces would lead the negotiations with Britain to secure immediate independence, a political objective that had both unifying and divisive effects when power was handed over in 1948. Many hard-line nationalists who had fought in the BIA and followed Aung San throughout the campaign sought to cut ties with Britain completely. But other stakeholders, mainly minorities and members of the civil service elite, were less sure about decoupling from Britain, preferring that the British remain custodians until Burma had rebuilt itself. Unfortunately, Aung San was assassinated by a political opponent in July 1947, leaving the country without a clear leader.

The British handed power over in 1948, leaving the country's future in the inexperienced hands of disparate groups such as the radical AFPFL, the communists, returning pro-British civil servants, ethnic separatist groups, a new army and armed militias in the countryside. The country was in economic tatters, with little remaining infrastructure, massive debt and a paucity of material goods. With the British and Japanese gone, the various remaining stakeholders – divided by ethnicity and ideology – began fighting among themselves for the future of the country.

THINKING ABOUT MINORITISED COMMUNITIES

MANDY SADAN

The introduction to this book makes clear that one of its main intentions is to challenge some common (mis)perceptions about Myanmar. One of these perceptions relates to the idea that the country has historically always been relatively isolated. The origins of this idea are fairly easy to trace, and they became embedded from the mid-1960s to the mid-1990s. During this time the country was indeed subject to very tight border controls under the rule of its nationalistic, military government led by General Ne Win (1910/11–2002).[1] Under his rule the Myanmar army staged its first coup, removing the emerging democratic system and putting the modern history of the country on a path towards dictatorship and control.[2] Military rule extended to all social and cultural life with an ideology called the 'Burmese Way to Socialism'. Every aspect of daily life, in theory at least, came under government surveillance, if not entirely under its control.[3] The need to monitor minutely led to the closing-down of cross-border interactions and the introduction of strict limitations on foreign actors entering or remaining in the country. All industrial output and production was nationalised, ending the open economy and most international trade. These policies were intended to foster self-reliance and 'freedom' from the exploitative desires of foreign powers. From them developed the international understanding of Myanmar as a country isolated from the rest of the world.

The realities for local people were serious. Shortages of basic goods became a facet of everyday life. Even buying a new *htamein* or *pasoe*, the generic names for everyday female and male skirt-cloths, required getting a permission note for purchase from the local government store. The gradual deterioration of living standards eventually led to Myanmar being given the status of 'Least Developed Nation' in the 1980s.[4] This, in turn, contributed to the first major popular uprising that aimed to oust the military regime in 1988. However, unlike protest movements in recent years, there were very few images or reports of these tumultuous events in the international media, consolidating the impression that Myanmar was a country largely impenetrable to the international gaze.[5]

The Burmese Way to Socialism described the idiosyncratic set of economic, cultural and political policies that defined the military regime's rule from the 1960s onwards. Isolationism was therefore a policy of relatively recent origin. However, this period of modern rule set the framework for thinking about Myanmar because its claims went beyond this relatively recent time. The Burmese Way to Socialism required the reinvention of Myanmar's history to justify the ideological position of the military government. The narrative was that the country's isolation was needed as a historical corrective to the negative experience of colonial rule. Myanmar had always been proudly independent and relied on its own resources; the Burmese Way to Socialism was an attempt to reinstate that historical reality of autonomy and self-reliance. The militarised ideology also emphasised that precolonial Myanmar had historically been a regionally dominant power. Its armies had once laid waste to the centre of Thai power, and it was expanding territorially when British colonisers entered its domains.

While reflecting some historical realities, the nationalist claims of the Burmese Way to Socialism were increasingly rooted in a xenophobic rhetoric that had gained traction in popular resistance to colonialism from the 1930s onwards.[6] The tragic outcome is seen in recurring cycles of populist violence against communities that have been deemed to be 'foreign'. This is the same ideological trajectory that attracted global attention and condemnation in 2017 when it was used to justify extreme acts of violence against the Rohingya people, who have been castigated as 'interlopers' from Bangladesh. What emerged from the late colonial era was an ideological system that emphasised historical and contemporary Myanmar's autonomy, downplaying the contributions of other nations or cultures in its emergence.

British colonial rule was viewed as a critical historical marker in state discourse for what would happen if Myanmar lost its autonomy to outsiders again. Myanmar's colonial experience was one in which a foreign power

Previous pages
A bridge in Putao, Kachin State, on the
route to Mt Hkakabo Razi.

7.1
Rice merchants in Rangoon (Yangon),
early 20th century.

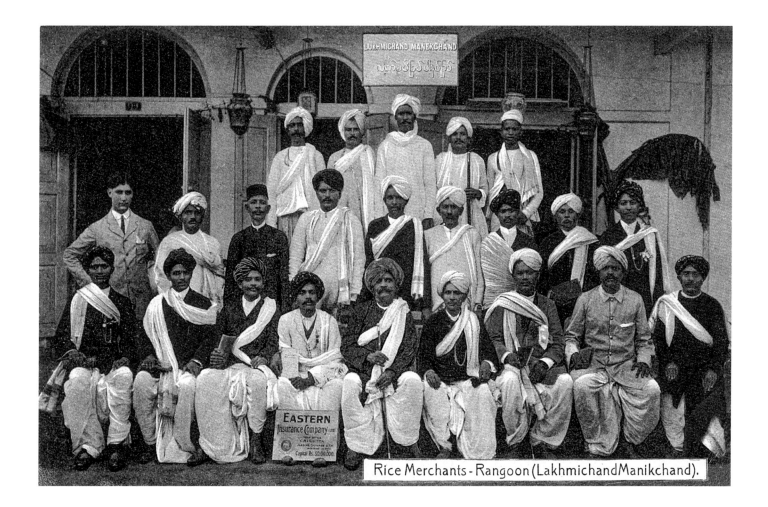

Rice Merchants - Rangoon (LakhmichandManikchand).

placed the state under the governmental authority of British India, exploited its resources and diverted its economic development to its own needs. Populations of South Asian or East Asian origin in Myanmar increased during the colonial period. Indian people filled a variety of positions in British Burma, including as labourers and in business, as seen here (fig. 7.1). They were easily categorised as interlopers who had entered the country riding the Trojan horse of colonialism.[7] An emergent perception of these populations focused on the extractive and exploitative role of immigrants rather than the interactions and connections they stimulated within Burmese society.[8] Communities and individuals of South Asian origin seemed to dominate key sectors such as rice production and administration.[9] Communities and individuals of East Asian origin, especially those from China, were castigated as being concerned only with developing networks for trade and business, which were viewed as closed to Burmese participation because of distinctions of language and culture. In this rhetoric, historical relations between Myanmar and its neighbours were distorted by colonialism.

The Burmese Way to Socialism was perceived as having a responsibility to remove this negative influence so that the country could unlearn the feeling of being dominated and exploited. The newly independent nation also had to relearn the historical 'truth' of Burmese cultural, political, social and economic dominance as a regional power.

This reimagining of Myanmar's history has been compelling for Burmese people since the 1960s. Its power comes partly from the control of the education system in which students learned this narrative as a historical fact.[10] When combined with high levels of propaganda and censorship across all areas of life, 'history' was not a subject of inquiry and discussion but instead functioned as a narrow project designed to support the nationalist military state. The newly independent Burmese state was neither unique nor alone in this endeavour to create an understanding of 'history' that supported the vision of the new nation.[11] All the newly recognised states that emerged from the Second World War period in Southeast Asia engaged in a similar process of writing national histories, with the primary purpose of justifying territorial boundaries and a dominant cultural ideology of nations emerging from colonial control and war.

Perhaps more surprising is the degree to which a skewed understanding of Myanmar and its history also shaped international discussions about the country's past in the post-independence period. The Western colonial roots of intellectual endeavours focusing on Burmese civilisation through language, culture and statecraft have long been established in international Myanmar studies. Buddhist iconography, epigraphy and a focus on Burmese kingship were a focus of inquiry by scholar-officials engaged in the colonial state.[12] Evolving eventually into the scholarly activities of the Burma Research Society, founded in 1910,[13] this emphasis was recentred rather than decentred. The distinctiveness of Burmese cultural and political traditions relative to those of neighbouring countries was important for colonial scholar-officials and Burmese scholars who sought to make claims for Burma's self-governance within a British imperial system focused upon India.[14] Only in 1937 did Myanmar achieve administrative autonomy, separate from India, with the establishment of the Burma Office as a distinct entity. While there was a recognition that other cultures, languages, traditions and regional trade had had an important role in the making of a specifically Burmese cultural identity, the acts of interaction or exchange tended to be downplayed to emphasise the Burmese-ness of those cultural interactions. However, the goal of exceptionalising Myanmar during the colonial period to encourage separation from India has lent support to a populist, xenophobic rhetoric with both intended and unintended consequences.[15] This is not the only reason such a refocusing on Myanmar's wider engagements is important – but it is undoubtedly significant. The need to understand more clearly the interactions and influences of the local, regional and global in the making of historical Burma and modern Myanmar is an important intellectual project.

Myths about minority communities and their visibility in Burmese history

As noted, 'Myanmar studies' internationally has, until very recently, tended to focus on the cultural and religious norms of what is identified as 'Burmese culture'. The dominant Burmese culture is viewed largely as a development from courtly culture, although with some interest in the 'folk practices' associated with popular spirits called *nats* (fig. 7.2). Often connected with Buddhist communities, such spirits can be associated with features of the landscape, guardian figures, or named individuals whose mythological histories are often associated with historical royal figures.[16] Yet, Burmese culture is in fact far more diverse than this. There were many different local practices and traditions, as well as varying Burmese dialects.[17] Limitations on research during military government control have hampered our understanding of this rich array of local traditions. Linguistic archaeologists have only recently begun excavating the many spoken Burmese dialects and their

7.2
Nat shrine on Mount Popa, the home of
nat spirits in central Myanmar, 2014.

interactions.[18] The growth of a national education system, extensive rural-to-urban migration, and standardisation of language and cultural norms through the spread of visual, audio and other media have all led to the homogenisation of national identities around select core attributes that are popularly promoted as 'standard' Burmese culture.

Yet, many linguistic and cultural communities were never deemed subgroups of the dominant Burman culture and have become the 'Others Within' in the new state. Some of these had rich textual histories and played a significant role in the historical development of religion and Burmese statecraft. The Mon people, for example, lay claim to a much longer historical presence in mainland Southeast Asia than Burmans, who were, relatively speaking, rather late arrivals in the central Irrawaddy heartlands, where the core of Burman culture is deemed to reside. The Mon people claim to have brought Buddhism to this region, and their impact is seen at Bagan.[19] The Shan states were

also influential communities in the cultural, economic and political life of early Burmese kingdoms, having their own literary and religious traditions and settled political and agricultural life.[20]

Other communities had less visible influence but interacted extensively with the settled kingdoms of the region. These groups have been categorised as Hill Tribes and grouped within ethnic categories that minoritised them. Minoritisation is the process by which a community is identified as a minority in relation to another identity deemed to be the majority and therefore 'normative'.[21] Implicit in the term, therefore, is the notion of a subordinate–dominant relationship with the majority.[22] Because of this, minoritisation also carries connotations of marginalisation and, often, persecution or vulnerability to structural oppression. Structural oppression can take many forms, but a good example would be the control of the teaching of history that marginalises or excludes the minoritised group or considers it only in the context of what it has contributed to the history of the majority. Another area of structural oppression is the refusal to allow the teaching of minoritised languages or their use in the education system, even in areas where the minoritised language is spoken by the majority.[23] Until recently, it was impossible to study the histories of minoritised communities in the Myanmar education system or teach in languages other than Burmese. The state engages in forceful 'Burmanisation', where the Burmese language and Burman Buddhist cultural values are imposed upon other languages and cultures as a part of nation-building. While some relaxation of these policies was occurring before the most recent military coup in February 2021, this situation reflects the experience of most minoritised communities in Myanmar.[24]

Myanmar is considered to have one of the most diverse ranges of minoritised communities in Southeast Asia. Today, the government officially recognises 135 Indigenous ethnic groups in Myanmar. These are grouped into eight national races,[25] reflecting that, after independence in

7.3 *opposite top*
James Henry Green, A group of Falam Chin men, 1920s–30s. Falam, Chin Hills. Photographic print. H. 19 cm, W. 25 cm. James Henry Green Collection, Brighton & Hove Museums, WA0581.

7.4 *opposite bottom*
James Henry Green, Chinghpaw (Jinghpaw), Yawyin, Maru and Lashi women, 1920s–30s. Photographic print. H. 8.5 cm, W. 12.5 cm. James Henry Green Collection, Brighton & Hove Museums, WA0671.

1948, Myanmar was constructed geographically into seven ethnic minority states or divisions and the central Burman-dominated regions (see fig. 0.2).[26] These regions were named after the largest ethnic categories that had been identified and codified by the British during the colonial period: Shan, Mon, Karen (Kayin), Kachin, Chin, Karenni (Kayah) and Rakhine. Yet, within each state, these ethnic categories were mapped onto a large number of subgroups. For example, in the Kachin ethnic category, six official subgroups were recognised: Jinghpaw, Lachik (Lashi), Zaiwa (Atsi), Lisu, Nung-Rawang and Lhaovo (Maru).[27] Categorisation was facilitated by the shots photographers such as Colonel James Henry Green set up to show the diversity of dress among the highland communities (figs 7.3–7.4). However, such ethnic maps were deceptively simple. It gave the impression that all Kachin people lived in Kachin State, for example, and that there was a neat alignment between territory and ethnic category. This was rarely the case in reality. For instance, although many Karen people live(d) in Karen (now Kayin) State, far more Karen-identifying people live(d) elsewhere, especially in the delta region in the south and west.[28]

Neither was there always a clear alignment around language use. Although Jinghpaw could claim to be a widely used lingua franca among many well-established Kachin communities in the northern Kachin State, a very different situation was visible next door. In Chin State, the proliferation of local dialects has long been considered an impediment to collective political action to claim greater rights. Local people sometimes failed to find a common local language as they moved from one valley to the next, so extreme was the linguistic fragmentation. In the Shan states, linguistic and cultural diversity was also pronounced. Although the Shan states had clear historical identities that could rival some of the older Burmese kingdoms, the hill- and uplands-dwelling communities that did not identify as Shan were nonetheless brought within the Shan umbrella. Many of these communities had long-standing relationships with Shan chiefs, but the notion of 'Shan' was not limited by the Burmese borders with Thailand or Yunnan in China.

As mobile, migratory communities, their affiliation to the new nation of Myanmar rather than to other forms of authority, within and beyond the Burmese borders, was not inevitable. As a linguistic and cultural patchwork of communities with diverse affiliations and historical alliances in a challenging geography, post-independence Shan State became one of the most difficult regions for the nationalist Burmese military government to assert its control in. This is one of the reasons why it has been so important as a site of resistance among a variety of armed ethnic organisations and militia groups throughout the whole of contemporary Myanmar's history.

National races were recognised as distinctive to the formation of modern Myanmar in the post-independence constitutions.[29] Recognition of such status was granted with the idea that they existed as territorially defined communities before the British colonial interventions started in the 1820s. This historical reference point has become a particularly problematic issue in relation to ideas of citizenship and claims to rights. Some communities were not given official status as national races, and they have had to navigate identity politics in modern Myanmar in various ways. For example, Naga-identifying communities in the hill regions between northern Myanmar and northeast India were not given this status. In the early years following independence in 1948, there were many demands that the Naga Hills be recognised as a distinct minority region in postcolonial Myanmar. Yet, Naga identity politics has long been considered with suspicion by governments in both Myanmar and India, where struggles for recognition with the post-independence Indian state have been as violent and problematic as with the Myanmar military.[30]

Other groups without a claim for territorial recognition were also part of this complex tapestry of minoritised communities. For example, Gurkha communities were well established in several parts of post-independence Myanmar. Partly this was because of the settlement of soldiers from the Gurkha Rifles, who were an important part of the colonial military infrastructure. However, relations with

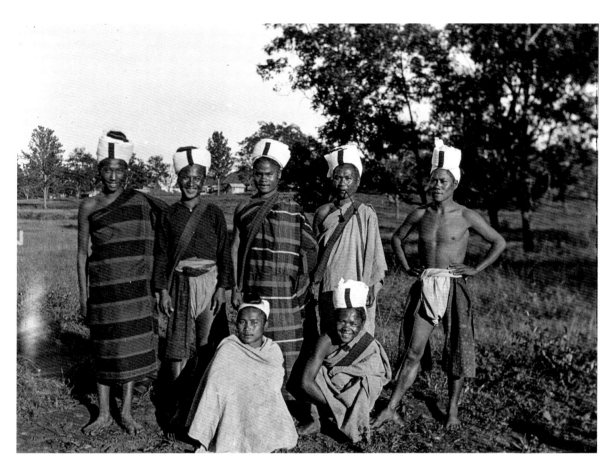

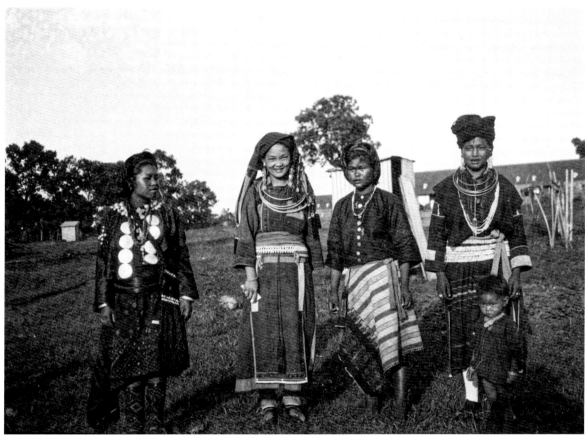

7.5
James Henry Green, Kachin chief's
house fortifications, 1920s–30s.
Photographic print. H. 10 cm, W. 14.5 cm.
James Henry Green Collection,
Brighton & Hove Museums, WA0328.

communities across the wider Himalayan regions had long
preceded this. The active trade routes from southwest China
across what are now the northern states of Myanmar into
the Himalayan states were vibrant and long-standing. In the
1950s Gurkha communities pressed for fuller recognition as
an official minority community but were unsuccessful.

The most tragic case, however, is that of the Rohingya.
The porous interstate spaces across land and sea at the
northern reaches of the Bay of Bengal had for many
centuries seen people from this area move back and

forth between the polities of Bengal and Arakan. This
historical reality was denied when the Rohingya people
were identified as contemporary interlopers by xenophobic
modern Myanmar nationalists, targeting their religious
and ethnic identity with genocidal intent. The Myanmar
government also does not acknowledge the Rohingya as an
ethnicity, referring to them as Bangladeshis and refusing
them citizenship.

When the focus is shifted away from the ideologically
and culturally dominant Burman identity, a rich cultural

7.6
James Henry Green, Kachin burial
mound (*lup sen*), 1920s–30s.
Photographic print. H. 16.5 cm, W. 12 cm.
James Henry Green Collection,
Brighton & Hove Museums, WA0343.

landscape emerges. This richness reflects the interactions
of regional and global trade routes and connections over
an extended historical period and the diverse communities
that are distinctive for not being 'Burman' even though they
may have Burmese citizenship (or not, as in cases such as the
Rohingya). Aside from the Mon and Shan, however, many
of these communities are not easily visible historically or
materially, partly because their cultural productions were
not collected or investigated by colonial officials or, later,
the modern Burmese state. For example, some Kachin
peoples built houses with stone fortifications around them,
as can be seen in this photograph of the home of a chief
(fig. 7.5). There are also stone burial mounds and earthworks
associated with the graves of important Kachin figures
(figs 7.6–7.7). However, colonial officials did not investigate
such sites, as opposed to others considered historically
important such as the brick temples of Bagan. Unlike
Buddhism in Myanmar, other religions and religious
practices, as mentioned above, are little studied outside
local communities, if at all, and associated objects have
not been collected for museums generally. Furthermore,
many ideas, practices and objects are being discarded
in part because Christianity increasingly dominates the
local landscape. Kachin beliefs and material culture
associated with ancestor spirits and spirit mediums (*myihtoi*)
are examples of the loss of cultural elements (fig. 7.8).
Other examples include the Chin practices associated
with death, which involve erecting memorial posts for the
deceased (figs 7.9–7.10). When produced in wood, these
objects commemorate specific people or sometimes whole
families, and those in stone also record histories and rituals,
functioning as archival documents in societies where oral
traditions still predominate.[31]

This lack of interest in cultures other than Buddhist
Burmans has led to the second predominant myth on the
making of contemporary Myanmar: that non-Burman
communities are of lesser civilisational development and
have therefore made little or no positive contribution to
the emergence of the Burmese state historically, other than

as border guards or military groups that could facilitate
or disrupt trade routes as their own set of narrow and
selfish interests determined. The nationalist narrative of
Myanmar's history relates that these communities were
given an enhanced status by the alliances that martial
hill-dwelling communities forged with the colonial
military state. The fact that Kachin, Chin and Karen men
predominated in the British colonial regiment called the
Burma Rifles – and even fought alongside Western forces
against Burmese loyalists (who for a while fought alongside

7.7
James Henry Green, Kachin burial
trench, 1920s–30s. Photographic print.
H. 12 cm, W. 16.5 cm. James Henry
Green Collection, Brighton & Hove
Museums, WA0161.

the invading Japanese) during the Second World War – is used as evidence of their supposedly conflicted loyalties to the Burmese state, an understanding that has become a nationalist myth. Furthermore, the fact that several prominent minoritised groups showed a strong conversion rate to Christianity was also taken as evidence of their Otherness and failure to integrate into, and appreciate,

the cultural value of dominant Theravada Buddhist religious practices. The reality is much more complicated. Conversion to Christianity was not something that the British colonial state encouraged as a policy, especially within the military. There were frequently frosty relations between Christian missionaries and colonial officials. The latter could see how conversion was sometimes disruptive

7.8
James Henry Green, *Myihtoi* (spirit
medium) altars, 1920s–30s. Kachin
regions. Photographic print. H. 16.5 cm,
W. 12 cm. James Henry Green Collection,
Brighton & Hove Museums, WA0308.

of local political authority and could lead to community divisions and tensions. However, the Christian missions filled an important gap in these regions. They were often the sole providers of education, both vocational and at lower levels in the Burmese national education system. This image of a school and church built close together demonstrate how the two often went hand in hand (fig. 7.11). As such, becoming Christian was often part of a broader social shift in which local villagers in rural upland and hill-dwelling communities could access routes to other forms of economic and social advancement. The timeline for whole-community conversion was not as linear or rapid as the national (and ethnonational) historical myths may claim. For example, while there were undoubtedly early Christian converts in the Karen region from the early nineteenth century, most Karen-identifying individuals remain Buddhist. However, their residence in more broadly distributed villages and closer integration with Burman and Mon communities have tended to downplay the significance of this. Furthermore, the majority of Chin and Kachin conversions has taken place in recent decades in response to experiences of marginalisation and minoritisation and to support ethnonationalist resistance to what is seen as an aggressive colonising modern state.

It is clear, therefore, that many myths have proliferated about what Myanmar is today and what it was historically. Moreover, the narrative constructed around minoritised communities is frequently discriminatory and marginalising. One of the aims of this book is to challenge these myths, although how to do so is not always easy to decide.

The challenge of displaying minoritised cultures

In recent years engagement with collections of national and international significance, such as those at the British Museum, Victoria and Albert Museum and Brighton & Hove Museums in the United Kingdom, and the Denison Museum in Granville, Ohio, United States, has moved significantly beyond representations of objects as having a singular meaning in time and space. There are new levels of public consciousness about how political and cultural shifts can affect how objects are understood and given meaning. This is particularly important in relation to collections acquired mainly in the context of colonial and sometimes neocolonialist opportunism. The visibility or invisibility of particular places,

people and perspectives has become an important challenge for curators who want to respect the historically contingent nature of objects and collections but also to show their discursive and fluid qualities over time and space.

At the time of writing, it is impossible to discern a clear or even likely outcome of the present political upheavals in Myanmar. The military coup in February 2021 has thrown the country into a state of violence that has been shocking in its intensity – although neither shocking nor surprising to many minoritised communities in the country who have been at the sharp end of the Myanmar military's violence for decades. Displays of Myanmar arts and cultures in museums and galleries at this time could seek to stand above and beyond the present situation and avoid a simplistic politicisation of its messages and meanings. However, this is difficult when it comes to the representation of minoritised communities. Forms of representation are charged and political because they are deployed to create and maintain narratives of marginalisation. In the absence of other forms of cultural representation, such things matter.

Some of the artefacts in this book illustrate the structures upon which this discriminatory minoritisation has been built. For example, male and female figures, each wearing the 'typical' traditional dress of a recognised minority, have become standard tourist fare (see fig. 4.21). They originated from a colonial setting where vocational subjects taught in mission schools often emphasised the production of tourist-quality artefacts that could lead to income generation. They have subsequently been developed as a form of cheap representation deemed to capture the 'essence' of minority communities through their dress. Many collections of clothing and textiles from the colonial era demonstrate a high degree of local vitality and innovation in dress, form and use of materials (see figs 3.2–3.4 and 5.1–5.13). This kind of collecting fitted a European tradition of amassing many different forms of an object type. The various examples were then used as a way of categorising peoples and their respective levels of civilisation, as well as establishing

the boundaries of cultural areas. However, in the post-war period – in which Marxist–Leninist understandings of cultural distinctiveness were influential across East Asia and many parts of Southeast Asia from Viet Nam to Myanmar – this kind of representation took on new meanings. Under the hybrid influence of British colonialism, Burmese neocolonialism and ideological interest in the cultural demarcations of Marxism–Leninism via Chinese communism, recognition as an 'official' minority was determined to depend on cultural attributes. Communities had to demonstrate that they had a distinctive linguistic identity as well as a unique set of cultural traditions, including 'traditional' dress and other attributes relating to 'life ways'. Without these, formal recognition was not granted when the frameworks of minoritisation were being laid out in newly independent nations of the region after the Second World War.

In this context, it has been important to have a distinctive form of dress – and so much the better

if, significantly, that distinctiveness could be proved historically because the identity being claimed and 'verified' by the state is visible within historical collections, as this photograph of a Chin chief and his wife does (fig. 7.12). It also explains the ongoing interest and importance attached by minoritised communities to collections such as those of the British Museum or Brighton & Hove Museums. However, there are mixed feelings towards the historical mode of their acquisition and the experience of colonisation when set against the current political value of being made historically visible.

How one interprets a collection of objects like the wooden figures (see fig. 4.21), therefore, is complex, and there is in fact no singular way of interpreting them. On the one hand, they represent the flawed essentialisation of minoritised communities, as if their only cultural contribution was through the production of 'traditional' textiles and forms of dress. On the other hand, they can be seen to enter a complex range of competing political discourses. In these discourses, visibility is a way to make claims about territory, rights, autonomy and respect.

Therefore, a significant challenge in an exhibition or display is balancing the competing meanings of representation. Concerning minoritised communities, this is particularly difficult in navigating notions of integration and autonomy. If the myth being deconstructed is the marginalisation of communities within the grand narrative of nation-building, then the primary need would seem to be to demonstrate their role in, and contribution to, the production of that nation. However, this can also perpetuate a central narrative in which other cultures and communities are valued primarily according to the degree to which they play supporting roles. Another point is that separating out minoritised communities can continue to play into their Othering and a sense that they are not fully a part of the country at its core. It is also complicated by the lack of equivalence historically to the central culture, given that so much cultural production from minoritised communities is not preserved over extended time frames.

The lack of a textual or literary tradition makes histories over which they can claim 'ownership' more difficult to represent. Of course, the oral traditions and intangible cultural heritage of these communities provide many opportunities for discussing minoritised groups' historical presence and cultural distinctiveness. However, in a museum setting where visual appeal, grandeur and the 'wow factor' often drive visitor numbers, the representation of historical material culture becomes challenging to achieve beyond the display of textiles. Additionally, a 'spectre of comparisons', where peoples' self-awareness causes them to match themselves against others, can be observed in the competition between groups to be represented in museums as a means to validate their culture.[32]

Therefore, the curatorial challenge is to present a coherent, diverse and inclusive picture of Myanmar's history that demonstrates the richness of cultural production, interactions and connections. Given the multidirectional perspectives needed to represent Myanmar, it is probably impossible to resolve these tensions completely. Yet, raising important questions about how to find new ways of integrating and disentangling minoritised communities from the dominant narrative of the Burmese state intrinsically demonstrates that progress can be made in this area.

The imperative for change in how minoritised communities are re-presented and discussed comes partly from within Myanmar itself. As noted, the outcomes of the present resistance to the military coup of February 2021 are impossible to predict, but what has been apparent is that it seems to have generated a greater degree of sensitivity to the experiences of minoritised communities in their much longer histories of resistance. While leading armed ethnic organisations have frequently been castigated as opponents of the state and as the problem rather than the solution, this perception is starting to change. For example, young people resisting the Myanmar military have been going to areas controlled by armed ethnic organisations for military training. This has resulted in exposure to a situation few of them had previously

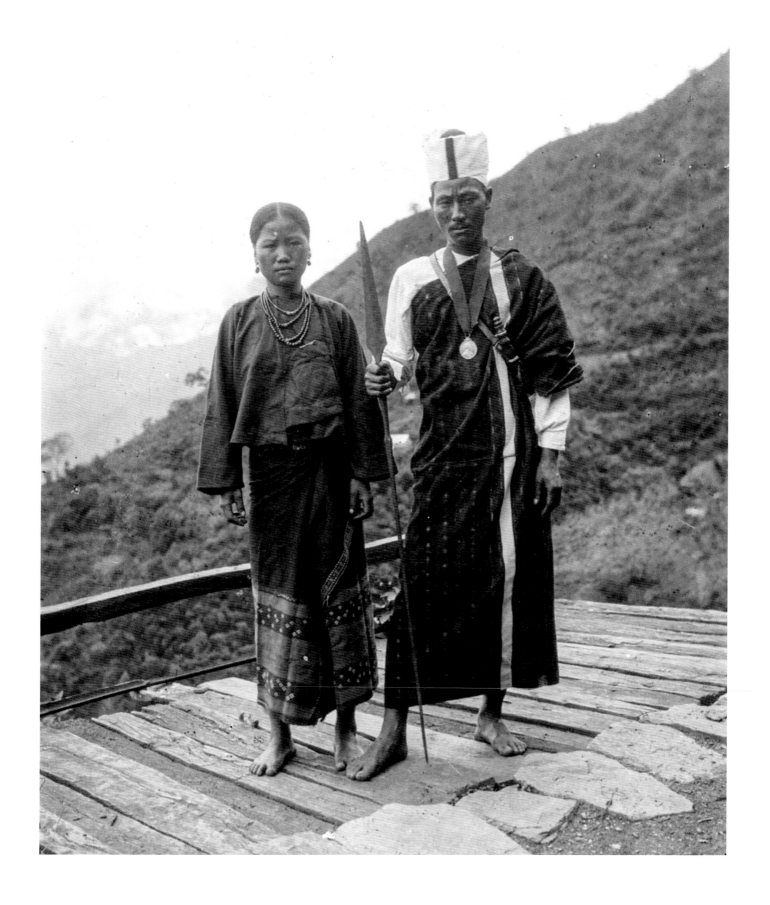

encountered. They report learning about why so many communities have backed the resistance of these groups to the Myanmar military, as well as about their sense of history and their experiences of discrimination and loss of land, resources and rights as the Burmese state has exerted its power.

Most people in Myanmar are familiar with a singular narrative about the relationship of minoritised groups to the newly emerging independent nation. A critical historical reference point is that of the Panglong Conference held in February 1947, at which several of the leading ethnic minority communities made a strategic decision to ally with the Burmese national movement led by the 'father' of the nation General Aung San to hasten independence. This agreement was rather hastily and poorly developed, but its key concern was to encourage the minority political elites to support a speedy independence with the promise of a federal system as the prize.

The rapid and continuous move away from the promise of a federal system has been the unmaking of trust between minority and Myanmar politicians ever since. For many viewing this from the Burmese centre, the role of Aung San as the initiator and leading force of intelligence in this alliance has been the dominant narrative. The agreement subsequently collapsed because the minorities failed to see that their future lay in supporting and strengthening the independent Burmese state. This has been the dominant myth proclaimed by Burmese nationalist and military historical accounts since the 1960s. From the other side, the failure of the agreement is rooted in the feeling that politicians, especially those associated with the national army, cannot be trusted to honour their promises and are motivated by a desire to control and bring all resources for their own use and to strengthen their power. What has been significant since the military coup in February 2021 is that many young people now encounter this different narrative with a degree of empathy that has been previously absent. The nationalist and xenophobic military rhetoric targeting minoritised communities is now visible in the brutalities being meted out against the majority Buddhist Burmans with a similar concern for holding and deepening power.

There is clear evidence that there is now more enthusiasm for unlearning the narratives of history that valorised a single cultural and ideological entity over all others. There is a desire to learn more about the experiences of those marginalised from this narrative or misrepresented in it. This is where the importance of exhibitions, displays and bringing together groups of objects can be seen. This book is part of the discussion about how (un-)learning can take place, even if determining how these mutual conversations can be developed is still a work in progress.

Perhaps the best suggestion is to hold the objects in each chapter up to multiple interrogations and possibilities. How would a minoritised community relate to each? What might their role be in its creation? Where are they visible or invisible? Of course, this would not produce common answers – different communities have different forms and levels of interaction, including with each other – but recognising that there may be alternative ways of narrating each section in line with multiple perspectives is an important starting point.

For example, the resources that constitute stunningly beautiful court artefacts are very frequently derived from interactions with areas that were only under the limited or indirect authority of any Burmese monarch. Amber, silver, gold and other precious minerals were mainly mined in regions that came under other local authorities and were brought into the realm of the court through political relations, tribute, prestige and other interactions (see chapter 1). The mines were typically run by non-Burmans, many local but also frequently from other communities, especially from East Asia, where there was great expertise in mining practices. Even when looking at the high-culture artefacts of Burmese kingship, there is the need to insert new narratives – some of which might be about integration and connection, others of which might remain steadfastly local and tied to other narratives not intimately connected with Myanmar or its court.

A good example of thinking about this in more detail is perhaps through a consideration of jadeite objects (see fig. 1.4). Although these artefacts may be labelled 'Burmese' or sometimes of 'Chinese origin' and gifted or traded, the stones originate in the mines of what is today Kachin State. The history of jadeite mines is poorly understood within Myanmar (and outside it), which is significant given the importance of this gemstone to the cultural and political development of China, as well as the social, political and economic development of the Kachin region, and indeed of Myanmar as a whole. In recent years, attention has come to be focused on the jadeite mining region of Hpakant as a site where drug misuse is rampant and exploitative extraction policies have devastated the local landscape irreparably. In reality, this situation became entrenched only following the opening of Myanmar to foreign trade and investment and the exploitative joint-venture and other extraction companies that introduced heavy machinery to extract a finite resource. This industrial-scale mining and the resulting environmental calamity has occurred mainly within the last twenty years.

However, before the mid-1990s, jadeite extraction was predominantly controlled by Kachin miners, who engaged directly with stone traders from China. A deep and rich culture had developed around the mines in which these wider interactions were part of everyday reality. Control by the Kachin Independence Army, one of the largest armed ethnic organisations, meant that those who wanted to trade using the output of the mines were able to do so, and the mines themselves provided a vital source of income for households across the region in a setting of conflict.[33]

When looking at this history of jadeite mining, much more is revealed about the interactions of Kachin communities with a broad regional trade over an extended period and how Kachin political history was also influenced by the fluctuations of the international jadeite trade over time and space.[34] Jade objects therefore open up important new questions about the different forms of connection that took place not just between the Chinese and the Burmese courts but with a host of other communities. Many of these people held substantial influence over key local trade routes and developed significant expertise in interactions between humans and the environment. Yet, they have been made invisible through the ongoing presentation of myths promoted by the military and other nationalists.

So many artefacts in this book could be subjected to similar inquiries. For example, textiles are a rich source of information about interactions and exchange (see chapters 3 and 5) as well as boundary-marking. Objects can be re-presented where they draw on resources that must have been traded or on skills that were possessed only by specific communities, such as carving, textile production or blacksmithing. The impact of this extraction, trade or skill on the community must be understood in greater detail. In this way, there is a disentangling of much more complex but insightful narratives that have been hidden from our understanding by a historically narrow focus on either Myanmar's courtly and religious culture or the Othering of the cultural output of minoritised communities. From these kinds of explorations over time, new histories of Myanmar that are more inclusive, more diverse and more encompassing of richness and complexity will slowly emerge, just at the time when its political actors require such a knowledge base upon which to build a more sustainable and peaceful future.

MATERIAL CULTURE
AFTER INDEPENDENCE

ALEXANDRA GREEN & ANONYMOUS

On 4 January 1948 Burma achieved independence from Britain. When the British departed, the country was devastated economically and physically, with a high level of debt, extensively damaged or destroyed infrastructure, and faced with the daunting task of uniting numerous disparate groups that had never been part of a single state. The negotiation process for independence involved multiple stakeholders, complicating the path to freedom. The British had administered the highland regions around the lowland river valleys separately as the Scheduled Areas. In 1946 these regions had been renamed the Frontier Areas and established with their own administration. In February 1947 the Burmese interim government, led by General Aung San (1915–1947), convened a meeting at Panglong in the Shan states. The gathering brought together leaders from the Frontier Areas, including Shan *saohpas* (rulers) from the Shan States Federation, as well as Kachin and Chin representatives, to discuss their future relationships. During the Panglong meeting, it was agreed that, with independence, the Frontier Areas would come under the Burmese central government for matters such as defence and foreign relations but would retain full internal autonomy.[1]

At independence, Burma assumed the territorial shape it possesses today. Nevertheless, the country soon became embroiled in civil wars as the new government faced challenges from various quarters. Widespread ethnic rebellions,[2] the Burmese Communist Party, and remnants of the Chinese Guomindang army, who had fled following their defeat by the Chinese Communist Party after 1949, all posed significant obstacles. The coalition that formed Burma in 1948 was inherently fragile, requiring skilful leadership to unite the disparate elements. Unfortunately, such leadership was lacking, exacerbating the challenges faced by the nation. In response to these struggles, General Ne Win (1910/11–2002), as the commander of Burma's state military, the Tatmadaw,[3] took steps to enhance weaponry and establish command and administrative structures. These efforts eventually enabled the army to assume control of the state in 1962, a position it maintained until 2011 when a power-sharing arrangement between civilian and military elites ushered in a period of semi-democracy. The hiatus was short-lived, however, as the military seized authoritarian control over the state again in 2021.

Independence and the early years of modern Burma: 1947–62

Before independence, General Aung San emerged as a prominent political figure. During his student years, he exhibited remarkable political energy and dedication, exploring various political concepts and ideologies. He helped form multiple political parties and organisations, including the Communist Party and the Burma Socialist Party. Initially, he aligned with the Japanese forces during the war, hoping to expedite the end of British rule. However, Aung San's stance shifted when it became clear that Japanese support for Burmese independence was insincere and that their side would likely lose the war. He then led the Anti-Fascist People's Freedom League (AFPFL) to victory in the April 1947 election of the Constituent Assembly, a transitional measure agreed to by the British government in response to the AFPFL's demands for independence. Tragically, Aung San and most of his executive council were assassinated on 19 July 1947, mere months before full independence. The evidence pointed to U Saw, a political opponent, as the primary suspect in the assassination.

Aung San's untimely death cast a shadow over the country's independence in 1948, as he was widely revered as the founder of modern Burma for his pivotal role in liberating it from British rule. There are actually few photographs and images of Aung San remaining. A rare plaster bust of him was found at a temple shop in Mandalay in 1988 (fig. 8.1). Plaster busts were a common production in socialist countries during the Cold War. More prevalent from the 1940s to the 1980s was the same portrait of Aung San featured on banknotes (figs 8.2–8.5),

demonstrating his significance to conceptions of the nation state. These banknotes combined Aung San's image with other elements that represented Burmese national culture, such as peacocks – which were associated with the Konbaung dynasty (1752–1885) and later became symbols of the Burmese nation and its struggle for democracy – as well as *chinthe* (lions) and so forth. Notably, the imagery on the banknotes predominantly reflected the majority Burman Buddhist context rather than providing equal representation of the diverse cultures within the country. This early trend set a precedent for Burmanisation during the nation's formative years. When Aung San's daughter, Aung San Suu Kyi (b. 1945), emerged as a symbol of resistance against authoritarian dictatorship through her charismatic participation in the 1988 uprising against the military government, Aung San's image was removed from the banknotes. Only in 2019, following the consolidation of power by a democratically elected government unofficially led by Aung San Suu Kyi as State Councillor, was Aung San's picture reinstated on banknotes.

Aung San's assassination in 1947 did not halt the momentum towards independence. The Constituent Assembly ratified the Constitution in September of that year. Sao Shwe Thaik (1896–1962), the *saohpa* of Yawnghwe in the Shan states, was chosen as the president (1948–52), and U Nu, who had been involved in politics since his days as a student at Rangoon University in the 1930s, became the prime minister (1948–58 and 1960–2). The Assembly unanimously voted against joining the British Commonwealth. The Anglo-Burmese treaty was signed in October 1947 and took effect in January 1948 after being voted through the British Parliament.

At the Panglong meeting in 1947, the Shan, Kachin and Chin region representatives had agreed to join the newly formed Burmese nation. However, the failure to uphold the agreement's promises of internal autonomy and the right to secede was seen as a betrayal and fuelled separatist movements and civil conflicts in the following years. The Karen peoples, who were not part of the agreement, began

fighting for an independent state in 1949, and other groups followed suit in the 1950s.[4]

A typical Shan bag that was given by President Sao Shwe Thaik to James Henry Green (a retired colonel of the British army once tasked with mapping Kachin regions) during an official visit to Britain hints at the uneasy alliances that formed the country upon independence (fig. 8.6). Woven with silk supplementary weft yarns, the cotton and silk bag promotes independent Burma on one side and, on the other, an independent Namkham of the Northern Shan States (NSS). Yet, others were also subsumed into the nation state without due consideration in 1948. For example, the Mon and Arakan areas – marginalised in history following annexation by the central Myanmar court and subsequent colonial rule – only gained political recognition twenty-six years after independence, with the 1974 Constitution.

The 1950s proved to be a challenging period for Burma. U Nu, leader of the coalition AFPFL party, struggled to govern effectively and establish robust state institutions.[5] The economy remained reliant on rice exports, as it had been during the colonial era, and was vulnerable to fluctuations in the international market. Furthermore,

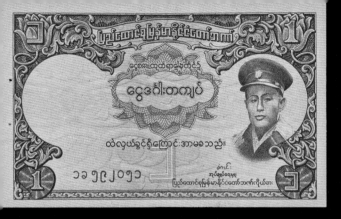

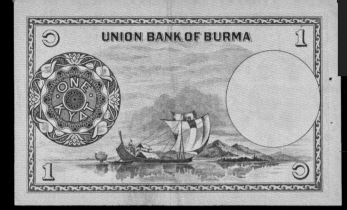

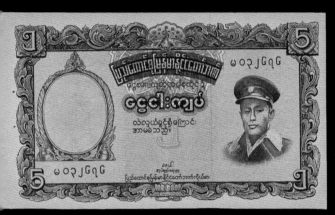

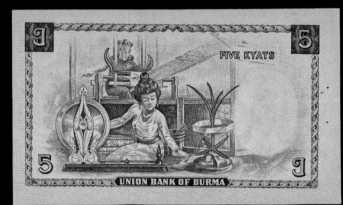

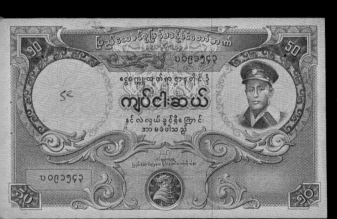

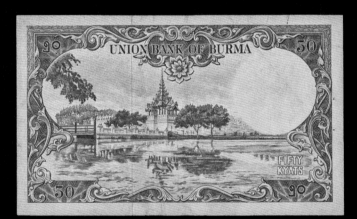

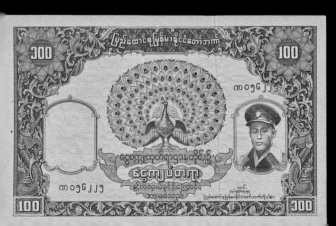

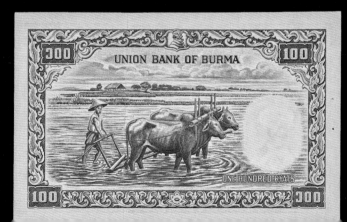

8.2–8.5
1 kyat, 5 kyat, 50 kyat and 100 kyat
banknotes with images of General
Aung San. 1940s–80s. Paper.
H. 6.6–10 cm, W. 10.8–16 cm. British
Museum, London, 1989,0904.4567–8
(bequeathed by Carlo Valdettaro);
1984,0605.2067–8 (purchased from
the dealer William Barrett).

8.6
Commemorative bag, late 1940s–52.
Shan State. Cotton and silk. H. 25 cm
(without strap), W. 24 cm. Brighton &
Hove Museums, WAG000005. Given by
President Sao Shwe Thaik to Colonel
James Henry Green during an official
visit to the UK in 1952; donated in 1992.

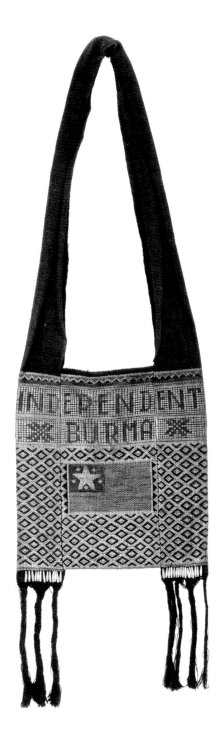

economic control still largely rested in the hands of non-
Burmese entities, including Chinese, Indians, Europeans
and Americans. The implementation of socialist policies
faced obstacles due to the flight of foreign capital. Moreover,
the country faced mounting pressures arising from the
Cold War. As Burma slid towards chaos, Ne Win and the
armed forces assumed the role of a caretaker government
for six months in late 1958, aiming to restore order and
reduce bureaucratic inefficiencies and corruption.[6] The
caretaker government proved highly effective and had
its term extended for an additional six months. After the
restoration of a civilian government with U Nu as prime
minister in 1960, political, economic and social issues
resurfaced, and discussions regarding replacing Burma's
unitary constitution with a federal one gained momentum.
The military coup of 1962 was substantially in response to
U Nu's idea to give minoritised groups greater autonomy.
This caused the military to envisage the collapse of the
country, because the union was predicated on the concept
of including eight national races. Presumably, the military
also feared the loss of various resources, such as gems,
jade, amber, silver and teak (see chapter 1) as, indeed, the
successor regime today might be concerned about rare
earths predominantly located in the various ethnic states.

However, despite the political turmoil and the ongoing
struggles against political fragmentation, Burma in the
1950s experienced a notable level of cultural and economic
vibrancy. For example, although there were restrictions
on importing Burmese-language materials from abroad to
curb the influx of propaganda from China and the Soviet
Union, the national press remained relatively unrestricted,
with challenges pursued through legal channels.[7]
There were over thirty daily newspapers in Burmese,
Chinese, various Indian languages and English, along
with numerous periodicals, magazines and pamphlets.[8]
The press was used for propaganda purposes internally.
Cartoons, posters and plays were created endorsing various
political and economic policies and cautioning against
foreign political manipulation. The government took

initiatives to promote traditional arts, establishing in 1952 the Ministry of Culture, a state school of fine arts, music and drama, and the combined national library, museum and art gallery known as the Cultural Institute. The latter's objective was to 'strengthen the national unity of Burma by raising the cultural level of the people … and to create an awareness of the cultural heritage of the past'.[9] However, the government's promotion of culture remained primarily focused on the Burman Buddhist (majority) context.

Art and culture, besides being conceived of in a unified sense, were also heavily affected by socio-political events of the nineteenth and early twentieth centuries. This can be seen on a silver tea set presented by Prime Minister U Nu to Queen Elizabeth II during his world tour in 1955, when he sought to demonstrate Burma's neutrality in the Cold War by visiting countries like the United States, the United Kingdom, Israel and Yugoslavia (fig. 8.7). The tea set, including a teapot, milk jug, sugar bowl and tray, displays decorative motifs and arrangements popularised during the colonial period. The knob of the teapot takes the form of a *chinthe*, while scrolling foliage encircles the upper edges and the domed feet of the teapot, milk jug and sugar bowl. The upper band of the teapot depicts vegetation with mythical creatures, a style that emerged in the 1920s and 1930s. The lower edges of the pot, sugar bowl and jug display overlapping acanthus and lotus forms, the former being a European import that gained popularity in British Burma in the late nineteenth century.

The imagery on the sides of the three pieces includes scenes of rural life, as popularised during the colonial period, as well as imagery from the Vessantara Jataka, one of the stories of the Buddha's previous lives. The tray combines openwork motifs around the edge with scrolling vegetation around the centre, featuring flowers similar to those on Indian trade textiles from the seventeenth and eighteenth centuries. It also includes a peacock in full display, symbolising the Konbaung dynasty.[10] The workmanship of the tea set may not match the highest standards of the colonial period, but this is understandable

considering the devastation caused by the Second World War. Much silver was sold or melted down in the 1940s, and the demand for silver decreased after independence.[11] As the country entered an isolationist phase following the 1962 coup and goods became less available (see below), silver bowls were replaced with cheap aluminium and zinc examples, though the designs and patterns remained similar to those developed in the nineteenth and early twentieth centuries. By the late twentieth century, only a few places, such as Yangon, Ywataung in Sagaing Division and Ywama on Inle Lake in Shan State, continued to produce elaborate silver pieces reminiscent of earlier times.[12]

In addition to promoting traditional arts, Burma, before 1962, actively engaged with the international art scene and the wider Buddhist world. Foreign architects were invited to design buildings, particularly in Yangon, resulting in structures that combined international modernist forms with elements of local cultural traditions. Architects such as Soviet Pavel Stenyushin, American Benjamin Polk and British Raglan Squire participated in the construction boom of the 1950s. Squire was commissioned to design the Agricultural Institute at Insein (1954), the Engineering College of Rangoon University (1956) – which included an assembly hall nicknamed the 'Tortoise' due to its curved roof (subsequently demolished) – and a Yangon high school (1956).

Polk was invited to design the Tipitaka Library in the late 1950s as part of U Nu's efforts to forge strong connections between Buddhism and the nation. Constructed from concrete, the library's design reflected Buddhist concepts and numerology, with its four sections symbolising the Four Noble Truths and its three stories representing the Triple Gem: the Buddha, the *sangha* (community of monks) and the *dhamma* (the teachings of the Buddha).[13] The building housed a public library, auditorium, museum and a central sanctuary for meditation and study. Its construction was closely linked to the establishment of the Kaba Aye Pagoda, which was built in 1952 in preparation for the Sixth Great Buddhist Council – a gathering of monks from various Buddhist countries,

8.7
Tea set, 1954–5. Lower Myanmar.
Silver. H. 20.2 cm, W. 32 cm, D. 16 cm
(teapot); H. 10.6 cm, W. 13.6 cm, D. 8.5 cm
(milk jug); H. 9.3 cm, W. 15.5 cm, D. 8.3 cm
(sugar bowl). The Royal Collection / HM King
Charles III, RCIN 49777. Given by Prime
Minister U Nu to Queen Elizabeth II in 1955.

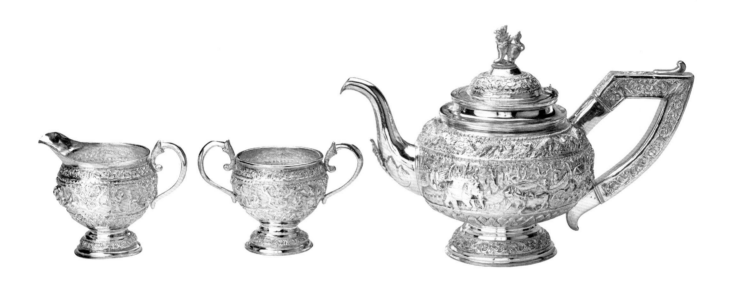

including Cambodia, Laos, Thailand and Sri Lanka, that lasted from 1954 to 1956 – and its completion coincided with the 2,500th anniversary of the Buddha's enlightenment. During this time, the idea of Buddhism as Burma's state religion was promoted. U Nu supported this notion not just because he was deeply religious himself but also because the *sangha* was a powerful institution. Some monks had advocated for Buddhism to be recognised as the state religion in the late 1940s due to its significant following among the population, and certain Buddhist associations strongly opposed the religious freedom granted in the 1947 Constitution.[14] However, the effort to give Buddhism primacy in the 1950s created divisions and alienated non-Buddhist citizens, some of whom were involved in the ongoing military conflicts with the government.

During the late 1950s, Burma came to play an increasingly prominent role at the United Nations (UN). U Thant, who had held the position of Permanent Representative of Burma to the UN since 1957, became vice-president during the General Assembly's fourteenth session in 1959. He later chaired the UN's Congo Conciliation Commission and a UN capital development fund. In November 1961 U Thant was unanimously elected as acting Secretary-General of the UN and, a year later, he became the Secretary-General. During his tenure, U Thant played a crucial role in negotiating between US president John F. Kennedy and Soviet leader Nikita Khrushchev during the Cuban Missile Crisis of October 1962, thereby helping to avert the threat of nuclear war. After completing his first term in 1966, he was re-elected

for a second term that lasted until December 1971. However, General Ne Win perceived U Thant as a threat and, following the latter's death in New York in November 1974, Ne Win ordered for him to be buried without official involvement or ceremony when his body was returned to Yangon. This sparked demonstrations, leading to casualties, injuries and thousands of arrests. Martial law was declared, and the universities were closed for five months.[15] Eventually, after being interred by students and monks and subsequently exhumed by the military, U Thant's body was laid to rest in a simple mausoleum – built in a style typical of modern housing across Southeast Asia – on Shwedagon Pagoda Road in Yangon.[16]

The Burmese Way to Socialism: 1962–88

In 1962 Ne Win set the country on the Burmese Way to Socialism. This unique state ideology fused elements of socialism, Buddhist values, and political isolationism with the belief that it would foster peace, prosperity and unity among the diverse population. However, the outcomes of this ideology fell short of expectations. The socialist policies, including the nationalisation of the economy, resulted in severe shortages of goods such as food, everyday items and materials for artistic production, and there was increasing impoverishment across the country. Most businesses were nationalised, leading to the departure of several hundred thousand Indians from the country in 1964. Indian Burmese individuals were also forcibly expelled under new nationalist policies. While the military claimed to favour the separation of state and religion, in 1966 it ordered the departure of foreign Baptist and Catholic missionaries, priests and nuns or refused to renew their visas.[17]

The military junta continued its efforts to promote a unified Burmese culture through strict censorship, a nationalist agenda and narrow ideas of what constituted 'Burmese art'.[18] State control extended to cinema, publications, music and art to ensure they aligned with, or at least did not undermine, national unity, security, laws,

traditions and morals. For instance, ballet was banned as it was deemed superfluous and too Western. In 1962 the Law on Registration of Printers and Publishers and the Union of Burma Cinematograph Law were enacted, leading to the elimination of private presses in 1963, as well as the closure of Chinese- and Indian-language newspapers.[19] The Library, Museum and Exhibitions Monitoring Act of 1964 further restricted creative expression.[20] In the same year, after persistent requests since the 1950s, Ne Win welcomed the royal regalia of the Konbaung dynasty back to Yangon.[21] This collection comprised over 140 gold or gilded items, including receptacles, candelabra, caskets, vases, pitchers, goblets, cups, bowls, shoes, a dagger, a fly whisk and a staff, all symbolising royal status. These regalia had been seized as indemnity at the end of the Third Anglo-Burmese War in 1885 and placed in the collections of the Victoria and Albert Museum in London in 1886. After their return, the regalia were housed in the National Museum in Yangon, where they remain to this day.[22] The return of the regalia symbolically validated Ne Win's position as leader, as they once did for Burmese kings. As a gesture of gratitude, the Burmese government donated one of the regalia pieces, a betel box in the shape of a *karaweik* (a mythical bird), to the British government (fig. 8.8). This intricate piece displays filigree work in gold on a gold ground inset with bands of rubies and pieces of green glass. Its feathers are carefully detailed and the base is covered with dense floral and vegetal motifs also found on other art forms.

Culture became a contentious issue in Myanmar as the Burman Buddhist majority was increasingly promoted as representative of the whole country. During the 1950s, U Nu renovated important Buddhist sites like the Shwemawdaw stupa at Pegu (Bago), and the military also continued sponsoring Buddhist restoration projects. The most controversial instance occurred in the 1990s when they ordered the reconstruction of the eleventh- to thirteenth-century buildings at Bagan (see fig. 2.1). Many of the brick structures were hastily topped with identical concrete superstructures and filled with crudely produced identical

Buddha images, often damaging the originals in the
process. However, from a Buddhist perspective, this work
generated merit for those who contributed funds.

Under the military regime from the 1960s to the 1990s,
numerous cultural practices became unsustainable due
to a deteriorating economy, scarcity of goods and limited
international tourism. However, with increased global
engagement starting in the late 1990s, art and heritage
contributed to defining national identity. This was
expressed through permanent displays in museums across
the country of replicas of the same important objects, such
as Pyu gold items, and the ten traditional arts (*pan se myo*;

literally, 'ten flowers'): painting, gold and silversmithing,
lacquerware, blacksmithing, wood and ivory sculpture,
bronze casting, stucco work, masonry, stone carving and
turnery. These traditions predominantly represented
the Buddhist Burman majority, while minority arts were
often excluded or reduced to simplistic displays featuring
mannequins wearing 'traditional' attire.

Archaeology and heritage management also became
part of the nation-building process, although they were
isolated from broader global interactions and frequently
controlled by political appointees. In some instances, the
Department of Archaeology has conducted work without
sufficient knowledge of basic methodologies and procedures
or has been required to do things that are not conducive to
the long-term preservation of objects and sites. In the early
1980s, temporary relaxation of restrictions allowed for an
international survey of the monuments at Bagan, resulting
in an eight-volume record of the site. More recently – in
2014 and 2019, respectively – the ancient Pyu-period cities
and Bagan have been listed as UNESCO World Heritage
Sites. Moreover, objects such as King Alaungpaya's Golden
Letter to King George II (see fig. 0.1), the Kuthodaw
inscriptions in Mandalay, the Myazedi quadrilingual
stone inscription from 1113, and King Bayinnaung's
bell inscription of the mid-1500s have been inscribed
on UNESCO's Memory of the World list. Colonial-era
structures from the nineteenth and early twentieth centuries
have been mainly left to decay, however, and, in contrast,
in the 1990s and early 2000s, anachronistic reconstructions
of King Anawrahta's and King Bayinnaung's palaces
were undertaken in a style associated with the Konbaung
dynasty, further reinforcing the association between a
central Burmese identity and the national one.[23]

In the 1960s and early 1970s, both the Revolutionary
Council and the Burma Socialist Programme Party
(BSPP), which became the sole governing party under the
1974 Constitution, prioritised agriculture. They allocated
funds for infrastructure such as water pipes, fertilisers
and insecticides to increase crop production. The socialist

8.9

Independence Day poster based on
U Khin Maung Latt's design for *The
Working People's Daily*, 1971. Paper.
H. 55 cm, W. 40 cm. Pansodan Gallery,
Yangon.

and the flag consisting of a red field and a blue canton with a large white star representing the union, surrounded by five smaller stars representing the five states (fig. 8.9).[24]

Union Day posters inevitably depicted stereotypical images of happy people wearing the supposedly traditional dress of the majority groups, defined as the eight national races.[25] Some artists attempted to portray the various races working together, as seen in a poster showing women from different ethnic groups listening to a Burman man demonstrating unity through the fable of bundled sticks that cannot be broken when kept together (fig. 8.10). Peasants' Day posters did not emphasise technological advancements as in other socialist nations but instead drew on traditional imagery such as bullocks, carts and non-mechanised forms of labour (fig. 8.11). The 1971 Peasants' Day poster employed a style reminiscent of traditional lacquerware, one of the ten traditional arts, with black figures against a lighter background. Yet, despite the goal of creating a just, peaceful, prosperous, moral and economically secure society, corruption was widespread and economic stagnation led to significant unrest in the 1970s and 1980s. Ne Win stepped down as president in 1981 but continued to exert control over the BSPP from behind the scenes until 1988.

Despite the observance of Union Day, the challenges stemming from Burma's diverse landscape have persisted without resolution. These issues encompass a wide range of concerns, including narrow notions of ethnicity, conflicting ideas of civilisational primitivism versus progressivism, and the emergence of new definitions of citizenship, among other issues. In 1948, when the Burmese nation was established, the Union Citizenship Act outlined the criteria for determining genuine citizens and their corresponding rights. Genuine citizens were considered pure-blood nationals, including the eight national races.[26] Resident citizens comprised immigrants who followed the prescribed rules to apply for citizenship, while naturalised citizens were immigrants who did not complete the proper application process but met the government's criteria.

programme had promised an 'agrarian revolution' in 1965. In addition to Independence Day and Union Day, which celebrated the end of British rule and acknowledged the Panglong Conference that brought the Frontier Areas into the union in 1947, a Peasants' Day was established to honour the importance of agricultural workers. Posters promoting these nationalist events followed standardised formats. For example, Independence Day posters often featured combinations of the Independence monument in Yangon

8.10
Union Day poster based on U Chit
Mye's design, 1970s. Paper. H. 27 cm,
W. 44 cm. Pansodan Gallery, Yangon.

8.11
Peasants' Day poster based on U Khin
Maung Latt's design for *The Working
People's Daily*, 1971. Paper. H. 56 cm,
W. 48 cm. Pansodan Gallery, Yangon.

woman, and sometimes carrying a child, dressed in clothing that serves as an ethnic marker. This mode of representation resembles the small wooden figures that were popularised during the colonial era (see fig. 4.21 and p. 196). An example of this genre is a painting by U Ngwe Gaing (1901–1967) featuring a non-Burman woman wearing a black turban, plug earrings and a silver necklace (fig. 8.12).

In the face of war, destruction and cultural suppression (such as the prohibition of local languages being taught in schools) that many minority groups endured after

In 1981 new citizenship laws introduced a classification system consisting of three categories: Indigenous, mixed race (such as individuals with Burmese and Chinese, European or Indian parents), and naturalised citizens. It was anticipated that, over time, only genuine Indigenous citizens would remain, as the descendants of resident or naturalised citizens would be deemed genuine citizens after three generations.[27] However, the Burman Buddhist majority has maintained dominance, with other religions and ethnic groups experiencing long-term social discrimination, political and economic exclusion, active cultural suppression and the perpetuation of atrocities against them. This discrimination can be traced back, in part, to the British colonial period, which established a simplified categorisation of non-Burman groups through the census and rigid classifications, as well as through the varying forms of colonial control. Ideas of what constituted 'civilisation' existed before the arrival of the British, but these were based on criteria that could be changed, including connections with the court, dress and so forth, rather than an immutable category. Ethnographic portraits became another way of fixing people into categories, as well as displaying their difference from the majority. Such images typically depict a single figure, often a

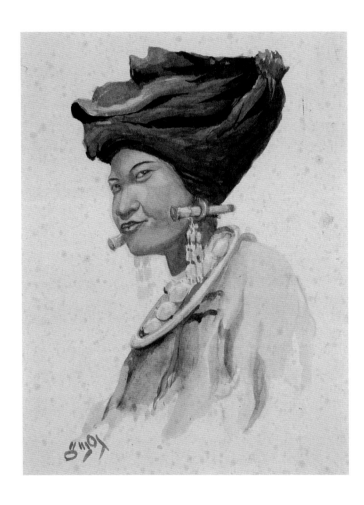

independence, a pressing concern arose over how to present a strong and authoritative stance to the government as part of their efforts to be culturally and territorially autonomous. For example, this can be seen among Kachin peoples, whose claims to autonomy, in part, rely on a Kachin majority in Kachin State (a status threatened by voluntary and forced migration of non-Kachin individuals into the state). Defining the category of 'Kachin' has been crucial in this context. Kachin peoples historically have flexibly embraced diversity, and the name currently refers to a family of related groups, including the Jinghpaw, Zaiwa, Lisu, Nung-Rawang,

Lashi/Lachik and Lawngwaw/Maru and their subgroups. Religion has also been another means of resistance against the military government. While missionaries introduced Christianity in the nineteenth century, local proselytisation in the 1970s led to a significant wave of conversions among Kachin peoples in the late twentieth century.[28] A further avenue of resistance has been through cultural efforts. In 1960 the Kachin State government established the Kachin Customary Law Inquiry Commission to document traditional practices on the verge of disappearing. Subsequently, the Kachin Independence Organisation and the Kachin Independence Army, as the major leadership, military and policing entities in Kachin State, played a role in standardising cultural practices.

The issue of traditional dress has become highly relevant to identity since the 1990s, with elements of the Jinghpaw attire emerging as the representative model, recognisable as characteristic of the Kachin people at a national level (fig. 8.13).[29] Drawing inspiration from the majority and culturally dominant Jinghpaw group, the standardised Kachin outfit for men typically consists of loose black trousers influenced by Shan men's fashion, a white shirt, a white Mao-style jacket, a yellow silk turban, a red bag adorned with supplementary weft designs and silver decorations, and a sword with a silver hilt and sheath (see fig. 3.35).[30] The women's attire is more elaborate and includes a handwoven red skirt-cloth with supplementary weft designs, a headdress and leggings similar to the skirt-cloth, a cotton belt, a black velvet jacket embellished with silver discs and tassels, silver neck-rings and cane waist-rings.[31] Similar, though not identical, endeavours have been observed among other ethnic groups in Myanmar, where specific forms of dress have been developed to represent whole communities.

During Union Day celebrations organised by Myanmar's military regime, ethnic diversity is showcased, with various groups required to perform dances in 'traditional' attire. Minoritised communities partially resist the dominance of a unified state and the negative stereotypes directed towards them by displaying clothing that reflects new

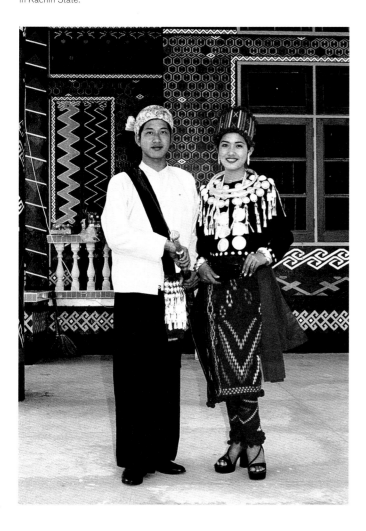

ideas of modernity and tradition. Standardised forms of 'neo-traditional' dress are regularly used at major events to emphasise unity and strength. Many such outfits are now factory-made, but designers from these communities are also creating new forms of clothing that integrate earlier ideas, patterns, techniques and fabrics.[32]

The responses mentioned above can be understood as both reactions to internal politics and outcomes of long-standing civil wars that have displaced people, forcing them to seek refuge in camps located in Thailand. For instance, a massive exodus of Karen peoples occurred in the 1980s when the Burmese military razed whole villages, committed extrajudicial killings, engaged in acts of rape, and press-ganged villagers into working as porters for the military during the ongoing conflict with the Karen National Union. This pattern persisted until the ceasefire agreement of 2015. Within refugee camps, different branches of Karen groups have come into contact with each other, some for the first time. Consequently, changes in attire have played a role in revealing an emerging pan-Karen identity.[33] Since independence, the inability of the Burmese state to foster an identity that encompasses the diversity of the country has resulted in the consolidation of disparate ethnic identities, rather than producing the state's desired homogenisation.

Revolution and the new military government: 1988–2010

The collapse of the BSPP and the departure of Ne Win in 1988 were triggered by a minor corruption incident that escalated into massive protests and widespread brutality by the military. These protests, which began in March 1988 and culminated in a massacre on 8 August (known as the 8888 Uprising), reflected people's pent-up frustration with the government. The country had been grappling with economic difficulties since the mid-1980s, as revenue from rice exports significantly declined. In addition, the Burmese economy witnessed a rapid expansion of the black market, exacerbating the scarcity of essential goods. To combat the underground economy, the government resorted to currency demonetisation.

Burmese currency production was carried out in Britain from the colonial period until 1962 when it shifted to East Germany. In 1972 the decision was made to produce Burmese currency domestically. From that time until the military coup of 2021, the German company Giesecke & Devrient supplied the raw materials, supplies and system components for the production of the Burmese kyat. In

8.14
45 kyat Union of Burma Bank banknote,
1987. Paper. H. 7.5 cm, W. 15.7 cm.
British Museum, London, 2006,0718.2.
Donated by T. Richard Blurton, acquired
while travelling in Myanmar in the early
1990s.

8.15
90 kyat Union of Burma Bank banknote,
1987. Paper. H. 7.5 cm, W. 16 cm.
British Museum, London, 2023,4004.1.
Donated by Alexandra Green in 2023.

late 1985, faced with a failing economy, the government unexpectedly demonetised the 50 and 100 kyat notes, replacing them with 35 and 75 kyat notes. The latter change was possibly intended to commemorate Ne Win's upcoming seventy-fifth birthday. In 1987, supposedly following Ne Win's affinity for the number 9, the 25, 35 and 75 kyat notes were replaced with 15, 45 and 90 kyat notes (figs 8.14–8.15), resulting in the overnight erasure of people's savings without compensation, as few individuals used banks. The new notes followed earlier precedents, featuring elements of Burman culture, including traditional depictions of a wizard (*zawgyi*), socialist-realist imagery of oil workers and farmers, and notable figures from the anti-colonial struggle – Aung San, Thakin Po Hla Gyi (1909–1943) and Saya San (1876–1931).[34]

Amid the breakdown of governmental authority in August 1988, the military grew increasingly alarmed by the potential loss of power and the defection of soldiers and even entire units to the protesters' side.[35] During this period, Aung San Suu Kyi emerged as a prominent leader of the pro-democracy movement and became one of the founders of the National League for Democracy (NLD) party. While BSPP members voted to hold a multi-party general election, a faction of the military subsequently seized control and established the State Law and Order Restoration Council (SLORC). The SLORC promised to allow elections once law and order were restored and governmental administration was re-established. It also changed the country's name from the Socialist Republic of the Union of Burma, assigned in 1973, to the Union of Myanmar.[36] Furthermore, the English spellings of city, river and ethnic group names were amended – for example, Rangoon to Yangon, Pegu to Bago, Pagan to Bagan – to align more closely with Burmese-language pronunciation and to exclude non-Burman names and languages.

Elections were held in June 1990, resulting in a landslide victory for the NLD. However, the SLORC delayed handing over power, driven partly by the military's concern over perceived external interference. This paranoia contributed to the coup in 1962 and has persisted throughout military rule. In the late 1980s, Aung San

8.16
Plate decorated in the *shwezawa*
gold-leaf technique with Arabic
calligraphy, late 20th century. Bagan.
Lacquer, bamboo and gold. H. 3.7 cm,
Diam. 26 cm. British Museum, London,
1996,0501.45. Purchased new from
Tun Handicrafts in 1996.

Suu Kyi's international connections and family, negative
Western media coverage and domestic calls for greater
democratisation further caused the army to entrench its
position.[37] Aung San Suu Kyi was placed under house
arrest for the first time in July 1989. Despite the oppressive
political climate and the conspicuous consumption of the
military elite and their associates under General Than
Shwe (b. 1933),[38] efforts were made to improve Myanmar's
international image and showcase its rich cultural heritage.
National competitions for performing arts were initiated
in 1992 and a new National Museum was constructed in
Yangon in 1996. The same year was designated the Year
of Tourism, promoted as 'Visit Myanmar 1996', although
visitor numbers fell short of expectations.

In 1997 the SLORC was renamed the State Peace and
Development Council (SPDC), and Myanmar became
a member of the Association of Southeast Asian Nations
(ASEAN). An influx of tourists and visitors led to a revival
of some traditional arts such as lacquerware and woodwork.
Artisans produced objects tailored for specific markets, as
exemplified by a black lacquer plate adorned with a gold-leaf
Arabic inscription ('Allah light of the heavens and earth')
in the *shwezawa* technique against a floral motif commonly
in use since the Bagan period (fig. 8.16).[39] There was also
a focus on catering for the Chinese market as the People's
Republic of China became more involved with the military,
supplying them with substantial quantities of weaponry.
The increasing Chinese presence in Myanmar and the
production of goods for such clientele is evident in the long-
standing stone-carving industry in Amarapura. Although
white stone statues have been exported to China since the
nineteenth century, it is only recently that sculptors have
started substituting a Chinese style of Buddha image for the
nineteenth-century Mandalay one (see chapter 4).

As in the colonial era, there was growing anxiety over
the sinification of Mandalay and the numerous Chinese
businesses entering the country. People felt unable to voice
their concerns and believed that the nation's resources were
being sold to neighbouring countries to benefit the junta
at the expense of the general population. Cartoons from
the late 1980s to the 2000s depicted these feelings and the
ongoing hardships most of the population faced. Extensive
surveillance persisted, as portrayed in U Pe Thein's (1923–
2009) image of an older man reading a paper under the
watchful gaze of his own shadow (fig. 8.17). A 2012 cartoon
by U Kyaw Thu Yein (b. 1984) critiqued a proposed dam
construction in Kachin State for exporting electricity to
China, highlighting Myanmar's struggle to meet its internal
energy needs – with many having to make do with candles –
while supplying power to neighbouring countries (fig. 8.18).
The anguish and despair resulting from extreme oppression
are poignantly captured in U Aw Pi Kyeh's (b. 1959; known
as APK) cartoon, which depicts a conflict between two
individuals – one wielding a pen and the other a sword
(fig. 8.19). This illustration subverts the original message
of British author Edward Bulwer-Lytton's famous phrase

8.17 *left top*
U Pe Thein, *There is No Private Space*,
1988.

8.18 *left bottom*
U Kyaw Thu Yein, *Electricity Supply*,
2012.

8.19 *opposite top*
U Aw Pi Kyeh, *The Pen versus the Sword*, 1993. Prepared for the 1993 PEN American Report on censorship in Burma.

8.20 *opposite bottom*
U Aw Pi Kyeh, *Computers*, 1991.

of 1839 that 'the pen is mightier than the sword'. Here, the sword is mightier, with the sword-fighter claiming victory with a laugh and asserting the indestructibility of his weapon made from a thousand pen nibs. Another of APK's cartoons humorously satirises the introduction of computers to offices, highlighting the low levels of computer literacy resulting from an inadequate educational system and limited training opportunities (fig. 8.20). The cartoon depicts an office worker typing on a computer, with the screen displaying the equation '1 + 2 = 4', possibly referencing George Orwell's dystopian novel *1984*. His colleague cheerfully remarks, 'This is great! With these computers, you can give your mind a break.'

With the sudden removal of fuel subsidies in 2007, another significant protest movement emerged. It became known as the Saffron Revolution due to the leading role played by Buddhist monks. Although the protest was violently suppressed, some participants were later pardoned and released as political repression gradually eased after 2011.

2010 to the present

In 2008 a revised Constitution, proposed in the aftermath of the 1988 protests and the 1990 election, was completed, leading to elections in 2010. The NLD boycotted this first election, and the Union Solidarity and Development Party (USDP), a new military-backed party, assumed power. The NLD participated in subsequent elections and gradually increased its seats in parliament, ultimately assuming power in 2015. Between 2011 and 2015 under General Thein Sein (b. 1945), censorship was eased, though not eliminated; tourism increased, providing an outlet for arts and crafts; and the contemporary art scene expanded significantly. The growth of the middle class in the twenty-first century has played a role in sustaining the arts and crafts industries, particularly in the production of religious artefacts, despite fluctuations in tourism. Additionally, Myanmar's engagement with international organisations, such as UNESCO and the World Monuments Fund, facilitated restoration projects,

including the nineteenth-century wooden Shwenandaw Monastery in Mandalay (see fig. 1.8), along with various training and capacity-building programmes. Local cultural and heritage groups were also established across the country, encompassing diverse ethnic and religious communities beyond the Burman Buddhist majority. These developments continued after the 2015 elections with the NLD in power and Aung San Suu Kyi the de facto leader as State Councillor.[40] In 2016 Myanmar became a member of the International Council of Museums and, a year later, a Myanmar chapter of the International Council on Monuments and Sites was formed.

Even with the change in government and later the election of the NLD, Myanmar's relationships with minoritised communities continued to face significant challenges.[41] For example, the ceasefire agreement negotiated with the Kachin Independence Army in 1994 collapsed in 2011, leading to conflict that continues to this day. The country garnered international attention in 2013 with the rise of the extremist Buddhist monk Wirathu, who promoted anti-Muslim sentiments and called on Burmese Buddhists to boycott Muslim businesses, fuelling Buddhist nationalism and resulting in pogroms in several cities.

Religious tensions simmered, culminating in the Rohingya crisis and genocide in 2017, to which Aung San Suu Kyi and the NLD were largely silent and unresponsive. The Rohingya, a Muslim group, have been denied citizenship and excluded from the list of 135 recognised national ethnic groups, with the Myanmar government regarding them as illegal immigrants from Bangladesh. Systematic discrimination and violence have forced many Rohingya to flee Myanmar since the 1990s and, since 2012, a significant number of Rohingya have been arbitrarily held in detainment camps within Rakhine State. In August 2017, after attacks on local police posts, the military and local Buddhist civilians responded by burning villages and assaulting and killing Rohingya civilians. The violence escalated, resulting in the destruction of nearly 300 villages and the mass displacement of Rohingya into Bangladesh. To this day, approximately one million Rohingya live in refugee camps under poor

conditions, facing unemployment and limited resources.
An artistic photograph by Ro Mehrooz (b. 1999), a poet and
photographer from Buthidaung, Rakhine State, currently
residing in Cox's Bazar refugee camp, hints at life as a refugee
(fig. 8.21). This photograph captures the swirling layers of mud
and water that serve as sources of bathing and drinking water,
presenting a visually captivating yet painfully indicative
image of the dire circumstances faced by the Rohingya
community. It was submitted as part of the Rohingya

Photography Competition, an annual event since 2020 that
promotes Rohingya photographers and enables some to
generate income by selling their images.[42]

Cartoonists have expressed a prevalent belief that the
military deliberately created tensions between Muslims
and Buddhists from as far back as the early 2000s. One
such depiction by U Harn Lay (1962–2022) portrays a
military figure clandestinely playing both sides of a chess
game, symbolising the alleged manipulation (fig. 8.22).

However, in recent times, many cartoonists have sided with the government's narrative, satirising the situation by portraying the Rohingya as illegal migrants from Bangladesh. The proliferation of social media, particularly Facebook, has exacerbated the strife, as misinformation containing inflammatory images and theories about Muslim threats to Buddhism has circulated unchecked. In 2019 The Gambia filed a case against Myanmar with the International Court of Justice, accusing the country of committing atrocities against the Rohingya that violate the provisions of the Convention on the Prevention and Punishment of the Crime of Genocide. Widely reported in the media, the case is still ongoing.

The semi-civilian NLD-led government elected in 2015 disappointed many, internally and internationally, as it struggled to address competing claims, protect or negotiate with minoritised groups and maintain stability in regions affected by ongoing warfare. Various sectors, including the economy, education and healthcare, continued to face significant challenges. The arrival of the Covid-19 pandemic in early 2020 dealt a severe blow to Myanmar, with tourism coming to a halt and the economy suffering further damage. Despite these circumstances, campaigning for the November 2020 elections continued, as evidenced by the production of face masks adorned with images of Aung San Suu Kyi and promoting the NLD (figs 8.23–8.24). As predicted, the NLD secured the majority of parliamentary seats, despite dissatisfaction with the government's limited progress on social and economic fronts. Local and international poll monitors verified the results as legitimate. However, on 1 February 2021, the military, under Min Aung Hlaing (b. 1956), staged a coup, citing fraudulent voting as the justification for overturning the official results. He detained elected leaders, including Aung San Suu Kyi, declared himself commander-in-chief of Myanmar, and established the State Administration Council as the country's ruling body. Subsequently, members of the elected government who escaped arrest gathered in exile as the National Unity Government (NUG), while the country was plunged into deep civil unrest that now encompasses the central region, in addition to the ethnic states.

In 2022 Myanmar was ranked as one of the world's least democratic nations by the Economist Intelligence Unit. The nation continues to grapple with rampant Covid-19 transmission, a collapsed economy, exceptional levels of violence and the reinstatement of harsh censorship and restrictions on personal and cultural expression. In response, many individuals, through various media platforms and art forms, including social media, have demonstrated increased sympathy for the suffering of minoritised people since independence and have called for the NUG to endorse a federal system. The near future, however, remains bleak and uncertain.

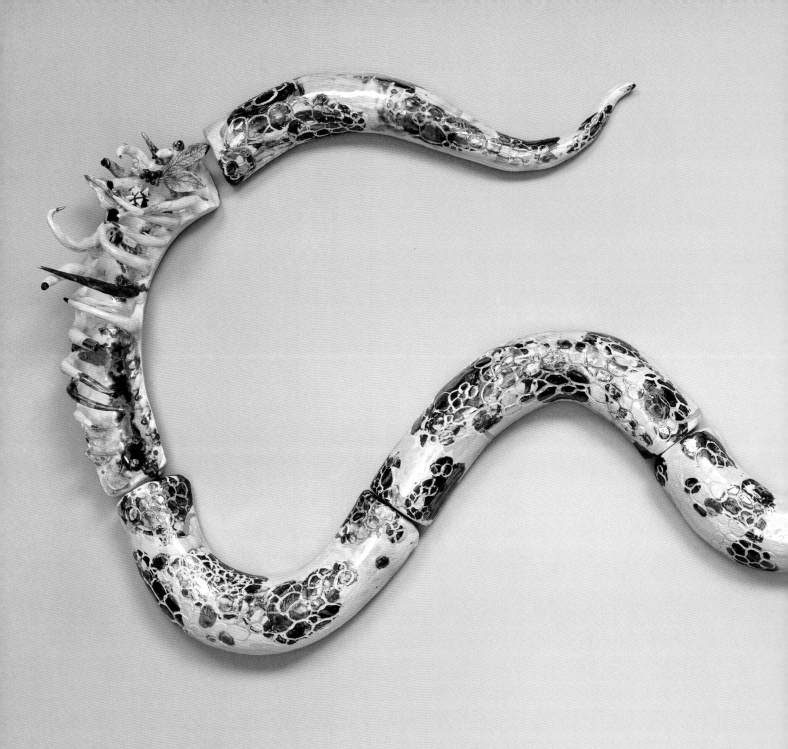

MODERN AND CONTEMPORARY ART ACTIVISM, 1948–PRESENT

MELISSA CARLSON

After more than 120 years of British rule (1826–1948) and just over a decade of independence (1948–62), General Ne Win's 1962 coup d'état propelled Burma into a downward spiral of authoritarianism, isolationism and censorship. This rapid transition jolted the country's avant-garde artists. Following nearly fifteen years of open borders and uninhibited flows of cultural material, experimental artists found themselves severed from global artistic networks. They were further sidelined by domestic channels of the visual arts that focused on training artists and anonymous artisans to paint nostalgic landscapes or produce religious artwork. Nonetheless, the time since independence has proved to be a period of intense creativity for artists interested in non-traditional or modern art practices. A generation of avant-garde artists emerged who defined themselves as 'modern artists' due to their rejection of traditional painting subjects and styles advocated by the state art schools and the Ne Win government. These artists experimented with new materials and, most notably, their artwork portrayed their lived experiences.[1]

The artwork generated since 1962 reveals a politically and socially engaged avant-garde art community that created new modes of expression to explore broader notions of nationhood. In the European context, where modernism is understood to be synonymous with freedom of expression and radical creativity, the artwork discussed here suggests that in Myanmar – a cultural context in which freedom has been politically circumscribed – the terms of modernism take a different course. Contrary to the Western definition of the avant-garde as politically and socially disengaged, the avant-garde artist as an activist is etched into Myanmar's past and present. Avant-garde artists have played a unique role in shaping Myanmar's postcolonial national identity and forging new ways to remain connected with the world.

Independent Burma (1948–62): fraught politics, vibrant cross-cultural exchanges

From 1948 to 1962, a generation of artists trained in realism during British colonial rule won scholarships to study abroad, enmeshing Burmese artists in post-war artistic currents and intellectual thought in Asia and Europe. For instance, Ba Gyi (1912–2000) secured a scholarship from the French government to study at the École nationale supérieure des Beaux-Arts in Paris in 1949 and participated in exhibitions in Paris, London and Monte Carlo.[2] Bagyi Aung Soe (1923–1990), often viewed as the country's first avant-garde artist, received a scholarship from the government of India to study at Rabindranath Tagore's Visva-Bharati University in Santiniketan near Calcutta (Kolkata) in 1951.[3] There, he overlapped with the expressionist painter Affandi (1907–1990)[4], already a famous modern artist in Indonesia, and studied under Nandalal Bose (1882–1966), Abanindranath Tagore (1871–1951) and Ramkinkar Baij (1906–1980).[5]

Influenced by Nandalal Bose, Bagyi Aung Soe returned to Burma with three key principles: the idea of artists having a civic duty, the necessity for artists to include a viewpoint in their paintings, and the concept of pan-Asianism, an Asia unified in political and economic ideology to counter Western powers.[6] Bagyi Aung Soe melded the two-dimensional lines of Burmese temple mural paintings with his own spiritual goals, depicted in wild brushstrokes and sunburst colours that his contemporaries would brand 'psychopathic art', yet soon emulated. *Indian Woman*, for instance (fig. 9.1), transforms the line drawings of traditional paintings in India and Burma to portray an idealised rice harvester, a figure presented as emblematic of Burmese traditional culture and values, in tribute to his studies at Santiniketan, India. After his return to Burma, Bagyi Aung Soe, a solitary figure, would, by default, lead the modern art movement in Rangoon as his illustrations in magazines and journals circulated throughout the country, inspiring a new generation of artists.[7]

9.1
Bagyi Aung Soe, *Indian Woman*,
c. 1980–90. Yangon. Pencil, gouache
and marker drawing on paper. H. 23 cm,
W. 29.5 cm. Gajah Gallery, Singapore.

Other artists experimented with a variety of media. In 1962 architect and artist Kin Maung Yin (1938–2014) spent eighteen months in Dhaka, Bangladesh, where he discovered Indian director Satyajit Ray's films. He returned to Burma inspired to produce movies and, like Ray, translated scenes of proletarian Rangoon life onto his canvases and into his films.[8] In one untitled painting (fig. 9.2), Kin Maung Yin depicts monks watching village life unfold, echoing the line drawings of traditional Burmese mural painting, using minimal forms and bold outlines to demonstrate his new interest in quotidian activities and cinematic panoramas. He also encountered the work of American-born, German-trained artist Lyonel Feininger (1871–1956), an expressionist painter who used cubism to

9.2
Kin Maung Yin, *Untitled*, 1965. Yangon.
Oil on canvas. H. 48.3 cm, W. 68.6 cm.
Collection of Dr Arthur Sun Myint, UK.

capture Germany's landscape, a form Kin Maung Yin experimented with in his paintings of Bagan temples.[9] Other members of the avant-garde mailed entries to join art competitions and sought membership in organisations abroad. From Burma, Nan Waii (1926–2008) exhibited in the Royal Institute of Painters in Water Colours summer exhibition in London and the Soviet-sponsored 1955 Youth League exhibition in Warsaw and even became a member of the London-based Imperial Arts League in 1957.[10]

A younger generation of artists studying modern painting techniques in Mandalay under Khin Maung (Bank)[11] (1911–1983), the leader of modernism in the former royal capital, furthered their studies with American instructors by mail.[12] In 1959 Paw Oo Thett (1936–1993) and Win Pe (b. 1935) secured scholarships for a correspondence course offered by the Famous Artists School,[13] where they discovered Norman Rockwell's idyllic portrayals of American values and the bright watercolours of Dong Kingman (a Chinese American

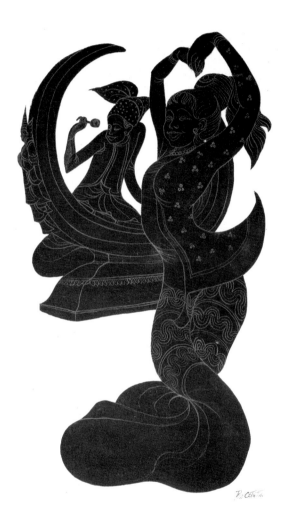

artist) depicting urban scenes. The imagery led both artists to experiment with depicting traditional Burmese culture through cubism and impressionism in cheerful colours. In an early painting by Paw Oo Thett (fig. 9.3), he blends his initial work as a cartoonist with the aesthetics of Burmese lacquerware to depict elements of Burmese culture: a musician plays the *pattala*, or Burmese xylophone, to accompany a twirling dancer. Both figures display large smiles, a soon-to-be motif in his paintings. Paw Oo

Thett also discovered Andrew Wyeth at the United States Information Service (USIS) library in Mandalay, catapulting Wyeth's realist portrayal of domestic scenes, the lived experiences of distinct individuals and placid landscapes into a Burmese context and soon prominence among the Burmese avant-garde.[14] Just like Bagyi Aung Soe, he developed a unique style and pushed modernism forward.

Such artists propelled painting from watercolours of romanticised landscapes to more modern practices, particularly oils on canvases imbued with brighter colours, freer brushstrokes, scenes of daily life and spiritual explorations. They also brought new perspectives on how Burma was imagined by others. Like their peers across South and Southeast Asia, they explored how to define postcolonial traditional culture and values, often producing work that idealised village life, farmers and religious festivals, believing these embodied the purest form of Burmese culture. Throughout the 1950s, Paw Oo Thett and Win Pe also immersed themselves in the left-leaning Ludu Press in Mandalay, where they designed cover illustrations and created cartoons and other content for the daily newspaper *Ludu* (The People).[15] Soon, their illustrations became infused with humour that interpreted domestic, regional and global current events alongside social commentary. Their work dispersed a new aesthetic throughout the country to eager readers and perpetuated the colonial-era role of the cartoonist as an astute political and social observer. Their critiques in cartoons remained separate from their roles as professional artists. Until this point, overt political commentary in paintings remained rare or hidden under layers of euphemism, as in the colonial era.[16]

Artists and Cold War cultural politics

Early in the Cold War, Burma's proximity to China positioned it as a potential flashpoint in the spread of communism in Southeast Asia; according to both pro- and anti-communist powers, the ideological trajectory of Burma

and Viet Nam signified the fate of the entire region.[17] Post-war nations in Southeast Asia brought artists to the forefront of national identity debates as they attempted to define culture amid Cold War tensions. In 1955 delegates from Asia assembled for the Rangoon Conference on Cultural Freedom in Asia. Under the slogan 'Hear Asians Speaking for Asia', attendees debated post-Second World War identities alongside strategies to preserve traditional cultures as the region emerged from colonialism and countries experimented with democracy. Leaders positioned artists and writers as the final frontier between freedom and authoritarianism. The inaugural speaker at the conference warned that totalitarianism 'is the spiritual vacuum which results from the rejection of traditional philosophies' and cited artists as a key barrier to communism.[18]

Artists immersed themselves in right- and left-leaning texts and films from around the world. Cold War cultural diplomacy infused new forms of music and dance into the orbit of Burmese artists, including Duke Ellington, Martha Graham,[19] Alvin Ailey, Thomas J. Dorsey Jr of the Lenni-Lenape Tribal Nation[20] and the Benny Goodman Orchestra.[21] The United States of America, the Soviet Union, China and East and West Germany all published translations of books into Burmese. Publishing houses in Rangoon, such as Sarpay Beikman, became epicentres for concerts, exhibitions and performances. A domestic press thrived. Popular magazines such as *Shumawa* (1946–1992), *Thway Thauk* (est. 1948) and *Moe Way* (est. 1969)[22] featured short stories, poetry and illustrations or paintings by Burmese authors, poets and artists, alongside reporting on culture.[23] Meanwhile, the U Nu government launched *Myawaddy* magazine (1952) to counteract a freewheeling domestic print media critical of the government.[24] The *Illustrated Journal of India* introduced modern artists from India and the wider world, while weekly comics such as *Beano*, *The Dandy*, *The Topper* and *The Beezer* arrived from the United Kingdom.[25] Other artists recalled learning about regional artists and art movements, such as expressionism and surrealism, in

Movie Lover magazine (1960s), published by the writer and artist Yangon Ba Swe (1915–1986), or reading books about Vincent van Gogh (1853–1890), Pablo Picasso (1881–1973) and Henri de Toulouse-Lautrec (1864–1901) gifted to them by foreigners.[26] As the Cold War escalated, the journal *Soviet Literature* (1946–1990), the German magazine *Der Spiegel* (1947–present) and *Time* magazine (1923–present) circulated alongside publications by foreign embassies, introducing foreign films, art and books. Artists found employment painting movie posters the length of entire buildings. Films from Burma, India, the Soviet Union and Hollywood inspired new ideas of scale, fashion, imagery, colours and humour in their art.[27]

Soon communities of artists interested in debating the latest books and films began to exhibit their own modern art. For example, in Rangoon, in late 1963 Kin Maung Yin abandoned architecture for painting and established an artists' hub at the architectural studio Architects Incorporated (AI), where he lived above his former office on the corner of 24th Street and Strand Road.[28] There, he painted and played classical music, attracting artists, architects and poets interested in modernism.[29] By day, Paw Oo Thett painted watercolours for tourists, but in his spare time he began inserting himself and his friends into his paintings, alongside undertaking various spiritual explorations on his canvases. Nan Waii captured urban life and structures around Rangoon in bright oils. Separately, Bagyi Aung Soe continued to create hundreds of paintings, illustrations and book covers that gradually associated his modern art with new trends in writing. The widespread popularity of print media further circulated his unique imagery among readers and inspired a new generation of modern artists across Burma.

In Mandalay, under the tutelage of an older generation of modern artists, Paw Oo Thett and Win Pe launched a parallel modern art movement to create art forms that reflected traditional Burmese culture. They fused elements of the impressionism of their instructors with cubism, Bagan-period wall painting formats and the imagery and colours of cartoons

to capture domestic scenes. In the early 1960s they joined group exhibitions in Rangoon alongside Kin Maung Yin, Bagyi Aung Soe, Aung Myint (b. 1946), Arthur Sun Myint (b. 1948) and Nan Waii, hanging modern paintings alongside more traditional landscapes. Paw Oo Thett moved into the AI offices alongside Kin Maung Yin, further aligning the Mandalay and Rangoon avant-garde communities during his trips home to see his family.[30] But then, just as artists became accustomed to a vibrant cultural scene and access to regional and global artistic circuits, political life imploded.

Socialist Burma (1962–88): artists persist despite the onset of isolationism

On 2 March 1962 General Ne Win staged a coup d'état to oust prime minister U Nu and his party. His objective in part was to halt U Nu's willingness to grant concessions to ethnic minorities' demands for greater autonomy alongside rising threats to national unity from communists excluded from participating in the U Nu government. Ne Win launched his 'Burmese Way to Socialism' to shift the country from a perceived chaotic, multi-party democracy to a one-party system based on a unique blend of Marxism, nationalism and Buddhism.[31] The altered social, political and economic landscape of Socialist Burma permeated all facets of life, including the visual arts. The impact on the arts occurred early. In July 1962 the military dynamited the Rangoon University Students' Union building, killing an untold number of student protesters.[32] The building, a symbol of anti-colonial resistance from the 1920s, was also the site of countless art exhibitions and where some artists, such as Nan Waii, stored their artwork.[33]

Overnight, the 1963 Enterprise Nationalisation Law converted private industries into state industries divided into various 'corporations'.[34] Soon, artists could only access art supplies at a centralised store for stationery and books consolidated under the name Corporation 9.[35] Dutch and French oil paints disappeared, to be replaced by lower-quality Chinese acrylics. The withering economic climate and decreased access to the international community crippled artists trying to survive in a market emptied of buyers. In Mandalay, Kyaw Moe Tha (1947–2019) made canvases from domestic cotton and linen and relied on friends at embassies to supply him with paint.[36] Painter and cartoonist Yin Minn Pike (b. 1946) detailed how artists would soak army groundsheets to remove the paint and then use both sides as a type of canvas. Lacking tarp, artists used 'plywood, cardboard or thick Chinese fabric'.[37] They were also forced to adapt to acrylic paints from expensive and increasingly rare oil paints, though they appreciated the former's faster drying time. As artists adjusted to constraints in sourcing materials, they discovered that their accustomed access to travel and information was also restricted.

Ne Win's policy of isolationism was a move to limit Burma's dependency on foreign economies and to preserve a perceived Burmese traditional culture rooted in Buddhism. As a result, the government restricted issuing passports, curtailing artists' ability to participate in international exhibitions. Government corruption, alongside isolationism, also limited artists' access to education. For instance, in 1983, the Italian embassy granted a scholarship to Kyaw Moe Tha (b. 1947), a Mandalay artist interested in abstraction who, like other modern artists, was self-taught in non-traditional techniques. At the time, government officials told him he could only receive a passport if he took one of their children with him to Italy. Unfortunately, the Italian embassy refused to accept this second application.[38] Meanwhile, university fine arts curriculums remained entrenched in the artistic practice of realism, so art education in modern techniques remained limited to self-study in magazines, books and journals. Artists also faced new barriers to accessing print material.

The government slowed international mail and halted the flow of foreign magazines, books and films. Soon it shuttered libraries run by diplomatic missions and nationalised once-vibrant bookshops, publishing houses and cinemas, all sources of information and ideas for artists. Artists relied

on borrowing books from friends with well-stocked home libraries, but the bookshelves contained primarily material from before 1962. In 1970, offering a platform for domestic artists and writers, the actor and novelist Win Oo (1935–1988) published *Sandar* magazine, which featured comics, poetry and short stories, plus artists' paintings and illustrations, all printed in colour.[39] Although the domestic press flourished with culture-related magazines and journals featuring short stories and poetry, it was curtailed by the onset of press censorship in 1962, which decimated publications of longer novels and halted more experimental forms of writing. The costs to authors and publishers, both in terms of finance and time, of submitting longer-form material to the Press Scrutiny Board, alongside the arbitrary deletion of material by state censors pre- and post-publication, resulted in self-censorship or writers simply not publishing work.[40]

Despite the obstacles presented by the Ne Win government and the reluctance of the state-run Artists and Sculptors' Council to exhibit modern art, let alone permit public group or solo shows of modern art, avant-garde artists held multiple shows in the 1960s and 1970s, often with the help of the diplomatic community. The 1967 *Burmese Modern Art Exhibition*, held at the YMCA in downtown Rangoon, was the first public exhibition of modern art after the military coup. It triggered a succession of exhibitions as avant-garde artists negotiated using public and private spaces for their shows.[41] The Alliance Française also featured a show of modern art in 1970.[42] The 1971 establishment of Lokanat Galleries in Rangoon, the first private art gallery in Burma, provided a permanent exhibition space with a room dedicated to modern artwork; traditional art was featured in the main room.[43] In 1978 artist Paw Thame (1948–2014) opened Peacock Gallery in Rangoon, one of the first galleries dedicated to modern art, hosting a series of key modern art exhibits.[44] However, as public exhibition spaces for modern art expanded, the Ne Win government soon turned its attention to regulating the visual arts. In response, a younger generation of avant-garde artists activated their canvases to protest and resist the state.

Censorship of the visual arts

The Soviet Union and the People's Republic of China both used art to legitimise state power and signify a break with 'corrupt' traditions. Despite the almost parallel historical development, the Ne Win government, lacking a founding mythology and external narrative, did not copy the socialist realism model from the Soviets or state-sanctioned woodblock prints from China. Instead, the Burmese government encouraged artworks of an idealised, almost mythic Burma. Given the regime's steadily ineffective use of art for propaganda purposes, to the extent that it did concern itself with art, it was with an eye towards maintaining order and avoiding discord.

The British had regulated visual expression in Burma through the Dramatic Performances Act of 1876 and the Cinematograph Act of 1918 and had overseen the emergence of the first censorship board.[45] These colonial-era legal codes formed the blueprints for subsequent postcolonial governments in Burma to censor imagery, police public exhibition spaces and institute an art certification system. The Ne Win government formed a Censorship Board (the Board), overseen by the Press Scrutiny and Registration Division, which consisted of rotating government workers from various ministries, and enacted the 1964 Library, Museum and Exhibitions Monitoring Act (the 1964 Code), which provided the basis for censoring art exhibitions.[46]

In general, artists' subject matter was expected to align with state policies. Yet, in the absence of major government economic or social programmes and the unpopularity of Burma's military leaders, nondescript landscapes that deflected from real-life conditions proved the most palatable with censors. The censors, who had little, if any, training in the visual arts, veered towards an ad hoc application of the prohibitions. Artists and gallery owners were required to invite the Board to preview an exhibition's artwork on the opening day. The censors would survey the paintings and question the artists, removing any paintings they deemed problematic. These inspections allowed artists and curators to negotiate,

9.4

Arthur Sun Myint, *Me, Not I*, 1970.
Yangon. Oil on canvas. H. 70 cm,
W. 91.4 cm. Collection of Dr Arthur
Sun Myint, UK.

to a degree, with the censors. Sometimes, artists alleviated the censors' concerns with creative explanations for their paintings. Other artists altered their paintings or sculptures to satisfy censors' requirements. Many artists concealed potentially problematic artwork in the safety of their homes, a form of self-censorship. As conceptual artist Chan Aye (b. 1954) stated, 'We just made modern art in our studio and kept it.'[47]

Artists began to decode the seemingly arbitrary concerns of Board officials; for example, the excessive use of four colours – black, white, red and green – provoked censorship.

Censors worried that black risked signifying despair while white symbolised purity. After 1988 the rationale shifted and white was believed to represent support for Aung San Suu Kyi by referring to the white flowers she often wore in her hair. Red was interpreted as support for revolution, blood and, after the violent crackdown of 1988, allegiance with Aung San Suu Kyi's National League for Democracy (NLD). Green could be viewed as commentary on the military, alluding to the colour of uniforms or tanks. The scrutiny of colour and content made holding an exhibition a fraught experience.

In general, censors banned nudity, enacting a conservative interpretation of Burmese morality. They also censored any artwork they deemed either direct or indirect criticism of Ne Win's policies or a critique of life in Socialist Burma. Yet, in addition to this, and perhaps most problematically for artists interested in modern art practices, the censors disliked abstract paintings or any type of painting that was not realist, considering such artwork to be in opposition to traditional Burmese culture.[48] Censors favoured realist imagery that they could immediately understand. This category drew on traditional precolonial themes and defined the cornerstones of Burmese national identity as agrarian, Burman and Buddhist, thereby excluding minorities. The military rulers viewed Buddhist imagery as a source of legitimacy, while bucolic rural scenes demonstrated the stability their rule brought to the countryside. Keenly aware of this type of approved imagery, avant-garde artists seeking to convey a political protest co-opted the artistic practice of realism to navigate censorship and resist the state.

Despite the constraints of censorship, isolationism and a shattered economy, avant-garde artists persevered. For example, by 1970, Arthur Sun Myint had achieved the correct combination of content and form to circumvent repeated censorship of his nudes. His self-portrait *Me, Not I* (1970), painted in the sepia tones of an old photograph as he looked into a mirror, used realism to depict himself shirtless with his eyes shielded behind sunglasses (fig. 9.4). The title is based on the Buddhist idea that what you see on the surface is not reality, just an illusion of life, perhaps also alluding to the type of realism in art favoured by the state censors and a critique of state propaganda about life in Socialist Burma. The painting, the first nude accepted into an exhibition by the Burma Arts Council, uses a style of realism developed and deployed to comply with the censors while permitting artists to tap into a visual language of resistance. Artists used realism like this to make social or political points, trigger recognition among their viewers, navigate censorship and even engage with censors. Yet, such successes were short-lived. In 1974 the censors banned Sun Myint from exhibiting paintings for one year.[49]

Accessing modernity through literature and poetry

From the 1960s, artists increasingly read books by leftist writers and pro-communist figures. In Mandalay in the 1970s and 1980s, Phyu Mon (b. 1960) and Chan Aye (b. 1954) recalled reading biographies of Ho Chi Minh alongside anti-Viet Nam War poetry by Bertolt Brecht.[50] Soon, anti-Viet Nam War themes in poetry and literature served as a lens for Burmese youth to oppose the Ne Win government. As part of this revolutionary spirit taking hold of young artists, writers and poets, the very premise of being part of the avant-garde community became revolutionary. According to avant-garde poet Aung Cheimt (1948–2021), when one became an avant-garde poet or artist, one automatically got involved in politics because it was 'an aversion to authoritarianism, an unfair system of government, and the military intelligence system'.[51] Yet, artists needed a new visual language that would permit them to express complex ideas in an increasingly repressive environment. Experimental forms of writing soon offered them alternative outlets and means of visual expression.

In 1968 the poet and translator Maung Tha Noe (1934–2022) gathered together a series of English-language poems, translated them into Burmese and published them in a collection titled *In the Shade of the Pine Tree*.[52] The array of foreign poetry liberated Socialist-era poets from traditional rhyming schemes and injected metaphors, personification and similes into poetry and painting. Translations of foreign literature into Burmese tended to bypass the censors, so artists, seeking new modes of employment in the narrowing economy, began to find work illustrating translations of novels and avant-garde poetry. The new writing used metaphors and allegories to describe feelings, actual hardships and critiques of modern life. Inspired by the new forms of writing, avant-garde artists painted images for book covers and provided illustrations for texts, experimenting with realism, abstraction, surrealism and conceptualism. Soon, artists forged creative means to counter isolationism. They appropriated

9.5
Khin Swe Win, *Sleeping Lady*, 1981.
Yangon. Oil on canvas. H. 91.4 cm,
W. 121.9 cm. Collection of the artist.

intellectual currents in texts that had permeated Burma's borders before the onset of isolationism. These included the fractured figures and social dystopias depicted by Van Gogh, Toulouse-Lautrec and Amrita Sher-Gil, or even verses construed by such modernist poets as T.S. Eliot. Eliot's 'The Love Song of J. Alfred Prufrock' (1915), popularised through its inclusion in *In the Shade of the Pine Tree*, resonated with an entire generation of artists. The artist Khin Swe Win (b. 1958) interpreted in visual form the melancholy of the poem's opening lines, the personification of an endless night sky, for a proposed book cover (fig. 9.5).[53] The censors banned the painting due to the nudity implied by the sheer fabric of the woman's dress. Still, Eliot's use of metaphor to focus on lost opportunities reverberated with a generation of avant-garde artists seeking new means of visual protest.

9.6

Maung Theid Dhi, exhibited as *Untitled*
(1974) and as *Hunters* (1976), 1974.
Yangon. Oil on teak. H. 63.5 cm,
W. 44.5 cm. British Museum, London,
2022,3027.1. Purchased from the
artist's family in 2022 via the Brooke
Sewell Permanent Fund.

The avant-garde activated: realism as resistance

In 1979 the artist and former Rangoon University instructor
Nan Waii cautioned a group of young experimental artists
enrolled at the university not to limit themselves to the
university's arts curriculum, which was lagging under the
reforms of the Socialist era.[54] Days later, the students,

including San Minn (1951–2021), established the Gangaw
Village art collective to create modern art in response to
their chaotic political landscape.[55] Their canvases soon
marked a sharp deviation from the bucolic, nostalgic,
impressionistic landscapes based in realism favoured by the
censors to depictions of their surroundings. While Western
avant-garde artists rejected realism, Gangaw Village avant-
garde artists deployed the language of realism to prioritise
details, form and figure in recording the objects, people
and places that reflected life in Socialist Burma. Brash
strokes, loud cartoonish colours and fragmented forms
conveyed moral messaging, documented injustices and
triggered recognition and familiarity among audiences,
even censors. Anonymous figures once embedded in temple
scenery or dotted among rice paddies gave way to distinct
facial features, key details, emotion and even insertion of
the artists themselves. Canvases depicted in realism soon
covered issues of gender, such as the daily monotony of a
housewife, the drudgery of labour and the hardships of life
under Socialism. Yet, as government oppression spiked with
a brutal crackdown in 1974 on student protests associated
with the death of former UN Secretary-General U Thant,
painting became less about the purity of the form and more
a platform to protest against the state.

In the same year as the student protests, Maung Theid Dhi
(1950–2019) submitted to the *Wild Eye Modern Art Exhibition*
in Rangoon a lifelike portrait of himself with long hair, an
indication of social radicalism and solidarity with student
protesters, on teak (fig. 9.6).[56] Maung Theid Dhi encircled
the teak board with a metal chain that looped the image
multiple times, with long sections of the chain hanging loosely
along the painting's sides. He topped the entire piece with a
metal star, a blatant symbol of the military. He exhibited the
painting as *Untitled* to evade the censors if they skimmed a list
of artwork titles rather than visit the gallery in person. Despite
this, the censors removed the painting from the exhibition
on the first day, not even permitting Maung Theid Dhi to
address their concerns. When the self-portrait was returned to
him after the show closed, it had been stripped of the metal

9.7

San Minn, *Express 2*, 1986. Yangon.
Oil on canvas. H. 61 cm, W. 102 cm.
British Museum, London, 2022,3029.1.
Purchased from the artist's family in
2022 via the Brooke Sewell Permanent
Fund.

star and chain. He took his self-portrait home, determined to engage the censors again.

For a 1976 exhibition in Rangoon, Maung Theid Dhi transformed his self-portrait into an installation and performance-art piece and showed it using a different name, *Hunters*. This time, he wrapped the teak board in leather and threaded ropes through the holes where the chain once hung and sat the painting on a deer's skull in its antlers. For his performance, he dragged the skull with the upright painting wedged in the antlers around the centre of the exhibition space, presenting himself as captive prey and transforming his self-portrait into a commentary on surveillance and authoritarianism. More importantly, he demonstrated his absolute refusal to be silenced. The authorities arrested him immediately after the show and imprisoned him for one week.[57] This was not an isolated event, as other avant-garde artists also dared to expose the fallacies of Ne Win's government.

The policies of isolationism and nationalisation undertaken by the military regime tipped a fragile economy that had not yet recovered from colonial extraction or the destruction of infrastructure during the Second World War into the abyss, resulting in soaring inflation and a black-market economy.[58] However, individuals with connections to the military benefited from subsidised housing, schooling and medical

9.8
Kin Maung Yin, *Untitled* (*Seated Dancer*
series), 2005. Yangon. Oil on canvas.
H. 88.9 cm, W. 61 cm. Suvannabhumi
Art Gallery, Chiang Mai.

of tyres, there are olive green tank treads, thereby overtly linking, through colour and imagery, such cars to military oppression. The red referred to the bloodshed by the military. The car itself symbolised a luxury that only those with government jobs could afford. To anyone driving such a car or someone on the street standing and watching such cars go by, the division was clear about which side one stood on morally, ethically and politically. Unsurprisingly, the censors did not allow the painting to be exhibited.

Junta Myanmar (1988–2011): coded visual vocabulary and new modes of expression

The economic devastation wrought by the legacies of colonialism and postcolonial government policies and corruption came to a head with the 8 August 1988 protests (also called the 8888 Uprising), to which the government responded by killing thousands of those involved. In 1988 the State Law and Order Restoration Council (SLORC) replaced Ne Win's Burma Socialist Programme Party (BSPP) and launched a new era (1992–2011) under General Than Shwe. Artists continued to encounter severe restrictions on freedom of expression and movement. Censors, more conservative in their scrutiny of artwork as political instability heightened alongside regime change, began to deface rejected artwork with stamps. Yet, the era also brought Aung San Suu Kyi, the daughter of General Aung San, to the fore. As she became a source of hope, artists began to depict her. After she was placed under house arrest in 1989, such imagery was forbidden but, as before, artists found ways to circumvent the restrictions, and viewers looked to art for symbols of resistance, as seen in Kin Maung Yin's *Seated Dancer* series from the early 1970s onwards.[59]

Referencing traditional depictions of Burmese dancers in state-approved paintings, Kin Maung Yin painted his dancers seated with lifeless hands in their laps.[60] Some collectors viewed the pose as dancers refusing to dance in protest against an illegitimate regime or the later

care, plus access to goods unobtainable by the average person. A small sector of society accumulated vast wealth as senior military officials profited from participating in nationalised industries and corporations while the majority suffered inflation and shortages. San Minn exposed this corruption in a 1986 painting titled *Express 2*, in which he captured his dismay at the inequality between those with and without military connections (fig. 9.7). The painting depicts a red car of a type commonly imported during the 1980s. Instead

imprisonment of Aung San Suu Kyi (fig. 9.8). 'At that time, every artist who painted in a modern style was anti-government. They expressed their freedom of expression in a quiet way,' noted artist and Pansodan Gallery owner Aung Soe Min of the series.[61] Former friend of Kin Maung Yin and Suvannabhumi Art Gallery owner Mar Mar explained, 'The dancer's job is always to dance, but the dancer's sitting without doing her job.'[62] In this series, the white in the dancers' clothing, sometimes repeated in flowers in the dancers' hair, echoed the white *gangaw* flower often worn by Aung San Suu Kyi in her hair; the colour also referenced purity and peace.[63] The series proved popular with collectors in Burma, with many looking to the paintings for hidden symbolism, whether or not intended by the artist. An artist simply drawing a female figure also proved to be an act of rebellion, with censors wary of any depictions of Aung San Suu Kyi. By repeating these images, Kin Maung Yin harnessed the power of art to convey a message to the like-minded and circumvent censorship. The depictions of lone women in paintings soon became a way for artists to test the boundaries of political resistance while also rallying silent support among viewers.

Facing a new, more authoritarian regime, avant-garde artists pivoted from realism, cubism and impressionism to abstraction and experimentation with brushstrokes and colour to mask political and social commentary while resonating with aggrieved viewers. For instance, Aung Myint activated red, black and white to perform key conceptual roles in his paintings. Black symbolised purity, and he viewed red as synonymous with strength and bravery. He distilled his canvases to minimal lines, patterns and shapes centred on concepts, at once trying to engage viewers while operating within the narrowing space for artistic freedom. Yet, censors became increasingly fearful of meanings associated with colours and scanned paintings for political protest. Aung Myint, no longer able to express himself through colour, turned to creating canvases in black and white. In 2000 he distilled his iconic *Mother and Child* series, previously depicted in vivid colours using cubism

or impressionism, to a single, unbroken black line painted on handmade *mong kung* paper from Shan State (fig. 9.9).[64] Using a curved, one-dimensional line to create the gesture of a mother holding her infant, Aung Myint melded the visual language of temple mural paintings and Burmese circular script to honour the loss of his mother as an infant, and perhaps as a symbolic embrace of his nation. In the following decades he recreated the figures on paper and canvas and as more conceptual forms in sculptures, using found objects, sand, stone, metal, mud and wood.[65]

Art exhibitions and education also adjusted to the constant threat of state violence and ongoing censorship. In 1989, in the aftermath of the 1988 mass protest, Aung Myint, alongside San Minn and other avant-garde artists, opened the Inya Gallery of Art in Yangon,[66] creating a refuge in Aung Myint's garage where artists could congregate, access books on modern art and display their work. Echoing Kin Maung Yin's mobilisation of artists between 1960 to 1970 from his base at the AI studio in downtown Rangoon, the Inya Gallery of Art under Aung Myint's tutelage rallied the next generation of modernists. Aung Myint embraced Kin Maung Yin's philosophy that artistic style emerged after endless hours of painting rather than technical instruction.[67] As in earlier times, artists accessed modern practices through self-study in books, magazines and journals and the daily practice of painting, using art to process emotions and observations of the world around them. Opportunities to travel abroad remained negligible, and most artists producing artwork outside the perimeters of state-approved content remained within Myanmar's borders. However, the 1996 exhibition *New Painting from Myanmar* at the Substation gallery in Singapore granted Aung Myint, Kin Maung Yin, MPP Yei Myint, San Minn and Chan Aye an opportunity to travel abroad.[68] There, they witnessed performance artist Lee Wen's (1957–2019) work, a pivotal moment in introducing the genre to Myanmar artists.[69] Aung Myint returned to Singapore for a 1997 group exhibition and met performance artist Seiji Shimoda (b. 1953), who introduced him to Japanese and Southeast Asian performance-art networks.[70]

An encounter in Yangon with another performance artist
and scholar soon provided formal instruction in expressing
concept-based artwork. In 1996 artist and art historian Jay
Koh shared videos of performance and installation art
from Europe with Inya Gallery artists.[71] Images of artists
using their bodies and props to convey conceptual work
alongside political and social commentary captivated the
avant-garde art community, already accustomed to *zat pwe*
(travelling theatre).[72] In 1997 Aung Myint and Phyu Mon
created their first performance pieces, and soon avant-garde
artists performed for audiences. Two years later Aung Myint
travelled to Japan to perform alongside Seiji Shimoda,
who visited Myanmar multiple times over the next decade,
collaborating on pieces with Aung Myint and Aye Ko
(b. 1963).[73] Performance art permitted artists such as Aye
Ko, a former political prisoner from 1990 to 1993, to process

9.10
Kin Maung Yin, *Untitled (Portrait of Aung San Suu Kyi)*, 2011.
Yangon. Pencil on paper. H. 37 cm,
W. 27.5 cm. British Museum, London,
2022,3018.1. Purchased in 2014 by the
Suvannabhumi Art Gallery; acquired
by the British Museum in 2022 via the
Brooke Sewell Permanent Fund.

and comment on state oppression in ways that transcended paint on canvas.[74] But not even performance art, with its unscripted dialogues, lack of recording mechanisms and secret invitations and locations, could escape state scrutiny. In 2005, just one year after his release from prison, Htein Lin (b. 1966) performed *Mobile Art Gallery / Mobile Market* with Chaw Ei Thein (b. 1969) in the streets of Yangon to protest against inflation. The performance involved selling low-priced goods and issuing expired currency to customers. It resulted in five days of detention and interrogation of the artists, after which both departed Myanmar for self-imposed temporary exile.[75]

By the onset of the 2000s, travel restrictions eased as the government welcomed tourists. In 2002 Jay Koh, the artists of Inya Gallery and the Gangaw Village artists held an international art symposium and workshop.[76] The following year Jay Koh and artist and academic Chu Yuan established the Network Initiative for Culture and Arts (NICA) to connect international artists, educators, curators and critics with Myanmar artists and writers. A 2004 exhibition of Bangladeshi artists at NICA's exhibition space in Yangon also included a residency for multimedia Bangladeshi artist Tayeba Begum Lipi (b. 1969). NICA also secured residencies abroad through the Japan Foundation and Arts Network Asia, sending artists to Finland, Malaysia and Cambodia.[77] In 2008 Aye Ko opened New Zero Art Space in Yangon, focusing on maintaining international connections through artists' residencies in Myanmar and abroad.[78]

The semi-civilian era, 2011–21: navigating self-censorship and new boundaries

In 2011, when Than Shwe ended the military junta that he had controlled since 1992,[79] Kin Maung Yin sketched Aung San Suu Kyi's portrait, testing the new-found limits of freedom of expression and the supposed end of censorship (fig. 9.10). Mirroring the stoic poses of the women in his *Seated Dancer* series, Kin Maung Yin outlined and shaded with orange pencil the contours of Aung San Suu Kyi's distinctive features and flower in her hair. However, arbitrary enforcement of the previous era's censorship policies continued and at times galleries received notices when they failed to follow the certification process. In 2013 the government revised the 1964 Code to provide more concrete directives on holding art exhibitions. However, it still included language that enabled the arbitrary regulation of imagery, such as the prohibition of work that created 'conflict' or was 'inappropriate' in theme.[80] Despite the

9.11
Sawangwongse Yawnghwe, *Rohingya
Portraits*, 2015. Thailand. Ink on rice
paper. Installation view at the *A Beast, a
God and a Line* exhibition. Myanm/art,
Yangon, 2018.

state reforms, self-censorship persisted. A new censorious force appeared in the post-2011 era, as Buddhist nationalists began criticising the cultural and political content of modern artworks. The religious backlash became an additional concern for Myanmar's artist community, even eclipsing the previous era's burden of bureaucratic censorship. Starting in 2012, Buddhist nationalist groups, such as the 969 movement and Ma Ba Tha, have framed the nation's religion, culture and sovereignty as under siege by Muslims.[81]

Yet, artists soon had multiple galleries in which to exhibit modern and contemporary art. In 2015 Min Wae Aung (b. 1960), artist and owner of the Yangon-based New Treasure Art Gallery, hosted a series of Myanmar–South Korea art exhibitions and exchanges with organisations in Busan, sending artists such as Chan Aye to South Korea.[82] In 2016 curator Nathalie Johnston opened Myanm/art, the first gallery dedicated to contemporary art in Yangon. The gallery has hosted talks by foreign artists and curators from India and Indonesia, injecting contemporary practices and regional networks into Myanmar. It has also featured joint exhibitions between Myanmar and foreign artists, such as the 2020 exhibition of Maria Brinch (b. 1984) and Aung Myint.[83] The new alliances with global and regional artists and artist networks, along with exhibition spaces open to more contemporary practice, propelled Myanmar artists towards more ideologically complex issues.

Artists took bold steps in testing the perimeters of freedom of expression beyond representations of Aung San Suu Kyi. Merging performance and installation art, Htein Lin cast plaster moulds of the hands of over 300 former political prisoners for his 2015 series *A Show of Hands*, which debuted at the Goethe-Institut Myanmar in Yangon, recording each person's memories of imprisonment as the plaster set. A political prisoner from 1998 until 2004, Htein Lin's unveiling of histories in a public forum, unimaginable pre-2011, created a public record of the sacrifices of an older generation of activists.[84] Also documenting unwritten histories, San Minn's 2018 solo show *Prison Series* at Lokanat Galleries depicted his four-year imprisonment for his role in protesting against

the U Thant funeral crisis in 1974 (see p. 208). He recreated from memory the cramped cells, faces of former inmates, and overall inhumanity of detention, injecting into public discourse a once unspeakable history of state oppression.[85]

A surge in ownership of mobile phones collided with the popularity of social media platforms such as Facebook. Artists used online networks to exhibit their work, educate one another about global artists, connect with artists worldwide, and create archives and tributes to Myanmar's avant-garde art movement and its figures, threading Burmese artists into global modern art history. However, as digital information channels opened, misinformation and hate speech targeting the Rohingya, a long-persecuted Muslim minority group in Myanmar, infiltrated feeds alongside legitimate news. Amid escalating violence in Myanmar, the horrors of the 2016 and 2017 genocide against the Rohingya by the Myanmar military shocked the world. Some artists attempted to process the genocide in their art and even exhibited their work in Yangon, demonstrating a new cultural space for more diverse political activism in art.

Sawangwongse Yawnghwe (b. 1971), a Shan artist in self-imposed exile, contributed his *Rohingya Portraits* (2015) to the June 2018 international exhibition *A Beast, a God and a Line* that travelled from Dhaka to Warsaw and then Yangon. The paintings featured images of mass grave sites and murdered individuals, as recalled by Rohingya refugees, and debuted at an offshoot exhibition space of the Myanm/art gallery (fig. 9.11). The portraits, running at eye level along a purple wall, confronted viewers who circulated the room. The images documented an atrocity and reminded viewers of a shared humanity. In early 2019, as part of *Concept, Context, Contestation*, a touring exhibition of Southeast Asian contemporary conceptual art, Htein Lin recreated a life-size charred structure, *Recently Departed*, reminiscent of the burned villages and abandoned homes previously seen in occasional news reports from minority areas decimated by military campaigns.[86] The *Recently Departed* installation featured at the politically and historically sensitive Secretariat building (the site of the 1947

assassination of General Aung San). It visually challenged attempts by the state to erase alternative histories within a historically significant site that had been locked to the public throughout the Socialist and military eras. Six months earlier, in the same place, Htein Lin had curated the major exhibition *Seven Decades* to mark the seventieth anniversary of Myanmar's independence in 1948.[87] He invited leading Myanmar artists to create installations in the Secretariat that would each interpret a decade of Myanmar's post-independence history. These exhibitions signalled a new era of artwork that encouraged viewers to imagine a more inclusive sense of nationhood and a broader definition of the oppressed.

A young generation of artists interested in contemporary practices produced work that further challenged the boundaries of Myanmar identity, including openly criticising political and religious leaders and tackling prejudices towards LGBTQ+ communities, minority groups and women. In 2018 the artist working under the pseudonym Bart Was Not Here (b. 1996) created pop-art posters of world leaders, including Than Shwe, Ne Win and extremist monk Wirathu in his *Old Dirty Bastards* series. After overcoming initial issues sourcing an outlet willing to print the images, Myanm/art sold the posters from the gallery's office in Yangon. In 2020 the gallery featured Richie Htet's (b. 1995) *A Chauk* solo exhibition. Using the Burmese derogatory term for queer people as its title, the work presented Burmese Buddhist mythology depicted by figures with queer identities alongside eroticised male nudity.[88] By situating well-known Buddhist legends and folklore within queer representations, the artist rejected cultural tropes about gender.[89]

9.12
Soe Yu Nwe, *Green Burmese Python*,
2018. Jingdezhen, Jiangxi Province,
China. Glazed porcelain, gold, mother-
of-pearl lustre and cone 6. L. 172.7 cm.
British Museum, London, 2022,3019.1.
Purchased from the artist in 2022 via
the Brooke Sewell Permanent Fund.

9.13–9.14
Khin Thethtar Latt, *Losing Identity*
series, 2021. Yangon. Digital prints on
paper. H. 60.9 cm, W. 91.4 cm (each).
British Museum, London, 2022,3025.1–2.
Acquired from the artist through Karin
Weber Gallery in 2022 via the Brooke
Sewell Permanent Fund.

During a 2018 residency in Jingdezhen, China, Soe Yu Nwe (b. 1989) used Chinese porcelain in *Green Burmese Python* (fig. 9.12) to explore her gender in a conservative society, as well as her ethnic Chinese identity in relation to her Myanmar identity.[90] The porcelain serpent alludes to both her Chinese zodiac symbol and the Burmese belief that pythons found near Buddhist temples are sometimes considered reincarnated monks.[91] Sliced open, with its fragile ribs, thorns and floral elements exposed, the artwork showcases how each identity is enmeshed in a delicate relationship. The medium's fragility, as well as its ability to last over long periods in the archaeological record, permitted Soe Yu Nwe to comment on the survival of women in a patriarchal society alongside the intricate melding of identities.

Since the 2021 coup: a new avant-garde steps forward

After the 2021 coup d'état and the unrelenting state violence that followed, the old systems of censorship, whether state, societal or self-imposed, resurfaced. A new cycle of military rule and bloody suppression of protests has further spurred artists to use their canvases for political protest, document injustices and preserve communal memory. Moreover, a new generation is rising to prominence. Using the internet and social media, artists today have much greater access to the outside world than previous generations isolated by state oppression. Yet, a devastating dismay at the return of repression, censorship and state violence is palpable.

In 2021 Khin Thethtar Latt (b. 1990) created her *Losing Identity* series. It comprises photographs of herself, family, friends and strangers in intimate and public spaces with

9.15
Thynn Lei Nwe, *The Moving Years*,
2022. Yangon. Watercolour on paper.
H. 54.6 cm, W. 38.1 cm (each). British
Museum, London, 2022,3039.1.a–b.
Purchased from the artist in 2022 via
the Brooke Sewell Permanent Fund.

their faces obscured by the colour red (figs 9.13–9.14).
The erasure of the people's faces indicates that with
the coup, all sides have lost something – independence,
freedom and control over their identity. This occurs
regardless of whether they are ordinary citizens, as seen
in the representation of two individuals in a kitchen with
takeaway food, suggesting the need to stay inside for safety,
or members of the military, as seen in the image of a
soldier with his hand gripping a gun that reveals the crude

handwriting of someone with limited education. Here, his
identity has been entirely subsumed by his uniform.

In *The Moving Years* (2022), Thynn Lei Nwe (b. 1991) also
questioned national identity in Myanmar but returned to
the coded visual language of older generations of artists to
address genocide, statelessness and forced migration (fig. 9.15).
In the aftermath of the February 2021 coup, she saw images
of fleeing civilians and burned villages when the Myanmar
Army attacked areas suspected of harbouring protesters.

9.16
Nan Da, *Persistence 1*, 2022. Yangon.
Ink and acrylic on paper. H. 76.2 cm,
W. 55.9 cm. British Museum, London,
2022,3040.1. Acquired from the artist
in 2022 via the Brooke Sewell
Permanent Fund.

The images reminded her of foreign news coverage of Rohingyas displaced by state violence in 2015. When she exhibited the series at Myanm/art, she described the original impetus: 'The first image that got me interested was [a photo of] a large number of people on a small boat, stranded in the ocean for a long time. I could see the pain and loss in all of them.'[92] The ongoing brutality associated with the 2021 coup compelled her to re-examine all lives ruptured by authoritarianism. Evocative of psychological distress and bewilderment, figures in this diptych emerge from the ocean with wooden boats in place of human heads, hands holding oars. In one, fragments of a capsized boat bob in the water nearby. The figures, seemingly lost at sea, ask who can belong and who is safe amid universal violence and displacement.

Despite the extreme risks, protests continue, and painting remains an act of rebellion. After the February 2021 coup and Aung San Suu Kyi's subsequent reimprisonment, Myint Soe (b. 1953) and Nan Da (b. 1981) have returned to painting images of Aung San Suu Kyi to continue this mode of resistance (fig. 9.16). Once again, artists are deploying realism to connect with viewers. Others seek more immediate platforms to protest against the state and they work in anonymous collectives for safety. An anonymous group of artists armed with slide projectors, the 100 Projectors or Projector Fighters, beamed images of resistance on the external walls of buildings in several Myanmar cities after the coup. A different anonymous group of artists constructed a virtual mausoleum, *The Revolution Forest* (2022), a gallery-like virtual space that offered the freedom of an unmonitored art exhibition and a place of solitude and mourning in which artists could pay tribute to fallen protesters. On the website, viewers enter a garden complex to walk among a virtual forest of trees representing saplings planted across Myanmar in honour of protesters killed in the aftermath of the coup. There, visitors can view artwork and listen to songs and poetry created in their memory.[93] A sculpture of a three-fingered salute – a gesture taken from the *Hunger Games* films and adopted by pro-democracy

protesters across Asia – is next to a 'Forest of Life' memorial wall that acknowledges the loss of thousands of lives since the start of what has come to be known as the Myanmar Spring Revolution.[94] Art installations, videos, photos, songs and recordings of poetry readings appear as one scrolls through the rows of virtual trees. As in previous generations, artists offer space for community and momentary solace for a collective grief. The trees sway, leaves falling, each representing a life taken in the resistance movement against the February 2021 coup d'état.[95]

APPENDIX: ANALYTICAL DETAILS AND CONDITIONS

Broadband multispectral imaging (MSI)

All images were taken using a modified Canon 40D camera body. The modification consists of removing the inbuilt UV-IR blocking filter to exploit the full sensitivity of the CMOS sensor (c. 300–1,000 nm). The lens used is a Canon EF 50 mm f/1.8II. The camera is operated in fully manual mode. A reference greyscale, comprising a set of Lambertian black, grey and white tiles, is placed in the same plane as the object under investigation. In each case, the object is illuminated by two radiation sources symmetrically positioned at approximately 45° with respect to the focal axis of the camera and at about the same height. A filter, or combination of filters, is placed in front of the camera lens to select the wavelength range of interest. The combinations of radiation sources and filter(s) used for each MSI technique are summarised in Table 1.

All RAW images are transformed into 16-bit TIF (tagged image file) format using the camera software or external programs such as Adobe Photoshop, with enhancements turned off (such as contrast and saturation). Post-processing procedures for the standardisation and calibration of the VIS, IRR, UVL and UVR images and the creation of IRR and UVR false-colour images are then carried out using 'BM_workspace', a plug-in for Nip2, the open-source graphical user-interface of VIPS, a free image-processing software.[1]

Fibre-optic reflectance spectroscopy (FORS)

Fibre-optic reflectance spectra were recorded with an Avantes (Apeldoorn, The Netherlands) AvaSpec-ULS2048XL-USB2 spectrophotometer equipped with an AvaLight-HAL-S-IND tungsten halogen light source. The detector and light source were connected with a fibre-optic bundle to an FCR-7UV200-2-1.5 × 100 probe. In this configuration, light was sent and retrieved by the bundle set at approximately 45° from the surface normal, therefore excluding specular reflectance. The spectral range of the

TABLE 1
Summary of the combination of radiation sources and filter(s)
used for each of the multispectral imaging techniques considered.

MSI technique	Radiation sources	Filter(s) in front of camera	Range investigated
Visible-reflected imaging (VIS)	2 x Classic Elinchrom 500 Xenon flashlights, each equipped with a softbox (diffuser)	IDAS-UIBAR interference UV-IR blocking bandpass filter (c. 380–700 nm)	c. 380–700 nm
Ultraviolet-induced visible luminescence imaging (UVL)	2 x Wood's radiation sources (365 nm) filtered with a Schott DUG11 interference bandpass filter (280–400 nm)	Schott KV418 cut-on filter (50% transmission at c. 418 nm) + IDAS-UIBAR bandpass filter (c. 380–700 nm)	c. 420–700 nm
Infrared-reflected imaging (IRR)	2 x Classic Elinchrom 500 Xenon flashlights, each equipped with a softbox (diffuser)	Schott RG830 cut-on filter (50% transmission at c. 830 nm)	c. 800–1,100 nm
Ultraviolet-reflected imaging (UVR)	2 x Wood's radiation sources (365 nm) filtered with a Schott DUG11 interference bandpass filter (280–400 nm)	Schott DUG11 interference bandpass filter (280–400 nm)	c. 350–400 nm
Visible-induced visible luminescence imaging (VIVL)	2 x high-power LED (red, green and blue) light sources (Eurolite LED PAR56 RGB spots 20W, 151 LEDs, beam angle 21°). Blue LEDs (λ_{max} = 465 nm)	IDAS-UIBAR bandpass filter (400–700 nm) + Tiffen Orange 21 filter (50% transmission at 550 nm)	c. 540–700 nm
Multiband-reflected imaging (MBR)	2 x Classic Elinchrom 500 Xenon flashlights, each equipped with a softbox (diffuser)	MidOpt BP 660 dark red bandpass filter (c. 640–680 nm) then MidOpt BP735 infrared bandpass filter (715–780 nm)	n/a

detector was 200–1,160 nm; nevertheless, due to poor blank correction on both the extremes of the range, only the range between 350 and 900 nm was considered; as per the features of the monochromator (slit width 50 μm, grating of UA type with 300 lines/mm) and of the detector (2,048 pixels), the best spectra resolution was 2.4 nm calculated as full width at half maximum (FWHM). Spectra were referenced against the WS-2 reference tile provided by Avantes. The diameter of the investigated area on the sample was approximately 1 mm, obtained by setting the distance between the probe and sample at 1 mm. The instrumental parameters were 100 ms integration time and 5 scans for a total acquisition time of 0.5 s for each spectrum. The whole system was managed by the software AvaSoft 8 for Windows.

Optical microscopy (OM) under visible and UV light

The samples were placed on a glass slide and photographed using a Leica DM 4000 M microscope equipped with a Leica EL 6000 UV light source.

Digital microscopy (DM)

A Keyence VHX-5000 digital microscope was used to record magnified images (20-200x). The microscope is equipped with a lens VH-Z 20R, an automated stage VHX-S 550E and LED-reflected illumination.

Scanning electron microscopy – energy-dispersive X-ray spectroscopy (SEM-EDX)

Samples were placed uncoated on an adhesive carbon disk mounted onto an aluminium SEM stub. The examination was carried out using a variable pressure SEM (Hitachi S-3700N) using the backscatter electron (BSE) detector, mostly at 16 kV. The working distance was 10 mm. The SEM chamber was only partially evacuated (mostly 40 Pa).

The EDX spectra were collected using an Oxford Instruments AZtec EDX spectrometer with a 0–20 KeV spectral range, 150 seconds live time number of channels 2048. AZtecEnergy analysis software (Oxford Instruments) was used to process the data.

High-pressure liquid chromatography – diode array detector – electrospray ionisation – quadrupole – time of flight (HPLC-DAD-ESI-Q-ToF)

The dye extraction was performed using a method published in *Archaeological and Anthropological Sciences*,[2] which briefly consists of a double mild extraction procedure, using dimethylsulphoxide (DMSO) first, and secondly a mixture of methanol, acetone, water and 0.5M oxalic acid at 30:30:40:1 (v/v/v/v).

The instrumentation consisted of a 1260 Infinity HPLC (Agilent Technologies) coupled to an 1100 DAD detector (Hewlett-Packard) and a Quadrupole-Time of Flight tandem mass spectrometer 6530 Infinity Q-ToF detector (Agilent Technologies) by a Jet Stream ESI interface (Agilent Technologies). Separation was achieved using a Zorbax Extend-C18 column (2.1 mm × 50 mm, 1.8 μm particle size) with a 0.4 mL/min flow rate and 40°C column temperature, and a gradient of water with 0.1% formic acid (eluent A) and acetonitrile with 0.1% formic acid (eluent B). The elution gradient was programmed as follows: initial conditions 95% A, followed by a linear gradient to 100% B in 10 mins and held for 2 mins. Re-equilibration time for each analysis was 10 mins. 5 μL injection volume was adopted for MS experiments and 10 μL for MS/MS experiments.

The DAD detector (cell volume 50 μL) scanned in the range 190–700 nm with 2 nm resolution. The ESI operating conditions were drying gas (N_2, purity >98%) temperature 350°C and 10 L/min flow; capillary voltage 4.0 kV; nebuliser gas pressure 40 psig; sheath gas (N_2, purity >98%) temperature 375°C and 11 L/min flow. High-resolution MS and MS/MS spectra were acquired in both negative and positive modes in the range of 100–1,700 m/z. The fragmentor was kept at 100 V, nozzle voltage 1,000 V, skimmer 65 V and octopole RF 750 V. For the MS/MS experiments, different voltages (from 10 to 50 V) in the collision cell were tested for Collision Induced Dissociation (CID) to maximise the information obtained from the fragmentation of the single molecules. The collision gas was N_2 (purity 99.999%). The data were collected by targeted MS/MS acquisition with an MS scan rate of 1.0 spectra/sec and an MS/MS scan rate of 1.0 spectra/sec. Auto-calibration was performed daily using Agilent tuning mix HP0321 (Agilent Technologies) prepared in 90% water and 10% acetonitrile.

MassHunter Workstation Software was used to carry out diode array detector and mass spectrometer control, data acquisition and data analysis. In particular, DAD and extract ion chromatograms were obtained using the software EIC function and selecting the correct wavelength or mass.

TABLE 2
Summary of the results obtained for the
six Karen textiles under investigation.

Accession number	Dyes	Fibres	Mordants
As1979,Q.101 (see fig. 5.1)			
Blue/black ground	Indigo + tannins	Cotton	
Light green embroidery	Indigo + tannins	Cotton	
Yellow embroidery	Gamboge (*Garcinia* sp.)	Cotton	Aluminium
Red embroidery	*Morinda citrifolia* (red)	Cotton	Aluminium
Red horizontal strips	*Morinda citrifolia* (red) + flavonoid yellow (?)	Cotton	Aluminium
Thread attaching seed	Undyed	Cotton	
As.7765 (see fig. 5.3)			
Blue/black warp	Indigo	Cotton	
Blue/black stripe	Indigo	Cotton	
Grey/blueish stripe	Indigo	Cotton	
Green/blue stripe	Indigo + *Morinda* yellow	Cotton	
Yellow stripe	Turmeric (*Curcuma* sp.)	Cotton	
Red stripe	*Morinda* red	Cotton	
Blue/black decorative pattern	Indigo	Cotton	
Light blue decorative pattern	Indigo + *Morinda citrifolia* (yellow)	Cotton	
Green decorative pattern	Indigo + *Morinda citrifolia* (yellow)	Silk	
Yellow decorative pattern	Turmeric (*Curcuma* sp.)	Cotton	
Yellow fluorescent decorative pattern	Turmeric (*Curcuma* sp.) + Chinese cork tree (*Phellodendron chinense*)	Silk	
Red decorative pattern	*Morinda citrifolia* (red)	Cotton	
Pink decorative pattern	Lac dye (*Kerria lacca*)	Silk	
White	Undyed	Cotton	
As1919,0717.200 (see fig. 5.6)			
Blue *ikat*	Indigo	Cotton	
Blue warp	Indigo	Cotton	
Blue stripe	Indigo	Cotton	
Red stripe	*Morinda citrifolia* (red)	Cotton	
Green stripe	Indigo + chrome yellow/orange	Cotton	
Orange stripe	*Morinda citrifolia* (red) + chrome yellow/orange	Cotton	
White	Undyed	Cotton	
As,+.6880 (see fig. 5.9)			
Blue	Indigo	Cotton	

Red band	Lac dye (*Kerria lacca*) + cochineal (probably *Dactylopius coccus*) + young fustic (*Cotinus coggygria*)	Felted wool	Tin
Red embroidery	Lac dye (*Kerria lacca*)	Cotton	
Green embroidery	Indigo + chrome yellow/orange	Cotton	
Orange stripe	Lac dye (*Kerria lacca*) + chrome yellow/orange	Cotton	
Pink stitch	Cochineal	Cotton	
White	Undyed	Cotton	
Thread attaching seed	Undyed	Cotton	
As1966,01.481 (see fig. 5.11)			
Black ground	Synthetic black (ingrain dye?) + chrysamine G (C.I. 22250, synthesised in 1884)	Cotton	
Red band	Synthetic alizarin (C.I. 58000, synthesised in 1868) + PR53:1 (C.I. 15585:1, synthesised in 1902)	Cotton	
Red embroidery	Synthetic alizarin (C.I. 58000, synthesised in 1868) + PR53:1 (C.I. 15585:1, synthesised in 1902)	Cotton	
Beige/orange embroidery	Synthetic orange (Congo red class/ingrain dye?)	Cotton	
Yellow embroidery	Chrome yellow ($PbCrO_4$)	Cotton	
Green embroidery	Indigo + chrome yellow ($PbCrO_4$)	Cotton	
Light green embroidery	Turmeric (*Curcuma* sp.) + diamond green B (C.I. 42000, synthesised in 1877)	Cotton	
Thread attaching seed	Undyed	Cotton	
As1901,0318.217 (see fig. 5.13)			
Bright pink Salmon pink	Rhodamine B (C.I. 45170, synthesised in 1887) + auramine O (C.I. 41000, synthesised in 1883)	Felted wool	
Dark red	Orange I (C.I. 14600, synthesised in 1876)	Felted wool	Chrome
Emerald green	Diamond green G (C.I. 42040, synthesised in 1879) + naphthol yellow S (C.I. 10316, synthesised in 1879)	Felted wool	
Dark blue	Crystal violet (C.I. 42555, synthesised in 1883)	Felted wool	
Light green	Nitrobenzene/phenol class?	Felted wool	
Dark green	Nitrobenzene/phenol class?	Felted wool	Chrome
White ground	Undyed	Cotton	
Fringe	Undyed	Cotton	

ဘားမားမှ မြန်မာသို့

နိဒါန်း

ALEXANDRA GREEN

မြန်မာနိုင်ငံသည် ပထဝီဝင် အနေအထားနှင့် ယဉ်ကျေးမှုအရ မြောက်မြားစုံလင်၊ ရှုပ်ထွေး သောနိုင်ငံ ဖြစ်ပါသည်။ မြန်မာနိုင်ငံ၏ ပထဝီသွင်ပြင်ကို တောင်တန်းများ၊ ကုန်းမြင့်ဒေသ များ၊ မြေပြန့်လွင်ပြင်များနှင့် ကမ်းရိုးတန်းများဖြင့် ပါဝင်ဖွဲ့စည်းထားပါသည်။ နိုင်ငံအတွင်း နေထိုင်သူ တိုင်းရင်းသားလူမျိုး ၁၃၅ မျိုး ရှိသည်ဟု ပြောဆို၊ ယူဆကြသော်လည်း တရားဝင် အသိအမှတ်မခံရသူများ ထည့်သွင်းပါက အမှန်တကယ်အားဖြင့် ထိုထက် များပြားနိုင်ဖွယ် ရှိပါသည်။ ဘာသာရေး အရလည်း မွတ်စလင်၊ ဟိန္ဒူ၊ နတ်ကိုးကွယ်သူ၊ ခရစ်ယာန်၊ ဂျူးနှင့် ဗုဒ္ဓဘာသာဝင် နေထိုင်သူများ အဖြစ် အမျိုးမျိုး ကွဲပြားနေပါသည်။ လက်ရှိနိုင်ငံတွင်း ထင်ရှားသောမြို့တော်ကြီးများကို ၁၉ ရာစု အတွင်းတွင် စတင် တည်ထောင်ခဲ့ခြင်းဖြစ်ပြီး နိုင်ငံ၏ ရာခိုင်နှုန်းအတော်များများမှာ ကျေးလက်ဒေသများ အဖြစ် ကျန်ရှိနေဆဲ ဖြစ်ပါသည်။

လက်ရှိ မြန်မာနိုင်ငံကို ဗြိတိသျှတို့မှ လွတ်လပ်ရေးရပြီးနောက် ၁၉၄၈ ခုနှစ်တွင် စတင် ဖွဲ့စည်းခဲ့ခြင်းဖြစ်သည်။ ထိုအချိန်မှစ၍ အစိုးရအဆက်ဆက်သည် မတူကွဲပြားသည့် ဒေသ အသီးသီးကို စုစည်း၍ နိုင်ငံစစ်နိုင်ငံတည်အဖြစ် ဆောင်ရွက်အုပ်ချုပ်နိုင်ရန် ကြိုးပမ်း ခဲ့ကြပါသည်။ ထိုသို့ဖြစ်ရသည့် အကြောင်းအရင်း တစ်စိတ်တစ်ဒေသမှာ ထိုငယ်မြေ၊ ဒေသအသီးသီးသည် ၁၉၄၈ ခုနှစ်မတိုင်မီအထိ တစ်စုတစ်စည်းတည်း မရှိခဲ့သောကြောင့် ဖြစ်သည်။ မတူညီသည့် အပြိုင်အဆိုင် ရှုထောင့် အမျိုးမျိုးက အက်ကြောင်းရာအထပ်ထပ် နှင့် နိုင်ငံတော်ကို ဖန်တီးပေးခဲ့သည်။ ထို့ပြင် ပြည်ထောင်စုအဖြစ် ပေါင်းစည်းဖော်ဆောင် ရေးအတွက် ပျော့ပျောင်းပျော့ပျောင်း မရှိခဲ့သည့် အတွေးအခေါ်များကလည်း စည်းလုံး ညီညွတ်မှု၏ အဟန့်အတားဖြစ်နေစေခဲ့သည်။ နိုင်ငံ၏ ကောင်းစွာမလည်ပတ်နိုင်မှု၊ စစ် အာဏာရှင်အဆက်ဆက်၊ ၁၉၆၀ မှ ၁၉၉၀ ပြည့်လွန်နှစ်များအတွင်း ပြင်ပကမ္ဘာနှင့် အဆက်အသွယ် အပြတ်ခံထားရမှုစသည် အကြောင်းအရပ်ရပ်ကြောင့် ကမ္ဘာ့ဇာတ်ခုံတွင်မူ သယံဇာတပေါကြွယ်ဝပြီး ပထဝီအနေအထားကောင်းမွန်ပါလျက် ဆင်းရဲစေတေနေသော နိုင်ငံတစ်ခုခုဖြစ်သာ ရှုမြင်ခံရစေခဲ့ပါသည်။ သို့ရာတွင် သမိုင်းကြောင်းအဆက်ဆက်ကို ပြန်လည် ရှုမျှော်ကြည့်ပါက ၎င်းအချက်မှာ မှန်ကန်မှုမရှိပေ။

၎င်းစာအုပ်သည် မြန်မာနိုင်ငံနှင့် ပတ်သက်သည့် ယေဘုယျအတွေးများကို ပြောင်းပြန် လှန်ပစ်ရန်ဖြစ်ပြီး၊ ထို့ပြင် မြန်မာ့သမိုင်းကို ရှုထောင့်များစွာမှ ရှုကြည့်ခြင်းအားဖြင့် စာ ဖတ်သူများအား အတွေးတစ်စ ပေးဆောင်နိုင်ရန်လည်း ရည်ရွယ်ပါသည်။ မြန်မာနိုင်ငံသည် မဆင်းရဲပါ၊ သယံဇာတ ပေါကြွယ်ဝပါသော်လည်း ခွဲဝေစေရာချမှု အလွန်ခဲ့တရာ ညံ့ဖျင်းခဲ့ ပါသည်။ ဗြိတိသျှကိုလိုနီစနစ်ပြီးဆုံးပြီးနောက် စစ်အာဏာရှင်စနစ်စတင်ချိန် များမကြာမီ ကမှ ကမ္ဘာ့နှင့် အဆက်အသွယ်ဖြစ်မှု စတင်ခဲ့ခြင်းဖြစ်သည်။ ကိုလိုနီခေတ်မတိုင်မီကမူ လက်ရှိမြန်မာနိုင်ငံဧရိယာ များစွာသော ဘုရင်နိုင်ငံများ၊ ပြည်ထောင်များနှင့် မျိုးနွယ် စုအဖွဲ့ကြီးအငယ်များ၏ ရှုထွေးကျယ်ပြန့်သည့် အုပ်ချုပ်မှုကွန်ရက်များဖြင့် ဖွဲ့စည်းထားခဲ့ ပြီး ပတ်ဝန်းကျင်ကမ္ဘာနှင့် အဆက်အဆံ မပြတ်ခဲ့ပါ။ မြန်မာနိုင်ငံအလယ်ပိုင်းမှ ဘုရင် နိုင်ငံတော်များသည် ဒေသတွင်း အဓိကအင်ပါဝါ နှစ်ကြိမ်မတိုင်တိုင်ဖြစ်ပြီး မြောက်မြား စွာသော လူမျိုးစုမြေများအား တိုက်ခိုက်၊ သိမ်းပိုက်ခြင်းနှင့် လက်ဆောင်ပဏ္ဏာ အဆက်သခံးခြင်းများ ရှိခဲ့သည်။ သို့ရာတွင် ဗြိတိသျှကိုလိုနီ အုပ်ချုပ်မှု လက်အောက်ရှိ မူ မျက်မှောက်ခေတ် မြန်မာနိုင်ငံအတွင်း ပါဝင်သော ဒေသ၊ နယ်ပယ်အသီးသီး၏ ဘာသာ

ရေး၊ လူမှုရေးရာ အခြေခံများစွာကို ဖျက်ဆီးခဲ့သည်အပြင် ၂၀ ရာစုနှင့် ၂၁ ရာစုအစောပိုင်း အထိ ပဋိပက္ခများကို ပေါ်ပေါက်စေသော အယူအဆများကိုပါ မျိုးစေ့ချပေးခဲ့ပါသည်။

၎င်းစာအုပ်ကို မြန်မာ့သမိုင်းဖြစ်စဉ်များအား တည့်တိုးတင်ပြဟန်ဖြင့်မဟုတ်ဘဲ၊ ယဉ်ကျေးမှု ကူးလူးဆက်နွှယ်ခြင်း၊ ရှုထောင့်မှ ရှုမြင်စူးစမ်းကြည့်ဟန်ဖြင့် ဖွဲ့စည်းထားပါသည်။ ထို့ပြင် ၎င်းစာအုပ်အတွင်းမှ အခန်းများကို အောက်ပါ ယူဆချက်ဖြင့် အစပြုထားပါသည် - 'ယဉ်ကျေးမှုဟူသည်' "...အပေါင်းအစပ်များ (မိမိကိုယ်တိုင်၏ ကိုယ်ပိုင်ယဉ်ကျေးမှု များ တင်မက၊ အခြားချင်း စိမ့်ဝင်ပျို့နှံ့လာခဲ့သော ယဉ်ကျေးမှုများနှင့် ပေါင်းစပ်ဖြစ်ပေါ်လာ သော ယဉ်ကျေးမှုများ) ကိုပါ ကောင်းစွာခြင်စိတ်ဖြင့်၍ ရှုမြင်သုံးသပ်နိုင်ရန် ကျွန်တို့အား တွန်းအားပေးပါသည်။" (Civilisation Recast, စာ - ၁၁)။ မြို့ပြယဉ်ကျေးမှု၏ လက္ခဏာ များသည် ဇင်းတို့ပတ်ဝန်းကျင်မှ အစိတ်အပိုင်းများကို ညင်ညင်သာသာပေါ်စပ်ပြီး တစ် ချိန်တည်းမှာပင် ထိုပတ်ဝန်းကျင်ကို အပြောင်းအလဲများ ယူဆောင်လာပေးတတ်ကြသည်။ ၎င်းစာအုပ်သည် မြန်မာ့သမိုင်းတစ်လျှောက်မှ ထိုသို့သော အပြောင်းအလဲဖြစ်စဉ်များကို မြန်မာနိုင်ငံအတွင်းရှိ အမျိုးမျိုးသော ရုပ်ဝတ္ထုပစ္စည်းယဉ်ကျေးမှုများအား ကြားခံအဖြစ် အသုံးပြုလျက် လေ့လာဆန်းစစ်ထားခြင်းဖြစ်ပါသည်။

၎င်းစာအုပ်ပါ ဝတ္ထုပစ္စည်းများအားလုံးနီးပါးသည် ဗြိတိန်နိုင်ငံ (ယူကေ) ရှိ အမျိုးမျိုးသော စုဆောင်းမှုများမှ ဖြစ်ပါသည်။ မြန်မာနိုင်ငံသည် ဗြိတိသျှတို့၏ အရေးပါသော ကိုလိုနီနိုင်ငံ ဖြစ်ခဲ့သော်ငြား ယနေ့ခေတ်ဗြိတိန်နိုင်မှု မြန်မာနိုင်ငံမှာ တဖြည်းဖြည်း လူသိနည်းလာနေ ပါသည်။ ဗြိတိသျှကိုလိုနီလက်အောက်ခံဖြစ်ခဲ့ခြင်း၏ ရလဒ်အနေဖြင့် ယူကေရှိ ပြတိုက် နှင့် အဖွဲ့အစည်းများစွာ၏ စုဆောင်းမှုများတွင် မြန်မာနိုင်ငံမှ ပစ္စည်းများ အနည်းငယ် တော့ ရှိစုမြဲဖြစ်ပါသည်။ ၎င်းပြပွဲအတွက် ပစ္စည်းများရှာဖွေရန် ဗြိတိန်နိုင်ငံတစ် ဝှမ်းသို့ ရာပုံတော်ခရီးထွက်ရင်း ပြတိုက်ပေါင်းများစွာတွင် မြန်မာ့ အနုလက်ရာ ပုံတူ များတွေ့ရခြင်းကလည်း အံ့သြစရာဖြစ်ခဲ့ပါသည်။ မြန်မာနိုင်ငံ၏ ဖန်တီးထုတ်လုပ်ခဲ့ကြ သည့် လက်မှုပညာပေါင်းမြောက်များစွာမှ ပုံတူပစ္စည်းများရွေးချယ်စုဆောင်းခြင်းကို ရည်ညွှန်းပါသည်။ ဆိုလိုသည်မှာ မြန်မာအနုပညာရှင်များ ဖန်တီးထုတ်လုပ်ခဲ့သော အရာ များဆိုသည်ထက် ဗြိတိသျှတို့၏ စိတ်ကြိုက်ရွေးချယ်မှုပေါ်၌ ပိုမှီနီးစပ်စပ် ထင်ဟပ် နေခဲ့သည်ဟု တွေးထင်စရာဖြစ်ပါသည်။ လန်ဒန်မြို့ရှိ ဗိတိုရိယနှင့် အဲလ်ဘတ်ပြတိုက်၏ စုဆောင်းမှုများအတွင်း Felice Beato ၏ စာတိုက်မှ မှာယူသော ကုန်ပစ္စည်းစာရင်း ကက်တလောက် (မေးလ်အော်ဒါ) ကို တွေ့ရှိပြီးနောက်တွင်မူ ယူကေတစ်ဝှမ်းမှ ပုံတူ မြန်မာပစ္စည်းများအကြောင်းမှာ ပိုမိုရှင်းလင်းပြတ်သားလာခဲ့ပါသည်။ ထိုသို့ ထပ်တလဲလဲ စုဆောင်းခဲ့သည့် ပစ္စည်းများမှာ မြန်မာပြည်တွင်း၌ ဗြိတိသျှလူမျိုးအများစု လက်လှမ်းမီခဲ့ သည့်ပစ္စည်းများ ဖြစ်ခဲ့ကြပြီး ၁၉ နှင့် ၂၀ ရာစုအစောပိုင်း ဥရောပ လူနေမှုပုံစံများအတွက် လိုအပ်ခဲ့သည့်အရာများလည်း ဖြစ်နေခဲ့ခြင်း ဖြစ်ပါသည်။ ယူကေတစ်ဝှမ်းရှိ စုဆောင်းမှု များတွင် ကျွန်ုပ်တို့ တွေ့မြင်ရသည်မှာ မြန်မာ့လက်မှုအနုပညာထုတ်လုပ်မှုနှင့် ဗြိတိသျှတို့ နှစ်သက်သဘောကျသည့်ပစ္စည်းများအပေါ် စိတ်ဝင်စားမှုကို ပြန်လည်ပေါင်းစပ်ခဲ့ခြင်း၏ ရလဒ်များ ဖြစ်ပါသည်။ ဗြိတိန်နိုင်ငံတစ်ဝှမ်းရှိ မြန်မာ့အနုပညာလက်ရာပစ္စည်းများအား ထည့်သွင်းဖော်ပြထားသည့် ၎င်းစာအုပ်သည် မြန်မာ့သမိုင်းကို ရှုထောင့်သစ်တစ်မျိုးမှ ပုံ ဖော်ရန်ရည်ရွယ်ပါသည်။ ထိုမျှမက နိုင်ငံရပ်ခြားယဉ်ကျေးမှုတစ်ခုကို ရုပ်ဝတ္ထုပစ္စည်းများ မှတစ်ဆင့် ကိုယ်စားပြုဖော်ရာတွင် ရေးဟောင်းပစ္စည်းဈေးကွက်သစ်များနှင့် စုဆောင်းမှု တို့၏ အကျိုးသက်ရောက်ပုံ (ဥပမာ - အရေးကြီး၊ ထင်ရှား၍ စုဆောင်းရန် ထိုက်တန်သည့် ပစ္စည်းများကိုသာ စုဆောင်းခြင်း) များအားလည်း ထင်ဟပ်ထားပါသည်။ ရလဒ်အနေဖြင့် ၎င်းစုဆောင်းမှုများကို ကြည့်ခြင်းအားဖြင့် မြန်မာနိုင်ငံ၏ လူသိများသည့် ရှုထောင့်များ ကိုသာ တွေ့မြင်ရပြီး အခြားအကြောင်းအရာများကိုမူ ကိုယ်စားပြုမှု နည်းပါးသလို ကောင်းမွန်စွာ ထင်ဟပ်နိုင်ခြင်းမခဲ့သည်ကို သိသာစေပါသည်။ သာဓကတစ်ခုအနေဖြင့် မွတ်စလင် အသိုင်းအဝိုင်းများသည် မြန်မာနိုင်ငံတွင် ကာလရှည်ကြာ နေထိုင်၊ ရပ်တည် ခဲ့ကြပြီးဖြစ်သော်လည်း စုဆောင်းသူများ၏ အယူအဆအရ ဗမာ သို့မဟုတ် ဗုဒ္ဓဘာသာ

ဝင်လူများစုကို ကိုယ်စားမပြုသောကြောင့် ၎င်းတို့၏ ယဉ်ကျေးမှုနှင့် ဆက်စပ်ပစ္စည်းများ ကို ဖြိတ်သျှူတို့က ဝယ်ယူစုဆောင်းခြင်း မပြုခဲ့ကြပေ။ ထိုနည်းတူစွာပင် ဗမာမဟုတ်သည့် တိုင်းရင်းသားလူမျိုးစုများ၏ ယဉ်ကျေးမှုများကိုလည်း ဗမာ၊ ဗုဒ္ဓဘာသာဝင်လူများစုကဲ့သို့ စိတ်ပါဝင်စားမှု မရှိခဲ့ကြပေ။ လူမျိုးစုများရာ ယဉ်ကျေးမှုများကို ရိုးရာအထည်များစုဆောင်း ခြင်းဖြင့် ဆောင်ရွက်ခဲ့ကြသော်လည်း စုဆောင်းသူများက ယင်းပစ္စည်းများကို 'အနုပညာ ပစ္စည်း' အနေနှင့် ယူဆကြသည်တော့ မဟုတ်ပါ။ ယင်းသည်ပင် အခြားနည်းလမ်းတစ် ခုဖြင့် လူမျိုးစုများကြား ခွဲခြား ဆက်ဆံခြင်းပင် ဖြစ်ခဲ့ကြောင်း စုဆောင်းမှုမှတ်တမ်းများ မှတစ်ဆင့် သိရှိရပါသည်။ ထိုသို့သော တတ္ထုပစ္စည်းများနှင့် ၎င်းတို့အား မည်သို့စုဆောင်း ခဲ့သည်ဆိုသည်ကပင် အနုပညာဖန်တီးထုတ်လုပ်မှုနှင့် စုဆောင်းမှုတွက် စေ့စော် တိုက်တွန်းမှုများကို မြင်သာစေသည် ရှုမြင်စရာတံခါးပေါက်များအဖြစ် ရှိနေပါသည်။

အချုပ်အားဖြင့်ဆိုရလျှင် ၎င်းစာအုပ်သည် မျက်မှောက်ခေတ်မြန်မာနိုင်ငံဟု အများသိကြ သော ဒေသတစ်ခုအတွင်းမှ အနုပညာလက်ရာများကို ဖန်တီးထုတ်လုပ်ဖြစ်စေသည့် မြောက်မြားစွာသော လူမှုစုများ၊ ဇာတ်ကြောင်းများနှင့် အတွေးစမ်းများအား ရှုမြင်စူးစမ်း ကြည့်ခြင်းဟုသာ ဆိုချင်ပါသည်။ ထိုသို့ စူးစမ်းလေ့လာခြင်း၏ ရလာဒ်တစ်ခု ဖြစ်သည့် ၎င်းစာအုပ်ကို အလယ်ပိုင်း မြေပြန့်ဒေသမှ အခြေခံအုတ်မြစ်ဖြင့် လက်ခံ၊ တည်ဆောက် ထားသည့် လက်ရှိမြန်မာနိုင်ငံသည် မလွဲမသွေ တစ်သားတည်းသာ ဖြစ်နေသင့်ကြောင်း အယူအဆအား ပြန်လည် စိစစ်တင်ပြရန် ရည်ရွယ်ထားပါသည်။

သယံဇာတ ပေါများကြွယ်ဝမှု

ALEXANDRA KALOYANIDES

မြန်မာနိုင်ငံတွင်တွေ့ရှိရကာ ထူးခြား၊ လက်ရာမြောက်အနုပညာပစ္စည်းများကို ဖန်တီး ရာတွင် အသုံးပြုခဲ့သည့် အဖိုးတန်သဘာဝသယံဇာတများအကြောင်းကို ၎င်းအခန်း တွင် လေ့လာတင်ပြထားပါသည်။ ထို့ပြင် တူးဖော်ရရှိသည့် ကျောက်၊ သတ္တု၊ သစ်တော နှင့် တိရစ္ဆာန်ထွက်ပစ္စည်းများမှတစ်ဆင့် တန်ဖိုးကြီးမားသည့် အသုံးအဆောင်ပစ္စည်းများ အဖြစ် ပြောင်းလဲသွားပုံကိုလည်း ဆန်းစစ်တင်ပြထားပါသည်။ ၎င်းအခန်းအတွင်း ဆန်းစစ် ထားသော ပစ္စည်းများထဲတွင် - မိုးကုတ် ပတ္တမြားများဖြင့် စီခြယ်ထားသည့် ပစ္စည်းများ၊ ကျွမ်းကျင်စွာ ပုံဖော်ထုဆစ်ထားသည့် ကျွန်းကုလားထိုင်၊ မြိတ်မြို့နေလူထုမှ ပေးပို့ခဲ့သည့် ကနကမစ္စာအုပ်၊ နူးညံ့သိမ်မွေ့စွာ ပုံဖော်ထွင်းထားသော ကျောက်စိမ်းအိုးတို့အပြင် လွန်ခဲ့သည့် နှစ်သန်းပေါင်း ၁၀၀ နီးပါးက သတ္တဝါရုပ်ကြွင်းများပါဝင်သော မြန်မာ့ ပယင်း ကျောက်တုံးတို့ပါဝင်ပါသည်။

၎င်းအခန်းတွင် သယံဇာတအရင်းအမြစ်များကို ထုတ်ယူဖန်တီး၊ ရောင်းဝယ်ဖောက်ကား ပုံနှင့် အသုံးပြုပုံတို့ကို အထူးအာရုံစိုက် တင်ပြထားပါသည်။ ဥပမာအားဖြင့်ဆိုရသော် ပတ္တမြားသည် မြန်မာနိုင်ငံအတွင်းရှိ အနည်းကျဉ်းကျောက်တောင်များတွင် တူးဖော်ရ နိုင်သည့် ရှားပါးကျောက်မျက်ဖြစ်ပါသည်။ ဤရုတ်၏ အထက်တန်းလွှာများသည် အဖိုးတန် ရှားပါးကျောက်မျက်ရတနာများကို အမျိုးသမီးဆံထိုးများ၊ အရာရှိခါင်းဆောင်းများ စသည် တို့တွင် ရာစုနှစ်များစွာတိုင် အမှတ်တရနီးတပ်ဆင်အသုံးပြုလေ့ရှိကြသည့်အတွက် ပတ္တမြား ကို တရုတ်နိုင်ငံ ကဲ့သို့သော အိမ်ချင်းနိုင်ငံများနှင့် ရောင်းဝယ်ဖောက်ကားခဲ့ကြသည်။ ကျောက်စိမ်းမှာမူ မြန်မာနိုင်ငံ၏ ဒုတိယ တန်ဖိုးအဆင့်ဆုံး ကျောက်မျက်ရတနာဖြစ်ပြီး ကချင်ပြည်နယ်တွင် အများဆုံးတွေ့ရှိရသည်။ ကချင်ပြည်နယ်အတွင်းရှိ ကျောက်တူး လုပ်သားများ၏ လုပ်အားဖြင့် မြန်မာနိုင်ငံကို ကမ္ဘာ့အကြီးဆုံး ကျောက်စိမ်းတင်ပို့သူအဖြစ် ယခုချိန်၌ ရပ်တည်နိုင်စေပြီး ဖြစ်သည်။ တရုတ်လူမျိုးတို့က ကျောက်စိမ်းကို အထူး မြတ်နိုးကြသည့်အတွက်လည်း တရုတ်နိုင်ငံနှင့် ကာလကြာရှည်စွာ ရောင်းဝယ်ဖောက်ကား

နေခဲ့၊ နေဆဲဖြစ်သည်။ သို့သော် မကြာသေးမီက ဖားကန့်တွင် ကျောက်တူးဖော်မှုနှင့် ပတ်သက်၍ ခေါင်းပုံဖြတ် အမြတ်ထုတ်သည့် အလေ့အထများအကြောင်း အာရုံစိုက် မိမူက မျှတသည့် ကုန်သွယ်မှု အလေ့အထများနှင့် သဘာဝပတ်ဝန်းကျင် ထိန်းသိမ်း ရေးအတွက် စိုးရိမ်မှုများ၊ တောင်းဆိုမှုများအား ပေါ်ပေါက်စေသည်။ ပယင်းကျောက် ကိုလည်း ကချင်ပြည်နယ်တွင်ပင် တူးဖော်ရရှိနိုင်ပြီး ထိုကျောက်ဖြစ်ရုပ်ကြွင်း သစ်စေးမှ သည် ဒိုင်နိုဆောကပ်ခေတ်မှ သတ္တဝါများကိုပင် ၎င်း၏အစေးအတွင်း ထိန်းသိမ်းထား နိုင်သောကြောင့် မကြာသေးမီ ဆယ်စုနှစ်များအတွင်း အဖိုးတန်နိုင်ငံခြားတင်ပို့မှုတစ် ခု ဖြစ်လာသည်။ သို့ရာတွင် ၎င်းတင်ပို့မှုမှအမြတ်ငွေများသည် အစိုးရထံ ရောက်ရှိသွား ပြီး ပယင်းတူးဖော်သည့် ကချင်လူမျိုးများကဲ့သို့သော တိုင်းရင်းသားလူနည်းစုများကို အကြမ်းဖက်ဖိနှိပ်ရန်အတွက် ပြန်လည်အသုံးချကြသည့်အတွက် နိုင်ငံတကာ သိပ္ပံပညာ အသိုင်းအဝိုင်းက မြန်မာ့ပယင်းဝယ်ယူမှုကို စတင်သပိတ်မှောက်ခဲ့ကြသည်။

၎င်းအခန်းတွင် ကျောက်မျက်ရတနာများသာမက၊ မြန်မာနိုင်ငံတွင် လက်ရှိအထိအသုံးပြုနေ သော အဖိုးတန်သတ္တု၊ ဖြစ်သည့် ရွှေနှင့်တို့အနက် ဗုဒ္ဓဘာသာတုံးတစ်စဉ်လာအတွင်း အတွင်စွဲမှုထင်ထားကြသော ရွှေအကြောင်းကို အထူးအာရုံစိုက်တင်ပြထားပါသည်။ ရွှေ၏ ကွေးညွတ်နိုင်စွမ်းနှင့် အရောင်ဖိတ်လက်နိုင်စွမ်းသည် ဗုဒ္ဓ၏တန်ခိုးတော်၊ ဓာတ်တော်များ သယ်ဆောင်ထားသည်ဟု ယုံကြည်ထားကြသော ပစ္စည်းများကို ဖန်တီးသည့် ဗုဒ္ဓဘာသာ ဝင် အသိုင်းအဝိုင်းများ အတွက်မူ အထူးတန်ဖိုးရှိလာသည်။ လက်မှုပညာသည်များသည် ပြည်တွင်းပြည်ပမှ တင်သွင်းလာသော ရွှေမွန်များကို ရွှေမျက်ပါးလွှာများ အဖြစ်သို့ အချိန်ပိုင် ယူခတ်လုပ်ကြပါသည်။ ထိုမျက်ပါးလွှာ၊ ရွှေဆိုင်းများကို မြန်မာနိုင်ငံတဝန်းရှိ ဗုဒ္ဓဘာသာ ဝင်များက ဘုရားရုပ်ပွားတော်များနှင့် စေတီပုထိုးများကို ကပ်လှူပူဇော်ကြပါသည်။

ရေနံ၊တခု၍ ခိုင်ခဲ့သည့် သင်္ဘောများတည်ဆောက်ရန် အသုံးဝင်လှသည့်အတွက် မြန် မာ့ကျွန်းသစ်နှင့် သစ်တောထွက်ပစ္စည်းများမှ ဈေးကွက်အတွက် အဖိုးတန်လှပါသည်။ ကျွန်းသစ်ကို ဈေးကြီးပေးဝယ်သည့် တောင်အာရှနှင့် အရှေ့တောင်အာရှ တော်ဝင် အနွယ်များ၊ အင်ဒို-ပါရုဇ်ဒေသများအပြင် ဥရောပပတ်ကို အင်ပါယားများအတွက် ဘင် လားပင်လယ်အော်တစ်လျှောက်ရှိ ကုန်သည်များသည် မြန်မာ့ကျွန်းသစ်များကို ရှာဖွေ၍ ရောင်းဝယ်ဖောက်ကားခဲ့ကြသည်။ အခြားသစ်တောထွက်ပစ္စည်းတစ်ခုဖြစ်သည် ယွန်း သစ်စေးရည်ကိုမူ အသုံးအဆောင်ပစ္စည်းများကို သုတ်လိမ်းခြင်းဖြင့် တောက်ပြောင်ချော့မွေ့ သော မျက်နှာပြင်ကို ရရှိနိုင်သောကြောင့် တန်ဖိုးထားကြသည်။ ပန်းကန်၊ ခွက်ယောက်နှင့် လင်ပန်းများကဲ့သို့ နိုင်ငံတဝန်းရစဉ်အတိုင်ပြုလေ့ရှိသော အသုံးအဆောင် ပစ္စည်းများ ပင် သစ်စေးသုတ်လိမ်းထားသည့် ယွန်းထည်များဖြစ်ကြသည်။ ပိုမိုထူးခြား၊ ထင်ရှားလှပ သည့် ယွန်းထည် ပစ္စည်းများကိုမူ အစ္စလာမ်၊ ဟိန္ဒူ၊ ခရစ်ယာန်၊ ဗုဒ္ဓဘာသာနှင့် နတ် ကိုးကွယ်မှု အပါအဝင် နိုင်ငံ၏ ဘာသာရေး ဓလေ့ ထုံးတမ်းစဉ်လာ ပူဇော်ပွဲများတွင် တွေ့ နိုင်ပါသည်။ စိုက်ပျိုးရေးကဏ္ဍမှ ဝါ့ဝမ်းနှင့် ဆန်ကို ရာစုနှစ်ပေါင်းစွာ တင်ပို့ရောင်းချခဲ့ ကြပြီး နောက်ပိုင်းကာလများတွင်မူ ဘိန်းသည်းလည်း အဓိကသီးနှံဖြစ်လာသည်။ ကြေအခန်း ခရမများသည် အချို့သော သမိုင်းဝင် လူအဖွဲ့အစည်းများ၏ ကြွယ်ဝမှုနှင့် အဆင့်အတန်း ကို ရည်ညွှန်းပြသည့် အဓိကအခန်းကဏ္ဍမှ ပါဝင်ခဲ့သည်။ ထိုကြေအခန်းခရများကဲ့သို့သော မြန်မာ့ပင်လယ်ထွက်ကုန်များကိုလည်း ထောင်စုနှစ်ပေါင်းများစွာ တွင်တွင်ကျယ်ကျယ် ရောင်းဝယ်ဖောက်ကားခဲ့ကြသည်။

၎င်းအခန်းရှိ မြန်မာ့သဘာဝသယံဇာတ အရင်းအမြစ်များစွာကို ထည့်သွင်းစဉ်းစားခြင်း အားဖြင့် ထိုအရင်းအမြစ်များသည် မြန်မာနိုင်ငံ၏ ထူးခြားရှုပ်ထွေးသော သမိုင်းဝင်ဘု ရင့်နိုင်ငံတော်များ၊ ဒေသတွင်း နိုင်ငံတကာကုန်ပါယာများနှင့် အမျိုးသားနိုင်ငံများ၏ သမိုင်းဖြစ်ရပ်များတွင် မည်သို့သော အခန်းကဏ္ဍမှ ပါဝင်ခဲ့ကြောင်း မီးမောင်းထိုး ပြသ လျက်ရှိပါသည်။

CHAPTER 2

အစောပိုင်း ဘုရင့်နိုင်ငံတော်များ

သော်ဇင်လတ်၊ ပြည့်ဖြိုးကျော် နှင့် ALEXANDRA GREEN

ပုဂံမှာ မြန်မာနိုင်ငံအတွင်း ပထမဦးစွာပေါ်ပေါက်ခဲ့သည့် ဘုရင့်နိုင်ငံတော်မဟုတ်ခဲ့ပေ။ ပုဂံမတည်ထောင်မီ ပထမ ထောင်စုနှစ်အတွင်းမှာပင် နိုင်ငံစတ်ခွမ်းဒ္ဓ မတူကွဲပြားသည့် မြို့ပြည်ရွာကျေးမှုများ၊ လူနေမှုအထောက်အထားများ တည်ရှိနေရှိပြီးဖြစ်သည်။ ပုဂံမတိုင် မီ မြန်မာနိုင်ငံအလယ်ပိုင်းလွင်ပြင်တွင် ထွန်းကားခဲ့သည့် ပျူယဉ်ကျေးမှုနှင့် ခေတ်ပြိုင် တွင် ရခိုင်ဒေသည် ဆည်ဝတီ၊ ဝေသာလီသော မြို့တော်ဟောင်များ၊ အောက်မြန်မာနိုင်ငံ ရှိ မြို့ပြအထောက်အထားများစုဖြင့် အသီးသီး ထွန်းကားနေကြပြီးဖြစ်သည်။ ဤ အခန်းတွင် ဗုဒ္ဓဘာသာယဉ်ကျေးမှုများ ကမ္ဘာ့အရပ်ရပ်သို့ ကူးလူ ဆက်နွယ်ရာ၌ ပုဂံ ပြည်၏ ထင်ရှားအရေးပါခဲ့သည့် အခန်းကဏ္ဍကို မီးမောင်းထိုးတင်ပြထားပါသည်။ ထိုသို့ တင်ပြရာတွင် ခေတ်ပြိုင် ပြည်တွင်းကျောက်စာများနှင့် ပြည်ပ (အိန္ဒိယ၊ သီရိလင်္ကာ၊ တရုတ်) မှတ်တမ်းများ၊ နောင်းခေတ် မြန်မာ ရာဇဝင်များအပြင် ပုဂံခေတ်၏ ထူးခြား လက်ရာမြောက် အနုပညာပစ္စည်းများကို အဓိကအသုံးပြုထားပါသည်။ ပထမ ထောင်စုနှစ် အတွင်း နိုင်ငံအလယ်ပိုင်းလွင်ပြင်တွင် နေရာယူအုပ်ချုပ်ခဲ့ကြသည် ပျူမြို့ပြနိုင်ငံများသည် အိန္ဒိယ တောင်ပိုင်းနှင့် မြောက်ပိုင်းမှ ဟိန္ဒူ၊ မဟာယာနနှင့် ထေရဝါဒ ဗုဒ္ဓစာပေ၊ အနုပညာ နှင့် ဗိသုကာတို့ ကူးလူးလာမှုကို ပြည်ပ ကုန်သွယ်ရေးမှ အစကြုံခဲ့ပြီး တိုက်ရိုက် လွှမ်းမိုးမှု လက်ရာများအပြင် ကိုယ်ပိုင်မွမ်းမံများကိုလည်း ဖန်တီး ထုတ်လုပ် ခဲ့ကြသည်။ ပျူယဉ်ကျေးမှုသည် ၁၁ ရာစု အလယ်ပိုင်းတွင် စတင်တန်ခိုးထွားလာသော ပုဂံယဉ်ကျေးမှု စတင်ရာ ရေသောက်မြစ် ဖြစ်ခဲ့သည်။ ပုဂံခေတ် (၁၁ - ၁၃ ရာစု) တစ်လျှောက်တွင်မှု ပျူ တို့ လက်ဆင့်ကမ်းခဲ့သည့် ယဉ်ကျေးမှုများ သာမက ကုန်ကြောင်း၊ ရေကြောင်း ကုန်သွယ် မှုများမှ ဝင်ရောက်လာသည့် နိုင်ငံတကာ စာပေ၊ ဘာသာရေး၊ လူမှုနိုင်ငံရေး၊ အနုပညာ နှင့် ယဉ်ကျေးမှုများသည်လည်း ပုဂံတွင် ထပ်မံပေါင်းစည်းခဲ့ကြသည်။ ထို့ပြင် သီရိလင်္ကာ နှင့် ပုဂံအကြား ဗုဒ္ဓ သာသနာပြု မစ်ရှင်များနှင့် နိုင်ငံရေး အထောက်အပံ့များ၊ ဗုဒ္ဓဂယာ မဟာဗောဓိ� အား ပြုပြင်လှူ့ဒါန်းရန် စေလွှတ်ခဲ့သည့် ကိုယ်စားလှယ်အဖွဲ့များ၊ ပုဂံ မပျက်သုဉ်းမီ တရုတ်ပြည်သို့ သွားရောက်ခဲ့သည့် ရှျင်ဒိသာပါမောက်၏သံအဖွဲ့၊ စသည့် သမိုင်းဖြစ်စဉ်များမှလည်း ဘာသာရေးနှင့် နိုင်ငံရေးဖြစ်စဉ်တွင် နိုင်ငံတကာနှင့်ကူးလူး ဆက်သွယ်မှုပြုသည့် ပုဂံ၏အခြေအနေကို အကဲခတ်နိုင်သည်။ အိန္ဒိယမြောက်ပိုင်း နှင့် သီရိလင်္ကာမှ ရောက်ရှိလာသည့် ဗုဒ္ဓဘာသာကျမ်းဂန် များမှတဆင့် နိပါတ်တော်၊ ဗုဒ္ဓ၀င်ခန်းနှင့် နှစ်ကျိပ်ရှစ်ဆူဘုရားကျသို့ ထင်ရှားသည့်အကြောင်းအရာများကို လက်ခံ ယူခဲ့သည့်အပြင် ဗုဒ္ဓဆင်းတုတော်များကိုပင် ပါလခေတ်၊ အိန္ဒိယဟန်ဆန်သည့် မျက်နှာ ကိုယ်ဟန်များဖြင့် ပြုလုပ်ကိုးကွယ်ခဲ့ကြသည်။ ဗိသုကာအနေဖြင့်လည်း အိန္ဒိယၤ၊ကန် ကမိုး သည့် (သီရေရ) ကွမ်းတောင်ပေါ်က ဂူဘုရားများ၊ သီဟိုဠ်မှ ဓာတ်တော်တိုက်ဟန် (ဟာ မိက) စေတီလုံးများအပြင် ကိုယ်ပိုင်ဟန်များပေါက်ဖွားလာ ယဉ်ကျေးမှုလွင်ပြင်လည်း ဖြစ် ခဲ့သည်။ ဟိန္ဒူဗြဟ္မဏအယူဝါဒ အထောက်အထားများကိုလည်း ပုဂံတွင်တွေ့ရှိရသည်။ ပုဂံခေတ်တွင် အစပြုခဲ့သည့် ပြည်ရှင်ဘုရင်များနှင့် ဗြဟ္မဏပုဏ္ဏားများအကြားရှိ အခါတော် ပေးခြင်း အလေ့အထနှင့် နန်းတွင်းဟိန္ဒူ ယုတ်ကိုးကွယ်မှုသည် ဒေသရာခေတ်ပျက်သုဉ်း ခ်ိန် ၁၉ ရာစုအထိ ရှင်သန်ကျန်ရစ်ရသည်ကိုပင် တွေ့ရှိရသည်။ ပုဂံသည် ၁၃ ရာစု နောင်း ပိုင်းတွင် မင်းနေပြည်တော်အဖြစ်မှ ရွှေ့ လျော့ကျခဲ့သော်လည်း ဗုဒ္ဓဘာသာဆိုင်ရာ နှလုံး သည်းပွတ်အဖြစ် ဆက်လက် တည်ရှိနေခဲ့ခြင်းကို နောင်ခေတ်အဆက်ဆက်မှ ဗုဒ္ဓဘာသာ အနုလက်ရာများက ဖော်ပြနေဆဲ ဖြစ်ပါသည်။ ပုဂံပြည်၏ အစောပိုင်း ဗုဒ္ဓဘာသာ ဗဟိုဆုံချက် အင်ပါယာဖြစ်မှု၊ ပြိုင်ဘက်ကင်း အနုပညာ ဗိသုကာ လက်ရာများ နှင့် ရှင်သန် ဆဲ ဗုဒ္ဓဘာသာ ထုံးတမ်းဓလေ့လေ့များကြောင့်ပင် ကုလသမဂ္ဂဆိုင်ရာ ပညာရေး၊ သိပ္ပံနှင့် ယဉ်ကျေးမှုအဖွဲ့အစည်း (ယူနက်စကို) ၏ ကမ္ဘာ့အမွေအနှစ်စာရင်းသို့ ၂၀၁၉ ခုနှစ်တွင် ဝင် ရောက်နိုင်ခဲ့ပါသည်။

CHAPTER 3

ပြည်ထောင်များနှင့် ကူးလူးယှက်နွှယ်မှုများ – ချဲ့ထွင်မှုနှင့်ပြိုကွဲမှု ဖြစ်စဉ်များ၊ ၁၅၀၀ – ၁၉၀၀

ALEXANDRA GREEN

၁၄ ရာစုနှင့် ၁၅ ရာစုအတွင်းတွင် မြန်မာနိုင်ငံအလယ်ပိုင်း၊ ရော၀တီမြစ်ဝှမ်းလွင်ပြင် တွင် ပင်းယ၊ အင်း၀စသော မင်းနေပြည်တော်များ၊ ဘင်္ဂလားပင်လယ်အော် ကုန်သွယ်ရေး ကွန်ရက်များနှင့် ချိတ်ဆက်ထားသည့် ရခိုင်မင်းနေပြည်တော် မြောက်ဦး၊ အောက် မြန်မာနိုင်ငံ ကုန်တွင်းဆိပ်ကမ်းမြို့တော် ဟံသာဝတီ (ပဲခူး)၊ မြောက်ပိုင်းနှင့် အရှေ့ပိုင်း ကုန်းမြင့်ဒေသ များမှ မြောက်မြားစွာသော ရှမ်းစော်ဘွားနယ်များအစရှိသည့် နိုင်ငံရေး ဗဟိုဆုံချက်အသစ်များ ပေါ်ပေါက်လာခဲ့ပါသည်။ မြန်မာနှင့် လန္ဈား၊ မဏိပူရနှင့်၊ တရုတ် နိုင်ငံတို့ကြား တောင်ပေါ်ဒေသများတွင်လည်း မျိုးနွယ်စုများနှင့် ကုန်သွယ်ရေးကွန်ရက် များမှတဆင့် ကျယ်ပြန့်သော ဒေသများကို အုပ်ချုပ်သည့် အကြီးအကဲများလည်း ရှိခဲ့ သည်။ ထိုသို့ စုံလင်ကွဲပြားနေမှုသည် အရှေ့တောင်အာရှကျွန်းဆွယ်ဒေသ၏ ကိုလိုနီ ခေတ်ကြို နိုင်ငံရေးဖွဲ့စည်းပုံ ဝိသေသလက္ခဏာများ ဖြစ်ခဲ့သည်။ နယ်နိမိတ်များသည် ရောနောယှက်တင်လျက်ပင် ရှိနေခဲ့ကြပြီး နိုင်ငံရေးအရ သွေဇာဆက်ရောက်မှု ဆိုသည်မှာ ပြည်ထောင်တစ်ခုစီ၏ ပုဂ္ဂိုလ်ရေးအရ သစ္စာတော်ခံမူအပေါ်တွင် များစွာမှီခိုနေပါသည်။ အဆိုပါ နိုင်ငံရေး ဆုံချက်အမျိုးမျိုးသည် ထွေရောယှက်တင်မှု၊ စစ်ရေးရေရာအားပြိုင်မှုများ၊ နိုင်ငံရေး၊ ဘာသာရေး၊ လူမှုရေးနှင့် ယဉ်ကျေးမှု စသော နည်းလမ်းများဖြင့် အချင်းချင်း အပြန်အလှန် ကူးလူးဆက်ဆံခဲ့ကြသည်။ ထိုမှတစ်ဆင့် ပထဝီဝင်အနေအထားအရ ဝေးကွာ သော ဒေသများအချင်းချင်း ၎င်းတို့၏ အနုပညာလက်ရာပစ္စည်း ထုတ်လုပ်ရေးတွင် အဆက်အသွယ်ကွန်ရက်များ အထင်အရှား ပေါ်ပေါက်လာခဲ့ခြင်းပင် ဖြစ်ပါသည်။

၁၆ ရာစု အလယ်ပိုင်းမှ ၁၈ ရာစု အစောပိုင်း ကာလများအတွင်း မြန်မာနိုင်ငံအလယ်ပိုင်းမှ ဘုရင့်နိုင်ငံတော်များသည် အရှေ့တောင်အာရှကျွန်းဆွယ်ဒေသ၏ အကြီးဆုံးအင်ပါယာ နှစ် ကြိမ်တိုင်တိုင်ဖြစ်လာခဲ့ကြသည်။ ထိုအင်ပါယာများမှာ အနောက်ဘက်တွင် အာသံနှင့် မဏိပူ ရနယ်မြေများမှ အရှေ့ဘက်တွင် ထိုင်းနှင့် လာအိုနိုင်ငံများအထိပင် ကျယ်ပြန့်ခဲ့ကြသည်။ ထိုမြန်မာမင်းနေပြည်တော်များ၏ နိုင်ငံရေးသြဇာလွှမ်းမိုးမှုသည် နှစ်ပေါင်း ၂၅၀ ခန့် ဆုတ် လိုက်၊ တက်လိုက်ခဲ့ရှိခဲ့ပြီး ၁၈.၂၄-၂၆ ပထမ အင်္ဂလိပ်-မြန်မာစစ်ပွဲပြီးတွင်မှ ပြည်ဖုံးကား ကျသွားခဲ့သည်။ စစ်ပွဲများအတွင်း သုံ့ပန်းအဖြစ် အတင်းအဓမ္မ ရွှေ့ပြောင်းနေထိုင်စေ ထိုင်စေ များကြောင့် ဇာတ်ကြောင်းအသစ်၊ အနုပညာဆိုင်ရာ နည်းစနစ်၊ ဒီဇိုင်း၊ ခေတ်နှင့်လျော့ညီ သော ဝတ်စားဆင်ယင်မှု၊ ကစားခုန်စား၊ ယုံကြည်မှုလေ့ထုံးတမ်းစသည့် အသစ်အသစ် တို့ဖြင့် လူ့အသိုင်းအဝိုင်းများ ပေါင်းစည်းနေထိုင်ကြခဲ့ကြသည်။ မြန်မာမှုပြုခြင်း၏ ထင်ရှား သော ဥပမာတစ်ခုမှာ ၁၇၆၇ ခုနှစ်တွင် အယုဒ္ဓယကို သိမ်းယူပြီးနောက် မြန်မာ့ တော်ဝင် ဝတ်လဲတော် ဝံ့စံသစ်များ တီထွင်ခဲ့ခြင်းဖြစ်သည်။ မြန်မာနိုင်ငံ အလယ်ပိုင်းသို့ သောင်းနှင့် ချီသော သုံ့ပန်းများကို ပြန်လည်ခေါ်ဆောင်လာကာနောက် ထိုင်းဘုရင်ခံပညာရှင်များ၏ ဝတ်စားဆင်ယင်မှုကို နှစ်ခြိုက်ကြသည့်အားလျော့စွာ နန်းတွင်းအဆောင်အယောင် ဝတ်ရုံ များအဖြစ် ထပ်ဆင့်တီထွင် ဖန်တီးခဲ့ကြခြင်း ဖြစ်သည်။ အလားတူပင် ၁၈ ရာစုနှောင်းပိုင်း နှင့် ၁၉ ရာစုအစောပိုင်းတွင် ဟိန္ဒူပုဏ္ဏားများနှင့် မွတ်စလင်များအပအစ် မဏိပူရနယ် မှ လူအများအပြားကို ခေါ်ဆောင်နေရာချပြီးနောက်ပိုင်းတွင် မြန်မာနိုင်ငံ အလယ်ပိုင်းတွင် ရှိရာအထည်ဒီဇိုင်းအသစ်နှင့် ရက်လုပ်နည်းအသစ်များ ပေါ်ပေါက်လာခဲ့သည်။ ထို့ပြင် မဏိ ပူရ မြင်းတပ်သားများကို မြန်မာစစ်တပ်တွင် တရားဝင်ပေါင်းစည်းပြီးနောက် ပိုလို (ဂူလို) သည်လည်း မြန်မာ့ နန်းတွင်း ကစားနည်းတစ်ခုအဖြစ် ရေပန်းစားလာခဲ့သည်။

ရခိုင်ပြည်သည် ၎င်း၏ မဟာဗျူဟာမြောက်တည်နေရာအရ ဒေသတွင်း ပေါ်တူဂီနှင့် လူ့ဆို-အေးရှုန်း (ဘင်္ဂါ၍) အိုင်းအဝိုင်းများနှင့် ချိတ်ဆက်မှုမှတစ်ဆင့် စစ်ရေးအရ အားကောင်းလာကာ ဒေသတွင်းထင်ရှားသည့် နိုင်ငံရေး၊ စီးပွားရေးနှင့် သံတမန်ရေးအရ

အပြန်အလှန် ဆက်ဆံရေးများ တည်ဆောက်နိုင်ခဲ့သည်။ ၁၈၂၈-၃၂ ခုနှစ်များအတွင်း ပြုစုခဲ့သော မှန်နန်းရာဇဝင်ကဲ့သို့သော ဗမာရာဇဝင်ကျမ်းများတွင် ရခိုင်ဒေသသည် မြန်မာနိုင်ငံကို အမြဲခိုနေခဲ့ရကြောင်း ဖော်ပြထားသော်လည်း ရခိုင်ပြည်သည် မြန်မာ ပြည်အလယ်ပိုင်းနှင့် ဗုဒ္ဓဘာသာ ကိုးကွယ်ယုံကြည်ခြင်းသော တူညီမှုအရ ယဉ်ကျေးမှုအရ ဆိုပါက သိသိသာသာ ကွဲပြားပါသည်။ ရခိုင်ဒေသ၏ ကုန်သွယ်မှုအရ အရေးပါမှုကို ၁၆ ရာစုနှောင်းပိုင်းနှင့် ၁၇ ရာစုအစောပိုင်း ရခိုင်ပြည်အင်အားကြီးချိန်တွင် ရခိုင်၊ ဘင်္ဂါလီနှင့် ပေါ် ရှန်း အက္ခရာသုံးမျိုးဖြင့် သွန်းလုပ်ထားသည့် ဒင်္ဂါးများတွင် တွေ့နိုင်ပါသည်။ ရခိုင်ဒေသ သည် အနည်းဆုံးအနေဖြင့် ၈ ရာစုမှစတင်၍ သီရိလင်္ကာနိုင်ငံနှင့် ဗုဒ္ဓဘာသာ ဆိုင်ရာ အဆက်အသွယ်များရှိခဲ့ပါသည်။ ဟိမဝန္တာဒေသနှင့် တရုတ်နိုင်ငံတို့မှ ဝိသေသလက္ခဏာ များ ပေါင်းစပ်ထားသည့် မင်းဝတ်ဘုရားဟန်ကို ရခိုင်ဒေသတွင် များစွာတွေ့ရပါမူ ငှင်း ရုပ်ပွားတော်ဟန်သည် မြန်မာနိုင်ငံ အလယ်ပိုင်း မြေပြန့်ဒေသနှင့် သျှမ်းပြည်နယ်တို့အထိ ပင် ထပ်မံပျံ့နှံ့ရောက်ရှိသွားခဲ့သည်။

အောက်မြန်မာနိုင်ငံရှိ ဟံသာဝတီမင်းနေပြည်တော်မှာလည်း ငင်း၏အိမ်နီးချင်းနိုင်ငံများ နှင့် ကုန်သွယ်မှု၊ ဘာသာရေးနှင့် စစ်ရေးအရ ကူးလူးဆက်ဆံမှုများ ရှိခဲ့ကြသည်။ အောက် မြန်မာပြည်၊ ပဲခူးကို မြန်မာနိုင်ငံအလယ်ပိုင်းရှိ မင်းဆက်များက ကာလကြာရှည်စွာ ထိန်းချုပ်ထားနိုင်ခဲ့သော်လည်း ထိုင်းနိုင်ငံအတွက်မှ နယ်မြေဒေသနှင့် အဆက်အသွယ်မပြတ် ခဲ့ပေ။ ဥပမာအားဖြင့် မိကျောင်း ပုံသဏ္ဍာန်ဖျပ်စောင်းသည် တစ်ချိန်က ထိုင်းနိုင်ငံအလယ် ပိုင်းနှင့် ကမ္ဘောဒီးယားနိုင်ငံတို့၌ ထင်ရှား ပျံ့နှံ့ခဲ့သည်။ စည်ညီရောင်သုတ် မွတ္တ၍အိုးကြီး များနှင့် အခြားကြေည်ထည်များကိုလည်း နိုင်ငံတကာမှ ကုန်သည်များ အသုံးပြုရန်အတွက် အမြောက်အမြား တင်ပို့ရောင်းချရသည်။ ဘာသာရေးအဆက်အသွယ်များအနေဖြင့် သီရိလင်္ကာနိုင်ငံနှင့် ထိတွေ့ဆက်ဆံမှုများသည် ဒေသတွင်း သီဟိုဠ်ဟန်ခန့်ထွီယူသော စေတီပုထိုး၊ တည်ဆောက် ကိုးကွယ်မှုများကို ဖြစ်စေခဲ့သည်။ ထို့ပြင် အောက်မြန်မာနိုင်ငံ၊ မြန်မာနိုင်ငံ အလယ်ပိုင်း၊ ထိုင်းနိုင်ငံ မြောက်ပိုင်းနှင့် အိန္ဒိယ အရှေ့မြောက်ပိုင်းတို့အတွင်း ပျံ့နှံ့ရောက်ရှိနေသည့် ဗုဒ္ဓဝင်ဆိုင်ရာ ဇာတ်ကြောင်းနှင့် ဗိသုကာ၊ အနုပညာ လက်ရာများ ဖွံ့ဖြိုးတိုးတက်လာမှု အဆင့်ဆင့်တွင်လည်း တစ်စိတ်တစ်ပိုင်း ပါဝင်ခဲ့ပါသည်။

မျက်မှောက်ခေတ် မြန်မာနိုင်ငံ၏ အနောက်မြောက်ပိုင်း၊ အရှေ့မြောက်ပိုင်းနှင့် အရှေ့ပိုင်း ဒေသများတွင်လည်း နယ်မြေစိုးမိုးမှုအရပ်အစားနှင့် ဩဇာတိက္ကမ အမျိုးမျိုးကွဲပြားသည့် သျှမ်းစော်ဘွားနယ်များလည်း အထင်အရှား ရှိခဲ့ပါသည်။ ရင်တို့ဩဇာခံ တိုင်းရင်းသား စော်ဘွားနယ်များ အချင်းချင်းထံမှ လက်ဆောင်ပဏ္ဏာများ လက်ခံခဲ့ကြသည်နှင့်အမျှ ရင်တို့ အိမ်နီးချင်း မဟုတ်ပေမူ၊ မြန်မာနိုင်ငံအလယ်ပိုင်း၊ လန္နား (ထိုင်းနိုင်ငံမြောက်ပိုင်း)၊ တရုတ်နိုင်ငံစသည်တို့နှင့်လည်း ပဏ္ဏာတော်ဆက် ချစ်ကြည်ရေးနည်းအရ ပါဝင်သင်း ဆက်နွယ်ခဲ့ကြသည်။ တစ်ခါတစ်ရံ၌ ပဏ္ဏာဆက်ရန် ပြည်ထောင်တစ်ခုထက် ပိုသော အချိန်ကာလများလည်း ရှိခဲ့ပါသည်။ ၁၆ ရာစုနှောင်းပိုင်းတွင်မူ ဘုရင့်နောင်လက်ထက် မှ စတင်ကာ ရှမ်းပြည်ထောင်များအား နယ်မြေချဲ့ထွင်သိမ်းပိုက်မှုများ ရှိလာခဲ့သည်။ သျှ မ်း (တး)၊ ကရင်၊ ဝနှင့် ကချင်တို့ အပါအဝင် မတူကွဲပြားသော လူမျိုးစုအသီးသီးသည် ယနေ့မြန်မာနိုင်ငံ၏ တောင်တန်း ဒေသများတွင် နေထိုင်ယူခဲ့ပြီး ကျယ်ပြန့်သော မျိုးနွယ် စုများနှင့် ကုန်သွယ်ကွန်ရက်များ၊ မြို့ယ်များနှင့် ရွာများတွင် ပြုလုပ်သည့် ရိုးရာပွဲမန်း ဈေးနေများ၊ လက်ဆောင်ပဏ္ဏာဆက်သမှုနှင့် စစ်ပွဲ၊ ပဋိပက္ခများမှတဆင့် ကူးလူးဆက်ဆံ ခဲ့ကြပေသည်။ သျှမ်းပြည်နယ်၏ ဝိသေသဖြစ်သော ယဉ်ကျေးမှု ရောထွေးယှက်တင်ခြင်း လက္ခဏာများကို အထူးသဖြင့် ရိုးရာထည်များတွင် ကောင်းစွာတွေ့မြင်နိုင်ပါသည်။ ထိုင်းမြောက်ပိုင်း၊ လားအိုယဉ်ကျေးမှုများနှင့် ဆက်စပ်နေသော ဒီဇိုင်းဖွဲ့စည်းပုံများကို တွေ့ရသကဲ့သို့ မတူညီသောဒေသအမျိုးမှ ဝင်ရောက်လာသည့် ရက်ကန်းထည်အမျိုး မျိုးကိုလည်း သျှမ်းပြည်တွင် တွေ့ရသည်။ ဥပမာ ဆိုရလျှင် သျှမ်းလုံချည်တစ်ထည် ကို တရုတ်ပိုးဖြင့်၊ ဥရောပကတ္တီပါနှင့် ရိုးရာ ချည်ထည်တို့အား အသုံးပြု၍ ပေါင်းစပ် ဖန်တီးနိုင်ခဲ့ကြပါသည်။ ထိုသို့ ကျယ်ပြန့်စုံလင်သည့် ဖန်တီးမှုများကို တခြားသော သျှမ်း

အနုပညာပုံစံများတွင်လည်း တွေ့မြင်နိုင်ပြီး ၎င်းအချက်ကပင် အိမ်နီးချင်း ပြည်ထောင်များ နှင့် မည်မျှဆက်စပ်၊ ပတ်သက်ခဲ့သည်ကို ရည်ညွှန်း ဖော်ပြနေပါသည်။

မြောက်ပိုင်းဒေသရှိ ကချင်လူမျိုးစုအဆက်အကြီးအကဲများ၏ ဒေသဆိုင်ရာသြဇာလွှမ်းမိုးမှုမှာ တောင်ကြားလမ်း အဝင်အထွက် များအား မည်မျှထိန်းချုပ်ထားနိုင်ခဲ့ကြသည်ဆိုသည့် အချက်မှ ပေါ်ထွန်းလာခဲ့ပါသည်။ ထိုချက်ကြောင့်ပင် နယ်မြေဒေသ ပတ်စည်တွင်း လုပ်ရှားသွားလာမှု၊ ကုန်သွယ်မှုနှင့် သံတမန်ရေးရာ နီးနောဖလှယ်မှုများကို အထိအခိုက် ဖြစ်စေခဲ့သည်။ ဗမာ ကုန်းဘောင်မင်းဆက်၊ တရုတ် ချင်မင်းဆက်နှင့် ဖြိတ်သျှတို့က ကချင်ဒေသအား လူမှုရေးရာ ယဉ်ကျေးမှု မရောက်ပေါ်နိုင်သယောင် ပုံဖော်ရေးသားခဲ့သော်လည်း အမှန်စင်စစ်မှာ နိုင်ငံရေးဖွဲ့စည်းပုံ မြင်မြင် မားမား ရှိ ခဲ့ကြသည်။ ပြည်နယ်များအကြားရှိ ထိုအကြီးအကဲပိုင်ဒေသများတွင် နေထိုင်ခဲ့သည့် လူမှုစုများအတွက်မှု ယဉ်ကျေးမှု ဘာသာစကားအမျိုးမျိုးနှင့် စေ့စပ်ညှိနှိုင်းနိုင်စွမ်းများ ပင် အရေးကြီးသော အရည်အချင်းတစ်ခု ဖြစ်ခဲ့သည်။ အမှန်မှာ ယဉ်ကျေးမှုများစွာ နှင့် ဆက်သွယ်နိုင်စွမ်းသည်ပင် အာဏာလွှမ်းမိုးမှု၏ ပြယုဂ်တစ်ခုပင်ရှိခဲ့သည်။ ကချင် ဂျပ်ခုတ်ထည်သည် ဒေသတွင်းယဉ်ကျေးမှုကွဲပုံနှင့် အပြန်အလှန်ကူးလူးဆက်နွယ်မှု သဘောတရားများအပြင် ခေတ်နှင့်အမျှ ဝတ်စားဆင်ယင်ပုံများ မည်သို့မည်ပုံ ပြောင်းလဲ လာခဲ့သည်ကို အထင်အရှား သက်သေပြနေပါသည်။ အချို့သောဒီဇိုင်းနှင့် နည်းစနစ် များ၊ ဥပမာ - လုံကွင်းအနားသတ်ရှိ ဒေါင်လိုက်ချည်ထိုးဒီဇိုင်းများကိုမှ ဒေသတွင်း လူမျိုးစု များစွာ၏ ရိုးရာအထည် 'မိခင်ပုံစံ' များတွင် တူညီစွာထည့်သွင်းဖန်တီးကြသည်ကို တွေ့ နိုင်သည်။ သို့သော်လည်း မြန်မာနိုင်ငံမြောက်ပိုင်းဒေသရှိ အစိတ်အပိုင်း အတော်များများ တွင် လောလောလတ်လတ်အချိန်အထိ ရွှေ့ပြောင်း နေထိုင်မှုနှင့် ရေပုံစွန့်ခွာရသူ များပြား နေဆဲဖြစ်သည်။ ထိုအချက်က ခက်ခဲနေဆဲဖြစ်ပြီးဖြစ်သည့် ရှုပ်ထွေးပွေလီပြီးသား ဝန်းကျင် အတွင်း ပိုမို ရှုပ်ထွေးစေသည့်အတွက် မည်သည့် လူမျိုးစုက မည်သည့်ဒီဇိုင်းပုံစံ ဖန်တီး ထုတ်လုပ်ခဲ့ကြောင်း ဆုံးဖြတ်ရန် ခက်ခဲစေလေ့ ရှိပါသည်။

၁၆ ရာစုမှ ၁၉ ရာစုအတွင်း မြန်မာနိုင်ငံအတွင်းရှိ ပြည်ထောင်များ၊ ဘုရင့်နိုင်ငံတော်များ နှင့် အကြီးအက အုပ်ချုပ်ရေးများ၏ အပြန်အလှန် ကူးယှက်ဆက်ဆံရေးများကို စာပေ မှတ်တမ်းများတွင်သာမက ၎င်းအခန်းတွင် တင်ပြထားသော အနုပညာလက်ရာများမှ တစ်ဆင့်လည်း သိရှိနိုင်ပေသည်။ ထိုနည်းတူစွာပင် ဝတ္ထုပစ္စည်းများနှင့် အနုပညာဆိုင်ရာ ဖန်တီးထုတ်လုပ်ခဲ့မှုလည်း ၎င်းတို့၏ ပုံသဏ္ဍာန်၊ ဖွဲ့စည်းမှု၊ ဒီဇိုင်းနှင့် အသုံးပြုမှုသည် တို့မှတဆင့် ဒေသနှင့် ပြည်ထောင် မဟုတ်သည့် အခြေစိုက်နေရာများ၏ ရှုပ်ထွေးသည့် နိုင်ငံရေး အုပ်ချုပ်မှုပုံစံများနှင့် ကူးလူး ယှက်နွယ်မှုများအား ရှင်းလင်းစွာ ဖော်ညွှန်းပြသ လျက် ရှိပါသည်။

CHAPTER 4

ဖြိတ်သျှကိုလိုနီခေတ်၊ ၁၈၂၆ – ၁၉၄၈

ALEXANDRA GREEN

ဖြိတ်သျှတို့သည် မြန်မာနိုင်ငံကို ၁၉ ရာစု အတောအတွင်း စစ်ပွဲသုံးကြိမ်ဖြင့် ကျူးကျော် သိမ်းပိုက်ခဲ့ပါသည်။ ကိုလိုနီခေတ် တစ်လျှောက် မြန်မာနိုင်ငံတွင် ဖြစ်ပေါ် ပြောင်းလဲခဲ့ သည့် သမိုင်းဖြစ်စဉ်များကို ကိုလိုနီခေတ်မှ ရုပ်ဝတ္ထု ပစ္စည်းများက အကျယ်တဝင့် ဖော်ပြ နေပါသည်။ ယင်းပစ္စည်းများထဲတွင် အင်္ဂလိပ်-မြန်မာ စစ်ပွဲသုံးကြိမ်နှင့် ဆက်စပ်ပစ္စည်းများ အပြင်၊ ၁၈၈၅ ခုနှစ်တွင် ပဒေသရာဇ်စနစ် ပျက်သုဉ်းပြီး နောက်ပိုင်း၊ ဖြိတ်သျှအုပ်ချုပ်ရေး၊ တရားရီးရေးယန္တရားများနှင့် ပတ်သက်သည် အချက်အလက်ဆိုင်ရာ ပစ္စည်းများအထိ အမျိုးမျိုးပါရှိကာ ဘာသာရေးဆိုင်ရာ ဝတ္ထုပစ္စည်းများလည်း ပါဝင်ပါသည်။ သီပေါဘုရင် ပါ တော်မူပြီးနောက် မြန်မာဗုဒ္ဓဘာသာဝင်များ၏ ဘာသာရေးအပေါ်ရှုမြင်၊ ကိုးကွယ် ယုံကြည်

ပုံများ ကွဲပြားသွားခဲ့သည်။ သို့သော်လည်း သီပေါမင်းမတိုင်မီ မင်းတုန်းမင်းလက်ထက်၊ တိုင်းပြည်၏ အုပ်ချုပ်အခြေအနေ ကျဆင်းလာသည့်အချိန်ကပင် ဘာသာရေးဆိုင်ရာ အခွင့်အာဏာကို မြှင့်တင်ရန် မူဝါဒတစ်ခုကို မင်းတုန်းမင်းက ချမှတ်ထားခဲ့ပြီးဖြစ်ပါသည်။ ထိုကာလအတွင်း ဗုဒ္ဓရုပ်ပွားတော်ပုံအသစ်တစ်ခုလည်း ပေါ်ပေါက် လာခဲ့ပါသေးသည်။ ကိုလိုနီခေတ်အတွင်း ဖိနပ်ပြဿနာကို ကြည့်ခြင်းအားဖြင့်လည်း ဖြစ်သျှအုပ်ချုပ်မှုကို ခုခံ တော်လှန်ရာတွင် ဗုဒ္ဓဘာသာသည် အစကတည်းကပင္ ပါဝင်ခဲ့သည်ကို ညွှန်ပြနေ ပါသည်။ မင်းတုန်းမင်း၏ နောက်မူဝါဒတစ်ခုမှာ လွတ်လပ်စွာကိုးကွယ်ယုံကြည်ခွင့်ကို ပြုခဲ့ ခြင်းဖြစ်သည်။ မင်းတုန်းမင်းသည် ရင်၏ မင်းနေပြည်တော်တွင် ဗလီများနှင့် ခရစ်ယာန် ဘုရားကျောင်းများကို ဆောက်လုပ်ခွင့်ပြုခဲ့သည့်အပြင် မက္ကာမြို့သို့ သွားရောက်ဝတ်ပြုကြ သည် ဟာဂျီများအတွက် ဇရပ်တစ်ဆောင်ကိုပင် လှူဒါန်းခဲ့သေးသည်။ ခရစ်ယာန်ဘာသာ မှာ ဗုဒ္ဓဘာသာဝင်များကြားတွင် ရေပန်းစားခဲ့ခြင်းမရှိသော်လည်း၊ အခြားတိုင်းရင်း လူမျိုးစုများကမူ အားတက်သရော စိတ်ပါဝင်စားခဲ့ကြသည်။ သို့သော် ခရစ်ယာန် ဘာသာ ကူးပြောင်းမှုအများစုသည် နိုင်ငံရပ်ခြားမှ လာရောက် စည်းရုံး၊ သာသနာပြုများထက်စာ လျှင် ၂၀ ရာစုအလယ်ပိုင်း ပြည်တွင်းသာသနာပြုများကြောင့် ပိုမို အရှိန်အဟုန် မြင့်လာခဲ့ ခြင်း ဖြစ်ပါသည်။ ခရစ်ယာန်သာသနာပြုများသည် တိုင်းရင်းလူမျိုးစုများ၏ နှုတ်ပြော ဘာသာစကားများအတွက် အရေးအကွက်စနစ် ရေးဦးတီထွင်ရေးအတွက်လည်း များစွာ အကူအညီပေးခဲ့ကြသည်။

၁၉ ရာစု မြန်မာနိုင်ငံအတွင်း ဖြစ်ပေါ်ပြောင်းလဲခဲ့တို့မှာ မင်းမျိုးမင်းနွယ်နှင့် ဘာသာ ရေးဆိုင်ရာဖြစ်စဉ်တို့တွင် မကခဲ့ပေ။ လက်မှုအနုပညာရှင်များသည် ပြောင်းလဲလာ သည့် ဝယ်သူ၊ ဖောက်သည်အသစ်များနှင့် လိုက်လျောညီထွေ ဖြစ်စေရန်အတွက် ရင်း တို့၏ထုတ်ကုန်များကို လိုက်လျောညီထွေပြောင်းလဲကြသည်။ ဥပမာဆိုရလျှင် ပြည်တွင်းရှိ အိန္ဒိယလူမျိုးအသိုင်းအဝိုင်းအတွက် ဂန္ဓီရုပ်ပုံပါဝင်သည့် ယွန်းထည်များ၊ အနောက်တိုင်းသားတို့အတွက် ဥရောပဟန် ရောစွက်သည့် ငွေထည်များစဖြင့် အသီးသီး ထုတ်လုပ် ရောင်းချကြသည်။ ထို့အပြင် ဝယ်သူအသစ်များအကြိုက် အလှုပြုပန်းကန်ပြား၊ ဥရောပဟန်ကုလားထိုင်၊ အိန္ဒိယဟန်ထမင်းချိုင့်အစရှိသည့် အသစ်အသစ်သော ပုံစံတို့ကို လည်း တီထွင်ဖန်တီးခဲ့ကြသည်။ ဖြစ်သျှကုန်သွယ်မှုကွယ်ရက်များ၏ ရလဒ်တစ်ခုအနေဖြင့် ဓာတုဆိုးဆေးနှင့် ချည်မျှင်များသည် နိုင်ငံအနှံ့အပြားသို့ မြန်မြန် ဆန်ဆန် ရောက်ရှိသွား ခဲ့ပြီး ပြည်တွင်းနေ တိုင်းရင်းသားများ၏ ရိုးရာအထည် ထုတ်လုပ်ဖန်တီးမှုများအပေါ်တွင် များစွာ သက်ရောက်မှု ရှိခဲ့သည်။ မင်းတုန်းမင်းသည် မြန်မာ့သည်းပညာ၊ စက်မှုလက်မှု၊ စစ် ရေးနှင့် ဆက်သွယ်ရေးစနစ်များကို ခေတ်မီအောင် စတင်ကြိုးပမ်းခဲ့သည်။ တစ်နိုင်ငံလုံး သိမ်းယူပြီးသည့်အချိန်တွင်မူ ဖြစ်သျှတို့က ဆက်လက်လုပ်ဆောင်ခဲ့သည်။ ယင်းအချက် ကြောင့်ပင် ၁၉ ရာစုအလယ်ပိုင်း မန္တလေးတွင် ဖန်ချက်စက်ရုံနှင့် ချည်ထည်စက်ရုံစသည် တို့အပြင် ၂၀ ရာစုအစောပိုင်းတွင် ရက်ကန်းနှင့် ယွန်းထည် အတတ်သင်ကျောင်းများ ပါ ပေါ်ပေါက်လာခဲ့ကြခြင်းဖြစ်ပေသည်။ ကိုလိုနီခေတ်တွင် ဓာတ်ပုံ၊ ရုပ်ရှင်၊ စာနယ်ဇင်း၊ ကြော်ငြာနှင့် ကာတွန်းများပါအဝင် အနုပညာပုံစံသစ်များစွာ တိုးတက်ထွန်းကားလာ ခဲ့သည်။ ကိုလိုနီခေတ်ပန်းချီဆရာများသည် "စပ်"ပန်းချီကား (collage paintings) များ ကို ဖန်တီးပြုလုပ်ရန်အတွက် ဓာတ်ပုံပညာကို လိုက်လျောညီထွေဖန်တီးခဲ့ကြသည်။ ထို ပန်းချီဆရာများသည် အနောက်တိုင်း နည်းစနစ်များကိုလည်း လေ့လာခဲ့ကြပြီး ယင်း စနစ်တို့ကို မြန်မာ့အယူအဆ၊ ယဉ်ကျေးမှုဝမ္မသုတများနှင့် လိုက်လျော ညီထွေအောင် ပြောင်းလဲသုံးစွဲခဲ့ကြသည်။ ထို့တစ်ဆင့် ကြော်ငြာဘုတ်နှင့် ရုပ်ရှင်ပိုစတာများကိုပင် ထုတ်လုပ် ဖန်တီးနိုင်ခဲ့ကြသည်။ ထိုခေတ် နိုင်ငံရေးအခြေအနေများမှု ရွေ့ရှာဘကလေး အစရှိသော ကာတွန်းဆရာကြီးများက စတင်၍ ဝေဖန် သုံးသပ်ခဲ့ကြပေသည်။

အာရှနှင့် ဥရောပဒေသများမှ ဗုဒ္ဓဘာသာဝင်မဟုတ်သူများ အများအပြားဝင်ရောက်လာ မှုကြောင့် ၂၀ ရာစု အစောပိုင်း ကိုလိုနီ နယ်ချဲ့ဆန့်ကျင်ရေးလှုပ်ရှားမှုများမှာ မြန်မာ့ ယဉ်ကျေးမှုနှင့် ဗုဒ္ဓဘာသာကို ထိန်းသိမ်းစောင့်ရှောက်ခြင်း၊ အမျိုး၊ ဘာသာ၊ သာသနာ

စောင့်ရှောက်ရေးအယူအဆများနှင့် စတင်၍ ဆက်စပ်လာခဲ့သည်။ မည်သို့ပင် ဗမာလူမျိုး ကွဲသို့ ဝတ်စားဆင်ယင်ပြီး ဗမာစကားပြောနေပါစေ၊ အဂတိစစ်ပွဲကာလများအတွင်း ပြောင်းရွှေ့နေထိုင်ခဲ့ကြသော လူမျိုးစု အဆက်အနွယ်များအနေဖြင့် ရင်တို့ကိုယ်ရင်း တို့ ဗမာလူ မည်သို့မှ ရှုမြင်ခဲ့ကြမည်မဟုတ်ပေ။ အမှန်တကယ် ဖွဲ့စည်းထားသည့် လူမျိုးစု လက္ခဏာရပ်များကို ဥပေက္ခာဆန်ဆန် ရှုမြင်ဖွင့်ဆိုလိုက်ခြင်းက အဖြစ်မှန်နှင့် ကွဲပြားသွား စေခဲ့ခြင်း ဖြစ်ပါသည်။ မြန်မာနိုင်ငံ၏ ဖြစ်သျှအုပ်ချုပ်ခဲ့မှုမှာ ယနေ့ခေတ်မြန်မာနိုင်ငံ၏ မတူကွဲပြားသော အစိတ်အပိုင်းများ အချင်းချင်း သွေးခွဲအုပ်ချုပ်မှုကို အလေးပေးခဲ့ သည်ဟု ဆိုရမည်ဖြစ်ပါသည်။ ဖြစ်သျှတို့၏ အသစ် ကောင်ယူခဲ့ကြသည် သန်းခေါင်စာရင်း တွင် ထိုင်နိုင်ငံ၊ ချွန်ပြည်နယ်၊ ယူနန် အစရှိသည့် ဒေသအသီးသီးမှ ဗုဒ္ဓဘာသာဝင် များ ကိုပင် ဗမာလူမျိုးအုပ်စုအတွင်းသို့ သွတ်သွင်းခဲ့ကြသည်။ ရလဒ်အနေဖြင့် တိုင်းရင်းသား အုပ်စုများကို ခွဲခြား သတ်မှတ်ခြင်းများကို ဖြစ်စေခဲ့သည်။ ထိုပြင် ထိုသန်းခေါင်စာရင်းများ အတွင်းမှ တိုတောင်း၊ အရည်အချင်းမပြည့်မီသော အဖြေများသည် ထိုခေတ်နိုင်ငံတော် အား တိကျစွာ မှတ်တမ်းတင်နိုင်ခြင်း မရှိခဲ့ပါ - ဥပမာဆိုရလျှင် လူအတော်များများ ထံတွင် အလုပ်တစ်ခုထက် ပိုရှိခဲ့ကြပါသည်။ ထို့ပြင် ယနေ့ထိ လက်ခံယုံကြည်နေကြဆဲဖြစ် သော လူမျိုးစုများအကြောင်း ယေဘုယျဆုံးဖြစ်၊ ဖွင့်ဆိုချက်များကို ထိုခေတ်က စတင် ဖန်တီးခဲ့ကြခြင်းဖြစ်သည်။ ထိုသို့ လူမျိုးစုများနှင့်ပတ်သက်သော လိုရာဆွဲ၍ တွေးခေါ်ချက် များကို ကိုယ်စားပြု၊ စိတ်ကူးစုများဝတ်ဆင်ထားသည့် တိုင်းရင်းသားလူမျိုးစုများ၏ သစ်သား ရုပ်ငယ်များ ထုတ်လုပ်ခြင်း နှင့် ရေဆေးပန်းချီကားများ ရေးဆွဲ၊ မှတ်တမ်းတင်ခြင်း စသည့် ကိုလိုနီခေတ် အနုပညာလက်ရာများတွင် ကောင်းစွာ တွေ့မြင်နိုင်ပေသည်။

ဖြစ်သျှတို့သည် ဗမာမြေပြန့်နယ်များ၏ လူမှုရေး၊ နိုင်ငံရေး၊ ဘာသာရေး၊ ဖွဲ့စည်းမှုများ အားလုံးကို အသွင်ပြောင်း စနစ်သစ်ဖြင့် တိုက်ရိုက် အုပ်ချုပ်ရ အုပ်ချုပ်မှုပေးခဲ့ပြီး တောင်ပေါ်ဒေသ များကွဲသို့ သွယ်ဝိုက် အုပ်ချုပ်မှု ပေးထားသော ဒေသများတွင် အပြောင်းအလဲ နည်းနည်း ဖြင့် အုပ်ချုပ်ခဲ့ခြင်းက အဖိုးတန်သယံဇာတများ ထုတ်ယူရေးအတွက် ပိုမိုထိရောက်စေခဲ့ သည်။ သို့သော်လည်း ထိုအပြောင်းအလဲများက ပြည်တွင်းယဉ်ကျေးမှုကို ရှုတ်ချသည် ဖိအားများဖြင့် ပြန်လည်ဆန်သစ်ရန် တွန်းအားပေးဆောင်ခဲ့သည်နှင့်အမျှ ဝါဒဆန့် လှုပ်ရှားမှုအစဝင် အမျိုးမျိုးသော ဆန့်ကျင်ရေး လှုပ်ရှားမှုကြီးများ ကိုလည်း အားကောင်း လာစေခဲ့သည်။ အဆုံးပါ လှုပ်ရှားမှုကြီးများကို ကိုလိုနီခေတ် အသုံးအဆောင်ပစ္စည်းများတွင် ပုံဖော်၊ ရေးခြစ်ထားသည်တို့မှ တွေ့မြင်နိုင်ကြပါသည်။ သို့ရာတွင် မြန်မာ့လွတ်လပ်ရေး အရှိန်အဟုန်ဖြင့် ရရှိခြင်း၏ အဓိက အကြောင်းအရင်းမှာ ပြည်သူအသက်အိုးအိမ်စည်းစိမ်၊ အခြေအဆောက်အအုံနှင့် ငွေကြေးမြောက်မြားစွာ ရင်နှီးခဲ့ကြရသည့် ဒုတိယကမ္ဘာစစ်နှင့် ဂျပန်မျိုးကျော်စစ်ကာလ၏ ရလဒ်အသီးအပွင့်များသာလျှင် ဖြစ်ခဲ့ပါသည်။

CHAPTER 5

ကရင်ရိုးရာရက်ကန်းထည်များ – အစောပိုင်းဓာတုဆိုးဆေးသုံး ရက်ကန်းထည်ဖန်တီးမှု

DIEGO TAMBURINI, CAROLINE CARTWRIGHT, JOANNE DYER နှင့် ALEXANDRA GREEN

ဤအခန်းတွင် လန်ဒန်မြို့၊ ဖြစ်သျှပြတိုက်၏ စုဆောင်းမှုများထဲမှ ကရင်ရက်ကန်းထည် ခြောက်ထည်အား ဆန်းစစ် လေ့လာခြင်း ရလဒ်အဖြေများကိုအသုံးပြုလျက် ၁၉ ရာစု အတွင်း အဝတ်အထည်ထုတ်လုပ်မှု၌ ဆင်ကဲပြောင်းလဲမှု ဖြစ်စဉ်နှင့် အပြောင်းအလဲ များကို မီးမောင်းထိုးပြရန် ရည်ရွယ်တင်ပြထားသည်။ တွင်ထွက်ဆိုးဆေးများ (chrome yellow) နှင့် အခြားသော သတ္တုဆိုးဆေးများ (tin and chrome) တို့ကဲ့သို့ aniline ဆိုးဆေးများအသုံးပြုခြင်းအပြင် ဆေးဆိုးခြင်းနှင့် ချည်မျှင်ပြုလုပ်ခြင်း နည်းပညာအသစ် များကို ၁၈၇၀ ခုနှစ်မှစ၍ ၂၀ ရာစုအစောပိုင်းတစ်လျှောက် ထုတ်လုပ်သည် ရိုးရာအထည်များတွင်

စတင်တွေ့ရှိသည်။ အစေ့ပိုင်းအထည်များတွင်မူ Morinda citrifolia အပင်နှင့် ချိုပိုးမွှား (Kerria lacca) တို့မှ အနီရောင်၊ နနွင်း (Curcuma longa) နှင့် အဝါရောင်သစ်စေး (Garcinia sp.) မှ အဝါရောင်၊ မဲနယ်မှ အပြာရောင်တို့ပါအဝင် အရှေ့တောင်အာရှ ရိုးရာ သဘာဝဆိုးဆေးများကို ကျယ်ကျယ်ပြန့်ပြန့် ရေးခြယ် ဆေးဆိုးထားသည်ကို တွေ့ရသည်။ တရုတ်နိုင်ငံတွင် ထုတ်လုပ်ခဲ့သည်ဟုယူဆရသော ပိုးချည်မျှင်များကို အေဒီ ၁၈၇၂ ခုနှစ် မတိုင် မီက ချုပ်လုပ်ခဲ့သည့် ကရင်ထဘီအချို့၏ အသေးစိတ်ပန်းထိုးလက်ရာထဲများတွင် တွေ့ ရသည်။ ထိုအချက်က ကရင်လူမျိုးတို့ ဒေသအတွင်း ကူးလူးဆက်ဆံခဲ့ကြသည်ကို ဖော်ပြ နေသည်။ အချို့သော အထည်များတွင်မူ သဘာဝနှင့်ဓာတုဆိုးဆေးများ၏ ရောနော ယှက်တင်မှုကို စိတ်ဝင်စားဖွယ်တွေ့ရရှိပြီး တစ်ခါတစ်ရံတွင်မူ သီးခြားအရောင် တစ်ခုရရှိ ရန် ရောစပ်ကြခြင်းကို တွေ့ရသည်။ ဥရောပတိုက်မှ ရောင်စုံမျှင်အသစ်များ ရောက် ရှိလာပြီဖြစ်သော်လည်း ပိုမိုအမှုန်တင်ရှိသည့် ရိုးရာအရောင်များကို ရှာဖွေဖော်ထုတ် ရန်၊ အရောင်များကို ချိန်ညှိရန်အတွက် ဒေသခံ ဆေးဆိုးသူများ နှင့် အထည်ထုတ်လုပ်သူ များ စမ်းသပ်ကြိုးပမ်းမှုကို ညွှန်ပြမာ မီးမောင်းထိုးပြနေသည်။ တစ်ခါတစ်ရံတွင်မူ ဓာတုဆိုးဆေးများသည် အထည်များ၏ သက်တမ်းကို တွက်ချက်နိုင်သည့် အရေးကြီး အထောက်အထား ဖြစ်နေတတ်သည်။ ဥရောပမှ ဓာတုဆိုးဆေးအများစုမှာ ရှာဖွေတွေ့ရှိ သည့်နှစ်ကို အများအားဖြင့် သိရှိထားကြသောကြောင့် ယင်းဆိုးဆေးများကို အသုံးပြုထား သည့် အထည်များ၏ အစေ့ဆုံး ဖြစ်နိုင်ခြေရှိသည့်ရက်စွဲကို သိရှိရန် လွယ်ကူပါသည်။ မြန်မာနိုင်ငံအတွင်းသို့ ဆိုးဆေးနှင့် ဆေးဆိုးနည်းအသစ်များ ရောက်ရှိလာပုံနှင့် ပေါင်းစပ် ဖန်တီးခြင်းတို့ကို အပြည့်အဝနားလည်သဘောပေါက်နိုင်ရန်အတွက်မူ ကြိုတင်သုတေသန ကို မြန်မာနိုင်ငံနှင့် ဖြိတ္တိသျှ အင်ပါယာတို့အပြင် ဒေသတွင်း ကုန်သွယ်မှုဆိုင်ရာ မော်ကွန်း မှတ်တမ်းများဖြင့် ချိတ်ဆွဲဖြည့်စွက်ရန် လိုအပ်မည် ဖြစ်ပါသည်။ ဤအခန်းတွင် ဖော်ပြ ထားသော ရလဒ်ဖြေများမှတစ်ဆင့် ကိုလိုနီခေတ်အစ ဆယ်စုနှစ်အနည်းငယ်အတွင်း ဆိုးဆေးနှင့် ချည်မျှင်ရွေးချယ်မှုဆိုင်ရာ ရုတ်ခြည်းအပြောင်းအလဲများကို ရှင်းလင်းစွာတင်ပြ နိုင်ရန် ရည်ရွယ်ပါသည်။

CHAPTER 6

ဒုတိယကမ္ဘာစစ်တွင် မြန်မာပြည်

MAITRII AUNG-THWIN နှင့် စွမ်းရည်ထွန်း

မြန်မာနိုင်ငံတွင် ဒုတိယကမ္ဘာစစ်ကာလသည် တိုင်းပြည်၏အနာဂတ်ကို ပုံဖော်ပေးမည့် လှုပ်ရှားမှုများအစပြုရာ သမိုင်းအလှည့်အပြောင်း ကာလဖြစ်သည်။ မြန်မာနိုင်ငံ (ထိုစဉ် က ဗြိတ္တိသျှဘားမား) ကို ၁၉၄၂ ခုနှစ်၊ ဒီဇင်ဘာလ နှောင်းပိုင်းမှ ၁၉၄၅ ခုနှစ်၊ မေလအထိ ဂျပန်က ကျူးကျော်သိမ်းပိုက်ထားခဲ့ပြီး ရင်ကာလ မြန်မာနိုင်ငံတွင် ဗြိတ္တိသျှ အုပ်ချုပ်ရေး စနစ်ကို လည်ပတ်နိုင်ခြင်း မရှိတော့သည့်အပြင် အရေးပါသည် အခြေခံအဆောက်အအုံ များ အဖျက်ဆီး ခံရခြင်း၊ ဂျပန်အင်ပါယာ၏ နယ်ချဲ့အုပ်ချုပ်မှုအောက်မှ လွတ်မြောက်လို သူ ထောင်ပေါင်းများစွာကိုပါ အုံးမွဲ့အိမ်မွဲ ဖြစ်စေခဲ့သည်တို့ကိုလည်း ဖြစ်စေခဲ့သည်။ ထိုခေတ်နှစ်ဘက်တပ်ဖွဲ့အမျိုးမျိုး၏ မြေလှုန်တိုက်ခိုက်ရေး မူဝါဒများသည် အနုပညာ နှင့် ရုပ်ပိုင်းဆိုင်ရာယဉ်ကျေးမှုများ ပျက်စီးခြင်းသို့ ဦးတည်စေခဲ့သည်။ အကြောင်းမှာ တပ်ဖွဲ့များ၏ တိုက်ရိုက် ဖျက်ဆီးခံခြင်းအပြင် ဆင်းရဲမွဲတေမှု၏ ရလဒ်အဖြစ် လူပုဂ္ဂိုလ် များနှင့် အဖွဲ့အစည်းများသည် ယင်းတို့ပိုင် ရတနာ ပစ္စည်းများ၊ ငွေထည်များ၊ ရက်ကန်း ထည်များ၊ ပေ၊ ပုရပိုက်များ စသည်တို့ကို စားဝတ်နေရေးအတွက် ရောင်းချရန် လိုအပ်လာ ကြရခြင်းကြောင့် ဖြစ်ပါသည်။ လွတ်လပ်ပြီးခေတ် မြန်မာနိုင်ငံကို တည်ထောင်သူ၊ ဗမာ့ လွတ်လပ်ရေး တပ်မတော် (ဘီအိုင်အေ) ခေါင်းဆောင် ဗိုလ်ချုပ်အောင်ဆန်းအပါအဝင် ဗြိတ္တိသျှတို့ထံမှ လွတ်လပ်ရေးရယူလိုသော ဗမာအမျိုးသားရေးလှုပ်ရှားသူများ (သခင်များ) သည် ဂျပန်များကို ကြိုဆိုခဲ့ပြီး ဂျပန်တို့အုပ်ထိန်းမှုအောက်တွင် အာဏာ ရရှိလာခဲ့သည်။ ထိုရုပ်သေးအစိုးရာစစ် လက်ထက်တွင် ဂျပန်တို့သည် ဗြိတ္တိသျှနှင့်ဥရောပ ဩဇာလွှမ်းမိုး

CHAPTER 7

တိုင်းရင်းသားလူမျိုးစုများအကြောင်း တွေးတောစဉ်းစားခြင်း

MANDY SADAN

ဤအခန်းတွင် မြန်မာ့ရုပ်ဝတ္ထုယဉ်ကျေးမှုကို ပြသရာတွင် မြန်မာနိုင်ငံနှင့် မြန်မာနိုင်ငံ တွင်းရှိ တိုင်းရင်းသား လူမျိုးစု များအား မည်သို့ကိုယ်စားပြုဆွေးနွေးမည် ဆိုသည်ကို ပြန်လည်သုံးသပ်ရန် အရေးကြီးကြောင်း သုံးသပ် တင်ပြ ထားပါသည်။ ဤအခန်းကို တံခါးပိတ်မူဝါဒနှင့်အတူ ယဉ်ကျေးမှုမြင့်မားသည့် နိုင်ငံတစ်ခုအဖြစ် ယေဘုယျကျကျ ရှု မြင်ကြသည့် အကြမ်းဖျင်းအယူအဆများကို သုံးသပ်ခြင်းဖြင့် စတင်ထားသည်။ ယင်း အယူအဆသည် ၁၉၆၀ ပြည့်လွန်နှစ်များကတည်းက ပုံနှိပ်နေခဲ့ပြီးဖြစ်သည်။ ဤစာတမ်း အတွင်း မြန်မာ့သမိုင်းကို ရေးသားရာတွင် ဘေးဖယ်ခြင်း ခံထားရသည့် တိုင်းရင်းသား လူမျိုးစုများအတွက် သမိုင်းအသစ်ပြန်လည်ရေးသားခြင်းသည် မည်မျှအထောက်အကူ ဖြစ်နိုင်ကြောင်း တင်ပြထားပါသည်။ မြန်မာနိုင်ငံနှင့် ဒေသတွင်း သို့မဟုတ် ကမ္ဘာလုံး ဆိုင်ရာ အပြန်အလှန်ဆက်ဆံရေးနှင့် ချိတ်ဆက်မှုပုံစံများကို တွေးတောစဉ်းစားသည့် အခါ ရိုးရှင်း၍ တည့်တိုးဆန်ပါသည်။ သို့သော် တစ်ခါတစ်ရံတွင် ရှေ့နောက် မညီလှ သည်မှာ ဗမာလူမျိုးများနှင့် ကျန်တိုင်းရင်းသားလူမျိုးစုများ၏ ယဉ်ကျေးမှုကူးလူးဆက်ဆံ ရေးအပေါ် ရှင်းလင်း ပြတ်သားစွာ ရှုမြင်သုံးသပ်ရန်မှ ပိုမိုခဲ့ချက်ခဲ့သည်ကို တွေ့ရ သည်။ ဗမာလူမျိုးများနှင့် ဗမာမဟုတ်သောလူမျိုးများအကြား ဆက်ဆံရေးကို နားလည် သဘောပေါက်ရန် ရှုထောင့်နှင့် နည်းလမ်းပေါင်းများစွာရှိနေသည့်အတွက် ဤဆက်ဆံရေး ကို တင်ပြပုံတစ်မျိုးတည်းဖြင့် ကိုယ်စားပြုရန် မဖြစ်နိုင်ပေ။ ဤမေးခွန်းများကို ဖော်ထုတ် ခြင်းအားဖြင့်လည်းကောင်း၊ နိုင်ငံ၏ မြင့်မားသောယဉ်ကျေးမှုထုတ်လုပ်မှုနှင့် ယှဉ်တွဲ ကာ တိုင်းရင်းသားလူနည်းစုများထံမှ ဖန်တီးပေါ် ပေါက်လာသော ယဉ်ကျေးမှု အနုပညာ ပစ္စည်းများကို ထိုးထွင်းဉာဏ်စွမ်းသုံး၍ နေရာချထားခြင်းဖြင့်လည်းကောင်း၊ အဆိုပါ ဆက်ဆံရေးကို နားလည်သဘောပေါက်ရန် နည်းလမ်းသစ်များ ထုတ်ပေါ် လာနိုင်ပါသေး သည်။ ဤသို့သော နားလည်သဘောပေါက်မှု အသစ်များသည် ပြဝပွားလာဦးမည့်ပရိသတ်များ နှင့် ပြက်ကမှုများအတွက်သာ အရေးကြီးသည်မဟုတ်ပါ။ ထိုအသိမြင်သစ် များသည် မတူညီသော လူမှုအသိုင်းအဝိုင်းများ၏ အတွေ့အကြုံများကို ပိုမို နားလည်သဘောပေါက် ပြီး လုံး၀ အလေးအမြတ်တန်ဖိုးထားမှုဆီသို့ ပြောင်းရွှေ့ပေးနိုင်သည်။ အနာဂတ်၏ မ တူညီသော နိုင်ငံရေးရလဒ်များကို အထောက်အကူ ပြုနိုင်သော၊ ယဉ်ကျေးမှုနှင့် နိုင်ငံ ရေးဆိုင်ရာ သဘောပေါက်မှုအသစ်များကို အားပေး၊ အထောက်အကူ ပြုရန်အတွက်လည်း အရေးကြီးလှပါသည်။

(မူကို နှိမ့်ချရန်။ "အာရှသားများအတွက် အာရှ" လူ့ရာမူကို ပိုမိုဖြန့်ကျက်ရန် တစ်စိတ် တစ်ပိုင်းအဖြစ် ရိုးရာယဉ်ကျေးမှုပုံစံများ၊ ဘာသာ စကားများနှင့် သမိုင်းများကို မြှင့်တင် ရန်စသ ရည်ရွယ်ချက်များအတွက် မြန်မာလူမျိုးများကို အားပေးအားမြှောက်ပြုခဲ့သည်။ ၁၉၄၅ ခု နှစ်တွင်မူ ဗိုလ်ချုပ်အောင်ဆန်းနှင့် ဗမာ့လွတ်လပ်ရေးတပ်မတော် (ဘီအိုင်အေ) တို့သည် ဂျပန်ကို ပြန်လည် တိုက်ခိုက်ရန် အင်္ဂလိယူရန်အတွက် ဖြိတ္တိသျှ ဗိုလ်ချုပ်ကြီး လူဝီမောင့် ဘက်တန် လက်အောက်ရှိ မဟာမိတ်တပ်များနှင့် ပူးပေါင်းခဲ့ ကြသည်။ မြန်မာနိုင်ငံတွင် ဒုတိယကမ္ဘာစစ်ကာလ၏ အတွေ့အကြုံများမှတစ်ဆင့် တိုင်းပြည်လွတ်လပ်ရေးရရန် နိုင်ငံရေးအခြေအနေများကို ရယူခဲ့သည့်အပြင် အချုပ်အခြာအာဏာပိုင် နိုင်ငံတစ်ရပ် တည်ထောင်ရန် စတင်ကြိုးပမ်း လူ့ရာနိုင်သည်အထိ အစပျိုးနိုင်ခဲ့ပါသည်။)

အခန်းအကျဉ်းချုပ်များ 253

လွတ်လပ်ပြီးခေတ် ရုပ်ဝတ္ထုယဉ်ကျေးမှု

ALEXANDRA GREEN နှင့် အမည်မဖော်လိုသည့်စာရေးသူ

၁၉၄၈ ခုနှစ်မှစတင်၍ လွတ်လပ်ခဲစ မြန်မာနိုင်ငံသည် ကြီးမားထင်ရှားသည့် စိန်ခေါ်မှု များကို ရင်ဆိုင်ကြုံတွေ့ခဲ့ရသည်။ ကမ္ဘာ့စစ်ကြောင့် စီးပွားရေးအရနှင့် ရုပ်ပိုင်းဆိုင်ရာ အရပါ ပျက်စီးဆုံးရှုံးခဲ့သည့် တိုင်းပြည်တစ်ခုသာမက၊ သမိုင်းဖြစ်စဉ် များအတွင်း နိုင်ငံ တစ်ခုအဖြစ် တစ်စုတစ်စည်းထဲ မရှိခဲ့ဖူးသည့် အုပ်စုများအား ပေါင်းစည်းရေး ပြဿနာ တစ်ခုကိုပါ ဖြေရှင်းတို့တွေ့ ချရရစ်ထားခဲ့ကြသည်။ ၂၀ ရာစု နောင်ပိုင်းနှင့် ၂၁ ရာစု အစောပိုင်းတစ်လျှောက် ကမ္ဘာနှင့် အဆက်အသွယ် ဖြတ်ကာ အထီးကျန်နိုင်ငံတစ် ခုအဖြစ် တည်ရှိနေသော်လည်း မြန်မာနိုင်ငံသား ပုဂ္ဂိုလ်ကျော်တစ်ချို့မှာမူ ကမ္ဘာ့ ရေးရာ များနှင့် ယဉ်ကျေးမှုကူးလူးဖြစ်သန် လုပ်ဆောင်မှုများတွင် ပါဝင်ပတ်သက်ခဲ့ကြ သည်။ ဗိုလ်ချုပ် အောင်ဆန်းသည် လွတ်လပ်ရေး ရရှိရန် ညှိနှိုင်း ကြိုးပမ်းပြီး ရင်းအား ဂုဏ်ပြုသောအားဖြင့် ဗိုလ်ချုပ် အောင်ဆန်းရုပ်ပုံပါ ငွေစက္ကူများကို ရိုက်နှိပ်ထုတ်ဝေခဲ့ ကြသည်။ စစ်အေးကာလအတွင်း မြန်မာနိုင်ငံ၏ ကြားနေမှုကို ထိန်းသိမ်းရန်အတွက် နိုင်ငံတော် ဝန်ကြီးချုပ် ဦးနုသည် ဖြစ်နံဘုရင်မကြီး ဒုတိယအဲလစ်ဇာဘက်ထံသို့ ၁၉၅၅ ခုနှစ်တွင် ချစ်ကြည်ရေးခရီး လာရောက်ခဲ့သည်။ ထိုခရီးစဉ်အတွင်း မြန်မာ့ရိုးရာ လက်မှု အနုပညာနှင့် ဥရောပတိုင် ပေါင်းစပ်ထားသည့် ရွှေထည် လက်ဖက်ရည်ရာကိုတစ်စုံကို လည်း လက်ဆောင်ပေးအပ်ခဲ့သည်။ ဦးသန့်သည် ၁၉၆၁ ခုနှစ်မှ ၁၉၇၁ ခုနှစ်အထိ ကမ္ဘာ့ ကုလသမဂ္ဂအဖွဲ့ကြီး၏ အထွေထွေ အတွင်းရေးမှူးချုပ် ဖြစ်လာခဲ့သည်။ ရင်း၏ သက်တမ်းအတွင်း အမေရိကန် သမ္မတ ကနေဒီနှင့် ဆိုဗီယက်ပြည်ထောင်စု ဝန်ကြီးချုပ် ခရူးရက်ဗ်တို့ကြီး စေ့စပ်ညှိနှိုင်းခြင်းဖြင့် ကျူးဘားဒုံးပျံ အရေးအခင်း ကိုလည်း ကျွမ်း ကျင်ကျင်ကျင် ဖြေရှင်းနိုင်ခဲ့သည်။ တိုင်းရင်းသား စည်းလုံးညီညွတ်ရေးကို ကာ ကွယ်ရန် ဟူသော အကြောင်းပြချက်ဖြင့် ဗိုလ်ချုပ်နေဝင်းက နိုင်ငံကို ပြင်ပကမ္ဘာနှင့် အဆက်အသွယ်ဖြစ်တော်ကာ မြန်မာ့နည်း မြန်မာ့ဟန် ဆိုရှယ်လစ်လမ်းစဉ်ကို ချမှတ် ခဲ့သည်။ သို့သော် ဖြိတ္တိသျှတို့ယူဆောင်သွားပြီး ဝိတိုရိယနှင့် အဲလ်ဘက်ပြတိုက်တွင် ထား ရှိသည့် မြန်မာ့မင်းခမ်းတော်ပစ္စည်းများ ပြန်လည်ရယူရန်အတွက်မူ လန်ဒန်မြို့သို့လာ ရောက်ခဲ့သေးသည်။

ဗိုလ်ချုပ်ကြီးနေဝင်း လက်ထက်တွင် အိန္ဒိယနွယ်ဖွား မြန်မာလူမျိုးများနှင့် နိုင်ငံရပ်ခြား မှ သာသနာပြုများကို ပြည်နှင်ဒဏ် ပေးခဲ့သည်။ ဗမာလူမျိုးနှင့် ဗုဒ္ဓဘာသာဝင်များကို သာ တိုင်းပြည်၏ယဉ်ကျေးမှုပြုယုတ်အဖြစ် ပုံဖော်ခဲ့ခြင်းက နိုင်ငံအတွင်း တင်းမာမှုများ ကို ဆက်လက် ဖြစ်ပွားစေခဲ့သည်။ အခြားသော ဘာသာဝင်များနှင့် လူမျိုးစုများသည် သမိုင်းနှင့်ယဉ်ကျေးမှု ဖျောက်ဖျက်ခံရမှုများ၊ လူမျိုးရေး ခွဲခြားမှု၊ လူစီးပွား တိုးတက်ရေး ကို ချန်လှပ်ထားခဲ့မှုများအပြင် ပြည်တွင်းစစ်နှင့် ရက်စက် ကြမ်းကြုတ်မှုများကိုပါ ကာလ ကြာရှည်စွာ ခါးစည်းခံခဲ့ကြရသည်။ စစ်ပွဲများ၊ တိုက်ခိုက် ဖျက်ဆီးမှုများနှင့် ယဉ်ကျေးမှု ဆိုင်ရာ ဖိနှိပ်မှုများ (ဥပမာ - ကျောင်းများတွင် တိုင်းရင်းသား စာပေနှင့် ဘာသာစကားများ သင်ကြားခွင့်ပေးခြင်း) ကို ရင်ဆိုင်နေကြရသော တိုင်းရင်းသားလူမျိုးစုများ၏ လိုလားမှု မှာ တောင်တန်းဒေသ စည်းလုံးညီညွတ်ရေးနှင့် ကိုယ်ပိုင် အုပ်ချုပ်ခွင့် ပြုနန်းခွင့်တို့ပင်ဖြစ် ပါသည်။ ဥပမာဆိုရလျှင် တိုင်းရင်းသားဝတ်စုံများစုံပြုလိုခြင်း သို့မဟုတ် ရိုးရာ စိတ်စုံစံ များ တီထွင်လိုက်ခြင်းသည် အတိတ်ကာလမှ ဒေသတွင်း ရှုပ်ထွေးပွလီမှုများကို မျက်ကွယ် ပြုသော လုပ်ရပ် တစ်ခုသာလျှင် ဖြစ်ခဲ့ပါသည်။

ဆိုရှယ်လစ်ခေတ်အတွင်းတွင်မူ ရိုးရာလက်မှုပစ္စည်း အသုံးပြုမှု ကျဆင်းလာခဲ့သည်။ အနုပညာရှင်များက ဆိုရှယ်လစ် အစိုးရ၏ အကျင့်ပျက်ခြေစားမှုနှင့် ဖိနှိပ်ချုပ်ချယ်မှု များအပေါ် အနုပညာလက်ရာများဖြင့် ထုတ်ဖော်ဝေဖန်ခဲ့ကြသည်။ တံခါးပိတ်ကာလ အတွင်း တတ်စွမ်းသလောက်သော ပစ္စည်းများကိုသာ အသုံးပြုဖန်တီးခဲ့ကြရပြီး အချို့

သောပစ္စည်းများမှာ တရုတ်နိုင်ငံမှ ရရှိခဲ့ခြင်းဖြစ်သည်။ ထိုသို့သောပုံစံသည် ၁၉၈၈ ခု နှစ် လူထုလှုပ်ရှားမှုကြီးအပြီး၊ ဒေါ် အောင်ဆန်းစုကြည်နှင့် အမျိုးသားဒီမိုကရေစီအဖွဲ့ ချုပ် ပေါ်ပေါက်လာမှုမှသာ စတင်ပြောင်းလဲတော့သည်။ ၁၉၉၀ ပြည့်လွန်နှစ်များ အတွင်း စစ်တပ်က ထပ်မံအားကောင်းလာခဲ့သည့်နည်းတူ နိုင်ငံတကာမျက်နှာစာတွင် ပိုမိုကောင်းမွန်သော အသွင်အပြင်တစ်ခုကို ရရှိရန်နှင့် မြန်မာ့ယဉ်ကျေးမှုကို မြှင့်တင် ရန် ကြိုးပမ်းခဲ့သည်။ ယွန်းထည်ကဲ့သို့သော လက်မှုအနုပညာတစ်ချို့မှာ ထိုကာလတွင် ပြန်လည်ရှင်သန်လာခဲ့သည်။ တရုတ်နိုင်ငံသည်လည်း မြန်မာ့တပ်တော်နှင့် ပိုမိုပလံနံ ပဒင် လာခဲ့သည် အတွက် တရုတ်ဈေးကွက်အတွက် ပစ္စည်းအမြောက်အမြားထုတ်လုပ် ခဲ့ရသည်။ သို့သော်လည်း ပြည်သူများစုအတွက် စားဝတ်နေရေး ခက်ခဲနေမှုနှင့် အစွန်းရောက် နိုင်ငံတော်ဆင်ဆာ ဖြစ်တော်ဖက်မှုများ အကြောင်းကို ကာတွန်းများနှင့် အခြား အနုပညာပုံစံများမှတစ်ဆင့် ဆက်လက်ဖော်ထုတ်၊ ရေးဆွဲ၊ ဖန်တီးခဲ့ကြသည်။

အာဏာရှင်စနစ် တိုက်ဖျက်ရေးအတွက် ၂၀၀၇ ခုနှစ်၊ ရွှေဝါရောင်တော်လှန်ရေးကဲ့သို့ ကာလအလိုက် လှုပ်ရှားမှုကြီးများ ရှိခဲ့သော်လည်း ပြင်းထန် ရက်စက်စွာ အဖိနှိပ်ခံခဲ့ရ သည်။ သို့သော် ၂၀၀၈ ခုနှစ်တွင် ဖွဲ့စည်းပုံ အခြေခံဥပဒေကို ရေးဆွဲ ပြီးစီးခဲ့သည်။ ၂၀၁၀ ခုနှစ်တွင် စစ်အစိုးရက ရွေးကောက်ပွဲတစ်ခုကို ကျင်းပပေးပြီး ဆင်ဆာ ဖြတ်တော် မှုများ ဖြေလျော့ကာ၊ ခရီးသွားလုပ်ငန်းများကို မြှင့်တင်ခဲ့သည့်အတွက် အနည်းငယ် ပိုမို လွတ်လပ်သော ကာလတစ်ခုသို့ ရောက်ရှိလာခဲ့သည်။ ၂၀၁၂ ခုနှစ်တွင် ဒေါ်အောင်ဆန်း စုကြည်က နိုင်ငံတော်၏ အတိုင်ပင်ခံပုဂ္ဂိုလ်ဖြစ်ကာ အမျိုးသား ဒီမိုကရေစီအဖွဲ့ချုပ် မှ အာဏာရလာသည်။ ယူနက်စကိုနှင့် World Monuments Fund အစရှိသည့် အဖွဲ့ အစည်းများနှင့် ပိုမိုပူးပေါင်းဆောင်ရွက်လာခဲ့ကြခြင်းဖြင့် မြန်မာ့မြို့ဟောင်းတစ်ချို့မှာ ကမ္ဘာ့အမွေအနှစ်စာရင်း ဝင်ခဲ့သည့်အပြင် အရေးကြီးသော သမိုင်းဝင် အထိမ်းအမှတ် အဆောက်အအုံများကို ပြန်လည်ထိန်းသိမ်းရန် အစပျိုးလုပ်ဆောင်မှုများကို မြင်တွေ့ခဲ့ ရသည်။ သို့ရာတွင် ၂၀၁၅ ခုနှစ်တွင် ရွေးကောက်ခံခဲ့ကြရသော အရပ်သားတစ်ပိုင်း အစိုးရ သည်လည်း ပြည်သူများကို စိတ်ပျက်စေခဲ့သည်။ တိုင်းရင်းသားလူမျိုးများနှင့် ဗဟို အစိုးရကြား ဆက်ဆံရေးမှာ ကောင်းမွန်လာခြင်း မရှိခဲ့ပေ။ ထိုပြင် ဗုဒ္ဓဘာသာဝင်များနှင့် မွတ်ဆလင်ဝင်များအကြား ဘာသာရေးတင်းမာမှုများမှာလည်း ဆက်လက်ကျန်ရှိနေခဲ့သည်။ ထိုမှတစ်ဆင့် ၂၀၁၇ ခုနှစ်အတွင်း ရိုဟင်ဂျာလူမျိုးများအပေါ် မုန်းတီးမှုနှင့် လူမျိုးတုံး သတ်ဖြတ်မှုကိုပါ ဖြစ်စေခဲ့သည်။ ရိုဟင်ဂျာကုက္ကာသည်စခန်းများတွင် ကျင်းပသည့် ဓာတ်ပုံ ပြပွဲ၊ ပြိုင်ပွဲများ အနုပညာရှင်များ၏ ဝင်ငွေတစ်ခုကို ဖြစ်စေခဲ့သည်။ ကိုဗစ်-၁၉ ကပ် ရောဂါကြောင့် နိုင်ငံ၏စီးပွားရေးနှင့် ခရီးသွားကဏ္ဍကို ဆိုးရွားစွာ ထိခိုက်စေသော်လည်း ၂၀၂၀ ခုနှစ် အထွေထွေ ရွေးကောက်ပွဲကို ကျင်းပနိုင်ခဲ့သည်။ ထိုအကြောင်းအရာကို ကို ဗစ်ကပ်ရောဂါအလယ် ရွေးကောက်ပွဲကာလအတွင်း ထုတ်လုပ်ခဲ့သော နိုင်ငံရေးပုံရိပ်နှင့် ဆောင်ပုဒ်များပါရှိသည့် နာခါးစည်းများတွင် တွေ့နိုင်ရှိသည်။ ၂၀၂၁ ခုနှစ် ဖေဖော်ဝါရီလ တွင် မြန်မာစစ်တပ်၏ အာဏာသိမ်းမှုကြောင့် တိုင်းပြည်မှာ ပြင်းထန်သော ရက်စက် ကြမ်းကြုတ်မှုအလယ်သို့ ပြန်လည်ရောက်ရှိခဲ့ရသည်။ စစ်အာဏာရှင်စနစ်တကျော့ ပြန်လာခြင်းကို အနုပညာရှင်များနှင့် ပြည်သူတစ်ရပ်လုံးက ဆက်လက် တွန်းလှန်နေကြ သော်လည်း လက်ရှိပဋိပက္ခများသည် မြန်မာနိုင်ငံအား ပတ်ဝန်းကျင်ကမ္ဘာနှင့် ကူးလူး ထိ တွေ့ဆက်ဆံမှုကို ပြန်လည်ကန့်သတ်လိုက်ပြီဖြစ်ပါသည်။

ခေတ်သစ်နှင့် ခေတ်ပြိုင်အနုပညာလှုပ်ရှားမှု၊ ၁၉၄၈ – မျက်မှောက် ခေတ်

MELISSA CARLSON

ဤအခန်းတွင် လွတ်လပ်ပြီးခေတ် မြန်မာ့နိုင်ငံရေးလက္ခဏာအား ရုပ်အနုပညာအရ ဖော်ပြရာ၌ လွှမ်းမိုးခဲ့သည့် အစိုးရ ဆင်ဆာဖြတ်တောက်မှုများကို မြန်မာ့ဆိုရှယ်လစ် လမ်းစဉ်ပါခေတ် (၁၉၆၂–၈၈) မှ ခေတ်စမ်းပန်းချီဆရာများက လက်တွေ့ဆန်ဆန် ဖော်ပြမှု (ရီယယ်လစ်ဇင်) အသုံးပြုလျက် ပါဝင်တိုက်ပွဲဝင်ခဲ့ကြပုံကို ဆန်းစစ် တင်ပြထား ပါသည်။ လွတ်လပ်ရေးရရှိသည့်အချိန်မှ စတင်ဖန်တီးခဲ့သည့် အနုပညာလက်ရာ များသည် နိုင်ငံရေး၊ လူမှုရေးအရ ဆက်နွယ် နေသော ခေတ်စမ်းအနုပညာ အသိုင်းအဝိုင်း တစ်ခုကို မြစ်ဖျားခံရာဖြစ်ခဲ့သည်။ ထိုအနုပညာ အသိုင်းအဝိုင်းသည် လွတ်လပ်ပြီးစ နိုင်ငံ တစ်ခုအပေါ် ပိုမိုသိမြင်နားလည်နိုင်ရန်အတွက် ထုတ်ဖော် ပြောဆိုမှု ပုံအသစ် တစ်ရပ် ကိုလည်း ဖန်တီးပေးနိုင်ခဲ့သည်။ ဥရောပတိုက်ကဲ့သို့ အရှေ့ဒေသများတွင်မူ ခေတ်သစ် အနုပညာဆိုသည်မှာ လွတ်လပ်စွာ ထုတ်ဖော် ပြောဆိုမှုနှင့် ပြောင်းလဲဆန်းသစ်မှုနှင့် တူညီသည်ဟု၍ အများအားဖြင့် နားလည်ထားကြသည်။ ဤအခန်းတွင် တင်ပြ ဆွေးနွေး ထားသည့် အနုပညာ လက်ရာများကို ကြည့်ခြင်းအားဖြင့် လွတ်လပ်မှုကို နိုင်ငံရေး အရကန့်သတ်ထားသည့် မြန်မာ့ ယဉ်ကျေးမှုလုပ်ကွက်မှ ခေတ်သစ်အနုပညာ ဆိုသည်ကို တစ်မျိုးတစ်ဖုံ အဓိပ္ပါယ်ဖွင့်ရလောက်မည် ထင်ပါသည်။ ခေတ်စမ်း အနုပညာကို ကမ္ဘာ အနောက်နိုင်ငံများတွင် နိုင်ငံရေး၊ လူမှုရေးတို့နှင့် မဆက်နွယ်ဟန်ဖွင့်ဆိုကြသော်လည်း မြန်မာပြည်၏ အတိတ်နှင့် မျက်မှောက်ခေတ်ထိတိုင်အောင် အနုပညာရှင်များကို နိုင်ငံရေး တက်ကြွလှုပ်ရှားသူများ အဖြစ်သာ ပုံဖော်လေ့ ရှိခဲ့သည်။ ဤအခန်းတွင် အစိုးရ ဆင်ဆာ ဖြတ်တောက်မှုများအောက်မှ အနုပညာရှင်များ၏ ဘဝအမှတ်တရ မှတ်တမ်းများ သို့မဟုတ် ယနေ့အထိကျန်ရစ်သော ဆင်ဆာအဖြတ်ခံ ပန်းချီကားများကို မှတ်တမ်းတင် ခြင်းအားဖြင့် အာဏာရှင်စနစ်၊ တံခါးပိတ် နိုင်ငံခြားရေး မူဝါဒ၊ ဆင်ဆာဖြတ်တောက်မှု စသည်တို့ကို ခံခဲ့တော်လှုံ့ခဲ့သည့် မော်ဒန်အနုပညာ အကြောင်းကို တင်ပြထားပါသည်။ ထို့ပြင် မြန်မာနိုင်ငံ၏ ကိုလိုနီခေတ်လွန် အမျိုးသားရေးလက္ခဏာကို ပုံဖော်ရန်၊ ပြင်ပ ကမ္ဘာနှင့် အဆက်အသွယ် မပြတ်တောက်စေရန် နည်းလမ်း အသစ်များအား ပြုလုပ် ဖန်တီးသည့်နေရာတွင် ခေတ်သစ်အနုပညာ၏ တမူထူးခြား၊ ထင်ရှားခဲ့သည့် အခန်းကဏ္ဍ ကိုလည်း မှတ်တမ်းပြု ထားပါသည်။

၁၉၄၈ ခုနှစ် ဗြိတိန်နိုင်ငံထံမှ လွတ်လပ်ရေးရရှိပြီးနောက် မြန်မာနိုင်ငံတွင် ယဉ်ကျေးမှု နီးနောဖလှယ်မှုများ လွတ်လွတ် လပ်လပ် စီးဆင်းခဲ့သည်။ မူဝါဒချမှတ်သူများကလည်း အနုပညာရှင်များအား အမျိုးသားရေးလက္ခဏာဆိုင်ရာ ဆွေးနွေးပွဲများတွင် ရှေ့တန်းမှ ပါဝင်စေခြင်း၊ စစ်အေးကာလတွင်း ယဉ်ကျေးမှုသံတမန်ရေးရာတွင် အရှိန်မြှင့်ခြင်း အားဖြင့် လည်း ပြင်ပကမ္ဘာနှင့် ယဉ်ကျေးမှုဖလှယ်မှုများကို ပိုမိုအင်အားကောင်းခဲ့သည်။ ခေတ်သစ်ဝါဒကို စိတ်ပါဝင်စားသည့် အနုပညာရှင်များသည် ခိုင်မာအားကောင်းသော ပြည်တွင်းပုံနှိပ်မီဒီယာနှင့် ပြည်ပ ပညာရေးများ မှတစ်ဆင့် အသိပညာလမ်းကြောင်း အသစ်များနှင့် ထိတွေ့ဆက်ဆံလာခဲ့ကြပြီး ၎င်းတို့ကို ဒေသတွင်းနှင့် ကမ္ဘာတစ်ဝှမ်းရှိ အနုပညာနှင့် အနုပညာရှင်များထံ ထုတ်ဖော်ပြသခဲ့ကြသည်။ သို့သော်လည်း ဗိုလ်ချုပ် ကြီးနေဝင်း၏ ၁၉၆၂ ခုနှစ် စစ်အာဏာသိမ်းမှုသည် ထိုဆက်နွယ်မှုများကို ပိတ်ပင်ခဲ့ ပြီး ယဉ်ကျေးမှုဆိုင်ရာ ဝတ္ထုပစ္စည်းများ ယှက်တင်စီးဆင်းမှု ကိုလည်း ရပ်တန့်စေခဲ့ သည်။ ဆိုရှယ်လစ်အစိုးရသည် အစိုးရမူဝါဒများကို ဝေဖန်သည့် အနုပညာလက်ရာတိုင်း ကို ဗျူရိုကရက်ယန္တရားမှတစ်ဆင့် ဆင်ဆာဖြတ်တောက်လျက် လွတ်လပ်စွာ ထုတ်ဖော် ပြောဆိုခွင့်ကို ကန့်သတ်ထားသည့် အတွက် ခေတ်စမ်း အနုပညာရှင်များအနေဖြင့် စီးပွားရေး အခွင့်အလမ်းများ ကျဉ်းမြောင်း ကျပ်တည်းလာခဲ့သည်။ အများသူငှာဆိုင်ရာ ပြခန်းများတွင် ပြပွဲများကျင်းပရန် ပိုပိုခက်ခဲလာခဲ့ပြီး ဦးနေဝင်း၏ ပြည်သူပိုင် သိမ်းဆည်း

ခြင်းနှင့် နိုင်ငံ၏ တံခါးပိတ်နိုင်ငံရေး မူဝါဒများက များမကြာမီပင် အနုပညာ ဈေးကွက် ကို ကန့်သတ်ပစ်လိုက်ပါသည်။ ထို့အတွက် အနုပညာရှင်များသည် စာအုပ်၊ ဂျာနယ်၊ မဂ္ဂဇင်းနှင့် ရုပ်ရှင်ပိုစကာ သရုပ်ဖော်ရေးဆွဲခြင်းများကို ပြောင်းလဲ လုပ်ကိုင် ကြသည်။ ရသစာပေနှင့် ကဗျာစာစောင်များ၏ အတွင်းစာမျက်နှာများနှင့် မျက်နှာဖုံးများသည် ပန်းချီ အနုပညာရှင်များ၏ ရသမြောက် ထုတ်ဖော်ပြောဆိုမှုပုံစံအသစ်ကို မြေစမ်း ခရမ်းပျိုး သည့် နေရာများ ဖြစ်လာသည်။ ခေတ်စမ်း အနုပညာရှင်များသည် ဆင်ဆာဖြတ်တော် ခြင်းအကြောင်းအရင်းများကို ခွဲခြားသိမြင်လာကာ တစ်ချိန်တည်းမှာပင် ဆင်ဆာခွင့်ပြု သည့် သရုပ်ဖော်ပုံစံများကိုလည်း နားလည်သဘောပေါက်ခဲ့လာကြသည်။ ဆင်ဆာဘုတ် သည် အနီ၊ အနက်၊ အဖြူ သို့မဟုတ် အစိမ်းစသည်တို့ ပါဝင်သည့် စိတ္တဇဗန်းချီများအား မြှုပ်ကွက်နှင့် လျှို့ဝှက်သင်္ကေတများ ပါဝင် ရေးဆွဲထားခြင်း ရှိ၊ မရှိ ကြောင်ရှ့စိတ်ဖြင့် စိစစ်လေ့ရှိသည်။ တစ်ချိန်တည်းမှာပင် လက်တွေ့ဆန်ဆန်ဖြင့် ရသမြောက် သရုပ်ဖော် ထားသော ပန်းချီများကိုမူ ဆင်ဆာများက ခွင့်ပြုလေ့ ရှိကြောင်း အနုပညာရှင်များက သဘောပေါက်ခဲ့ကြသည်။ ထို့ကြောင့် အနုပညာရှင်များသည် ၎င်းတို့ ပတ်ဝန်းကျင်တွင် ဖြစ်ပေါ်နေသော နိုင်ငံရေး၊ စီးပွားရေးနှင့် လူနေမှုဆိုင်ရာ အပြောအလဲများကို မှတ်ချက်ပေး ဝေဖန်ရန်အတွက် အနုပညာ လက်ရာများကို ဖန်တီးရာတွင်ပင် ဆင်ဆာအဖွဲ့နှင့် ၎င်း တို့ကြား မျှခြေညီစေရန်အတွက် သရုပ်ဖော်လျှို့ဝှက်ကုဒ်တစ်ခုကို ပေါ် ထွန်းတိုးတက် စေခဲ့သည်။ ထိုကဲ့သို့ ထူးခြားသည့် လက်တွေ့ဆန်ဆန်ဖော်ပြမှု (ရီယယ်လစ်ဇင်) ပုံစံသည် အစိုးရဆင်ဆာဗျူရိုကရက်ကို အနှောင့်အယှက်မရှိ ဖြစ်သွန်းနိုင်ရန်၊ ကြည့်ရှုသူပရိသတ် အား နိုင်ငံရေးခံတော်လှုံ့မှုဆိုင်ရာ သတင်းစကားများ ပေးပို့ရန်နှင့် မတရားမှု များ ကို မှတ်တမ်းတင်ရန် လုပ်ဆောင်ပေးနိုင်ခဲ့သည်။ ယနေ့ခေတ်ကာလအထိတိုင်အောင် မျိုးဆက်သစ် အနုပညာရှင် များသည် စစ်အာဏာရှင် အစိုးရအသစ်ကို ထိပ်တိုက်ရင်ဆိုင်ကြ ရင်း ၎င်းတို့၏ နိုင်ငံရေးရပ်တည်မှုကို အနုပညာမှတစ်ဆင့် အခိုင်အမာ ဖော်ထုတ်၊ တင်ပြ လျက် ရှိကြပါသေးသည်။

NOTES

INTRODUCTION

1 Jacques P. Leider, *King Alaungmintaya's Golden Letter to King George II (7 May 1756)*, Hanover: Gottfried Wilhelm Leibniz Bibliothek, 2009.

2 Stephan Feuchtwang and Michael Rowlands, *Civilisation Recast: Theoretical and Historical Perspectives*, Cambridge: Cambridge University Press, 2019, p. 11.

3 Sheldon Pollock, 'The Cosmopolitan Vernacular', *Journal of Asian Studies*, vol. 57, no. 1 (1998), pp. 32–4.

4 Feuchtwang and Rowlands, *Civilisation Recast*, p. 37.

5 Jacques Leider, 'Myanmar and the Outside World', in *Buddhist Art of Myanmar*, ed. Sylvia Fraser-Lu and Donald M. Stadtner, New Haven, CT: Asia Society Museum/Yale University Press, 2015, pp. 34–43.

6 It is beyond the scope of this book to discuss how archaeology has been used to promote the military's narrative of the primacy of the central region.

7 Wong Hong Suen, 'Picturing Burma: Felice Beato's Photographs of Burma 1886–1905', *History of Photography*, vol. 32 (2008), pp. 1–26.

8 John Lowry, 'Victorian Burma by Post: Felice Beato's Mail-Order Business', *Country Life*, 13 March 1975, pp. 659–60.

9 Alexandra Green, 'From India to Independence: The Formation of the Burma Collection at the British Museum', *Journal of the History of Collections*, vol. 28, no. 3 (2016), pp. 449–63.

CHAPTER 1

1 Anne Sasso, 'The Geology of Rubies', *Discover Magazine*, 24 November 2004, www.discovermagazine.com/planet-earth/the-geology-of-rubies (accessed 30 January 2023).

2 'Sunrise Ruby Weighing 25.29 Carats Sells for $30 Million at Sotheby's Auction in Geneva', ABC News, 12 May 2015, www.abc.net.au/news/2015-05-13/ruby-sells-for-record-breaking-price/6465382 (accessed 30 January 2023).

3 Laichen Sun, 'Ming-Southeast Asian Overland Interactions, 1368–1644', PhD dissertation, University of Michigan, 2000, p. 135.

4 Elizabeth Dell (ed.), *Burma: Frontier Photographs 1918–1935*, London: Merrell Publishing, 2000, p. 144.

5 M. Ramakrishna Bhat, *Varahamihira's Brhat Samhita*, Delhi: Motilala Banarsidass, 1981, p. 750.

6 'The Burmese Ruby Tiara', 22 April 2017, www.thecourtjeweller.com/2017/04/the-burmese-ruby-tiara.html (accessed 30 January 2023).

7 Mandy Sadan, *Being and Becoming Kachin: Histories beyond the State in the Borderworlds of Burma*, Oxford: Oxford University Press, 2013, pp. 88–98.

8 Richard W. Hughes et al., 'Burmese Jade: The Inscrutable Gem', *Gems & Gemology*, vol. 36, no. 1 (2000), pp. 2–25.

9 Zheng Yangwen, *The Social Life of Opium in China*, Cambridge: Cambridge University Press, 2005.

10 The Opium Wars affected the jade trade with Kachin communities, as discussed in chapter 3.

11 Diana S. Kim, *Empires of Vice: The Rise of Opium Prohibition across Southeast Asia*, Princeton, NJ: Princeton University Press, 2020.

12 Jane M. Ferguson, *Repossessing Shanland: Myanmar, Thailand, and a Nation-State Deferred*, Madison: University of Wisconsin Press, 2021.

13 United Nations Office on Drugs and Crime, *Myanmar Opium Survey 2022: Cultivation, Production, and Implications*, Regional Office for Southeast Asia and the Pacific, Bangkok: Thailand, January 2023.

14 Barbie Campbell Cole, 'Heirloom Beads of the Kachin and Naga', *Beads: Journal of the Society of Bead Researchers*, vol. 20 (2008), pp. 3–25, at p. 6.

15 Ola Hanson, *The Kachins: Their Customs and Traditions*, Rangoon: American Baptist Mission Press, 1913, p. 48.

16 Lida Xing, Pierre Cockx, Ryan C. McKellar and Jingmai O'Connor, 'Ornamental Feathers in Cretaceous Burmese Amber: Resolving the Enigma of Rachis-Dominated Feather Structure', *Journal of Palaeogeography*, vol. 7, no. 13 (2018), doi.org/10.1186/s42501-018-0014-2 (accessed 11 May 2023). Thank you to Ryan McKellar for providing the image.

17 Joshua Sokol, 'Troubled Treasure', *Science*, vol. s364, no. 6442 (2019), pp. 722–9; Lucas Joel, 'Some Paleontologists Seek Halt to Myanmar Amber Fossil Research', *New York Times*, 11 March 2020, www.nytimes.com/2020/03/11/science/amber-myanmar-paleontologists.html (accessed 30 January 2023).

18 Than Tun, *The Royal Orders of Burma, AD 1598–1885*, part 5: *AD 1788–1806*, Kyoto: Center for Southeast Asian Studies, Kyoto University, 1986, p. 7.

19 Alexandra Kaloyanides, 'Buddhist Teak and British Rifles', *Journal of Burma Studies*, vol. 24, no. 1 (2020), pp. 1–36.

20 Shwe Yoe, *The Burman: His Life and Notions*, 2nd edn, London: Macmillan and Co., 1896, p. 491. Interestingly, Europeans of the nineteenth century took the opposite view, deeming wooden architecture to be of less significance than that in stone or brick.

21 Than Tun, *The Royal Orders of Burma, AD 1598–1885*, part 1: *AD 1598–1648*, Kyoto: Center for Southeast Asian Studies, Kyoto University, 1983, vol. 1, p. 100.

22 Than Htun, *Lacquerware Journeys: The Untold Story of Burmese Lacquer*, Bangkok: River Books, 2013, p. 27.

23 Sylvia Fraser-Lu and Donald M. Stadtner (eds), *Buddhist Art of Myanmar*, New Haven, CT: Asia Society Museum/Yale University Press, 2015, p. 222.

24 For more on Burmese lacquer traditions, see Than Htun, *Lacquerware Journeys*. See also Ralph Isaacs and T. Richard Blurton, *Visions from the Golden Land: Burma and the Art of Lacquer*, London: The British Museum Press, 2000.

25 Jonathan Saha, *Colonizing Animals: Interspecies Empire in Myanmar*, Cambridge: Cambridge University Press, 2021, p. 55.

26 Arash Khazeni, *The City and the Wilderness: Indo-Persian Encounters in Southeast Asia*, Oakland: University of California Press, 2020, p. 144.

27 Daniel Stiles, 'Ivory Carving in Myanmar', *Asian Art*, 19 November 2002, www.asianart.com/articles/ivory/index.html (accessed 20 March 2023).

28 Chris R. Shepherd and Vincent Nijman, *Elephant and Ivory Trade in Myanmar: A Traffic Southeast Asia Report*, Selangor, Malaysia: TRAFFIC Southeast Asia, 2008, www.traffic.org/site/assets/files/4084/elephant_ivory_trade_myanmar.pdf (accessed 20 March 2023), p. iii.

29 Dietrich Christian Lammerts, *Buddhist Law in Burma: A History of Dhammasattha Texts and Jurisprudence, 1250–1850*, Honolulu: University of Hawai'i Press, 2018, p. 188.

30 Noel Singer, 'Jengtung Lacquerware', *Arts of Asia*, vol. 21, no. 5 (1991), pp. 154–8.

31 Expanding rice production and maintaining and expanding the state's complex irrigation network were a focus of state energy.

32 Cheng Siok Hwa, 'The Development of the Burmese Rice Industry in the Late Nineteenth Century', *Journal of Southeast Asian History*, vol. 6, no. 1 (1965), pp. 67–8.

33 Jean-Pascal Bassino and Peter A. Coclanis, 'Economic Transformation and Biological Welfare in Colonial Burma', *Economics & Human Biology*, vol. 6, no. 2 (2008), pp. 212–27.

34 Raja Segaran Arumugam, *State and Oil in Burma: An Introductory Survey*, Singapore: Institute of Southeast Asian Studies, 1977.

35 For more on the Mahamuni Buddha, Shwedagon and the Golden Rock, see Donald M. Stadtner, *Sacred Sites of Burma: Myth and Folklore in an Evolving Spiritual Realm*, Bangkok: River Books, 2010.

36 Ei Ei Thu, 'Trustees Ban Offerings of Gold Leaf at Inle Pagoda', *Myanmar Times*, 1 January 2019.

37 Henry Yule, *A Narrative of the Mission Sent by the Governor General of India to the Court of Ava in 1855, with Notices of the Country, Government, and People*, London: Smith, Elder & Co., 1858, p. 345.

38 Sylvia Fraser-Lu, 'Emulating the Celestials: The Walters' *Parabaik* on Burmese Sumptuary Laws', *Journal of the Walters Art Museum*, vol. 73 (2018), pp. 10–24.

39 James George Scott and John Percy Hardiman, *Gazetteer of Upper Burma and the Shan States*, vol. 1, part 2, Rangoon: Superintendent of Government Printing and Stationery, 1900–1901, p. 177. Later, this was changed to an annual payment of 350 rupees.

40 Scott and Hardiman, *Gazetteer*, vol. 2, part 2, pp. 602–3. For more on Myanmar's history of this precious metal, see Alexandra Green, *Burmese Silver from the Colonial Period*, London: Ad Ilissum, 2022.

41 Jerome Mouat, 'Mark of Success', *British Museum Magazine*, Spring/Summer 2014, pp. 54–6. This example was most likely produced for shareholders and possible investors around the time Herbert Hoover retired from Burma Mines' board and sold off his shareholdings, so as to inspire confidence in the struggling enterprise.

42 Julia Wiland and San San May, 'Burmese Butterfly Book', in *Cabinet of Oriental Curiosities: An Album for Graham Shaw from his Colleagues*, ed. Annabel Teh Gallop, London: The British Library, 2006, item 28. Jim Potter and Ni Ni Aung, 'Better than a Pearl: A Letter to the Governor from the People of Myeik, c. 1907', unpublished manuscript.

43 Chen Yi-Sein, 'The Chinese in Upper Burma before A.D. 1700', *Journal of Southeast Asian Research*, vol. 2 (1966), pp. 81–94, at p. 87. Victor Lieberman, 'Secular Trends in Burmese Economic History, c. 1350–1830, and their Implications for State Formation', *Modern Asian Studies*, vol. 25, no. 1 (1991), pp. 1–31, at p. 10.

44 Jane M. Ferguson, 'Who's Counting? Ethnicity, Belonging, and the National Census in Burma/Myanmar', *Bijdragen tot de Taal-, Land- en Volkenkunde*, vol. 171, no. 1 (2015), pp. 1–28.

45 Bryce Beemer, 'The Creole City in Mainland Southeast Asia: Slave Gathering Warfare and Cultural Exchange in Burma, Thailand and Manipur, 18th–19th C', PhD dissertation, University of Hawai'i, 2013.

46 For more on Burmese urban planning during the reign of King Mindon, see François Tainturier, *Mandalay and the Art of Building Cities in Burma*, Singapore: NUS Press, 2021.

47 Joseph E. Schwartzberg, 'Southeast Asian Geographical Maps', in *The History of Cartography: Cartography in the Traditional East and Southeast Asian Societies*, ed. J.B. Harley and Davis Woodward, vol. 2, book 2, Chicago, IL: University of Chicago Press, 1994, pp. 741–827, at p. 745, 747, 753. See also Lieberman, 'Secular Trends', p. 21.

CHAPTER 2

1 The meanings of the names range from the city of victories against enemies to the hot land and the land of prosperity. Than Tun, *Hkit-haung Myanmar yazawin* [Ancient history of Burma], 2nd edn, Yangon: Maha Dagon Publishing, 1969, p. 117.

2 See www.whc.unesco.org/en/list/1588 (accessed 20 March 2023).

3 Silver lump coinage continued in use. See Dietrich Mahlo, *The Early Coins of Myanmar/Burma: Messengers from the Past: Pyu, Mon, and Candras of Arakan, First Millennium AD*, Bangkok: White Lotus Press, 2012.

4 The IRAW@Bagan Project publication is available here: www.irawbagan.files.wordpress.com/2019/03/report-on-the-2018-iraw4obagan-field-seasonefbbbf.pdf (accessed 23 February 2023).

5 Gordon H. Luce, *Old Burma–Early Pagán*, vols 1–3, Locust Valley, NY: J.J. Augustin, 1969–70. Gordon H. Luce, *Phases of Pre-Pagan Burma*, vols 1–2, Oxford: Oxford University Press, 1985. Michael Aung-Thwin and Maitrii Aung-Thwin, *A History of Myanmar since Ancient Times: Traditions and Transformations*, London: Reaktion Books, 2012, ch. 4.

6 Bob Hudson, U Nyein Lwin and U Win Maung, 'Digging for Myths: Archaeological Excavations and Surveys of the Legendary Nineteen Founding Villages of Pagan', in *Burma: Art and Archaeology*, ed. Alexandra Green and T. Richard Blurton, London: The British Museum Press, 2002, pp. 9–22.

7 U Kala mentions not only the mission to Sri Lanka but also the pursuit of the tooth relic in Sri Lanka. U Kala, *Mahayazawingyi*, vol. 1, Yangon: Pyi Gyi Man Daing Press, 1926, pp. 166–74. More recent evidence also suggests Anawrahta may have sought out Buddhist relics from Gandhara in present-day Pakistan, the Dali Kingdom in Yunnan of southwestern China, and China itself. Geok Yian Goh, 'The Question of "China" in Burmese Chronicles', *Journal of Southeast Asian Studies*, vol. 41, no. 1 (2010), pp. 125–52.

8 The Lesser Chronicle, the *Culavamsa*, gives an account of Sri Lankan history between the fourth and early nineteenth centuries.

9 Wilhelm Geiger, *Culavamsa*, part 1, Oxford: Oxford University Press, 1929, p. 202. Hema Goonatilake, 'Sri Lanka-Myanmar Historical Relations in Religion, Culture and Polity', *Journal of the Royal Asiatic Society of Sri Lanka*, vol. 55 (2009), pp. 77–114, at p. 79.

10 Geiger, *Culavamsa*, pp. 214–15. Tilman Frasch, 'A Buddhist Network in the Bay of Bengal: Relations between Bodhgaya, Burma and Sri Lanka', in *From the Mediterranean to the China Sea: Miscellaneous Notes*, ed. Claude Guillot, Denys Lombard and Roderich Ptak, Wiesbaden: Harrassowitz Verlag, 1998, pp. 69–93.

11 Wilhelm Geiger, *Culavamsa*, pt 2, Colombo: Ceylon Govt. Information Dept, 1953, p. 126.

12 Claudine Bautze-Picron, *Timeless Vistas of the Cosmos: The Buddhist Murals of Pagan*, Bangkok: Orchid Press, 2003, p. 5.

13 Tilman Frasch, 'A Pāli Cosmopolis? Sri Lanka and the Theravāda Buddhist Ecumene, *c.* 500–1500', in *Sri Lanka at the Crossroads of History*, ed. Zoltán Biedermann and Alan Strathern, London: UCL Press, 2017, pp. 66–76, at pp. 71–2.

14 *Mahavamsa* means Great Chronicle. It was written around the fifth century CE and gives an account of Sri Lankan history between the fourth century BCE and around the fourth to fifth centuries CE.

15 Frasch 1998, p. 86.

16 U Chit Thein, *Compendium of Mon Inscriptions*, Yangon: Ministry of Culture, 1965, p. 47.

17 See more information about the inscription and the king who sent the mission in Tilman Frasch, 'Early Burmese Inscriptions from Bodhgaya', in *Precious Treasures from the Diamond Throne: Finds from the Site of the Buddha's Enlightenment*, ed. Michael Willis et al., British Museum Research Publication 228, London: The British Museum, 2021, pp. 59–64.

18 Ibid., pp. 62–3.

19 Paul Strachan, *Pagan: Art and Architecture of Old Burma*, Arran: Kiscadale Publications, 1989, p. 100.

20 Earlier examples are difficult to identify as many temples' dedicatory inscriptions with dates have been lost. Tilman Frasch, 'A Note on the Mahabodhi Temples at Pagan', in *Southeast Asian Archaeology: Proceedings of the Seventh International Conference of the European Association of Southeast Asian Archaeologists*, ed. Wibke Lobo and Stefanie Reiman, Hull/Berlin: Centre for Southeast Asian Studies/Ethnologisches Museum, 2000, pp. 41–9, at p. 45.

21 Janice Leoshko, 'The Vajrasana Buddha', in *Bodhgaya: The Site of Enlightenment*, ed. Janice Leoshko, Bombay: Marg Publications, 1988, pp. 29–44, at p. 30. Jacob N. Kinnard, 'Reevaluating the Eighth–Ninth Century Pāla Milieu: Icono-Conservatism and the Persistence of Śākyamuni', *Journal of the International Association of Buddhist Studies*, vol. 19, no. 2 (1996), pp. 281–300.

22 Janice Leoshko, 'Buddhist Sculptures from Bodhgaya', in *Bodhgaya*, ed. Leoshko, pp. 45–60, at p. 59.

23 Ibid.

24 Charlotte Galloway, 'Buddhist Narrative Imagery during the Eleventh Century at Pagan, Burma: Reviewing Origins and Purpose', in *Rethinking Visual Narratives from Asia: Intercultural and Comparative Perspectives*, ed. Alexandra Green, Hong Kong: Hong Kong University Press, 2013, pp. 159–74.

25 Ibid., p. 164.

26 Kinnard, 'Reevaluating the Eight-Ninth Century Pāla Milieu', p. 288. Claudine Bautze-Picron, 'The Biography of the Buddha in Indian Art: How and When?', in *Biography as a Religious and Cultural Text*, ed. Andreas Schüle, Berlin: LIT Verlag, 2002, pp. 197–239.

27 A Pali Buddhist text narrating the chronicles of the Buddhas dated to the third second century BCE.

28 A late Sri Lankan Pali text written by Cula-Buddhaghosa in the fifth century CE.

29 Galloway, 'Buddhist Narrative Imagery', p. 173.

30 Luce, *Old Burma-Early Pagán*, vol. 1, pp. 321–2.

31 See a reverse glass painting of Saraswati at the British Museum, 1996,0507.0.7.

32 U Chit Thein, *Compendium of Mon Inscriptions*, pp. 8–9.

33 U Nyein Maung, *Ancient Myanmar Inscriptions*, vol. 5, Yangon: Archaeological Directorate, 1998, pp. 99–107.

34 François Tainturier, *Mandalay and the Art of Building Cities in Burma*, Singapore: NUS Press, 2021.

35 Some of the descendants of the *ponna* from the royal court at Mandalay still make their living as fortune-tellers as people depend on them to determine auspicious times for activities like getting married, moving house and so forth.

36 Aung-Thwin and Aung-Thwin, *A History of Myanmar since Ancient Times*, pp. 102–6.

37 U Nyein Maung, *Ancient Myanmar Inscriptions*, pp. 142–3.

38 Pe Maung Tin and Gordon H. Luce, *Selections from Inscriptions of Pagan*, Rangoon: British Burma Press, 1928, pp. 126–30.

39 Luce, *Phases of Pre-Pagan Burma*, vol. 1, pp. 47–76.

40 Claudine Bautze-Picron, 'Bagan Murals and the Sino-Tibetan World', in *Buddhist Encounters and Identities Across East Asia*, ed. Ann Heirman, Carmen Meinert and Christoph Anderl, Leiden: Brill, 2018, pp. 19–51.

41 John Guy, *Woven Cargoes: Indian Textiles in the East*, London: Thames & Hudson, 1998, pp. 56–8. See Claudine Bautze-Picron, 'Textiles from Bengal in Pagan (Myanmar) from late eleventh century and onwards', in *Studies in South Asian Heritage: Essays in Memory of M. Harunur Rashid*, ed. Mokammal H. Bhuiyan, Dhaka: Bangla Academy, 2015, pp. 1–10.

42 Alexandra Green, 'Patterns of Use and Re-use: South Asian Trade Textiles and Burmese Wall Paintings', in *India and Southeast Asia: Cultural Discourses*, ed. Anna Dallapiccola and Anila Verghese, Mumbai: The K.R. Cama Oriental Institute, 2018, pp. 459–84.

43 Gordon H. Luce and U Tin Htway, 'A 15th Century Inscription and Library at Pagan, Burma', in *Malalasekera Commemoration Volume*, ed. Oliver Hector de Alwis Wijesekera, Colombo: The Malalasekera Commemoration Editorial Committee, 1976, pp. 203–55.

CHAPTER 3

1 Laichen Sun, 'Ming-Southeast Asian Overland Interactions, 1368–1644', PhD dissertation, University of Michigan, 2000, p. 302. There were diplomatic gift-giving interactions with China, which occurred regularly until the tremendous success of Toungoo in the late sixteenth century. Subsequently there were only a few, one in 1628 and none after that until 1750 when there was a request for Chinese military assistance.

2 See Victor Lieberman, *Burmese Administrative Cycles: Anarchy and Conquest, c. 1580–1760*, Princeton, NJ: Princeton University Press, 1984.

3 Nai Thien (trans.), 'Intercourse between Burma and Siam as Recorded in Hmanan Yazawindawgyi', *Selected Articles from the Siam Society Journal*, vol. 6, part 2 (1959, originally published in 1912), pp. 1–119, at p. 50.

4 Michael Symes, *An Account of an Embassy to the Kingdom of Ava in the Year 1795*, reprint, New Delhi: Asian Educational Services, 1995 [1800], pp. 176–7.

5 Bryce Beemer, 'The Creole City in Mainland Southeast Asia: Slave Gathering Warfare and Cultural Exchange in Burma, Thailand and Manipur, 18th–19th C', PhD dissertation, University of Hawai'i, 2013, p. 224.

6 Ibid., p. 225.

7 Sylvia Fraser-Lu, *Textiles in Burman Culture*, Chiang Mai: Silkworm Books, 2021, pp. 225–6.

8 U Tin, *The Royal Administration of Burma*, trans. Euan Bagshawe, Bangkok: Ava Publishing House, 2001, p. 459.

9 Fraser-Lu, *Textiles in Burman Culture*, p. 95.

10 Sumptuary regulations, including the details of this military outfit, are described in Tin, *The Royal Administration of Burma*, p. 466.

11 See Robyn Maxwell, *Textiles of Southeast Asia: Tradition, Trade, and Transformation*, Canberra: Australian National Gallery, 1990, pp. 253–6.

12 Forrest McGill (ed.), *The Kingdom of Siam: The Art of Central Thailand, 1350–1800*, San Francisco, CA: Asian Art Museum, 2005, cat. entries 59 and 60.

13 See Beemer, 'The Creole City', ch. 4, for a general discussion, and p. 216. U Thaw Kaung, 'Ramayana in Burma Literature and Performing Arts', *Myanmar Historical Research Journal*, vol. 9 (June 2002), pp. 73–99, at pp. 83–4.

14 Beemer, 'The Creole City', p. 234. See also Maung Htin Aung, *Burmese Drama: A Study, with Translations, of Burmese Plays*, London: Oxford University Press

1957, pp. 41–2. Thant Myint-U, *The Making of Modern Burma*, Cambridge: Cambridge University Press, 2001, pp. 93–4.

15 Sebastian Manrique, *Travels of Fray Sebastian Manrique 1629–1643*, vol. 1: *Arakan*, Oxford: Hakluyt Society, 1927, p. 169.

16 Tin Myaing Thein, *Old and New Tapestries of Mandalay*, Oxford: Oxford University Press, 2000. Fraser-Lu, *Textiles in Burman Culture*, ch. 9.

17 There are examples in the Royal Collection Trust that were added to the collection in 1825.

18 For similar patterns found on Indian trade textiles specifically made for the Thai market, see McGill, *Kingdom of Siam*, cat. entries 82 and 84.

19 Ralph Isaacs and T. Richard Blurton, *Visions from the Golden Land: Burma and the Art of Lacquer*, London: The British Museum Press, 2000, p. 81. Fraser-Lu, *Textiles in Burman Culture*, p. 268.

20 For a full discussion of these narratives, see Alexandra Green, 'From Gold Leaf to Buddhist Hagiographies: Contact with Regions to the East Seen in Late Burmese Murals', *Journal of Burma Studies*, vol. 15, no. 2 (2011), pp. 305–58.

21 Lieberman, *Burmese Administrative Cycles*, pp. 207–11.

22 The map was copied from a larger cloth map that is now in the Royal Geographic Society. The RGS map was donated by G. Yule, who found it among family possessions in 1928. Therefore it was probably acquired by his uncle Henry Yule who accompanied the British mission to Ava in 1855. Joseph E. Schwartzberg, 'Southeast Asian Geographical Maps', in *The History of Cartography: Cartography in the Traditional East and Southeast Asian Societies*, ed. J.B. Harley and Davis Woodward, vol. 2, book 2, Chicago, IL: University of Chicago Press, 1994, part 5, ch. 18, pp. 741–827, at pp. 752–3.

23 The brown and yellow parallel lines across the yellow-dotted one indicate military fortifications. Correspondence indicates that the maps were drawn by officials responsible for land surveys to calculate taxes. Schwartzberg, 'Southeast Asian Geographical Maps', in *Cartography*, ed. Harley and Woodward, part 5, ch. 18, pp. 741–827, at p. 754.

24 See Beemer, 'The Creole City', pp. 258–9. Beemer notes that a number of villages still have people identifying as Kathe.

25 Vincenzo Sangermano, *A Description of the Burmese Empire*, 5th edn, London: Susil Gupta, 1966, p. 67.

26 Jacques Leider, 'Specialists for Ritual, Magic, and Devotion: The Court Brahmins (Punna) of the Konbaung Kings (1752–1885)', *Journal of Burma Studies*, vol. 10 (2005/2006), pp. 169–78.

27 Symes, *Embassy to the Kingdom of Ava*, p. 154.

28 Beemer, 'The Creole City', p. 349.

29 Thant Myint-U, *Making of Modern Burma*, p. 58.

30 Henry Yule, *A Narrative of the Mission Sent by the Governor General of India to the Court of Ava in 1855, with Notices of the Country, Government, and People*, London: Smith, Elder & Co., 1858, pp. 153–4.

31 Farooque Ahmed, 'Silk Trade, Look East Policy and Manipuri Muslims: Geopolitical and Historical Insight', *South Asia Politics* (April 2009), pp. 19–23.

32 Fraser-Lu, *Textiles in Burman Culture*, pp. 190–213. In the twentieth century the distinctive wavy pattern began to be copied in less time-consuming methods of production, and today it is a standard pattern seen on many skirt-cloths.

33 Sun, 'Ming-Southeast Asian Overland Interactions', p. 210.

34 Fraser-Lu, *Textiles in Burman Culture*, pp. 196 and 198.

35 Matua Bahadur, *Art of the Textile: Manipuri Textiles from Bangladesh and Burma*, Imphal: Mutua Museum, 2009, pp. 119–20. For examples, see Mutua

Bahadur, *Traditional Textiles of Manipur*, Imphal: Mutua Museum, 1997. See also K. Sobita Devi, *Traditional Dress of the Meiteis*, Imphal: Bhubon Publishing House, 1998.

36 Beemer, 'The Creole City', pp. 338–45.

37 J. Horton Ryley, *Ralph Fitch: England's Pioneer to India and Burma: His Companions and Contemporaries; with his Remarkable Narrative Told in his Own Words*, London: T.F. Unwin, 1899, pp. 155 and 165. During his visit to lower Burma in 1586, Fitch mentions the many ships from Mecca, among other places, at the lower Burma port cities, including Than Lyin (Syriam).

38 Beemer, 'The Creole City', pp. 280–3.

39 Lieberman, *Burmese Administrative Cycles*, p. 226.

40 Jacques Leider, 'The Portuguese Communities along the Burma Coast', *Burma Historical Research Journal*, vol. 10, no. 2 (2001), pp. 53–88, at p. 61.

41 Myo Myint, 'Politics of Survival in Burma: Diplomacy and Statecraft in the Reign of King Mindon, 1853–1878', PhD dissertation, Cornell University, 1987, pp. 203, 239–40.

42 Yule, *A Narrative of the Mission*, pp. 150–2.

43 Ibid., p. 151. The result is that few museums hold Muslim objects, including those within Myanmar. Collectors have almost invariably focused on the Burman Buddhist majority or other groups, such as the Karen and Kachin, and, as mentioned in the Introduction, this bias also impacted the representation of Burmese Muslims in museum collections.

44 Manrique, *Travels of Fray Sebastian Manrique*, pp. 216–17.

45 Catherine Raymond, 'An Arakanese Perspective from the Dutch Sources: Images of the Kingdom of Arakan in the Seventeenth Century', in *The Maritime Frontier of Burma: Exploring Political, Cultural and Commercial Interaction in the Indian Ocean World, 1200–1800*, ed. Jos Gommans and Jacques Leider, Amsterdam: Koninklijke Nederlandse Akademie van Wetenschappen, 2002, pp. 177–98, at pp. 188–90.

46 Manrique, *Travels of Fray Sebastian Manrique*, p. 379.

47 Annabel Teh Gallop et al., 'A New Display of Southeast Asian Manuscripts from the Sloane Collection', The British Library, 2018, blogs. bl.uk/asian-and-african/2018/09/a-new-display-of-southeast-asian-manuscripts-from-the-sloane-collection.html (accessed 4 July 2023).

48 Leider, 'Portuguese Communities', p. 63.

49 Ibid., p. 72.

50 Richard M. Eaton, 'Locating Arakan in Time, Space, and Historical Scholarship', in *Maritime Frontier of Burma*, ed. Gommans and Leider, pp. 225–31, at p. 227.

51 Leider, 'Portuguese Communities', pp. 56–60. Local and regional Portuguese communities, some strong enough to intervene in political conflicts, were of importance to the region as part of trading networks, even after the rise of the Dutch in the seventeenth century.

52 Jacques Leider, 'These Buddhist Kings with Muslim Names: A Discussion of Muslim Influence in the Mrauk-U Period', in *Études birmanes en hommage à Denise Bernot*, ed. Pierre Pichard and François Robinne, Paris: École française d'Extrême-Orient, 1998, pp. 189–215, at p. 191.

53 Jacques Leider, 'On Arakanese Territorial Expansion: Origins, Context, Means and Practice', in *Maritime Frontier of Burma*, ed. Gommans and Leider, pp. 127–49, at p. 127.

54 For substantial discussions of the Konbaung efforts to promote its culture in the Arakan region, see Michael W. Charney, 'Beyond State-Centered Histories in Western Burma: Missionizing Monks and Intra-regional Migrants in the Arakan Littoral, c. 1784–1860', in *Maritime Frontier of Burma*,

ed. Gommans and Leider, pp. 213–24. Jacques Leider, 'Politics of Integration and Cultures of Resistance: A Study of Burma's Conquest and Administration of Arakan', in *Asian Expansions: The Historical Experiences of Polity Expansion in Asia*, ed. Geoffrey Wade, London: Routledge, pp. 184–213.

55 Thibaut d'Hubert, 'The Lord of the Elephant: Interpreting the Islamicate Epigraphic, Numismatic, and Literary Material from the Mrauk U Period of Arakan (ca. 1430–1784)', *Journal of Burma Studies*, vol. 19, no. 2 (2015), pp. 341–70, at p. 345.

56 Swapna Bhattacharya, 'Myth and History of Bengali Identity in Arakan', in *Maritime Frontier of Burma*, ed. Gommans and Leider, pp. 199–212, at pp. 201–2.

57 Pamela Gutman, *Burma's Lost Kingdoms: Splendours of Arakan*, Bangkok: Orchid Press, 2001, pp. 149–53.

58 Recent research suggests that the Mon arrived in lower Burma from northern and central Thailand around the eleventh century. See Om Prakash, 'Coastal Burma and the Trading World of the Bay of Bengal, 1500–1680', in *Maritime Frontier of Burma*, ed. Gommans and Leider, pp. 93–106.

59 Michael Aung-Thwin and Maitrii Aung-Thwin, *A History of Myanmar since Ancient Times: Traditions and Transformations*, London: Reaktion Books, 2012, p. 119.

60 Lieberman, *Burmese Administrative Cycles*, p. 10.

61 Duarte Barbosa, *The Book of Duarte Barbosa: An Account of the Countries Bordering on the Indian Ocean and Their Inhabitants*, trans. Mansel Longworth Dames, vol. 2, London: Hakluyt Society, 1921, p. 159.

62 Myo Thant Tyn and Dawn Rooney, 'Ancient Celadon in Burma: A New Ceramic Discovery', *Orientations*, vol. 32, no. 4 (April 2001), pp. 57–61, at p. 58–60.

63 Tun Aung Chain, 'Pegu in Politics and Trade, Ninth to Seventeenth Centuries', *Recalling Local Pasts: Autonomous History in Southeast Asia*, ed. Sunait Chutintaranond and Chris Baker, Chiang Mai: Silkworm Books, 2002, pp. 25–52, at p. 47.

64 The Portuguese established settlements around Asia. They intermarried with locals creating Luso-Asian communities. De Brito was married to Luisa da Saldanha, the daughter of Manuel de Saldanha and a Javanese woman. Luisa was also the niece of Ayres de Saldanha, the Portuguese governor and viceroy of India, who had spent most of his career in Asia. Tun Aung Chain, 'The *Pawtugi Yazawin* and the de Brito Affair', *Burma Historical Research Journal*, vol. 9 (June 2002), pp. 31–44, at p. 40. See also Leider, 'Portuguese Communities', pp. 66–7.

65 Arakan and the Tanintharyi (Tenasserim) region of lower Burma were annexed at the end of the First Anglo-Burmese War, and the remainder of the southern regions, including Bago, at the end of the Second Anglo-Burmese War.

66 Tun Aung Chain, 'Pegu in Politics and Trade', p. 46.

67 Donald M. Stadtner, *Sacred Sites of Burma: Myth and Folklore in an Evolving Spiritual Realm*, Bangkok: River Books, 2010, pp. 139–42. Donald M. Stadtner, 'King Dhammaceti's Pegu', *Orientations*, vol. 21, no. 2 (February 1990), pp. 53–60. Robert L. Brown, 'Bodhgaya and Southeast Asia', in *Bodhgaya: The Site of Enlightenment*, ed. Janice Leoshko, Bombay: Marg Publications, 1988, pp. 101–24.

68 Isaacs and Blurton, *Visions from the Golden Land*, pp. 134–5. This distinctive image was also replicated on clay religious tablets. See Alexandra Green, 'Buddha Images', in *Eclectic Collecting: Art from Burma in the Denison Museum*, ed. Alexandra Green, Singapore: NUS Press, 2008, pp. 191–222, at p. 216.

69 Jean Perrin, 'A propos d'un Buddha daté du pays môn', in *Essays Offered to G.H. Luce by his Colleagues and Friends in Honour of his Seventy-Fifth Birthday*,

ed. Ba Shin, Jean Boisselier and A.B. Griswold, special issue, *Artibus Asiae*, vol. 23 (1966), pp. 149–55.

70 Green, 'Buddha Images', pp. 202–3. Probably made in the eighteenth or very early nineteenth century, this Buddha image was likely acquired in the early nineteenth century when Britain annexed the Tanintharyi (Tenasserim) region.

71 Henry Ginsburg, *Thai Manuscript Painting*, London: The British Library, 1989, pp. 22 and 26.

72 While white paper manuscripts are also found in central Burma, they are not used for divination, primarily displaying courtly scenes and activities and stories of the Buddha's lives.

73 See Sai Aung Tun, *History of the Shan State from its Origins to 1962*, Chiang Mai: Silkworm Books, 2009.

74 Chen Yi-Sein, 'The Chinese in Upper Burma before A.D. 1700', *Journal of Southeast Asia Research*, vol. 2 (1966), pp. 81–94, at p. 85.

75 Sun, 'Ming-Southeast Asian Overland Interactions', p. 234.

76 Hsipaw is Thibaw in Burmese, and the last king of the Konbaung dynasty was given this name because his mother was a descendant of the Hsipaw *saohpa*. The last ruling prince of Yawnghwe, Sao Shwethaik, was the first president of Burma when it gained its independence from Britain in 1948.

77 Volker Grabowsky, 'The Tai Polities in the Upper Mekong and their Tributary Relationships with China and Burma', *Aséanie, Sciences humaines en Asie du Sud-Est*, vol. 21 (June 2008), pp. 11–63, at pp. 18–19.

78 Sun, 'Ming-Southeast Asian Overland Interactions', p. 284.

79 Ibid., pp. 304–5.

80 Ibid., p. 306.

81 Susan Conway, *The Shan: Culture, Arts and Crafts*, Bangkok: River Books, 2006, p. 15.

82 Ibid., p. 18.

83 Susan Conway, 'Power Dressing: Female Court Dress and Marital Alliances in Lan Na, the Shan States and Siam', *Orientations*, vol. 32, no. 4 (April 2001), pp. 42–9.

84 Conway, *The Shan*, p. 37.

85 Ibid., p. 36.

86 Alexey Kirichenko, 'Dynamics of Monastic Mobility and Networking in Upper Burma of the Seventeenth and Eighteenth Centuries', paper delivered at 'The Buddhist Dynamics Conference', Nalanda-Sriwijaya Center, ISEAS, Singapore, 10–11 March 2011, p. 2.

87 Joseph E. Schwartzberg, 'Conclusion to Southeast Asian Cartography', in *Cartography*, ed. Harley and Woodward, part 5, ch. 20, pp. 839–42.

88 Schwartzberg, 'Southeast Asian Geographical Maps', in ibid., p. 761.

89 G.E. Mitton (ed.), *Scott of the Shan Hills: Orders and Impressions*, London: J. Murray, 1936, pp. 262–72.

90 Andrew Dalby and Sao Saimöng Mangrai, 'Shan and Burmese Manuscript Maps in the Scott Collection, Cambridge University Library', unpublished fragmentary manuscript, cat. no. 47.

91 Sun, 'Ming-Southeast Asian Overland Interactions', pp. 188–9.

92 R.A. Innes, *Costumes of Upper Burma and the Shan States: In the Collection of Bankfield Museum, Halifax*, Halifax, Yorkshire: Halifax Museums, 1957, pp. 1–3.

93 Sandra Dudley, 'Shan State Area Textiles', in *Textiles from Burma: Featuring the James Henry Green Collection*, ed. Elizabeth Dell and Sandra Dudley, London: Philip Wilson Publishers, 2003, pp. 87–93, at p. 89.

94 Lisa Maddigan, 'Collecting Shan Textiles and their Stories', in *Textiles from Burma*, ed. Dell and Dudley, pp. 151–60, at p. 156.

95 The Pitt Rivers Museum has a similarly styled coat collected in Burma in the 1820s (reg. no. 1886.1.132.1). Although described as from Yangon, the fact that it is velvet and therefore would be too hot to wear in lower Burma means it probably was made for use elsewhere.

96 James George Scott and John Percy Hardiman, *Gazetteer of Upper Burma and the Shan States*, vol. 1, part 2, Rangoon: Superintendent, Government Printing and Stationery, 1900–1901, pp. 177, 193 and 445.

97 Yule, *A Narrative of the Mission*, p. 160.

98 There is a piece of Manipuri silver in the Curzon collection at Kedleston Hall. Whether this was produced in Manipur or made in one of the Shan states and given to the Manipur court is not clear. Both options indicate the connections between the two regions.

99 Sylvia Fraser-Lu, *Burmese Crafts: Past and Present*, Kuala Lumpur: Oxford University Press, 1994, p. 148. Sylvia Fraser-Lu, *Silverware of South-East Asia*, Singapore: Oxford University Press, 1989, p. 35. E.N. Bell, *A Monograph: Iron and Steel Work in Burma*, Rangoon: Superintendent of Government Printing, 1907, p. 27. R.S. Wilkie, *Burma Gazetteer Yamèthin District*, Rangoon: Superintendent of Government Printing and Stationery, 1934, p. 92.

100 Lisa Maddigan, 'Kachin Textiles', in *Textiles from Burma*, ed. Dell and Dudley, pp. 69–76, at p. 70, fig. 4.4.i.

101 Ola Hanson, *The Kachins: Their Customs and Traditions*, Cambridge: Cambridge University Press, 2012 [1913], p. 47.

102 Fraser-Lu, *Burmese Crafts*, p. 114.

103 Noel Singer, 'Rhino Horn and Elephant Ivory', *Arts of Asia*, vol. 21, no. 5 (1991), pp. 98–105, at p. 104.

104 Jelle J.P. Wouters and Michael T. Heneise, 'Highland Asia as a World Region', in *Routledge Handbook of Highland Asia*, ed. Jelle J.P. Wouters and Michael T. Heneise, London: Routledge, 2022, pp. 1–40, at p. 13.

105 This has now been adopted by the Kachin themselves.

106 Mandy Sadan, *Being and Becoming Kachin: Histories beyond the State in the Borderworlds of Burma*, Oxford: Oxford University Press, 2013, pp. 145–50.

107 Ibid., pp. 117–18, 133.

108 Ibid., p. 105.

109 The Hkahku are one of the groups who speak the Jinghpaw language.

110 Hanson, *The Kachins*, pp. 46–9. The Swedish-American missionary Ola Hanson, who lived in the Kachin region in the late nineteenth century, wrote that older men sometimes wore long Chinese-style silk coats and that Kachin men purchased clothes in Shan, Burman and Chinese markets.

111 Mandy Sadan, 'The Kachin Photographs: A Documentary Record of Contact', in *Burma: Frontier Photographs, 1918–1935; The James Henry Green Collection*, ed. Elizabeth Dell, London: Merrell Publishing, 2000, pp. 67–93, at pp. 66–7, 87–8. As one of the chiefs who strongly resisted British incursions, Duwa Nga Lang La was invited to attend the durbar held by the British in Rangoon in 1925 in an attempt to impress him. While there he asked for a car as a gift, which the British provided with some amusement (there were no roads or petrol in his northern territory). The chief, however, made arrangements to sell the car on his return home, thereby acquiring a considerable amount of money. See lostfootsteps.org/en/history/the-clever-duwa (accessed 4 July 2022).

112 Lieberman, *Burmese Administrative Cycles*, p. 13.

113 Sun, 'Ming-Southeast Asian Overland Interactions', pp. 122–3.

114 Lieberman, *Burmese Administrative Cycles*, p. 16. See Sun, 'Ming-Southeast Asian Overland Interactions', p. 178. Later, silver from the Americas was transferred via India and the Philippines, resulting in the Burmese economies being increasingly monetised.

115 Sadan, *Being and Becoming Kachin*, p. 94.

116 Chen Yi-Sein, 'The Chinese in Upper Burma', p. 87.

117 Sun, 'Ming-Southeast Asian Overland Interactions', p. 37.

118 Sadan, *Being and Becoming Kachin*, p. 56.

119 Ibid., pp. 47–8.

120 Ibid., p. 97.

121 Ibid., pp. 83–4.

122 Ibid., p. 143.

123 James Henry Green, 'The Tribes of Upper Burma North of 24° Latitude and Their Classification', unpublished dissertation, University of Cambridge, 1934, p. 65, quoted in *Burma: Frontier Photographs*, ed. Dell, p. 124.

124 Mandy Sadan, 'Kachin Textiles in the Denison University Collections: Documenting Social Change', in *Eclectic Collecting*, ed. Green, pp. 75–96, at pp. 90–91.

125 Ibid., pp. 88–90.

126 See Victor Lieberman's work *Strange Parallels: Southeast Asia in Global Context, c. 800–1830*, 2 vols, Cambridge: Cambridge University Press, 2003 and 2009, for an extensive discussion of these global tendencies.

127 Aung-Thwin and Aung-Thwin, *History of Myanmar since Ancient Times*, p. 126.

128 Sadan, *Being and Becoming Kachin*, p. 153.

CHAPTER 4

1 Michael Aung-Thwin, 'The British "Pacification" of Burma: Order without Meaning', *Journal of Southeast Asian Studies*, vol. 16, no. 2 (1985), pp. 245–61.

2 Michael Aung-Thwin and Maitrii Aung-Thwin, *A History of Myanmar since Ancient Times: Traditions and Transformations*, London: Reaktion Books, 2012, p. 181.

3 Jelle J.P. Wouters and Michael T. Heneise, 'Highland Asia as a World Region', in *Routledge Handbook of Highland Asia*, ed. Jelle J.P. Wouters and Michael T. Heneise, London: Routledge, 2022, pp. 1–40, at p. 18.

4 For a full discussion of the issues associated with the change in system, see Aung-Thwin and Aung-Thwin, *History of Myanmar since Ancient Times*, chs 9–10. Thant Myint-U, *The Making of Modern Burma*, Cambridge: Cambridge University Press, 2001, ch. 9. Michael W. Charney, *A History of Modern Burma*, Cambridge: Cambridge University Press, 2009, chs 1–3.

5 British Museum, Original Letters and Papers, vol. 6 (1826–8), CE 4/6/2185 (2 December 1826).

6 Charlotte Galloway, 'An Introduction to the Buddha Images of Burma', *TAASA Review*, vol. 10, no. 2 (2001), pp. 8–10, at p. 9. Sylvia Fraser-Lu, *Burmese Lacquerware*, Bangkok: Orchid Press, 2000, p. 54. Than Tun, 'Lacquer Images of the Buddha', *Shiroku*, vol. 13 (1980), pp. 21–36, at p. 21.

7 For further discussion, see Alexandra Green, 'From India to Independence: The Formation of the Burma Collection at the British Museum', *Journal of the History of Collections*, vol. 28, no. 3 (2016), pp. 449–63.

8 The British Library, Chester Beatty Library, National Army Museum and Bristol Museum all have manuscripts depicting Thibaw's departure.

9 Michael W. Charney, *Powerful Learning: Buddhist Literati and the Throne in Burma's Last Dynasty*, Ann Arbor: University of Michigan Press, 2006, pp. 258–61.

10 François Tainturier, *Mandalay and the Art of Building Cities in Burma*, Singapore: NUS Press, 2021, p. 3.

The book provides a full discussion of how this applied to the construction of the new city.

11 Thant Myint-U, *Making of Modern Burma*, p. 149.

12 See Alicia Turner, *Saving Buddhism: The Impermanence of Religion in Colonial Burma*, Honolulu: University of Hawai'i Press, 2014.

13 See Erik Braun, *The Birth of Insight: Meditation, Modern Buddhism, and the Burmese Monk Ledi Sayadaw*, Chicago, IL: University of Chicago Press, 2013.

14 Craig J. Reynolds, 'Buddhist Cosmography in Thai History, with Special Reference to Nineteenth-Century Culture Change', *Journal of Asian Studies*, vol. 35, no. 2 (1976), pp. 203–20. Richard Gombrich, *Theravada Buddhism: A Social History from Ancient Benares to Modern Colombo*, London: Routledge, 1988, ch. 7.

15 There are four postures commonly depicted in Buddha images. The first is the seated posture, indicating the Buddha's enlightenment and his use of meditation as a means towards spiritual development. The second is the standing posture, which can also demonstrate meditation, but in combination with specific hand gestures shows the Buddha granting boons or strengthening his followers' resolve. The third is the walking posture, reflecting the wandering nature of Buddhism as a mendicant tradition. It signifies the Buddha's constant travels and the spread of his teachings. Lastly, the reclining posture represents the Buddha's final liberation from the cycle of birth and rebirth (*parinirvana*) and his transcendence beyond worldly existence.

16 Turner, *Saving Buddhism*, pp. 120–33.

17 Myo Myint, 'Politics of Survival in Burma: Diplomacy and Statecraft in the Reign of King Mindon, 1853–1878', PhD dissertation, Cornell University, 1987, p. 203.

18 Patricia Herbert, 'Commentary on a Burmese Letter in Ottoman Archives', in *Ottoman-Southeast Asian Relations: Sources from the Ottoman Archives*, ed. Ismail Hakki Kadi and A.C.S. Peacock, Leiden: Brill, 2020, pp. 185–9.

19 Alexandra Kaloyanides, *Baptizing Burma: Religious Change in the Last Buddhist Kingdom*, New York: Columbia University Press, 2023, p. 9.

20 Gracie Lee, 'Early Printing in Myanmar and Thailand', *Biblioasia*, vol. 16, no. 2 (July–September 2020), pp. 46–9, at p. 47.

21 Kaloyanides, *Baptizing Burma*, pp. 9–10.

22 Similar and more successful modernising efforts were also being implemented by the monarchy in neighbouring Siam (now Thailand).

23 Thant Myint-U, *Making of Modern Burma*, p. 113.

24 Myo Myint, 'Politics of Survival', p. 57.

25 Thant Myint-U, *Making of Modern Burma*, p. 115.

26 Leslie Milne, *Shans at Home: Burma's Shan States in the early 1900s*, London: J. Murray, 1910, pp. 131–2.

27 Ibid., p. 137.

28 E.N. Bell, *A Monograph: Iron and Steel Work in Burma*, Rangoon: Superintendent Government Printing, 1907, p. 13.

29 Harry L. Tilly, 'The Art Industries of Burma', *Journal of Indian Art and Industry*, vol. 15 (1913), pp. 39–40, at p. 40.

30 John Lowry, 'Victorian Burma by Post: Felice Beato's Mail-Order Business', *Country Life*, 13 March 1975, pp. 659–60.

31 Alexandra Green, *Buddhist Visual Cultures, Rhetoric, and Narrative*, Hong Kong: Hong Kong University Press, 2018, pp. 125–9.

32 Henry Yule, *A Narrative of the Mission Sent by the Governor General of India to the Court of Ava in 1855, with Notices of the Country, Government, and People*, London: Smith, Elder & Co., 1858, p. 160.

33 Alexandra Green, *Burmese Silver from the Colonial Period*, London: Ad Ilissum, 2022, pp. 19–20.

34 George Watt, *Indian Art at Delhi*, Delhi: M. Banarsidass, 1987 [1903], p. 41. Burmese artists did well at the Delhi Durbar, also winning prizes in wood carving and lacquer work. Maung Yin Maung and his father Maung Shwe Yon are two of the most famous silversmiths working in the late nineteenth and early twentieth centuries in British Burma.

35 Green, *Burmese Silver*, p. 26.

36 H.L. Tilly, *Modern Burmese Silverwork*, Rangoon: Office of the Superintendent, Government Printing, 1904, p. 1.

37 Bernard S. Cohn, *Colonialism and its Forms of Knowledge: The British in India*, Princeton, NJ: Princeton University Press, 1996, p. 10.

38 Government of Burma, *Report of the Superintendent of Cottage Industries Burma for the Year ending 30th June 1928*, Rangoon, 1929, p. 20.

39 Government of Burma, *Report of the Superintendent of Cottage Industries Burma for the Year ending 30th June 1929*, Rangoon, 1930, p. 18.

40 The school was initially conceived of by a group of lacquer artists who wanted to preserve an industry that was being replaced by European glassware and crockery. See Sylvia Fraser-Lu, *Burmese Crafts: Past and Present*, Kuala Lumpur: Oxford University Press, 1994, p. 245.

41 Government of Burma, *Report of the Superintendent of Cottage Industries Burma for the Year ending 30th June 1925*, Rangoon, 1926, p. 14.

42 Government of Burma, *Report … for the Year ending 30th June 1928*, p. 17.

43 Government of Burma, *Report of the Superintendent of Cottage Industries Burma for the Year ending 30th June 1931*, Rangoon, 1932, pp. 6–7.

44 Government of Burma, *Report of the Superintendent of Cottage Industries Burma for the Year ending 30th June 1925*, Rangoon, 1926, letter dated 12 March 1926 from Secretary to Development Commissioner, Burma to the Secretary to the Government of Burma, Department of Agriculture, Excise and Forests included in printing of the 1925 report.

45 Government of Burma, *Report … for the Year ending 30th June 1925*, p. 21.

46 The first museum in Rangoon was the Phayre Museum in 1867, an independent venture.

47 Charney, *History of Modern Burma*, pp. 22–3. John L. Christian, 'Burma Divorces India', *Current History*, vol. 46, no. 1 (April 1937), pp. 82–6, at p. 82.

48 Charney, *History of Modern Burma*, pp. 23–4.

49 Arnold Wright (ed.), *Twentieth Century Impressions of Burma: Its History, People, Commerce, Industries, and Resources*, London: Lloyd's Greater Britain Publishing Company, 1910, pp. 334–66.

50 Ralph Isaacs and T. Richard Blurton, *Visions from the Golden Land: Burma and the Art of Lacquer*, London: The British Museum Press, 2000, pp. 197–8.

51 Charney, *History of Modern Burma*, p. 17.

52 Charney, *Powerful Learning*, pp. 125–45. There are many studies that demonstrate this. See also Alexandra Green, 'From Gold Leaf to Buddhist Hagiographies: Contact with Regions to the East Seen in Late Burmese Murals', *Journal of Burma Studies*, vol. 15, no. 2 (2011), pp. 305–58.

53 Charney, *History of Modern Burma*, p. 8. See Susan Conway, 'Power Dressing: Female Court Dress and Marital Alliances in Lan Na, the Shan States and Siam', *Orientations*, vol. 32, no. 4 (April 2001), pp. 42–9. Susan Conway, 'Court Dress, Politics, and Ethnicity in the Shan States', in *Burma: Art and Archaeology*, ed. Alexandra Green and T. Richard Blurton, London: The British Museum Press, 2002, pp. 133–42.

54 Quoted in Charney, *Powerful Learning*, p. 131; taken from Edward Judson, *The Life of Adoniram Judson*, New York: A.D.F. Randolph and Company, 1883, p. 204.

55 Ibid., pp. 125–45. Bryce Beemer, 'The Creole City in Mainland Southeast Asia: Slave Gathering Warfare and Cultural Exchange in Burma, Thailand and Manipur, 18th-19th C', PhD dissertation, University of Hawai'i, 2013, pp. 322–3.

56 This way of structuring Burmese history has now been debunked, and much has been written about it. For example, Michael Aung-Thwin, 'Myth of the "Three Shan Brothers" and the Ava Period in Burmese History', *Journal of Asian Studies*, vol. 55, no. 4 (1996), pp. 881–901. Victor B. Lieberman, 'Ethnic Politics in Eighteenth-Century Burma', *Modern Asian Studies*, vol. 12, no. 3 (1978), pp. 455–82. Patrick McCormick, 'The Position of the *Rajavamsa Katha* in Mon History-Telling', *Journal of Burma Studies*, vol. 15, no. 2 (2011), pp. 283–304.

57 Jane M. Ferguson, 'Who's Counting? Ethnicity, Belonging, and the National Census in Burma/Myanmar', *Bijdragen tot de Taal-, Land- en Volkenkunde*, vol. 171 (2015), pp. 1–28.

58 J.H. Green, 'A Note on the Indigenous Races of Burma', in *Census of India 1931*, ed. J.J. Bennison, vol. 11, part 1, Rangoon: Office of the Superintendent, Government Printing and Stationery, 1933, p. 245.

59 Thant Myint-U, *Making of Modern Burma*, p. 222.

60 Ibid., pp. 243–4.

61 Many of the Burmese textiles at the British Museum are from the Paris World Exposition of 1900.

62 There are examples at the Victoria and Albert Museum; Cambridge University Library; the Denison Museum, Granville, Ohio; Northern Illinois University Library; and the American Baptist Historical Society.

63 Found in paperwork associated with the figures.

64 Georg Noack, pers. comm., 21 June 2023. Similarly stereotyped images can also be seen in Burmese museums today. In galleries dedicated to the peoples of Myanmar, pairs of full-sized mannequins display the 'traditional' dress of the various ethnic groups.

65 Mandy Sadan, 'The Historical Visual Economy of Photography in Burma', *Bijdragen tot de Taal-, Land-en Volkenkunde*, vol. 170, no. 2–3 (2014), pp. 281–312, at p. 290.

66 Ibid., p. 288, citing W.W. Hooper, *Burmah: A Series of One Hundred Photographs, Illustrating Incidents Connected with the British Expeditionary Force to that Country*, London: J.A. Lugard, 1887.

67 Ibid., pp. 294–6.

68 John Falconer, 'Photography and Ethnography in the Colonial Period in Burma', in *Burma: Frontier Photographs 1918–1935*, ed. Elizabeth Dell, London: Merrell Publishing, 2000, p. 36.

69 Ibid., pp. 30–33.

70 See Dell (ed.), *Burma: Frontier Photographs*.

71 David Odo, 'Anthropological Boundaries and Photographic Frontiers: J.H. Green's Visual Language of Salvage', in ibid., pp. 41–9.

72 Ibid., p. 42.

73 Charney, *History of Modern Burma*, p. 12.

74 For further information on such pictures, see Gillian Green, 'Verging on Modernity: A Late Nineteenth-Century Burmese Painting on Cloth Depicting the Vessantara Jataka', *Journal of Burma Studies*, vol. 16, no. 1 (2012), pp. 95–9. Andrew Ranard, *Burmese Painting: A Linear and Lateral History*, Chiang Mai: Silkworm Books, 2009, pp. 34–9.

75 Ranard, *Burmese Painting*, chs 5–6.

76 Charney, *History of Modern Burma*, pp. 13–16.

77 Maurice Collis, *Into Hidden Burma*, London: Faber and Faber, 1953, pp. 185–6.

78 Ranard, *Burmese Painting*, pp. 103–4.

79 Charney, *Powerful Learning*, p. 19.

80 Wright (ed.), *Twentieth Century Impressions*, p. 139.

81 Ibid.

82 Jane M. Ferguson, 'The Silver Screen in the Golden Land: A History of Burmese Cinema', in *Southeast Asian Cinema*, eds. Gaetan Margirier and Jean-Pierre Gimenez, Lyon: Asiexpo Association, 2012, pp. 15–37, at p. 28.

83 Ibid.

84 Jane M. Ferguson, 'From Contested Histories to Ethnic Tourism: Cinematic Representations of Shans and Shanland on the Burmese Silver Screen', in *Film in Contemporary Southeast Asia*, ed. David C.L. Lim and Hiroyuki Yamamoto, London: Routledge, 2012, p. 37.

85 Jane M. Ferguson, *Silver Screens and Golden Dreams: A Social History of Burmese Cinema*, Honolulu: University of Hawai'i Press, 2023, p. 5.

86 Ranard, *Burmese Painting*, p. 92.

87 Ibid., p. 93.

88 U Bagale also called himself Shwe Yoe Bagalay to mock the pen name of J.G. Scott, the British superintendent of the northern Shan States, who had given himself a Burmese pen name (Shwe Yoe).

89 See www.lostfootsteps.org/en/history/burma-was-separated-from-india; www.lostfootsteps.org/en/history/burmas-first-ever-general-elections (accessed 30 May 2023).

CHAPTER 5

1 Here can be seen the problem of externally developed categories based on linguistics, dress and other features, which do not necessarily indicate how people view themselves or how they connect and interact with the people in the areas around them.

2 William Womack, 'Literate Networks and the Production of Sgaw and Pwo Karen Writing in Burma, *c.* 1830–1930', PhD dissertation, School of Oriental and African Studies, University of London, 2005, p. 38.

3 Ibid., p. 20.

4 Hitomi Fujimura, 'The Emergence of *Dawkalu* in the Karen Ethnic Claim in the 1880s and the Beginning of Contestations for "Native Races"', in *Living with Myanmar*, ed. Justine Chambers, Charlotte Galloway and Jonathan Liljeblad, Singapore: ISEAS Publishing, 2020, pp. 315–34, at p. 323.

5 Ananda Rajah, 'A "Nation of Intent" in Burma: Karen Ethno-Nationalism, Nationalism and Narrations of Nation', *Pacific Review*, vol. 15, no. 4 (2002), pp. 517–37.

6 Sandra Dudley, 'Diversity, Identity and Modernity in Exile: "Traditional" Karenni Clothing', in *Burma: Art and Archaeology*, ed. Alexandra Green and T. Richard Blurton, London: The British Museum Press, 2002, pp. 143–51, at p. 147. See also Sandra Dudley, 'Karenic Textiles', in *Eclectic Collecting: Art from Burma in the Denison Museum*, ed. Alexandra Green, Singapore: NUS Press, 2008, pp. 19–48, at p. 25.

7 Dudley, 'Diversity, Identity', p. 149.

8 Dudley, 'Karenic Textiles', p. 21.

9 Markets circled around towns and villages in a specific region over a set period, after which the cycle was repeated.

10 Sandra Dudley, 'Whose Textiles and Whose Meanings?', in *Textiles from Burma: Featuring the James Henry Green Collection*, ed. Elizabeth Dell and Sandra Dudley, London: Philip Wilson Publishers, 2003, pp. 40–1.

11 Dudley, 'Karenic Textiles', p. 23.

12 Ibid.

13 David Richardson and Sue Richardson, 'Yellow', Asian Textiles Studies website, 2017, www.asiantextilestudies.com/yellow.html (accessed 15 March 2023).

14 Victor J. Chen et al., 'Identification of Red Dyes in Selected Textiles from Chin and Karen Ethnic Groups of Myanmar by LC-DAD-ESI-MS', in *Dyes in History and Archaeology 33/34*, ed. Jo Kirby et al., London: Archetype Publications, 2021, pp. 92–101.

15 Richardson and Richardson, 'Yellow'.

16 Indigo plants were originally cultivated in India and exported to all tropical areas of Asia.

17 Dominique Cardon, 'The Discovery and Mastery of Mordants and Mordanting', in *Natural Dyes: Sources, Tradition, Technology and Science*, London: Archetype Publications, 2007, pp. 20–48.

18 Dudley, 'Karenic Textiles', p. 23.

19 Victor J. Chen et al., 'Chemical Analysis of Dyes on an Uzbek Ceremonial Coat: Objective Evidence for Artifact Dating and the Chemistry of Early Synthetic Dyes', *Dyes and Pigments*, vol. 131 (August 2016), pp. 320–32; Jian Liu et al., 'Identification of Early Synthetic Dyes in Historical Chinese Textiles of the Late Nineteenth Century by High-Performance Liquid Chromatography Coupled with Diode Array Detection and Mass Spectrometry', *Coloration Technology*, vol. 132, no. 2 (2016), pp. 177–85; Anna Cesaratto et al., 'A Timeline for the Introduction of Synthetic Dyestuffs in Japan during the Late Edo and Meiji Periods', *Heritage Science*, vol. 6, no. 22 (2018), doi.org/10.1186/s40494-018-0187-0 (accessed 15 March 2023); Diego Tamburini et al., 'Exploring the Transition from Natural to Synthetic Dyes in the Production of 19th-Century Central Asian *Ikat* Textiles', *Heritage Science*, vol. 8, no. 114 (2020), doi.org/10.1186/s40494-020-00441-9 (accessed 15 March 2023).

20 Diego Tamburini et al., 'The Evolution of the Materials Used in the *Yun* Technique for the Decoration of Burmese Objects: Lacquer, Binding Media and Pigments', *Heritage Science*, vol. 7, no. 28 (2019), doi.org/10.1186/s40494-019-0272-z (accessed 15 March 2023).

21 Chen et al., 'Identification of Red Dyes', pp. 92–101.

22 Joanne Dyer et al., 'A Multispectral Imaging Approach Integrated into the Study of Late Antique Textiles from Egypt', *PLoS ONE*, vol. 13, no. 10 (2018), doi.org/10.1371/journal.pone.0204699 (accessed 15 March 2023).

23 David Richardson and Sue Richardson, 'Morinda', Asian Textiles Studies website, 2017, www.asiantextilestudies.com/morinda.html#i (accessed 15 May 2023).

24 Richardson and Richardson, 'Morinda'.

25 Dudley, 'Karenic Textiles', p. 39.

26 Ibid., p. 24.

27 Diego Tamburini, 'Investigating Asian Colourants in Chinese Textiles from Dunhuang (7th–10th Century AD) by High Performance Liquid Chromatography Tandem Mass Spectrometry: Towards the Creation of a Mass Spectra Database', *Dyes and Pigments*, vol. 163 (April 2019), pp. 454–74.

28 Diego Tamburini and Joanne Dyer, 'Fibre Optic Reflectance Spectroscopy and Multispectral Imaging for the Non-invasive Investigation of Asian Colourants in Chinese Textiles from Dunhuang (7th–10th Century AD)', *Dyes and Pigments*, vol. 162 (March 2019), pp. 494–511.

29 Jian Liu et al., 'Profiling by HPLC-DAD-MSD Reveals a 2500-Year History of the Use of Natural Dyes in Northwest China', *Dyes and Pigments*, vol. 187 (March 2021), doi.org/10.1016/j.dyepig.2021.109143 (accessed 15 March 2023).

30 Edmund Knecht, Christopher Rawson and Richard Loewenthal, *A Manual of Dyeing: For the Use of Practical Dyers, Manufacturers, Students, and All Interested in the Art of Dyeing*, vol. 2, London: Charles Griffin & Co., 1893, pp. 667–74.

31 Some indication of the use of this dyeing method has recently been reported in: Irina Petroviciu, Iulia Teodorescu, Silvana Vasilca and Florin Albu, 'Transition from Natural to Early Synthetic Dyes in Romanian Traditional Shirts Decoration', *Heritage*, vol. 6, no. 1 (2023), pp. 505–23, doi.org/10.3390/heritage6010027 (accessed 15 March 2023).

32 For more information, see this recently published article: Diego Tamburini, Joanne Dyer and Caroline Cartwright, 'First Evidence and Characterisation of Rare Chrome-Based Colourants used on 19th-century Textiles from Myanmar', *Dyes and Pigments*, vol. 218 (2023), doi.org/10.1016/j.dyepig.2023.111472 (accessed 20 July 2023).

33 Cardon, 'Discovery and Mastery'.

34 Knecht et al., *Manual of Dyeing*, pp. 667–74.

35 Dudley, 'Karenic Textiles', p. 25.

36 Knecht et al., *Manual of Dyeing*, pp. 667–74.

37 Dudley, 'Karenic Textiles', p. 45.

CHAPTER 6

1 Government of Burma, *Report of the Superintendent of Cottage Industries Burma for the Year Ending 30 June 1931*, Rangoon, 1932, pp. 6–7.

2 Government of Burma, *Report of the Superintendent of Cottage Industries Burma for the Year Ending 30 June 1936*, Rangoon, 1937, p. 7. Sylvia Fraser-Lu, 'The Government Lacquer School and the Museum of Pagan', *Arts of Asia*, vol. 16, no. 4 (1986), pp. 104–11.

3 Sandra Dudley, 'Karenic Textiles', in *Eclectic Collecting: Art from Burma in the Denison Museum*, ed. Alexandra Green, Singapore: NUS Press, 2008, pp. 19–48, at p. 25.

4 John Cady, *A History of Modern Burma*, Ithaca, NY: Cornell University Press, 1958.

5 Robert H. Taylor, *The State in Myanmar*, Singapore: NUS Press, 2009.

6 Atsuko Naono and Michael W. Charney, 'The Burmese Economy Under the Japanese Occupation, 1942–1945', in *Economies Under Occupation: The Hegemony of Nazi Germany and Imperial Japan in World War II*, ed. Marcel Boldorf and Tetsuji Okazaki, London: Routledge, 2015, pp. 218–31.

7 Andrew Ranard, *Burmese Painting: A Linear and Lateral History*, Chiang Mai: Silkworm Books, 2009, p. 141. Charlotte Galloway, 'Art and Heritage: Creating and Preserving Cultural Histories', in *Myanmar: Politics, Economy and Society*, ed. Adam Simpson and Nicholas Farrelly, London: Routledge, 2020, pp. 171–85, at p. 172.

8 Sylvia Fraser-Lu, *Burmese Crafts: Past and Present*, Kuala Lumpur: Oxford University Press, 1994, p. 289.

9 Ibid., p. 308.

10 The Gurkhas are Nepalese soldiers known for their military prowess; they have been recruited into the British Army since 1815. Thousands of Gurkhas served in the Burma Campaign during the Second World War, with some subsequently settling in Burma. However, because they are not classified as an official ethnic group, the Gurkhas in Myanmar today are not eligible for citizenship.

CHAPTER 7

1 Robert Taylor, *General Ne Win: A Political Biography*, Singapore: Institute of Southeast Asian Studies, 2015.

2 Michael W. Charney, *A History of Modern Burma*, Cambridge: Cambridge University Press, 2009.

3 See Maung Bo Bo, 'The Burmese Military and the Press in U Nu's Burma', PhD dissertation, School of African and Oriental Studies, University of London, 2019, for information about censorship in this period.

4 Yoshihiro Nakanishi, *Strong Soldiers, Failed Revolution: The State and Military in Burma, 1962–1988*, Singapore: NUS Press, 2013.

5 Christina Fink, *Living Silence: Burma under Military Rule*, London: Zed Books, 2001. Martin Smith, *Burma: Insurgency and the Politics of Ethnicity*, London: Zed Books, 1991.

6 Matthew Bowser, '"Buddhism Has Been Insulted: Take Immediate Steps": Burmese Fascism and the Origins of Burmese Islamophobia, 1936–38', *Modern Asian Studies*, vol. 55, no. 4 (2021), pp. 1112–50.

7 See, for example, Yi Li, *Chinese in Colonial Burma: A Migrant Community in a Multi-Ethnic State*, New York: Palgrave Macmillan, 2017.

8 Mikael Gravers, 'Anti-Muslim Buddhist Nationalism in Burma and Sri Lanka: Religious Violence and Globalized Imaginaries of Endangered Identities', *Contemporary Buddhism*, vol. 16, no. 1 (2015), pp. 1–27.

9 Michael Adas, *The Burma Delta: Economic Development and Social Change on an Asian Rice Frontier, 1852–1941*, Madison: University of Wisconsin Press, 1974.

10 Marie Lall and Ashley South, 'Power Dynamics of Language and Education Policy in Myanmar's Contested Transition', *Comparative Education Review*, vol. 62, no. 4 (2018), pp. 482–502.

11 Gungwu Wang, *Nation Building: Five Southeast Asian Histories*, Singapore: Institute of Southeast Asian Studies, 2005.

12 Gordon H. Luce, *Old Burma–Early Pagán*, 3 vols, Locust Valley, NY: J.J. Augustin, 1969–70.

13 The BRS was established by people who became the major names in early Burma studies, such as J.S. Furnivall, J.A. Stewart, Gordon H. Luce, Pe Maung Tin and Charles Duroiselle.

14 Carol-Anne Boshier, *Mapping Cultural Nationalism: The Scholars of the Burma Research Society, 1910–1935*, Copenhagen: NIAS Press, 2018.

15 Md. Mahbubul Haque, 'Rohingya Ethnic Muslim Minority and the 1982 Citizenship Law in Burma', *Journal of Muslim Minority Affairs*, vol. 37, no. 4 (2017), pp. 454–69.

16 The *nats* also vary in different parts of Myanmar.

17 Justin Watkins, *Studies in Burmese Linguistics*, Canberra: Australian National University, 2005.

18 David Bradley, '*Miandianyu Fangyan Yanjiu* [Burmese Dialect Research] by Wang Danian and Cai Xiangyang' (review), *Anthropological Linguistics*, vol. 61, no. 1 (2019), pp. 135–9.

19 Ashley South, *Mon Nationalism and Civil War in Burma: The Golden Sheldrake*, London: Routledge, 2003.

20 The Shan states should not be confused with Shan State of modern Myanmar (see chapter 3). Chao Tzang Yawnghwe, *The Shan of Burma: Memoirs of a Shan Exile*, Singapore: Institute of Southeast Asian Studies, 2010.

21 Peter Kunstadter, *Southeast Asian Tribes, Minorities, and Nations*, vol. 1, Princeton, NJ: Princeton University Press, 2017.

22 On Barak, 'Infrastructures of Minoritisation', *Comparative Studies of South Asia, Africa, and the Middle East*, vol. 41, no. 3 (2021), pp. 347–54.

23 Marie Lall and Ashley South, 'Comparing Models of Non-state Ethnic Education in Myanmar: The Mon and Karen National Education Regimes', *Journal of Contemporary Asia*, vol. 44, no. 2 (2014), pp. 298–321.

24 Thein Lwin, 'Global Justice, National Education and Local Realities in Myanmar: A Civil Society Perspective', *Asia Pacific Education Review*, vol. 20, no. 2 (2019), pp. 273–84; Ashley South and Marie Lall, 'Language, Education and the Peace Process in Myanmar', *Contemporary Southeast Asia*, vol. 38, no. 1 (2016), pp. 128–53.

25 Nick Cheesman, 'How in Myanmar "National Races" Came to Surpass Citizenship and Exclude Rohingya', *Journal of Contemporary Asia*, vol. 47, no. 3 (2017), pp. 461–83.

26 Mikael Gravers (ed.), *Exploring Ethnic Diversity in Burma*, Copenhagen: NIAS Press, 2007.

27 Mandy Sadan, *Being and Becoming Kachin: Histories beyond the State in the Borderworlds of Burma*, Oxford: Oxford University Press, 2013.

28 Giulia Garbagni and Matthew Walton, 'Imagining Kawthoolei: Strategies of Petitioning for Karen Statehood in Burma in the First Half of the 20th Century', *Nations and Nationalism*, vol. 26, no. 3 (2020), pp. 759–74. Ardeth Maung Thawnghmung, *The 'Other' Karen in Myanmar: Ethnic Minorities and the Struggle without Arms*, Lanham, MD: Lexington Books, 2012; Ardeth Maung Thawnghmung, *The Karen Revolution in Burma: Diverse Voices, Uncertain Ends*, Singapore: Institute of Southeast Asian Studies, 2008.

29 Cheesman, 'How in Myanmar', pp. 461–83.

30 Marion Wettstein, *Naga Textiles: Design, Technique, Meaning and Effect of a Local Craft Tradition in Northeast India*, Stuttgart: Arnoldsche Art Publishers, 2014.

31 François Robinne, 'Memorial Art as an Anthropological Object (Chin State of Burma)', *Journal of Burma Studies*, vol. 19, no. 1 (2015), pp. 199–241. Sadan, *Being and Becoming Kachin*, pp. 391–7.

32 Benedict Anderson, *The Spectre of Comparisons: Nationalism, Southeast Asia, and the World*, London: Verso, 1998.

33 Mandy Sadan et al. (eds), *Rare Earth Elements, Global Inequalities and the Just Transition*, London: The British Academy, 2022.

34 Sadan, *Being and Becoming Kachin*.

CHAPTER 8

1 Michael W. Charney, *A History of Modern Burma*, Cambridge: Cambridge University Press, 2009, p. 65.

2 Anti-Union sentiment was not universal among Burma's ethnic minorities. Some factions among the Karen, for example, were pro-Union. See ibid., p. 99.

3 The military forces in Myanmar are known as the Tatmadaw, literally 'Royal Forces', implying legitimacy. In protest, some individuals refer to them as *sit-tat*, meaning 'armed forces'.

4 In relation to the conflicts involving Kachin peoples, Mandy Sadan highlights that ethnic relations and chauvinism have been used to explain these conflicts, often overlooking other factors such as ethnic and religious discrimination, as well as economic and political exclusion. See Mandy Sadan, *Being and Becoming Kachin: Histories beyond the State in the Borderworlds of Burma*, Oxford: Oxford University Press, 2013, p. 348.

5 Charney, *A History of Modern Burma*, p. 92.

6 While it was believed that U Nu asked Ne Win to assume temporary control, U Nu later stated that he was forced into the decision. Jane Ferguson, pers. comm., October 2022.

7 Charney, *A History of Modern Burma*, pp. 87–8.

8 Anna J. Allott, *Inked Over, Ripped Out: Burmese Storytellers and the Censors*, New York: PEN American Center, 1993, p. 4.

9 Director of Information, Union of Burma [April], Rangoon, 1953, p. 33, cited in Charlotte Galloway, 'Art and Heritage: Creating and Preserving Cultural Histories', in *Myanmar: Politics, Economy and Society*, ed. Adam Simpson and Nicholas Farrelly, London: Routledge, 2020, pp. 171–85, at p. 173.

10 For further discussions of silver patterning, see Alexandra Green, *Burmese Silver from the Colonial Period*, London: Ad Ilissum, 2022.

11 Sylvia Fraser-Lu, *Burmese Crafts: Past and Present*, Kuala Lumpur: Oxford University Press, 1994, pp. 179–80.

12 Ibid., pp. 174–81.

13 Ben Bansal, 'Concrete Flower of Myanmar: The Tripitaka Library, Yangon', *Uncube*, 18 August 2015, www.uncubemagazine.com/blog/15888275 (accessed 2 September 2022).

14 Charney, *A History of Modern Burma*, p. 89.

15 Ibid., p. 138.

16 Ben Bansal, Elliott Fox and Manuel Oka, 'U Thant Mausoleum', *Architectural Guide Yangon*, 1 October 2015, www.yangongui.de/u-thant-mausoleum (accessed 2 September 2022).

17 Charney, *A History of Modern Burma*, p. 119.

18 Such state-sanctioned categorisation of art had also occurred in the 1950s. The artist U Ngwe Gaing was sent to Britain on a government stipend in 1952 to sketch Burmese objects abroad. Upon his return, he received the prestigious *Alinga Kyaw Swa* artistic prize, as well as governmental support as part of a larger policy effort to promote Burmese art and culture. See Andrew Ranard, *Burmese Painting: A Linear and Lateral History*, Chang Mai: Silkworm Books, 2009, p. 142.

19 Charney, *A History of Modern Burma*, p. 112.

20 Melissa Carlson, 'Painting as Cipher: Censorship of the Visual Arts in Post-1988 Myanmar', *Sojourn: Journal of Social Issues in Southeast Asia*, vol. 31, no. 1 (March 2016), pp. 161–72, at p. 170.

21 For the full story, see John Clarke, 'On the Road Back to Mandalay: The Burmese Regalia – Seizure, Display and Return to Myanmar in 1964', in *Returning Southeast Asia's Past: Objects, Museums, and Restitution*, ed. Louise Tythacott and Panggah Ardiyansyah, Singapore: NUS Press, 2021, pp. 111–38.

22 In the 1960s and early 1970s, collections in Burma were nationalised, and museum management was placed under the Ministry of Culture.

23 For a summary of the arts under military rule, see Galloway, 'Art and Heritage', pp. 171–85. See also Thant Myint U, Moe Moe Lwin, Rupert Mann and Hugo Chan, *Yangon Heritage Strategy*, Yangon: Yangon Heritage Trust, 2016, www.burmalibrary. org/docs23/2016-08-Yangon_Heritage_Strategy-en-red.pdf (accessed 11 June 2023).

24 In 2011, following the adoption of a new Constitution and increasing political liberalisation, the national flag underwent a change. It now consists of three stripes – yellow, green and red – adorned with a large white star. The yellow represents solidarity, the green symbolises peace and the red signifies valour, while the star represents the union.

25 This categorisation of the eight national races fails to provide clear representation for certain groups, such as the Chinese, and completely excludes others, like the Rohingya.

26 Initially, the concept of 'eight national races' encompassed the Kachin, Karen, Karenni, Chin, Mon, Burman, Rakhine and Shan. Later, this list was expanded to include 135 ethnic groups believed to be 'validly' present in the country.

27 Charney, *A History of Modern Burma*, pp. 142–3.

28 For a full discussion, see Sadan, *Being and Becoming Kachin*, pp. 361–405.

29 Ibid., pp. 334–41. See also Lisa Maddigan, 'Kachin Textiles', in *Textiles from Burma*, ed. Elizabeth Dell and Sandra Dudley, London: Philip Wilson Publishers, 2003, pp. 69–75, at p. 69.

30 The sword and sheath are traditionally presented to a man on his wedding day. See Maddigan, 'Kachin Textiles', p. 69.

31 Ibid., pp. 69–70.

32 Pers. comm., Georg Noack, 21 June 2023. See Georg Noack, *Local Traditions, Global Modernities: Dress, Identity, and the Creation of Public Self-Images in Contemporary Urban Myanmar*, Berlin: Regiospectra, 2011.

33 Sandra Dudley, 'Diversity, Identity and Modernity in Exile: "Traditional" Karenni Clothing', in *Burma: Art and Archaeology*, ed. Alexandra Green and T. Richard Blurton, London: The British Museum Press, 2002, pp. 143–51, at p. 149. See also Ananda Rajah, 'A "Nation of Intent" in Burma: Karen Ethno-nationalism, Nationalism and Narrations of Nation', *Pacific Review*, vol. 15, no. 4 (2002), pp. 517–37.

34 Saya San led a rebellion against the British in 1930–31, while Thakin Po Hla Gyi, an oil worker, emerged as a prominent leader during a series of strikes against British rule in 1938–9.

35 Charney, *A History of Modern Burma*, p. 159.

36 In 2011, as part of further governmental changes, the country's name was once again revised to the Republic of the Union of Myanmar.

37 Charney, *A History of Modern Burma*, p. 169.

38 Ibid., p. 171.

39 Upon acquisition, the curator was informed that the plate had once been commissioned by an embassy of a Gulf state based in Yangon.

40 However, it should be noted that 25 per cent of parliamentary seats, as well as two vice-presidential positions and permanent control of the defence, border and home affairs ministries, automatically remained under the control of the military.

41 See, for example, 'The Face of Buddhist Terror', *Time Magazine*, 1 July 2013. General information about Myanmar is available on Amnesty International's website: www.amnesty.org/en/location/asia-and-the-pacific/south-east-asia-and-the-pacific/myanmar (accessed 11 June 2023). The Assistance Association of Political Prisoners, aappb.org (accessed 11 June 2023), has information about the country and records of statistics about it besides those about political prisoners.

42 Information about the competition can be found here: rohingyaphoto.com (accessed 11 June 2023).

CHAPTER 9

1 For additional reading on global modernism and terminology, see John Clark, *Modern Asian Art*, Honolulu: University of Hawai'i Press, 1998, and San Lin Tun, 'Terminologies of "Modern" and "Contemporary" "Art" in Southeast Asia's Vernacular Languages: Indonesian, Javanese, Khmer, Lao, Malay, Myanmar/Burmese, Tagalog/Filipino, Thai, and Vietnamese', *Southeast of Now: Directions in Contemporary and Modern Art in Asia*, vol. 2, no. 2 (October 2018) pp. 113–18.

2 Andrew Ranard, *Burmese Painting: A Linear and Lateral History*, Chiang Mai: Silkworm Books, 2009, p. 202.

3 Yin Ker, 'A Short Story of Bagyi Aung Soe in Five Images', *Asia Art Archive*, 1 December 2013, aaa.org.hk/en/ideas/ideas/a-short-story-of-bagyi-aung-soe-in-five-images/type/essays (accessed 10 March 2023).

4 Ranard, *Burmese Painting*, p. 241.

5 Yin Ker, 'Modern Burmese Painting According to Bagyi Aung Soe', *Journal of Burma Studies*, vol. 10 (2005/6), pp. 83–157, at pp. 89–90.

6 Ibid., p. 93.

7 Around 1953, Bagyi Aung Soe visited the Soviet Union, including Russia, and along the way stopped in Laos, India, Pakistan and Afghanistan, where he allegedly visited art museums to study 'Indian and Near Eastern arts'. Ranard, *Burmese Painting*, p. 242.

8 Kin Maung Yin's first movie *Hope No Longer, My Little Sister* (1963) featured extended shots of scenes from daily life. Ma Thanegi and Sonny Nyein, *This is Kin Maung Yin*, Yangon: Thit Sarpay, 2010, pp. 27, 33–7.

9 Arthur Sun Myint, pers. comm., 22 November 2022. Ma Thanegi, *Paw Oo Thett: His Life and Creativity (1936–1993)*, Yangon: Daw Moe Kay Khaing, 2004, p. 113.

10 San Minn, *A Man Called Nann Waii*, Yangon: Seikku Cho Cho, 2014, pp. 46–50.

11 Khin Maung added (Bank) to the end of his name to distinguish himself from the artist Khin Maung (Rangoon). Author interview with Arthur Sun Myint, digital platform, 7 December 2020. Ranard, *Burmese Painting*, p. 218.

12 Yin Ker, 'Modern Burmese Painting', p. 85.

13 Founded in 1948 in Westport, Connecticut, by members of the New York Society of Illustrators, the course typically consisted of twenty-four lessons. Upon completion of one lesson, the school mailed students the next one with each assignment being critiqued by a professional artist. Randy Kennedy, 'The Draw of a Mail-Order Art School', *New York Times*, 20 March 2014, www.nytimes.com/2014/03/23/arts/design/famous-artists-school-archives-go-to-norman-rockwell-museum.html (accessed 30 January 2023).

14 Ranard, *Burmese Painting*, p. 235.

15 Founded in 1946 in Mandalay, the Ludu Press served as an intellectual centre for artists and writers, publishing content that openly criticised the government. Ma Thanegi, *Paw Oo Thett*, p. 5.

16 Initial glimpses of artist as activist emerged in the colonial period, such as with Ba Nyan's (1897–1945) painting of a Rangoon harbour polluted by British steamers that suggested peril to Burmese traditional values. Such critiques were muted due to colonial-era restrictions on freedom of expression. See Ba Nyan, *Rangoon Harbour*, c. 1930s, in Ranard, *Burmese Painting*, p. 113.

17 Tony Day and Maya H.T. Liem, *Cultures at War: The Cold War and Cultural Expression in Southeast Asia*, Ithaca, NY: Cornell University Press, 2018, pp. 12–13.

18 Herbert Passin (ed.), *Cultural Freedom in Asia*, Tokyo: Charles E. Tuttle, 1956, pp. 4–5.

19 In 1955 and 1977 the US State Department sent Martha Graham and her dance troupe as ambassadors to Asia. 'Asian Tour Slated by Martha Graham and her Dancers', *New York Times*, 12 July 1974, www.nytimes.com/1974/07/12/archives/asian-tour-slated-by-martha-graham-and-her-dancers.html (accessed 10 March 2023).

20 Thomas J. Dorsey Jr of the Lenni-Lenape Tribal Nation, also known as Tom Two Arrows (1920–1993), performed in his traditional dress and lectured about his paintings at Sarpay Beikman in Rangoon (Yangon) in 1956. See www.albanyinstitute.org/tl_files/pdfs/library/Tom%20Dorsey%20Collection%2C%201935-2007.pdf (accessed 10 March 2023).

21 Author interview with Arthur Sun Myint, digital platform, 7 December 2020. Ma Thanegi and Sonny Nyein, *Kin Maung Yin*, p. 57.

22 Bo Bo, 'A Magazine is a Magazine: Vessels of Modern Burmese Culture', BBC News, 22 June 2022, www.bbc.com/burmese/in-depth-59511001 (accessed 10 March 2023).

23 Jennifer Leehy, 'Writing in a Crazy Way: Literary Life in Contemporary Urban Burma', in *Burma at the Turn of the 21st Century*, ed. Monique Skidmore, Honolulu: University of Hawai'i Press, 2005, pp. 175–205, at p. 201.

24 Mary P. Callahan, *Making Enemies: War and State Building in Burma*, Ithaca, NY: Cornell University Press, 2003, p. 183.

25 Author interviews with Arthur Sun Myint, 30 November 2020 and 7 December 2020.

26 Author interview with Chan Aye and Phyu Mon, 11 November 2020. Author interview with Maung Di, 13 November 2020. Author interview with Phyu Mon, 28 October 2020.

27 Soviet films such as *The Men of Daring* and *Sadko* featured Burmese subtitles. See Liam Kelley, 'Going to the Movies in 1954 Burma', Le Minh Khai's SEAsian History Blog (online blog), 5 April 2012, leminhkhai.blog/going-to-the-movies-in-1954-burma (accessed 10 March 2023).

28 Ma Thanegi, *This is Kin Maung Yin*, Yangon: Zabutalu Printing, 2010, p. 27. Author interview with Arthur Sun Myint, digital platform, 16 April 2023.

29 These individuals included such artists as Paw Oo Thett, Shwe Oung Thame, Maung Ngwe Tun, Maung Di, Byron and Alban Law Yone, Aung Taik, Myo Nyunt, Maung Maung Hla Myint, Kyi Twe, Sein Myint, Nan Waii, Bagyi Aung Soe and Arthur Sun Myint; poets Maung Tha Noe and Tin Moe; the writers Win Tin, Zaw Zaw Aung, Moe Thu, Thein Than Tun, Han Win Aung and Thein Tan; the movie star U Tun Wai; ambassador U Ohn and Colonel Kyi Maung; architect U Tha Tun and AI architects Bo Gyi, Aung Kyee Myint and Tin Tun (who founded AI in 1960). Interview with Arthur Sun Myint, 30 November 2020 and Ma Thanegi, *This is Kin Maung Yin*, p. 29.

30 Ma Thanegi, *Paw Oo Thett*, p. 7.

31 Burma Socialist Programme Party, *Party Seminar 1965: The Burma Socialist Programme Party, Central Organising Committee, Speeches of Chairman General Ne Win and Political Report of the General Secretary*, Rangoon, The Party, 1965, p. 105.

32 Andrew Selth, 'Death of a Hero: The U Thant Disturbances in Burma, December 1974', research paper, Griffith University, Queensland, Australia, July 2018, www.griffith.edu.au/__data/assets/pdf_file/0032/483827/AS-death-of-a-hero-U-Thant-disturbance-web-final.pdf (accessed 10 March 2023). Michael W. Charney, *A History of Modern Burma*, Cambridge: Cambridge University Press, 2009, p. 116.

33 U Thaung, *A Journalist, a General and an Army in Burma*, Bangkok: White Lotus Press, 1995, p. 55.

34 Mandy Sadan, 'The Historical Visual Economy of Photography in Burma', *Bijdragen tot de Taal-, Land- en Volkenkunde*, vol. 170, no. 2–3 (2014), pp. 281–312, at p. 304.

35 San Minn, 'Before Gangaw Village', unpublished.

36 Author interview with Kyaw Moe Tha, 30 September 2015, Mandalay.

37 Harry Priestly, 'A Very Burmese Way', *The Irrawaddy*, May 2005, www2.irrawaddy.org/article.php?art_id=4649 (accessed 10 March 2023).

38 Author interview with Kyaw Moe Tha, 30 September 2015, Mandalay.

39 Kyaw Hsu Mon, 'Laughter, the Best Medicine', *The Irrawaddy*, 29 August 2015, www.irrawaddy.com/news/burma/laughter-the-best-medicine.html (accessed 30 January 2023).

40 The Printers and Publishers Registration Law of 1962 established the legal codes to regulate print media and the Press Scrutiny Board formed the censorship body. See Anna J. Allott, *Inked Over, Ripped Out: Burmese Storytellers and Censors*, New York: PEN American Center, 1993, p. 5.

41 The YMCA exhibition featured Paw Oo Thett, Aung Taik, Shwe Oung Thame, San Myint, Alban Law Yone, Ma Yin Wyn, Maw Ba Han, Byron Law Yone and Kin Maung Yin.

42 Author interview with Arthur Sun Myint, 31 October 2022, London.

43 Around 1968, Shwe Oung Thein established gallery 555 on Merchant Street to display modern art, but it closed when Lokanat Galleries opened. Arthur Sun Myint, pers. comm., 14 July 2023.

44 Ma Thanegi and Sonny Nyein, *Kin Maung Yin*, p. 49.

45 The Report of the Indian Cinematograph Act (1927–8), Calcutta, 1928, details one such recommendation for censorship of visual imagery, a precursor to a Censorship Board.

46 Melissa Carlson, 'Painting as Cipher: Censorship of the Visual Arts in Post-1988 Myanmar', *Sojourn: Journal of Social Issues in Southeast Asia*, vol. 31, no. 1 (March 2016), pp. 116–72, at p. 117.

47 Author interview with Chan Aye, 22 June 2013, Yangon.

48 Melissa Carlson, Ian Holliday and Pyay Way, *Banned in Burma: Painting under Censorship*, unpublished exhibition guide, Nock Art Center and Hong Kong Visual Arts Centre, Hong Kong, October–November 2014.

49 Military intelligence had once filmed him selling a nude painting to a diplomat before an exhibition opened, and the censors later deemed the same painting problematic and removed it from the show. Author interview with Arthur Sun Myint, 30 November 2020.

50 Author interview with Phyu Mon, 20 October 2020.

51 Author interview with Aung Cheimt, 25 August 2020.

52 Maung Tha Noe, ထင်းရှူးပင်ရိပ် [Htin Shuu Pin Yeik, *In the Shade of the Pine Tree*], Rangoon: ယမင်းစာပေ [Yamin Sarpay], 1968.

53 T.S. Eliot, 'The Love Song of J. Alfred Prufrock', ll. 1–3.

54 Nan Waii studied at Rangoon University and worked there as an art instructor from 1965 to 1975. He taught many Gangaw Village members. Aung Min, *Myanmar Contemporary Art 1*, translated edition, Yangon: Myanmar Art Resource Center and Archive, 2017, pp. 48–9.

55 The founding Gangaw Village members included San Minn, Khin Swe Win, Kyee Myint Saw, Aung Kyaw Moe, Andrew, Aung Myint and Tito. Membership was limited to Rangoon University students. Aung Myint and Nathalie Johnston, *Aung Myint: 14 A.M.*, Yangon: n.p., 2014, p. 13.

56 Following the protests, soldiers patrolled downtown Rangoon streets and allegedly cut off the long hair of any young males they encountered, associating the hairstyle with anti-government sentiment. See Hla Oo, '1974 U Thant Uprising: A First Hand Account', *New Mandala*, 23 July 2008, www.newmandala.org/1974-u-thant-uprising-a-first-hand-account (accessed 10 March 2023).

57 After the 8 August 1988 uprising and the second military coup that marked the onset of the junta era (1988–2011), the authorities arrested Maung Theid Dhi. In 2000, seeking refuge in Mae Sot, Thailand, he painted portraits of Aung San Suu Kyi, a banned subject in Myanmar, and sold them in the local market. Local Thai police arrested him when he refused to bribe them and turned him over to Myanmar authorities. Without trial, officials sentenced him to two-and-a-half years in Insein Prison. Interview with Maung Theid Dhi, 7 October 2014, Yangon.

58 Ian Brown, *Burma's Economy in the Twentieth Century*, Cambridge: Cambridge University Press, 2013, p. 12.

59 Ma Thanegi, *This is Kin Maung Yin*, p. 53.

60 Artist and owner of Pansodan Gallery Aung Soe Min recalled that Kin Maung Yin told him that he modelled the original paintings after famous dancer Mya Chay Gyin Ma Ngwe Myaing. Aung Soe Min, pers. comm., 17 April 2023.

61 Ibid.

62 Mar Mar, pers. comm., 17 April 2023.

63 Ranard, *Burmese Painting*, p. 266.

64 Aung Myint and Nathalie Johnston, *Aung Myint*, p. 15.

65 Ibid.

66 Inya Gallery functioned as a community space, free from state censors, rather than a commercial gallery. See 'A Much-Needed Bridge (NICA, Yangon, 2003–2007)', Right People, Wrong Timing website, 2 October 2020, rpwt.greenpapaya.art/2020/10/a-much-needed-bridge-nica-yangon-2003.html?m=1 (accessed 10 March 2023).

67 Aung Myint and Nathalie Johnston, *Aung Myint*, p. 13.

68 Moe Satt, 'Short Introduction to Myanmar Performance Art', available at www.tfam.museum/File/files/05research/01modern%20art/%E7%B7%AC%E7%94%B8%E8%A1%8C%E7%82%BA%E8%97%9D%E8%A1%93%E7%B0%A1%E4%BB%8B.pdf (accessed 10 March 2023).

69 Aung Myint and Nathalie Johnston, *Aung Myint*, pp. 53–4.

70 Seiji Shimoda, pers. comm., 2 December 2022.

71 'A Much-Needed Bridge'.

72 Catherine Diamond, 'Drenched in Victory, Facing Drought: Staging Transitions in Myanmar's Performing Arts', *Asian Theatre Journal*, vol. 34, no. 2 (Fall 2017), pp. 347–71, at pp. 348–9.

73 Aung Myint went to Japan in 1999 for the 6th Nippon International Performance Festival (NIPAF '99). Seiji Shimoda, pers. comm., 25 November 2022.

74 Ellen Pearlman, 'An Artist-Run Nonprofit Helps Open up Myanmar to Contemporary Art', *Hyperallergic*, 1 September 2017, hyperallergic.com/384403/myanmar-contemporary-art-new-zero (accessed 30 January 2023).

75 Nora Taylor, 'Sedimented Acts: Performing History and Historicizing Performance in Vietnam, Myanmar and Singapore', *Southeast of Now: Directions in Contemporary and Modern Art in Asia*, vol. 6, no. 1 (March 2022), pp. 13–21, at p. 20.

76 The workshop was called 'Collaboration, Networking, Resource-Sharing: Myanmar' and was held over six days in June 2002 at Beikthano Gallery in Yangon.

77 San Minn travelled to Finland, Phyu Mon to Malaysia, Chaw Ei Thein to Cambodia and Htein Lin to Malaysia. Author interview with Phyu Mon, 19 October 2022.

78 Chan Aye recalled seeing performances by Morgan O'Hara in 2012 at New Zero's International Multimedia Art Festival (IMAF) in Yangon. Chan Aye, pers. comm., 14 October 2022.

79 A 2010 general election, widely perceived as fraudulent and boycotted by Aung San Suu Kyi's NLD party, resulted in a semi-civilian government led by the military-backed Union Solidarity and Development Party (USDP) with General Thein Sein as president.

80 Carlson, 'Painting as Cipher', p. 151.

81 Niklas Foxeus, 'Performing the Nation in Myanmar: Buddhist Nationalist Rituals and Boundary-Making', *Bijdragen tot de Taal-, Land- en Volkenkunde*, vol. 178, no. 2–3 (2022), pp. 272–305, at p. 272. See also Matthew Walton, *Buddhism, Politics and Political Thought in Myanmar*, Cambridge: Cambridge University Press, 2017.

82 Chan Aye, pers. comm., 14 October 2022.

83 'Ink Lake: Maria Brinch & Aung Myint', Myanm/art website, 5 April 2020, myanmartevolution.com/2020/04/05/ink-lake-maria-brinch-aung-myint (accessed 10 March 2023).

84 Nathalie Johnston, 'Myanmar Artists are Making History', *ArtReview Asia*, 1 April 2020, artreview.com/myanmar-artists-are-making-history (accessed 10 March 2023).

85 *San Minn: 15th One Man Show (Prison Series)*, Lokanat Galleries, Yangon, available on the *Asia Art Archive* website: aaa.org.hk/tc/collections/search/library/san-minn-15th-one-man-show-prison-series (accessed 10 March 2023).

86 'Concept, Context, Contestation: Art that Asks You to Look Inside Yourself', *The Irrawaddy*, 23 January 2019, www.irrawaddy.com/culture/arts/concept-context-contestation-art-asks-look-inside.html (accessed 10 March 2023).

87 Lwin Mar Htun, 'Post-Independence History Told through Artists' Memories', *The Irrawaddy*, 5 July 2018, www.irrawaddy.com/culture/arts/post-independence-history-told-artists-memories.html (accessed 10 March 2023).

88 Johnston, 'Myanmar Artists'.

89 Ibid.

90 Soe Yu Nwe and Nayoung Jeong, 'Virtual360 Konnect-Bounded Women', *Culture360 ASEF*, 25 November 2020, culture360.asef.org/magazine/virtual360-konnect-bounded-women (accessed 30 January 2023).

91 Soe Yu Nwe, pers. comm., 13 July 2023.

92 Thynn Lei Nwe, pers. comm., 1 August 2022.

93 Launched on 5 June 2021 in connection with Earth Day, *The Revolution Forest* included a campaign that requested supporters to plant actual trees across Myanmar in honour of those killed protesting the 2021 coup: www.therevolutionforest.com (accessed 15 March 2023). An online spreadsheet tracks deceased protestors and trees planted in their memory (the exact location remains hidden).

94 The author attended the virtual memorial launch and guided online presentation on 19 July 2021.

95 In addition to the main mausoleum, viewers can explore four rooms titled 'Forest of Life', 'Rest in Power', 'Every Step a Flower Blooms' and 'After Darkest Night, Comes the Dawn', each offering an outlet for mourning. Anonymous, pers. comm., 14 November 2022.

APPENDIX

1 For details on how to download 'BM_workspace' and the Nip2 software, as well as descriptions, workflows and data requirements for the post-processing of these images, see the manual on multispectral imaging techniques. See also Joanne Dyer, Giovanni Verri and John Cupitt, *Multispectral Imaging in Reflectance and Photo-Induced Luminescence Modes: A User Manual*, 2013, European CHARISMA Project, published online. Associated publications are: Joanne Dyer et al., 'A Multispectral Imaging Approach Integrated into the Study of Late Antique Textiles from Egypt', *PLoS ONE*, vol. 13, no. 10 (2018), doi.org/10.1371/journal.pone.0204699 (accessed 15 March 2023); Diego Tamburini and Joanne Dyer, 'Fibre Optic Reflectance Spectroscopy and Multispectral Imaging for the Non-invasive Investigation of Asian Colourants in Chinese Textiles from Dunhuang (7th–10th Century AD)', *Dyes and Pigments*, vol. 162 (March 2019), pp. 494–511.

2 Diego Tamburini et al., 'An Investigation of the Dye Palette in Chinese Silk Embroidery from Dunhuang (Tang Dynasty)', *Archaeological and Anthropological Sciences*, vol. 11, no. 4 (2018), pp. 1221–39.

SELECT
BIBLIOGRAPHY

Allott, Anna J., *Inked Over, Ripped Out: Burmese Storytellers and the Censors*, New York: PEN American Center, 1993.

Anderson, Benedict, *The Spectre of Comparisons: Nationalism, Southeast Asia, and the World*, London: Verso, 1998.

Ardeth Maung Thawnghmung, *The 'Other' Karen in Myanmar: Ethnic Minorities and the Struggle without Arms*, Lanham, MD: Lexington Books, 2012.

Aung-Thwin, Michael, and Maitrii Aung-Thwin, *A History of Myanmar since Ancient Times: Traditions and Transformations*, London: Reaktion Books, 2012.

Bahadur, Mutua, *Art of the Textile: Manipuri Textiles from Bangladesh and Myanmar*, Imphal: Mutua Museum, 2009.

Barbosa, Duarte, *The Book of Duarte Barbosa: An Account of the Countries Bordering on the Indian Ocean and Their Inhabitants*, 2 vols, trans. Mansel Longworth Dames, London: Hakluyt Society, 1918–21.

Bautze-Picron, Claudine, *Timeless Vistas of the Cosmos: The Buddhist Murals of Pagan*, Bangkok: Orchid Press, 2003.

Beemer, Bryce, 'The Creole City in Mainland Southeast Asia: Slave Gathering Warfare and Cultural Exchange in Burma, Thailand and Manipur, 18th–19th C', PhD dissertation, University of Hawai'i, 2013.

Braun, Erik, *The Birth of Insight: Meditation, Modern Buddhism, and the Burmese Monk Ledi Sayadaw*, Chicago, IL: University of Chicago Press, 2013.

Brown, Ian, *Burma's Economy in the Twentieth Century*, Cambridge: Cambridge University Press, 2013.

Charney, Michael W., *Powerful Learning: Buddhist Literati and the Throne in Burma's Last Dynasty*, Ann Arbor: University of Michigan Press, 2006.

———, *A History of Modern Burma*, Cambridge: Cambridge University Press, 2009.

Conway, Susan, *The Shan: Culture, Arts and Crafts*, Bangkok: River Books, 2006.

Dell, Elizabeth (ed.), *Burma: Frontier Photographs, 1918–1935; The James Henry Green Collection*, London: Merrell Publishing in association with the Green Centre for Non-Western Art, 2000.

——— and Sandra Dudley (eds), *Textiles from Burma: Featuring the James Henry Green Collection*, London: Philip Wilson Publishers, 2003.

Fraser-Lu, Sylvia, *Silverware of South-East Asia*, Singapore: Oxford University Press, 1989.

———, *Burmese Crafts: Past and Present*, Kuala Lumpur: Oxford University Press, 1994.

———, *Burmese Lacquerware*, Bangkok: Orchid Press, 2000.

———, *Textiles in Burman Culture*, Chiang Mai: Silkworm Books, 2021.

——— and Donald M. Stadtner (eds), *Buddhist Art of Myanmar*, New Haven, CT: Asia Society Museum/Yale University Press, 2015.

Ginsburg, Henry, *Thai Manuscript Painting*, London: The British Library, 1989.

Gommans, Jos, and Jacques Leider (eds), *The Maritime Frontier of Burma: Exploring Political, Cultural and Commercial Interaction in the Indian Ocean World, 1200–1800*, Amsterdam: Koninklijke Nederlandse Akademie van Wetenschappen, 2002.

Gravers, Mikael (ed.), *Exploring Ethnic Diversity in Burma*, Copenhagen: NIAS Press, 2007.

Green, Alexandra (ed.), *Eclectic Collecting: Art from Burma in the Denison Museum*, Singapore: NUS Press, 2008.

———, *Buddhist Visual Cultures, Rhetoric, and Narrative in Late Burmese Wall Paintings*, Hong Kong: Hong Kong University Press, 2018.

———, *Burmese Silver from the Colonial Period*, London: Ad Ilissum, 2022.

——— and T. Richard Blurton (eds), *Burma: Art and Archaeology*, London: The British Museum Press, 2002.

Gutman, Pamela, *Burma's Lost Kingdoms: Splendours of Arakan*, Bangkok: Orchid Press, 2001.

Guy, John, *Woven Cargoes: Indian Textiles in the East*, London: Thames & Hudson, 1998.

Horton Ryley, J., *Ralph Fitch: England's Pioneer to India and Burma: His Companions and Contemporaries; with his Remarkable Narrative Told in his Own Words*, London: T.F. Unwin, 1899.

Isaacs, Ralph, and T. Richard Blurton, *Visions from the Golden Land: Burma and the Art of Lacquer*, London: The British Museum Press, 2000.

Knecht, Edmund, Christopher Rawson and Richard Loewenthal, *A Manual of Dyeing: For the Use of Practical Dyers, Manufacturers, Students, and All Interested in the Art of Dyeing*, vol. 2, London: Charles Griffin & Co., 1893.

Laichen Sun, 'Ming-Southeast Asian Overland Interactions, 1368–1644', PhD dissertation, University of Michigan, 2000.

Leider, Jacques P., *King Alaungmintaya's Golden Letter to King George II (7 May 1756)*, Hannover: Gottfried Wilhelm Leibniz Bibliothek, 2009.

Leoshko, Janice (ed.), *Bodhgaya: The Site of Enlightenment*, Bombay: Marg Publications, 1988.

Lieberman, Victor, *Burmese Administrative Cycles: Anarchy and Conquest, c. 1580–1760*, Princeton, NJ: Princeton University Press, 1984.

———, *Strange Parallels: Southeast Asia in Global Context, c. 800–1830*, 2 vols, Cambridge: Cambridge University Press, 2003 and 2009.

Luce, Gordon H., *Old Burma–Early Pagán*, 3 vols, Locust Valley, NY: J.J. Augustin, 1969–70.

Mahlo, Dietrich, *The Early Coins of Myanmar/Burma: Messengers from the Past: Pyu, Mon, and Candras of Arakan, First Millennium AD*, Bangkok: White Lotus Press, 2012.

Manrique, Sebastian, *Travels of Fray Sebastian Manrique, 1629–1643*, Oxford: Hakluyt Society, 1927.

Murphy, Stephen A. (ed.), *Cities and Kings: Ancient Treasures from Myanmar*, Singapore: Asian Civilisations Museum, 2016.

Myo Myint, 'Politics of Survival in Burma: Diplomacy and Statecraft in the Reign of King Mindon, 1853–1878', PhD dissertation, Cornell University, 1987.

Pichard, Pierre, and François Robinne (eds), *Études birmanes en hommage à Denise Bernot*, Paris: École française d'Extrême-Orient, 1998.

Ranard, Andrew, *Burmese Painting: A Linear and Lateral History*, Chiang Mai: Silkworm Books, 2009.

Sadan, Mandy, *Being and Becoming Kachin: Histories beyond the State in the Borderworlds of Burma*, Oxford: Oxford University Press, 2013.

——— et al. (eds), *Rare Earth Elements, Global Inequalities and the 'Just Transition'*, London: The British Academy, 2022.

Sai Aung Tun, *History of the Shan State from its Origins to 1962*, Chiang Mai: Silkworm Books, 2009.

Sangermano, Vincenzo, *A Description of the Burmese Empire*, 5th edn, London: Susil Gupta, 1966.

Schwartzberg, Joseph E., 'Southeast Asian Geographical Maps', in *The History of Cartography: Cartography in the Traditional East and Southeast Asian Societies*, ed. J.B. Harley and Davis Woodward, vol. 2, book 2, Chicago, IL: University of Chicago Press, 1994, chs 17–20.

Scott, James George, and John Percy Hardiman, *Gazetteer of Upper Burma and the Shan States*, 2 vols, Rangoon: Superintendent of Government Printing and Stationery, 1900–1901.

Shwe Yoe, *The Burman: His Life and Notions*, 2nd edn, London: Macmillan and Co., 1896.

Simpson, Adam, and Nicholas Farrelly (eds), *Myanmar: Politics, Economy and Society*, London: Routledge, 2020.

Smith, Martin, *Burma: Insurgency and the Politics of Ethnicity*, London: Zed Books, 1991.

South, Ashley, *Mon Nationalism and Civil War in Burma: The Golden Sheldrake*, London: Routledge, 2003.

Stadtner, Donald M., *Ancient Bagan: Buddhist Plain of Merit*, Bangkok: River Books, 2013.

———, *Sacred Sites of Burma: Myth and Folklore in an Evolving Spiritual Realm*, Bangkok: River Books, 2010.

Strachan, Paul, *Pagan: Art and Architecture of Old Burma*, Arran: Kiscadale Publications, 1989.

Symes, Michael, *An Account of an Embassy to the Kingdom of Ava in the Year 1795*, London: W. Bulmer and Co., 1800 (repr. New Delhi: Asian Educational Services, 1995).

Tainturier, François, *Mandalay and the Art of Building Cities in Burma*, Singapore: NUS Press, 2021.

Taylor, Robert H., *The State in Myanmar*, Singapore: NUS Press, 2009.

Than Htun, *Lacquerware Journeys: The Untold Story of Burmese Lacquer*, Bangkok: River Books, 2013.

Than Tun, *The Royal Orders of Burma, AD 1598–1885*, 10 vols, Kyoto: Center for Southeast Asian Studies, Kyoto University, 1986.

Thant Myint-U, *The Making of Modern Burma*, Cambridge: Cambridge University Press, 2001.

Turner, Alicia, *Saving Buddhism: The Impermanence of Religion in Colonial Burma*, Honolulu: University of Hawai'i Press, 2014.

U Tin, *The Royal Administration of Burma*, trans. Euan Bagshawe, Bangkok: Ava Publishing House, 2001.

van Schaik, Sam, et al. (eds), *Precious Treasures from the Diamond Throne: Finds from the Site of the Buddha's Enlightenment*, British Museum Research Publication 228, London: The British Museum, 2021.

Wouters, Jelle J.P., and Michael T. Heneise (eds), *Routledge Handbook of Highland Asia*, London: Routledge, 2022.

Yi Li, *Chinese in Colonial Burma: A Migrant Community in a Multi-Ethnic State*, New York: Palgrave Macmillan, 2017.

Yule, Henry, *A Narrative of the Mission Sent by the Governor General of India to the Court of Ava in 1855, with Notices of the Country, Government, and People*, London: Smith, Elder & Co., 1858.

LIST OF CONTRIBUTORS

Anonymous

Maitrii Aung-Thwin is Associate Professor of Myanmar/Southeast Asian History and Convener of the Comparative Asian Studies PhD Programme at the National University of Singapore. His current research is concerned with nation-building, identity, knowledge production and resistance in South and Southeast Asia. Publications include *A History of Myanmar since Ancient Times: Traditions and Transformations* (2012, with Michael Aung-Thwin), *The Return of the Galon King: History, Law, and Rebellion in Colonial Burma* (2011) and *A New History of Southeast Asia* (2010, with Merle Ricklefs et al.). He is a trustee of the Burma Studies Foundation, USA, and editor of the *Journal of Southeast Asian Studies*.

Melissa Carlson is a PhD candidate at the University of California, Berkeley, focusing on Southeast Asian modernism in the late twentieth and early twenty-first centuries. Her dissertation examines the development of postcolonial Burmese modern art and national identity under the constellation of authoritarianism, isolationism and censorship. As a Fellow in Modern Art Histories of South and Southeast Asia (MAHASSA) (2019–20), she presented on innovative artist collectives as part of the 2020 Dhaka Art Summit. Select publications include chapters in *March Meeting 2021: Unravelling the Present* (Sharjah Art Museum, 2021) and *Ambitious Alignments: New Art Histories of Southeast Asia* (National Gallery of Singapore, 2018).

Caroline Cartwright is a Senior Scientist in the Department of Scientific Research at the British Museum. Her areas of scientific expertise cover the identification of organic materials, including wood, charcoal, fibres, macro-plant remains, ivory and shell, mainly using scanning electron microscopy. She has participated in many fieldwork and archaeological projects in the Middle East, Africa, Mesoamerica, the Caribbean and Europe. Reconstructing past environments, charting vegetation and climate changes, and investigating bioarchaeological evidence from sites and data also form important aspects of her research. Before joining the British Museum, she was a lecturer at the Institute of Archaeology, University College London.

Joanne Dyer is a Colour Scientist in the Department of Scientific Research at the British Museum and specialises in the study of colour, colourants and their sources. Trained as a photochemist and vibrational spectroscopist, her research interests lie in the interaction between light and the materials encountered on ancient polychrome surfaces and archaeological textiles. Her research uses non-invasive methods and imaging techniques for the study of these coloured surfaces, enabling them to be read and understood in new ways.

Alexandra Green is Henry Ginsburg Curator for Southeast Asia at the British Museum. She has written and edited numerous books and articles on Southeast Asian art and culture, including *Southeast Asia: A History in Objects* (2023), *Raffles in Southeast Asia: Revisiting the Scholar and Statesman* (2019), *Buddhist Visual Cultures, Rhetoric and Narrative in Late Burmese Wall Paintings* (2018), *Rethinking Visual Narratives from Asia: Intercultural and Comparative Perspectives* (2013), *Eclectic Collecting: Art from Burma in the Denison Museum* (2008) and *Burma: Art and Archaeology* (2002, with T. Richard Blurton). Besides Myanmar, her research interests include narrative theory and histories of collecting.

Alexandra Kaloyanides is Associate Professor of Religious Studies at the University of North Carolina at Charlotte and the author of *Baptizing Burma: Religious Change in the Last Buddhist Kingdom* (2023). Her writing has appeared in the *Journal of Southeast Asian Studies*, *Journal of Burma Studies*, *Material Religion*, *Asian Ethnology*, *Journal of the American Academy of Religion*, *MAVCOR Journal*, *Journal of Global Buddhism*, *Sojourn: Journal of Social Issues in Southeast Asia*, *Church History*, *Religions*, *Tricycle: The Buddhist Review* and *Marginalia Review of Books*.

Pyiet Phyo Kyaw specialised in contemporary sculpture at the University of Culture (now the National University of Arts and Culture), Yangon, graduating in 2002. He joined the archaeology postgraduate diploma programme at the University of Yangon (Rangoon University) in 2003, was invited to join the master's degree programme, and was awarded an MA in 2005. His PhD on the Bagan period was awarded in 2012. He first worked at the University of Yangon in 2005, before being appointed Professor in the Department of Archaeology at the University of Mandalay in 2020 and transferring to the University of Yangon in 2022. His research interests and publications focus on the ancient kingdom of Bagan.

Mandy Sadan is Professor of Global Sustainable Development at the University of Warwick. She has worked on issues of marginalisation, political representation and culture in the northern region of Myanmar since the mid-1990s and has published extensively about the Kachin region in particular. Recent projects with local research partners include studies of jadeite and rare earths extraction and the impact on local communities. A major research resource relating to the tangible and intangible material cultural heritage of Kachin-identifying communities, which explores many aspects of this work, is available at pjlarchive.omeka.net.

Arthur Swan Ye Tun is a PhD candidate at the National University of Singapore researching the First Anglo-Burmese War and the history of its presentation to the public. He has a master's degree in Strategic Studies from the S. Rajaratnam School of International Studies, Nanyang Technological University, Singapore and a bachelor's degree in Historical Studies and a minor in Drama and Theatre Studies from the Universiti Brunei Darussalam. His research interests include civil–military relations, pre-colonial Myanmar and military history. Outside of academia, he also makes content on Burmese history on YouTube.

Diego Tamburini is an analytical chemist who obtained his PhD in Chemistry and Materials Science from the University of Pisa in 2015. He held an Andrew W. Mellon postdoctoral fellowship at the British Museum focusing on the identification of dyes in textiles. In 2020, he moved to the Department of Conservation and Scientific Research of the National Museum of Asian Art (Smithsonian Institution) as a Smithsonian Postdoctoral Fellow to study nineteenth-century Central Asian *ikat* textiles. After a short postdoctoral fellowship at Northwestern University, Illinois, he rejoined the British Museum in 2021 in the role of Scientist: Polymers and Modern Organic Materials.

Thaw Zin Latt is a researcher currently based in London. After obtaining a BA in Archaeology from the University of Yangon and a postgraduate diploma from the Field School of Archaeology in Myanmar, he worked as part of the excavation of the ancient city of Hanthawaddy in Bago. He subsequently received a master's degree in the History of Art and Archaeology from the School of Oriental and African Studies (SOAS), University of London, and held an internship jointly with SOAS and the British Museum. His main research interests are the Hindu-Buddhist art of Myanmar and Southeast Asia.

ACKNOWLEDGEMENTS

This project has been a joint venture with many, many people. First, I would like to thank the contributors to the volume – Maitrii Aung-Thwin, Melissa Carlson, Caroline Cartwright, Joanne Dyer, Alexandra Kaloyanides, Pyiet Phyo Kyaw, Mandy Sadan, Arthur Swan Ye Tun, Diego Tamburini and the anonymous author. I am particularly grateful to Thaw Zin Latt for his work on many fronts. Without their efforts, this volume would not have come to fruition.

A community group advised about content and other matters. Many thanks are due to them, including Bo Bo Lansin, Bo Bo Lwin, Kyel Sin, Min Sett Hein, Moe Kyaw Soe, Mun Ja Sumlut, Soe Min Tun, Thaw Zin Latt, Theingi Lynn, Theint Aung, Zauli Lahkum-Lahpai and others who wish to remain anonymous. Ei Ei Saing helped with work on the Burmese-language chapter summaries.

Michael Charney, Sandra Dudley, Jane Ferguson, Tilman Frasch, Jotika Khur-Yearn, Rachel King, Zauli Lahkaum-Lapai, Victor Lieberman, Stephen Murphy, Georg Noack and Martin Smith liberally gave their time to read drafts of the content. Bryce Beemer waded through the entire volume, for which heartfelt thanks are due.

Aw Pi Kyeh and Kyaw Thu Yein generously allowed their cartoons to be reprinted, and I am also very grateful to Seikuchocho Publishing House, Ludu Press, Irrawaddy Press and the families of Pe Thein and Harn Lay for giving permission for the cartoons to be republished. I am very appreciative of the support from Burmese artists, including Aung Myint, Khin Swe Win, Khin Thethtar Latt, Ro Mehrooz, Nan Da, Sawangwongse Yawnghwe, Soe Yu Nwe, Arthur Sun Myint, Thynn Lei Nwe, the families of Bagyi Aung Soe, Kin Maung Yin, Maung Theid Dhi, Paw Oo Thett and San Minn and the artists who produced the 100 Projectors Project. I would like to thank Saya Nai Kon Ha Ti, Ein Dray Pyone Han, Mehm Chan Nai and many others who remain anonymous for their assistance.

I travelled across the UK from Aberdeen to the Isle of Wight, Exeter to Ipswich and many points between to examine objects in collections, as well as contacting many museums that I did not visit. I explored the collections of a few international institutions. I was kindly assisted by many people in these endeavours, including Patricia Allan, Daw Aye Aye Khine, Daw Aye Aye Thinn, Rachel Barclay, Nick Barnard, Sandra Bauza, Ian Beavis, Faye Belsey, Johannes Beltz, Katina Bill, Alex Blakeborough, Teri Booth, Frank Bowles, Carol Cains, Elinor Camille-Wood, Alessandra Cereda, Sau Fong Chan, Angela Clare, Joanna Cole, Chris Cooper, Ruth Cox, Hannah Crowdy, Nicholas Crowe, Clare Cunliffe, Bernadette Curley, Eli Dawson, Caroline Dempsey, Duncan Dornan, Tony Eccles, Abeer Eladany, Lisa Evans, Gillian Evison, Avalon Fotheringham, William Frame, Sally Goodsir, Lisa Graves, Mirat Habib, Triona White Hamilton, Toni Hardy, Tom Harper, Rachel Heminway Hurst, Doug Henderson, Melanie Hollis, Michael Hunter, Jana Igunma, Susannah Jarvis, Maria Kekki, Daw Khine Mon, Ella Kilgallon, Susanne Knoedel, U Kyaw Oo Lwin, Richard LeSaux, Inbal Livne, Alasdair Macleod, Margaret Makepeace, Thomas Mallinson, Emma Martin, Theresa McCullough, Ryan McKellar, Helen Mears, Daw Mie Mie Khaing, Philip Millward, Kate Newnham, Rosanna Nicolson, Georg Noack, Nu Mra Zan, Gerry O'Neill, Andrew Parkin, Rachel Peat, Al Poole, Jane Raftery, Mary Redfern, Calum Robertson, Maria Rollo, Andrew Ross, Jane Rowlands, Cam Sharp-Jones, Anna Spender, Pierrette Squires, Anne Taylor, Marianne Templeton, Thein Lwin, Nandini Thilak, Zenzie Tinker, Ian Trumble, Duncan Walker, Sinead Ward, Edward Weech, Matthias Wehry, Caroline Wilkinson, Liz Wilkinson, Ye Myat Aung and Noorashikin Zulkifli.

In searching for information, I was generously assisted by Stuart Allan, Larry Ashmun, Aung Soe Min, Aung Soe Myint, Bart Was Not Here, Bo Bo Lansin, Vicky Bowman, Stephanie Braun, Guy Carr, Nachiket Chanchani, Nance Cunningham, Sylvia Fraser-Lu, Christian Gilberti, Naomi Gingold, Nicole Hartwell, Htein Lin, Bob Hudson, Klemens Karlsson, Thalia Kennedy, Fiona Kerlogue, Khin Kyi Phyu Thant, Thomas Kingston, Ko Ko Thett, Jacques Leider, Janice Leoshko, Lin Htet, Kirt Mausert, Patrick McCormick, Forrest McGill, Sujatha Meegama, Elizabeth Moore, Ni Ni Khet, Noriuki Osada, Nathalie Paarlberg, Natasha Pairaudeau, Samerchai Poolsuwan, Jim Potter, William Pruitt, Shafiur Rahman, John Randall, Julian Sands, Soe Min Tun, Don Stadtner, François Tainturier, Yuri Takahashi, Thant Myint-U, Tharapi Than, Cherry Thinn, Padetha Tin, Alicia Turner and Justin Watkins.

Other people who assisted or supported the project include Jeff Allan, Joanna Barnard, Pamela Cross, Charlotte Galloway, Nathalie Johnston, Graham Honeybill, Kyaw Zwar Min, Sally Macdonald, Mai Ni Ni Aung, Jill Morley Smith, Phyo Win Latt, John Randall, Philippe Sands, Phil Thornton, Tahnee Wade and Terry Watkins.

As always, I was generously assisted by several people at the Foreign, Commonwealth & Development Office, including Rurik Marsden, Andrew Patrick, Peter Thomas and Peter Vowles. Sarah Deverall at the British Council in Myanmar was also enthusiastic.

Numerous people at the British Museum have worked on the Myanmar project. In Exhibitions, thanks go to Jane Bennett, Lauren Papworth, Lindsey Snook and Christopher Stewart. In Photography, I would like to thank David Agar, Stephen Dodd, Joanna Fernandes, Isabel Marshall, Saul Peckham and Bradley Timms. In the Conservation department, thanks are due to Rachel Berridge, Louisa Burden, Maxim Chesnokov, Eliza Doherty, Anna Harrison, Michelle Hercules, Loretta Hogan, Megumi Mizumura, Alex Owen, Monique Pullan, Matthias Sotiras and Keeley Wilson. I am very grateful to Helene Delaunay for co-ordinating conservation work. Christina Angelo, Hannah James, Imogen Laing and Ellie Welch meticulously prepared the objects, for which I am grateful. Many thanks are due to Gavin Bell and Rachel Mortlock, as well as to Paul Chirnside, Maria Howell, Declan Kilfeather, Keith Lyons, Simon Prentice, Miguel Roque, Benjamin Watts, Samantha Wyles and Stella Yeung. On the design front, I would like to thank Vicci Ward, Peter Macdermid and Helen Eger, as well as Paul Goodhead. Curatorially, thanks go to Hugo Chapman, Stephen Coppel, James Hamill, Emily Hannam, Tom Hockenhull, Olenka Horbatsch, Mizuho Ikeda, Zeina Klink-Hoppe, Liu Ruiliang, Luk Yu-ping, Carol Michaelson, Venetia Porter, Judy Rudoe and Helen Wang. The scientists who wrote chapter 5 would like to thank Antony Simpson for his assistance during the acquisition of digital microscopy images. In Learning and National Partnerships, I am grateful to Stuart Frost, Vicky Harrison, Alice Kirk, Laura Lewis, Kayte McSweeney and Hilary Williams. In Advancement, the project was supported by Evelyn Curtin, Jennifer Ebrey, Gina Grassi, Jessica Hogg, Lucy Holmes and Eleanor Leahy. Luminita Holban was very encouraging. Sean McParland, Jane Parsons, Kira Rogers, Alexandra Tilley-Loughrey, Connor Watson, Miranda Wiseman and Philip Woods from Marketing, Communication and Events have done a wonderful job. Thanks are also due to Joao Cordeiro, Tara Manser and Sian Toogood. Mica Benjamin-Mannix and Hannah Scully managed the complex administration required for a project of this scope well. I am particularly indebted to Stephanie Jong and Asha McLoughlin for their hard work and guidance. Last but not least, I would also like to thank Hartwig Fischer, Jonathan Williams, Jill Maggs, Jane Portal and Rosalind Winton for all their encouragement and support.

During the publication process, I was wonderfully supported by Lydia Cooper, who was heroic in editing the text and managing the project. I would also like to thank Toni Allum and Claudia Bloch, as well as Francesca Hillier, Robert Sargant and Jon Wilcox. Thank you to Beata Kibil for her work managing the production of the book, to Jules Bettinson, Rob King and Harry King at Altaimage, and to Daniela Rocha for the book's design.

Sadly, three people involved with the project did not live to see it come to fruition – John Okell, who generously helped me read sections of the Konbaung dynasty chronicles; Robert White, a person of great enthusiasm for the project who determinedly worked to make it happen; and John Clarke, my counterpart at the Victoria and Albert Museum who was going to write a chapter for this book.

I am of course very grateful to Zemen Paulos and Jack Ryan for their generous support; without them this project would not have been possible. Many thanks are also due to Ron and Gillian Graham for their unwavering encouragement, generosity and enthusiasm. Tim Butchard and the Charles Wallace Burma Trust are to be thanked for their important assistance too. I would like to thank Robert San Pe for his donation in loving memory of Professor Tony Hla Pe and Mrs Diana Marjorie Pe, and other supporters who wish to remain anonymous.

This book is a testimony to the hard work of all involved. It is an effort to pay tribute to the long histories of Myanmar's many peoples. Thank you.

CREDITS

INDEX